After Modern Art
1945–2000

Oxford History of Art

Dr David Hopkins is Senior Lecturer in Art History at the
University of Glasgow, where his broad areas of specialism are
Dada and Surrealism, the history and theory of post-1945 art, and
twentieth-century photography. He has published extensively on
Dada and Surrealism and related topics in post-war art. His
publications include *Marcel Duchamp and Max Ernst: the Bride
Shared* (Oxford University Press, Clarendon Studies in the History
of Art, 1998) and *Marcel Duchamp* (London, 1999), co-authored
with Dawn Ades and Neil Cox. He has recently curated an
exhibition of photographs by Weegee at the Stills Gallery,
Edinburgh. He also writes and performs poetry, often in
collaboration with other performers and visual artists.

Oxford History of Art

Titles in the Oxford History of Art series are up-to-date, fully illustrated introductions to a wide variety of subjects written by leading experts in their field. They will appear regularly, building into an interlocking and comprehensive series. In the list below, published titles appear in bold.

Oxford History of Art

After Modern Art
1945–2000

David Hopkins

OXFORD
UNIVERSITY PRESS

OXFORD
UNIVERSITY PRESS

Great Clarendon Street, Oxford OX2 6DP

Oxford New York
Athens Auckland Bangkok Bogotá Buenos Aires Cape Town
Chennai Dar es Salaam Delhi Florence Hong Kong Istanbul Karachi
Kolkata Kuala Lumpur Madrid Melbourne Mexico City Mumbai
Nairobi Paris São Paulo Shanghai Singapore Taipei Tokyo Toronto Warsaw
and associated companies in Berlin Ibadan

Oxford is a registered trade mark of Oxford University Press
in the UK and in certain other countries

0–19–284234–X *(Pbk)*
0–19–284281–1 *(Hbk)*

10 9 8 7 6 5 4 3

British Library Cataloguing in Publication Data
Data available

Library of Congress Cataloguing in Publication Data
Hopkins, David.
After Modern Art 1945–2000 / David Hopkins.
(Oxford history of art)
Includes bibliographical references and index.
1. Art, American. 2. Art, European. 3. Art, Modern–20th century–United States. 4. Art,
Modern – 20th century – Europe. I. Title. II Series.
N6512 .H657 2000 709'.04–dc21 00-036750

ISBN 0–19–284234–X *(Pbk)*
ISBN 0–19–284281–1 *(Hbk)*

Picture research by Thelma Gilbert
Typeset by Paul Manning
Design by John Saunders
Printed in Hong Kong on acid-free paper by C&C Offset Printing Co. Ltd

*The web sites referred to in the list on pages 266–8 of this book are in the public domain and
the addresses are provided by Oxford University Press in good faith and for information
only. Oxford University Press disclaims any responsibility for their content.*

Contents

Introduction

On 9 August 1945 an atom bomb fell on Nagasaki in Japan, bringing the Second World War to a close. During the six years of the conflict an incalculable number of people had lost their lives. Soon the West would become aware of the horrors of the Holocaust visited on Germany's Jewish population. Stalin's atrocities in Russia would also become apparent. Before long a new ideological 'Cold War' between Eastern Europe and America would structure international relations in the West. These are the stark realities from which this history of postwar Western art stems. The German Marxist Theodor Adorno once asserted that it would be barbaric to write lyric poetry after Auschwitz.[1] How, he implied, could art measure up to the immensities of technological warfare and the extermination of whole populations? Art in the age of the mass media would, in his view, have to take on a resistant character if it were not to become ineffectual and compromised. Much of this book examines the continuation of an 'avant-garde' artistic project after 1945, although not necessarily in Adorno's terms. The art it discusses is therefore frequently challenging, provocative, and 'difficult'. One of my main aims has been to retain a sense of its inner dynamic by emphasizing the critical and theoretical debates that nourished it, informed its contexts, and continue to make it meaningful.

This book's framework is broadly chronological, with much of the established artistic canon in place, although a number of non-standard names and lesser-known works have been included. One of the aspirations of recent art history has been the abandonment of an artist-led conception of the subject in favour of examining how 'representations' of various kinds are culturally produced. Whilst this book deals extensively with issues of cultural politics, gender identity, and the institutional support structures for art (the market, critics, education, and galleries), I have felt it necessary to preserve a strong sense of the historical agency of individual artists. In many ways this is appropriate to the period. Despite an ideologically motivated call for the 'death of the artist', the fact remains that in real terms the prestige of individual artists has continued to be paramount. An 'archaeology' of art's societal position is also more difficult to achieve for an era that is so close to us.

Detail of 48

The most pressing task still seems to be one of structuring the period as a historical entity, and making it coherent. As yet, few books have attempted to encompass the whole period from 1945 to the end of the twentieth century. Those that have done so have often ended up looking self-defeatingly encyclopaedic or self-protectively partisan.

The latter point notwithstanding, I should acknowledge that my interpretation has its biases. Although I have attempted to balance a range of contrasting opinions, this book would lack urgency if it lacked a viewpoint. Broadly speaking, I argue that the Duchampian attack on traditional aesthetic categories has been the engine behind the distinctive shifts in postwar art. As a consequence, photography, performance, conceptual proposals, installation art, film, video, and appropriations from mass culture play an equal part in this book alongside painting and sculpture. I have also avoided an overly narrow schematization of the period in terms of art movements. Whilst subsections deal with the various artistic formations, my chapters are largely thematic in orientation. They deal with Modernism and cultural politics, the establishment of the Duchampian model, the artist's persona, art and commodity culture, aesthetic debates, the questioning of the art object, and the shift to a 'postmodern' cultural situation. These themes are related to the gradual demise of Modernism, which in turn involves an ongoing examination of the dynamic interplay between European and American art. In the past, general histories of the period tended to be heavily slanted towards America. It would be a distortion to deny American art's central importance, but I have tried throughout the book to deal with how this was negotiated and often opposed in Europe.

The book's historical trajectory largely follows from the above. The narrative begins with the immediate postwar situation, dwells on the period up to the end of the Cold War in 1989, and ends with a discussion about the position of art at the close of the twentieth century.

Writing a book of this scope to a strict word limit imposes an enormous commitment of time and energy. I am particularly grateful to Kate for putting up with me and reading sections in draft form, and to my former colleague Simon Dell, whose conversation and thoughtful reading of the final manuscript were invaluable. Beyond this, my many intellectual debts are acknowledged in the text itself.

Katharine Reeve's encouragement and comments on the text have been deeply appreciated whilst Simon Mason, my original editor, was wonderfully enthusiastic. Thelma Gilbert's efforts in obtaining illustrations are also gratefully acknowledged, as are Paul Manning's care and patience with the production. Much of this book derives from my

teaching over a 15-year period. My students at the Art College in Edinburgh or at the Universities of Essex, Northumbria, Edinburgh, and St Andrews often shared unknowingly in formulating its arguments. My sincere thanks to them.

David Hopkins

The Politics of Modernism: Abstract Expressionism and the European *Informel*

1

Look closely at the image on page 6 of this book [1]. It appears to be an icon of postwar experimental art—an early 1950s abstraction by the American painter Jackson Pollock. However, read the caption and it is revealed to be a pastiche by Art & Language, a group of post-1960s Conceptual artists. In many ways it encapsulates the politics underpinning the subject of this chapter, the rise of Modernism after the Second World War. But how, exactly?

Give the image a couple of seconds, and something reveals itself among the abstract brushstrokes: Lenin's leftward-inclined profile, with familiar pointed beard. This peculiar marriage of styles is clearly bound up with two divergent artistic principles; realism and abstraction. In the immediate postwar years these were the dominant aesthetic orientations linked to the cultural climates of the world's most powerful political rivals. Communist Russia favoured legible Socialist Realism for a collective audience, whilst capitalist America and Western Europe in general attached considerable cultural kudos to the notion of a difficult or 'avant-garde' art. Like Art & Language's hidden image of Lenin, the art of postwar Russia and Eastern Europe is 'invisible' in the pages that follow. But the aesthetic and ideological alternatives it represented continued to be strangely active, usually at a submerged level. The direction of American and European art in the early Cold War years was haunted by discarded options.

Lost politics: Abstract Expressionism
A logical place to start is in America just before the Second World War. The spectacle of the 1930s Depression had encouraged many young artists to adopt left-wing principles. Established as part of President Roosevelt's New Deal, the Federal Art Project provided work for large

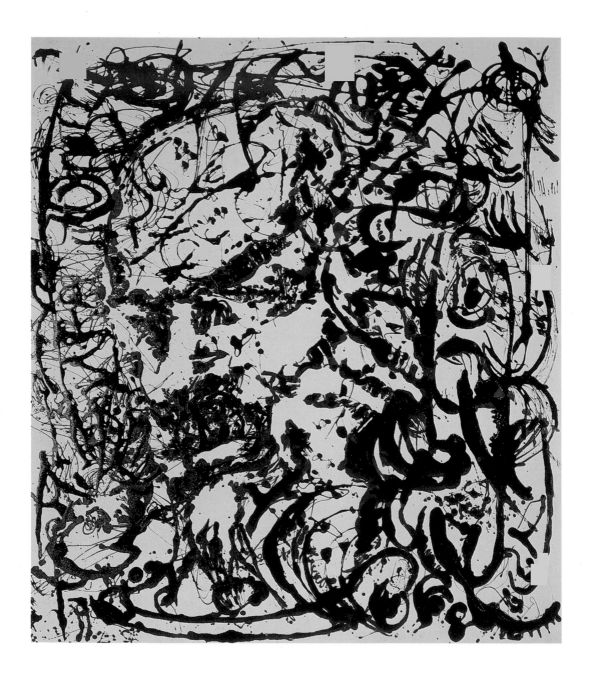

1 Art & Language

*Portrait of V. I. Lenin by
V. Charangovich (1970) in the
Style of Jackson Pollock II,*
1980

numbers of them, actively encouraging the production of public murals
in styles related to Soviet Socialist Realism. Certain areas of the Project
also allowed artists room to experiment. Several painters who were to
emerge as important avant-garde figures after the war, such as Jackson
Pollock, Mark Rothko, and Arshile Gorky, benefited from the liberal
atmosphere of the Project's New York-based 'Easel section'.

Pollock and Rothko had strong Marxist sympathies (hence the
aptness of [1] as a reminder of Pollock's residual concerns). They

supported the Popular Front set up by European Communists to combat Fascism. They also sympathized with the way that prewar European avant-garde formations such as French Surrealism or Dutch *de Stijl* had combined commitments to artistic innovation with radical social or political visions. All in all, the outlooks of Pollock and Rothko were internationalist. In this they departed from the 'isolationist' ideology of the Federal Art Project. For all its tolerance, the Project's basic concern was to promote socially accessible American vernacular imagery. For Pollock and Rothko such concerns were far too narrow.

From the mid-1930s both artists belonged to the Artists' Union, an organization dedicated to improving the conditions of working artists. It is significant, however, that Rothko, along with other artists and intellectuals, severely modified his political activities in the late 1930s when the American Artists' Congress, a body allied with the Popular Front, supported a series of controversial Soviet manoeuvres including Stalin's show trials, the Ribbentrop Pact of 1939, and the invasion of Finland. This dispute heralded an increasing disillusionment with political engagement on the part of many avant-garde artists in New York. In 1938 the French Surrealist leader André Breton had joined the Mexican muralist Diego Rivera and the exiled Communist Leon Trotsky to compose an important manifesto entitled 'Towards a Free Revolutionary Art' which asserted that artistic and socialist radicalism should go hand in hand. [1] The New Yorkers welcomed its refutation of Soviet aesthetic dogma but they gradually became wary of its affirmation of (socialist) revolutionary politics.

A contributing factor to their political pessimism was America's entry into the Second World War in 1942. The irrational basis for mankind's actions seemed to them irrefutable. In this atmosphere the arrival in the United States of various *émigrés* associated with prewar Surrealism (including André Breton, Max Ernst, and André Masson between 1939 and 1941) was remarkably well timed. It had seemed previously that two main aesthetic options were on offer; on the one hand realist modes, which although signalling social purpose seemed pictorially limited; and on the other post-Cubist European abstraction, which could look emotionally arid. The New Yorkers now found that Surrealism's commitment to the unconscious and myth allowed them to instil loaded content into their increasingly abstract pictures without directly addressing politics. In a famous letter to the *New York Times* in 1943 the painters Rothko and Adolph Gottlieb defended their recent work against critical incomprehension by asserting the profundity of its content: 'There is no such thing as good painting about nothing. We assert that only that subject matter is valid which is tragic and timeless.' [2]

Such concerns united an expanding group of artists, including figures such as Pollock, Rothko, Arshile Gorky, Willem de Kooning, Barnett Newman, Robert Motherwell, Clyfford Still, and Adolph

Gottlieb. Although they were soon to be labelled 'Abstract Expressionists' (a term coined in 1946 by Robert Coates in an exhibition review), they never organized themselves into a coherent avant-garde formation. They were, however, unified to some extent by the patronage of Peggy Guggenheim. This wealthy heiress was beginning to shift the emphasis away from Surrealism at her newly established Art of This Century Gallery, and she gave several Abstract Expressionists early exhibitions, notably Pollock. Critics such as James Johnson Sweeney and, most significantly, Clement Greenberg started to support the new tendencies from 1943 whilst exhibitions such as Howard Putzel's 'A Problem for Critics' (1945) overtly fished for ways of characterizing the new aesthetic momentum. Personal friendships aside, the artists themselves prized their individuality. Attempts at group definition tended to be short-lived. These included the formation of the 'Subjects of the Artist' school in 1948–9 and the 'Studio 35' discussions held in 1950.

What was distinctive about the work produced by this loosely defined group? Jackson Pollock's *Guardians of the Secret* [2] demonstrates how stylistic borrowings from Cubist-derived abstraction, Expressionism, and Surrealism tended to be fused with a growing interest in myth and primitivism (although key figures such as Robert Motherwell and Willem de Kooning were less taken with the latter). The loose, frenetic handling of paints conveys expressive urgency,

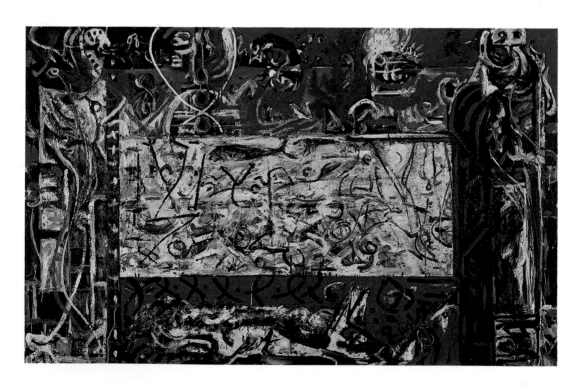

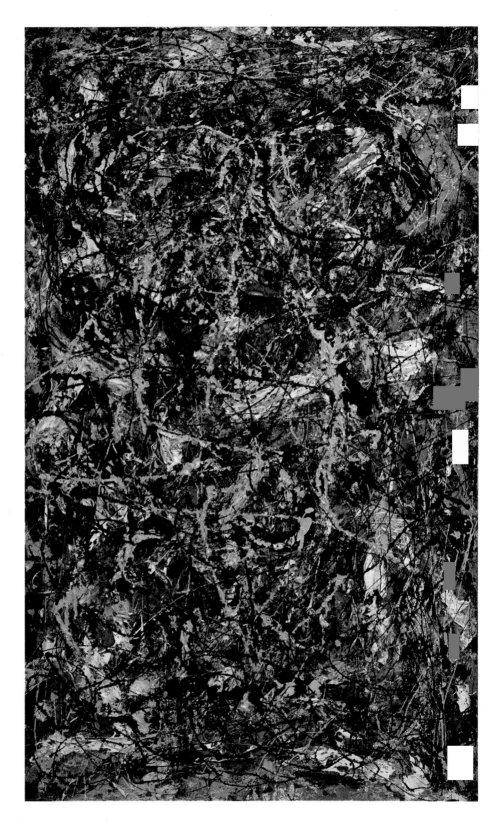

3 Jackson Pollock

Full Fathom Five, 1947

This comparatively small canvas was one of the first in which Pollock used his 'drip painting' technique. Given that the canvas was placed horizontally, the title, an allusion to Shakespeare's *The Tempest* ('Full fathom five thy father lies …'), conveys a sense of the image containing hidden 'depths', as does the incorporation of enigmatic foreign bodies (keys etc.) among the skeins of paint.

particularly in the central section where a form reminiscent of a scroll or tablet bearing calligraphy is pointedly untranslatable. Presumably this represents the 'secret' of the title. The 'figures' at left and right—which amalgamate influences from Picasso (a key exemplar for Pollock) and American Indian totems—are possibly archaic guardian figures. The picture has been interpreted as an analogue for the perils of Pollock's practice. His troubled personal background, which led to alcoholism and the decision to enter Jungian analysis at the end of the 1930s, predisposed him to see Surrealist procedures such as automatism (a kind of elevated doodling deriving from unconscious impulses) as a means towards self-realization.

This picture also foreshadows later developments in Pollock's work. Put rather crudely, the calligraphic 'secret' eventually swamped the entire surfaces of Pollock's massive 'drip paintings' of 1947–51 [3]. These uncompromisingly abstract works were produced in a dramatically different fashion from his earlier paintings. Using sticks rather than brushes, Pollock rhythmically hurled and spattered industrial paints onto huge expanses of unstretched canvas placed on his studio floor. In formal terms, a daring step beyond Cubism and prewar abstraction was achieved. A continuous visual 'field' was created which was accented by the fluid syntax, and associated punctuational concentrations of line and colour, rather than distinct compositional foci.

At the same time, Pollock's manner of working suggested a radical rethinking of picture-making's orientation from a vertical register (the wall or easel) to the horizontal. The figurative mediators from earlier works were submerged in an automatist tracery directly indexed to Pollock's bodily actions and impulses. In certain instances, such as the enormous *One (Number 31)* of 1950, it seemed as though Pollock had completely dispensed with elements of figuration. However, photographs of him at work on another significant work of that year, *Autumn Rhythm*, suggest that initial indications of animals or figures were later assimilated into broader visual patterns. The fact that Pollock, as he told his wife, the painter Lee Krasner, chose to 'veil' what may have been uncomfortably personal (and formally expendable) imagery returns us at this point to Art & Language's ironic opening image. Psychological remnants notwithstanding, this reminds us of a lost political dimension to Pollock's practice.

Cold War aesthetics

Politics returns more obliquely here in relation to the wider cultural ambience of late 1940s America. The art historian Michael Leja has shown that, as much as Abstract Expressionists like Pollock and Rothko dabbled in psychoanalysis and classical myth (and it should be noted that Pollock apparently read little), they were also directly affected by the topical theme of 'Modern Man'. Whether embodied

in magazine articles, films, or socio-philosophical treatises (by the likes of Lewis Mumford and Archibald MacLeish), this line of thought held man to be fundamentally irrational, driven by unknowable forces from within and without. Hence the typical *film noir* plot in which the haunted hero-figure becomes enmeshed in crime or violence for reasons beyond his control.[3] It is not difficult to imagine Pollock mythologizing himself in such terms, but the larger point is that, however much Abstract Expressionist bohemianism, which involved infamous brawls at New York's Cedar Tavern, continued a venerable anti-bourgeois tradition, it was inevitably part and parcel of this wider discourse. And in certain ways this was the ideology of a newly emerging class of 'business liberals'.

Basically, the interests of this emergent class were 'expansionist' in global terms, in opposition to the isolationist policies of the older conservative political establishment. Thus 'Modern Man' discourse, as articulated by the liberal ideologue Arthur Schlesinger in his influential *The Vital Center* (1949), paradoxically saw alienation and insecurity as the necessary accompaniments of the West's freedoms: 'Against totalitarian certitude, free society can only offer modern man devoured by alienation and fallibility.'[4] Psychoanalysis, which was as popular with the new liberal intelligentsia as with artists like Pollock, thus served to 'explain' man's alienation in a frightening but free world and to expose the irrational basis of extreme political options such as Fascism and Communism. Critics occasionally hinted at parallels between Pollock's psychic outpourings and the forces unleashed at Hiroshima and Nagasaki. There is a sense, then, in which Pollock ironically spoke to bourgeois needs, positing irrationality not only as man's lot but also as something controllable, just as America's governing elite saw the advances of psychoanalysis and nuclear technology as means of harnessing anarchic forces. His ability to express such contradictory concerns possibly helps explain his appeal to a liberal middle-class audience.[5] By 1948 his apparently unassimilable images had acquired appreciable market success, signalling Abstract Expressionism's cultural breakthrough.[6] However, the role played by Clement Greenberg's criticism of his work, to be discussed later, should not be underestimated.

The upshot of the above, in the words of the art historian T. J. Clark, is that 'capitalism at a certain stage … *needs* a more convincing account of the bodily, the sensual, the "free" … in order to extend its colonization of everyday life.'[7] In terms of economics, Serge Guilbaut has noted that such a process of colonization was originally extended to American art via the needs of a wealthy art-buying class starved of imports from France's prestigious art market during the war.[8] By the early 1950s this social sector, which incorporated the liberal intellectuals described above, was backing President Truman's increasingly imperialist foreign

policy and his stepping-up of a 'Cold War' against Communism (as initially symbolized by America's intervention in the Greek crisis of 1947).

Despite the best efforts of conservative anti-modernists such as the Senator for Michigan, George Dondero, the 'freedom' which liberals read into the paintings of Pollock and his contemporaries came to signify America's democratic values as opposed to the conformism of official Communist culture. Just as the Marshall Plan (initiated in 1947) sought to extend America's influence in Europe through much-needed economic aid, so America's new radical avant-garde art was eventually exported in the late 1950s under the auspices of New York's Museum of Modern Art (MOMA). American art now appeared to epitomize Western cultural values. However, this had been implied as early as 1948 by the critic Clement Greenberg. Bordering on chauvinism, he asserted: 'The main premises of Western painting have at last migrated to the United States, along with the center of gravity of industrial production and political power.'[9]

Art historians such as Guilbaut have argued that in the later 1950s the American government's promotion of Abstract Expressionism abroad amounted to cultural imperialism. As stated, New York's MOMA organized the touring exhibitions in question. Founded in 1929 as the first museum solely dedicated to modern art in the West, MOMA was well placed to position the American painting of the 1940s as the crowning culmination of a history of modern art from Impressionism onwards. Under its International Program (organized by Porter McCray), exhibitions underwritten by this logic regularly toured Europe in the late 1950s, most notably 'The New American Painting' of 1958–9, curated by Alfred J. Barr and seen in eight countries. Something of America's success in imposing its artistic authority on Europe can be gauged from the fact that when, in 1959, the Abstract Expressionists were shown *en masse* at the second 'Documenta' exhibition in Kassel (America's contribution representing about one-sixth of the total works on display), McCray was allowed to choose works himself since the German selectors felt unequal to the task.

At this point Art & Language's opening image [1] can clearly be seen as a demonstration, in line with the thought of historians such as Guilbaut and Leja, that Abstract Expressionism was unwittingly infused with the politics of the Cold War. It is important, however, to stress that this is a selective and inevitably partial interpretation of history. Its value lies in accounting for the extent to which US-based Modernism quickly commanded authority in the West. In fact the impetus behind official American backing for Abstract Expressionism and its offshoots came as much from 'local' European antagonisms as from the imagined evils of Russian Communism.

4 Renato Guttoso

The Discussion, 1959–60
According to the artist this painting depicted an 'ideological discussion'. As such it evokes the stormy realist–abstraction debates, and allied political differences, among artists in Italy after the Second World War. Stylistically, the work skilfully weds the rhythms of Italian baroque art to the prewar modernist idioms of Picasso and Cubism.

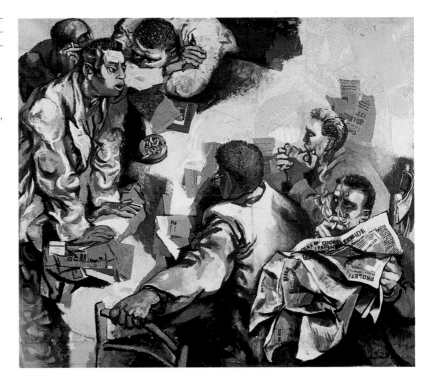

Art and social function

In France and Italy after the war, the emergence of strong Communist parties (initially invited to join coalition governments due to their roles in wartime resistance to Fascism) led to debates among artists concerning the competing claims of a socially oriented realism and those of self-expressive experimentalism. Ironically, these arguments revive the aesthetic choices open to American artists at the end of the 1930s.

Postwar Italy was politically volatile, with frequent changes of government. The eventual triumph of the Christian Democrats was resented by increasingly marginalized Socialist and Communist groups, and artistic positions reflected passionate political convictions. Realist critics, working in the wake of an important movement in film exemplified by Roberto Rossellini's Resistance story, *Rome, Open City* of 1945, regularly clashed with abstractionists. There were lively exchanges between groups linked to the PCI (Partito Communista Italiano) such as the Fronte Nuovo delle Arti (founded 1946) and pro-abstraction groups such as Forma (launched in 1947). The painter Renato Guttoso was attached to the former group until 1948 when it dissolved due to particularly inflexible policies on Realism on the part of the PCI. As an artist he combined elements of Picasso's post-Cubist vocabulary with stylistic and iconographic allusions to Italy's pictorial traditions in large-scale 'history paintings' addressed to matters of

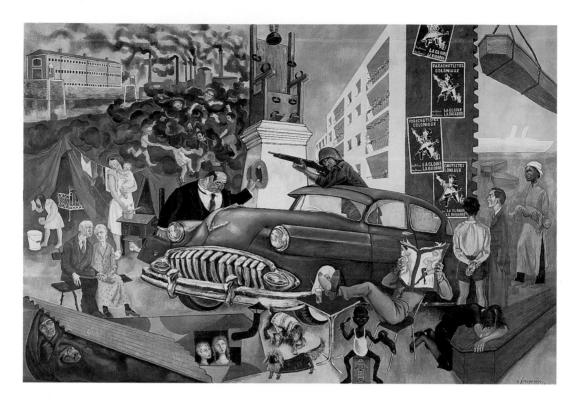

public concern. In 1942 his attempt at a modern religious painting, *Crucifixion*, provoked the indignation of Catholics due to the inclusion of a naked Magdalene. His commitment to a practice of painting embodying public or moral discourse is perhaps most directly expressed in the later work *The Discussion* of 1959–60 [**4**].

In France, Communist-affiliated Realists proved stubborn opponents of America's cultural and political aspirations for Europe. The country which had held unquestioned art-world dominance before 1939 was now severely demoralized after years of Occupation. Rather than prestigious artistic formations there now existed a complex cluster of factions. Among these, Socialist Realists attached to the PCF (French Communist Party) were again engaged in heated debates with abstractionists. After the expulsion of Communists from the government in 1947, they adopted an extreme opposition to American influence in France (millions of dollars were being poured into the country as part of the Marshall Plan, with the hidden agenda of securing a stable, 'centrist' position between the Communists and the right-wing Gaullists).[10] This was accompanied by hard-line support for an art addressed to themes reflecting the workers' historical heritage in accordance with the policies of the Soviet cultural ideologue Andrei Zhdanov. Artists such as Boris Taslitzsky and André Fougeron produced large paintings on themes such as Resistance heroism or industrial unrest.

France had a strong tradition of large-scale paintings of public import. The examples of the nineteenth-century painters David, Géricault, and Courbet were particularly vivid, and young French artists now looked to the example of senior figures such as Fernand Léger and Pablo Picasso, both of whom were attached to the PCF. In 1951 Picasso was to produce the *Massacre in Korea*, which implicitly criticized American intervention in the Korean conflict. However, Picasso's eclectic use of modernist idioms conflicted with the uncompromising realism of painters such as Fougeron. Even Fougeron was criticized by the ex-Surrealist Communist critic Louis Aragon for straying onto Trotskyist aesthetic territory with the anti-realist dislocations of scale of his *Civilisation Atlantique* of 1953 [**5**]. (As already noted, Trotsky and Breton had argued that art should be revolutionary in its form as well as its politics.) The imagery in *Civilisation Atlantique* amounted to a denunciation of the stepping-up of American Cold War policy in the early 1950s. Conceived very much as a 'history painting' addressing a broad public, it juxtaposed photographically derived images in a wilfully illustrational and populist manner. This was the antithesis of Abstract Expressionism, the embodiment of America's aesthetic latitude.

However, although Abstract Expressionist individualism was promoted by the American establishment to counter the collectivist ideals of Socialist Realism, the works by the Abstract Expressionists themselves were actually predicated on the notion of public address. As well as recalling his Federal Art Project background, Pollock's experiments in pictorial scale partly derived from his enthusiasm for murals by socially committed Mexican painters of the 1930s and 1940s such as Gabriel Orozco, David Siqueiros, and Diego Rivera. In this sense his paintings carried residues of a public function. Barnett Newman, who alongside Rothko represented a tendency in Abstract Expressionism

6 Barnett Newman

Vir Heroicus Sublimis, 1950–1
The assertive flatness of the implacable field of red is emphasized by the linear vertical 'zips'. Rather than functioning as 'drawing' within space, these reinforce and delimit the space as a whole. White 'zips' in Newman's works also evoke primal beginnings: the separation of light from darkness, the uprightness of man in the void.

away from Pollock's linear 'gesturalism' in favour of expanses of colour, exemplifies the contradictions involved here. His *Vir Heroicus Sublimis* of 1950–1 [6] presents the complete antithesis to Fougeron's *Civilisation Atlantique* in visual terms. Abandoning what he once described as the 'props and crutches' of conventional figurative subject-matter, Newman presents an uncompromising 15-foot-wide field of solid red broken only by 'zips' of colour. In its resolute elimination of traditional composition this has direct affinities with Pollock's 'drip paintings' of the previous years [3]. But Newman's work, like Fougeron's, implicitly assumes it has a public to address, if only by virtue of its scale. The question is, who constitutes this public? Recalling the early political sympathies of the Abstract Expressionists, Newman stated grandly in the late 1940s that, read properly, his works would signify 'the end of all state capitalism and totalitarianism'.[11] Ironically, of course, those able to buy and 'read' them tended to be upholders of state power.

Shrewdly noting the Abstract Expressionists' moves away from what he termed the 'cabinet picture', the critic Clement Greenberg wrote: 'while the painter's relation to his art has become more private ... the architectural and presumably social location for which he destines his produce has become, in inverse ratio, more public. This is the paradox, the contradiction, in the master-current of painting.'[12] Greenberg was correct in pinpointing the paradox. But whereas he was to number scale amongst the purely formal innovations of the new 'master-current' and eventually to denigrate the 'private' concerns of the artists, he appears to have lost track of the politics latent in their practice. So, to a degree, did the Abstract Expressionists. Or rather, political engagement for them gave way to a sense of awe in the face of historical forces. Whilst artists such as Newman and Robert Motherwell developed anarchist sympathies and saw their works as implicitly negating the values of American culture, the public state-ments of Rothko and Newman in the late 1940s were full of invocations of tragedy and sublimity. 'We are re-asserting man's natural desire for the exalted ... instead of making *cathedrals* out of Christ, man, or "life", we are making them out of ourselves, out of our feelings,' wrote Newman.[13] Leaving aside the complex dialogue between aesthetic integrity and political commitment outlined above, this concern with metaphysics suggests a new line of comparison with the French painting of the period.

The bodily and the transcendent: France and America

After the war France was obsessed with *épuration* (purging or cleansing). This desire to expunge memories of the Nazi Occupation in the country manifested itself in the ruthless hounding out of Nazi collaborators. This climate also bred existential philosophies empha-

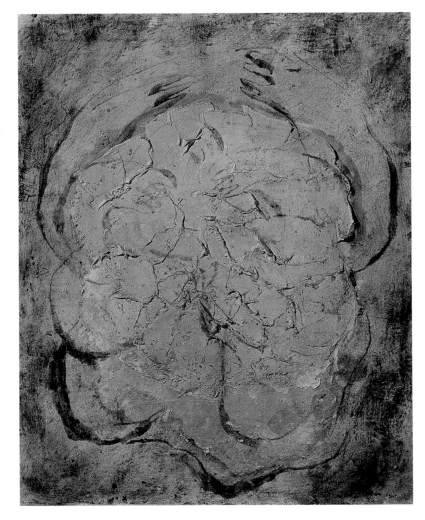

7 Jean Fautrier

La Toute Jeune Fille (Very Young Girl), 1942

Such barely recognizable human images were the outcome of a dialogue with materials. Layers of thick paste were applied to an absorbent sheet of rag paper laid on a canvas, with a layer of coloured paste and varnish finally added to the confection.

sizing moral probity and the dilemma of personal freedom, as developed by the likes of Jean-Paul Sartre and Maurice Merleau-Ponty. Its artistic spin-off was a trend established in a series of exhibitions at René Drouin's gallery from 1943 onwards. (Drouin had originally set up in partnership with the Italian-born Leo Castelli, but the latter left for America in 1941 and would later open a New York gallery, as will be seen.)

The painter Jean Fautrier's *Otages* (Hostages) exhibition at Drouin's in October 1945 was one of the first signs of this new artistic direction. Fautrier had been held briefly by the Gestapo in 1943, on suspicion of Resistance activities, and, while in hiding at a sanatorium at Châtenay-Malabry on the outskirts of Paris, had produced a series of heads and torsos morbidly inspired by sounds from the surrounding woods where the Occupying forces regularly tortured and executed prisoners [7]. The disturbing pulverization of the body involved in these images

8 Wols (Alfred Otto Wolfgang Schulze)

Manhattan, 1948–9

Wols's painted surfaces register a variety of different activities. Paint was stencilled, smeared, trickled, or thrown onto his canvases. Markings were incised using the artist's fingers or sticks. In essence, though, these images were more traditional in conception than the 'drip paintings' being produced in New York by Pollock at the same time. The title retrospectively has an ironic ring.

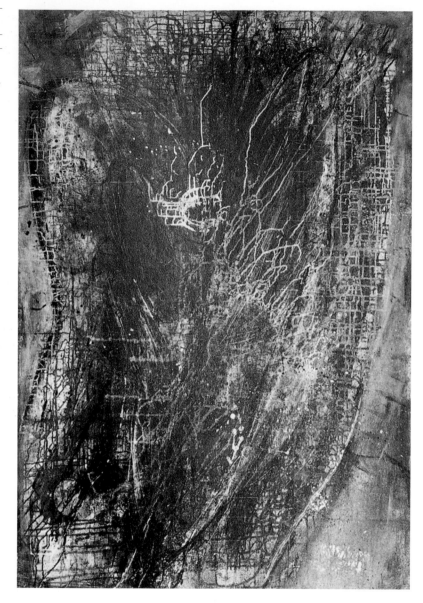

(which in some instances produces a perversely erotic effect due to the powdery surfaces) marks a move towards the *informel*—an aesthetic of brute materiality and formlessness. This was to be consecrated in critical terms by the writer Michel Tapié, in relation to artists such as the German-born Wols (short for Alfred Otto Wolfgang Schulze) and Jean Dubuffet.

The collapse of structural cohesion in this kind of work can be seen as a deliberate negation of the utopian prewar geometric abstraction epitomized by the Dutch Modernist Piet Mondrian. Whilst much of it retains links to organic or bodily subject-matter, the work of Wols in

particular posits a new gestural abstract language in which the worrying of the picture surface by the artist's scratchings and spillages [8] has some affinities with Pollock. However, Wols was very much an easel-painter. Furthermore, large areas of his output have a distinctly precious quality. His early drawings and watercolours, many of which recall the spidery graphics of the the Swiss-born modernist Paul Klee, were displayed at Drouin's in December 1945 in small illuminated boxes. Like the Abstract Expressionists, Wols internalized the tragic nature of his times. His art was suffused with romantic self-pity, primordial longings, inchoate gestures. As with the Americans, such preoccupations were echoes of Surrealist interests in myth and primitivism, but they could border on the maudlin.

With the most influential *informel* artist, Jean Dubuffet, introspective outpourings were combined with a more robust revival of other Surrealist obsessions: the art of children, the untrained, and the insane. Dubuffet explored imagery related to these sources in his *hautes pâtes* (raised pastes) which, although they preceded those of Fautrier, were not exhibited until his important *Mirobolus, Macadam et Cie* exhibition of January 1946. He also explored processes of engraving and gouging into resistant surfaces such as tarmacadam or oil mixed with gravel [9]. Such images had distinct associations with the wall graffiti and indentations, redolent of the sufferings of Occupied Paris, which Brassai photographed [10]. For Dubuffet, a kind of communality was evoked by these markings. His talk of 'instinctive traces' and the ancestral basis for spontaneous sign-production (again comparable with the Abstract Expressionists' understanding of myth) was furthermore bound up with a revulsion against received notions of the beautiful. He was thus more essentially disdainful of art as an institution than the Abstract Expressionists.

Ideas of a counter-aesthetic sphere came to be consolidated in France by the critic Michel Tapié, who developed the notion of *un art autre* whilst Dubuffet himself formed a collection of *Art Brut* (raw art, largely produced by social outsiders and the insane) which was shown at Drouin's gallery between 1947 and 1950.[14] Anti-aesthetic principles inform Dubuffet's *Corps de Dames* series of 1950 [9]. Turning to the female nude because of its links with 'a very specious notion of beauty (inherited from the Greeks and cultivated by the magazine covers)',[15] Dubuffet saw the celebration of a massively ravaged and distorted body image, splayed out like a map to the picture's limits, as part of an 'enterprise for the rehabilitation of scorned values.'[16] However, his obsessive investigation of the innards of his subjects also has a charged psychological atmosphere, evoking children's fantasies of bodily investigation and possibly infantile urges towards the destruction of the insides of the maternal body, as discussed by the British psychoanalyst Melanie Klein in the 1930s.[17]

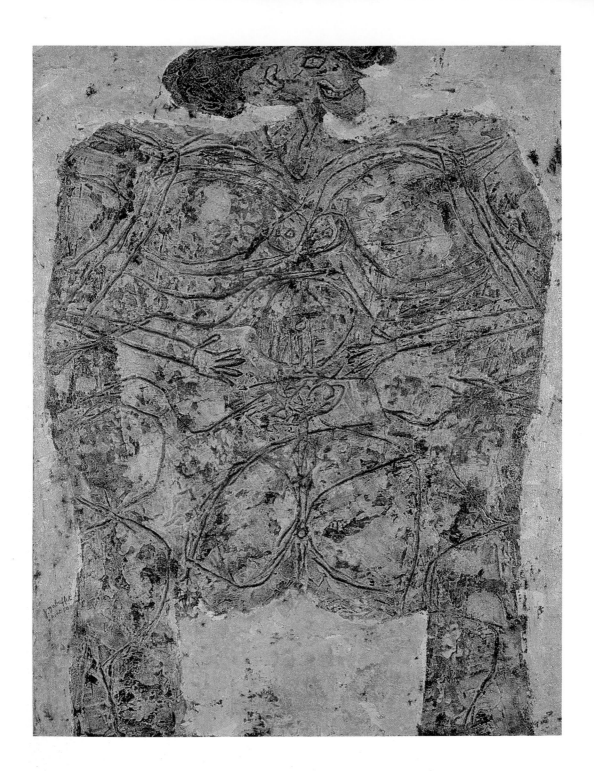

This concentration on abject bodily imagery in *informel* art has led to a suggestion that it may have connections with the thought of the French writer Georges Bataille. In the 1930s Bataille had developed influential notions of formlessness and 'base seduction', involving a materialist embrace of the repellent, the excessive, and the bodily, in order to undercut the idealist aesthetics he associated with Surrealism. Bataille in fact collaborated with Fautrier on certain projects, but the writer's savage anti-humanism was simply one position among several on offer from literary figures of the calibre of Jean Paulhan, Francis Ponge, and Sartre.[18] Given, however, that a Bataillean aura of 'base seduction' emanates from Fautrier's or Dubuffet's depictions of bodies it helps set up a pointed contrast with the fate of the figure in one of their American counterparts, the Abstract Expressionist Mark Rothko.

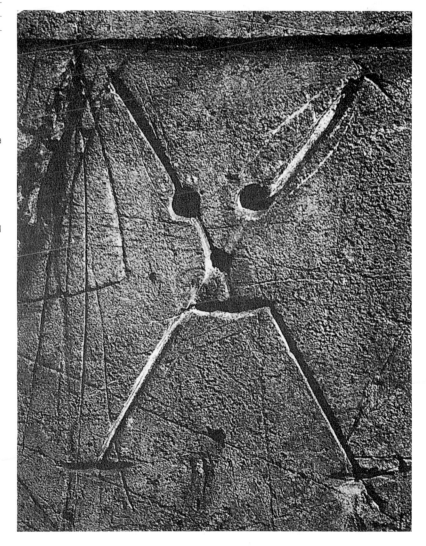

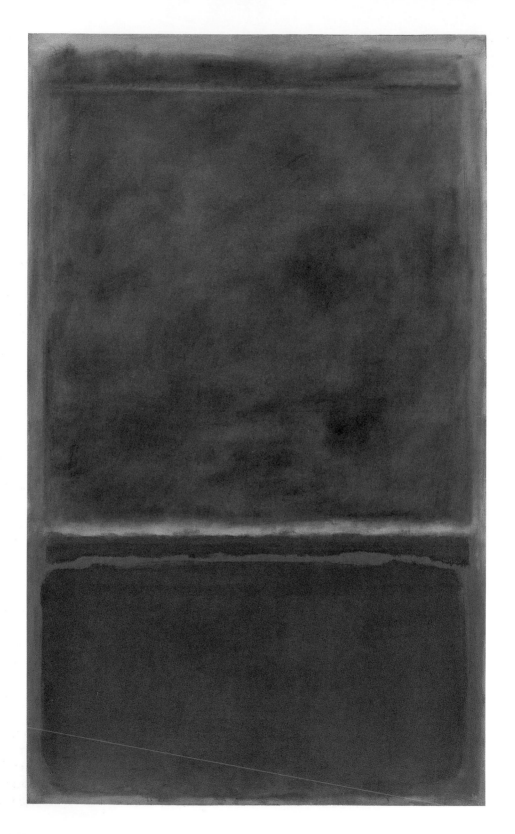

11 Mark Rothko

Untitled, 1951

In Rothko's abstractions the bounds of physical contingency were evacuated in favour of a glimpse of impersonal, cosmic imperatives. The scale of the works was calculated so that spectators could measure their physical size against the coloured masses. This could lead to the feeling of being enveloped or transported out of the body.

In the 1940s Rothko's paintings had moved from a concern with semi-figurative allusions to mythic and primitivist deities to a more abstract post-Cubist idiom in which residues of figuration lingered in soft-edged interacting patches of colour, (pre-eminently in the *Multiforms* of 1948-9). Whilst Rothko believed that the most significant artistic subject of the past had been the single figure 'alone in a moment of utter immobility',[19] he had gradually eliminated literal evocations of living presences from his work, feeling that the image of the figure could no longer possess spiritual gravitas. (A Russian immigrant, he had been raised as a Jew, a religious background he shared with Barnett Newman. This partly predisposed him towards the elimination of identifiably hieratic imagery.) For related reasons he was opposed to the kind of figural distortion practised by Dubuffet.

By the turn of the 1950s Rothko had arrived at the pictorial format which was to serve him for the rest of his career; horizontal lozenges of soft-edged colour hovering in a large vertically oriented field [11]. These clouds of colour were seen by him as abstract 'performers' possessing tragic or ethereal demeanours. In a sense, then, they became stand-ins for the body, although landscape associations were also present. Subject matter therefore continued to be central to his abstractions but, as with Pollock, a radical 'veiling' of the personal was enacted in favour of primal or transcendent invocations. It should be added that, at exactly the time Rothko started bodying forth such impalpable 'presences', his Abstract Expressionist colleague Willem de Kooning—a painter who never went so far as Pollock, Rothko, or Newman in the direction of abstraction—was embarking on painting a series of insistently physical images of women [23]. Comparable with Dubuffet's *Corps de Dames*, these represent counter-propositions to Rothko.

Rothko's transcendentalism clearly diverges from the concerns of Fautrier or Dubuffet. The Bataillean tenor of their *informel* aesthetic can further be contrasted with the mainstream Breton-derived Surrealist position which broadly informed Abstract Expressionism. In the case of an artist such as the Armenian-born Arshile Gorky, whom Breton particularly praised, this bred a highly aestheticized iconography of sexuality. Constructed from interactions between elegant skating lines and languorous smudges of colour, Gorky's semi-abstractions seemed to evoke sultry or neurotic reveries centring on the body. But they also spoke of the over-refined European sensibility that *informel* artists like Dubuffet, with their embrace of matter, were trying to bypass.

The Abstract Expressionists' hankerings after (prewar) European sophistication often sat uneasily alongside their desire to assert their 'American-ness'. Robert Motherwell is significant in this respect. He was the most intensively educated participant in the group (he studied at Harvard and Columbia University), and in the early 1940s had been

12 Robert Motherwell

At Five in the Afternoon, 1949
This painting deliberately combines a host of allusions to Spanish culture such as the stark black/white contrasts of Goya, Velasquez, and Picasso, the Spanish poet Lorca's lament to a dead bullfighter, 'Llanto por Ignacio Jánchez Mejías', and the (related) enlarged images of a bull's genitalia (a powerful metaphor for the 'virility' of Abstract Expressionism, to be discussed early in Chapter 2). The Spanish Civil War was also at issue here and the rounded forms pressing against dark 'bars' generate weighty metaphorical contrasts between freedom and constraint, life and death.

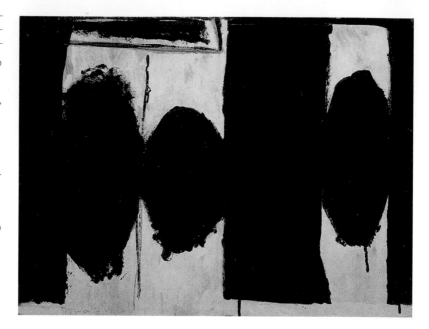

close to the *émigré* Surrealists. Later in that decade he became affected by the poetry bound up with Surrealism's artistic predecessor, Symbolism, in particular that of Baudelaire and Mallarmé. This esoteric climate lies behind the literary allusions packed into his large series of *Elegies to the Spanish Republic* initiated by *At Five in the Afternoon* of 1949, a work rooted in Motherwell's imaginary identification with the Spanish struggle against Fascism [12]. By identifying with Europe's recent past Motherwell could be seen as commenting ironically on the draining of political purpose from Abstract Expressionist art. (He must have been aware that at this time, the late 1940s, America was solidifying its Cold War stance.) However, on other occasions Motherwell sacrificed his European credentials to argue for America's new-found aesthetic superiority. In a discussion among artists and critics on the subject of pictorial 'finish', held in 1950, he argued that the work of contemporary French painters was too reliant on 'traditional criteria', such as the notion of the 'beautifully made object', whereas American art tended to forgo the niceties of finish in favour of 'process'.[20]

Motherwell came close here to the critic Clement Greenberg, who had played off French and American art, in the figures of Dubuffet and Pollock, in an interesting double review of February 1947. At one point Greenberg asserted that Dubuffet 'means matter, material, sensation, the all too empirical world' as opposed to the 'mysticism' of the Americans. Here he seems to be endorsing much that has been suggested above. Later, however, he reversed his terms in favour of Pollock, who was described as 'American and rougher and more brutal

… less of an easel-painter in the traditional sense than Dubuffet.'[21] It is telling that gender metaphors now appear to be in play. Greenberg's shift in emphasis allows American art to end up 'rougher' than French art while ensuring that it remains elevated above 'matter'. Implicitly it is more 'masculine'. Issues of gender will emerge again later, but it should be noted that Greenberg's desire to assert American superiority was also linked to the Cold War politicking discussed earlier in this chapter. Both he and Motherwell were correct to argue that Pollock and his contemporaries had moved beyond the aesthetics of easel-painting, which in turn allowed for a freer engagement with materials, but it is evident that their critical terminologies subtly opposed a model of a thrusting American art to a European model now conveniently implied to be effete. Greenberg was subsequently to become massively influential in setting the critical pace of the postwar period. It is appropriate, then, to examine his ideas in detail.

Modernism

Given much that has been said, it may appear surprising that Clement Greenberg's early art criticism of 1939–40, produced mainly for the left-oriented journals *Partisan Review* and *The Nation*, was heavily influenced by (Trotskyist) Marxism. In important texts such as 'Avant Garde and Kitsch' and 'Towards a New Laocoon',[22] Greenberg asserted that the current position of avant-garde art should be understood in the light of its historical relations to capitalism. He argued that, after 1848, the increasing alienation of artists from their own class (the bourgeoisie with its debased cultural values) led to a paradoxical situation in which, unable to communicate with their audience, avant-gardists took it upon themselves to maintain an ongoing self-critical purification of art's means, while ambivalently retaining economic links to the ruling class. Like the Frankfurt-School Marxist Theodor Adorno, Greenberg felt that art's autonomy had to be preserved against the incursions of mass culture, as a kind of mute repudiation of capitalism's values. At the same time, he argued that each art had to avoid confusion with its fellow arts—a situation which could only lead to the weakening of the criteria for self-definition (and critical evaluation) within the various art forms. Academic painting of the nineteenth century had, for instance, been too reliant on 'literary' effects; the arts should now follow the example of music's essential abstractness.

This amounted to a 'formalist' prescription for the abstract painting Greenberg was later to support as a critic. But it also became the basis on which a model of the unfolding of the avant-garde's destiny was constructed such that any painting hoping to qualify as art had, necessarily, to address a set of problems intrinsic to the nature of painting posed by previous avant-gardes. One painterly value that Greenberg notoriously stressed was that of 'flatness'. By the late 1940s and early

1950s he was to argue that certain instances of Abstract Expressionist painting had managed to answer the pictorial challenges raised by European artistic precedents such as Post-Impressionism, Analytic and Synthetic Cubism, and various forms of abstraction. This had been a twofold operation. First, painters had worked to establish a convincing pictorial balance between emphatic surface flatness and implied depth. Second, since that involved eliminating conventional compositional stucture, an 'all-over' conception of the picture had had to be developed such that, rather than being staged as a system of internal relations, it consisted of a 'largely undifferentiated system of uniform motifs that look[s] as though it could be continued indefinitely beyond the frame'.[23] This formal breakthrough to a specifically 'American' mode of avant-garde painting was largely credited to Pollock [3], although Greenberg had to concede that a West Coast painter, Mark Tobey, had beaten Pollock to it with his 'white writing' pictures of 1944, works which were nevertheless rejected as 'limited cabinet art'.[24]

What is particularly striking here is the way in which Greenberg's reading of Pollock edits out his Jungianism and the drama of 'veiling' discussed earlier. Questions of subject-matter, which had been crucial to painters such as Pollock, Rothko, and Newman, were simply deemed extraneous; indeed, in a 1947 overview of American art Greenberg had voiced some discomfort with Pollock's 'Gothicism'; his art's 'paranoia and resentment' which were said to 'narrow it'.[25] In the same review Greenberg made his own aesthetic interests clear. He advocated a 'bland, balanced, Apollonian art ... [which] takes off from where the most advanced theory stops and in which an intense detachment informs all.' This classical formulation clearly foreshadows his later espousal of Post-Painterly Abstraction [13] but it represents the very antithesis of Pollock—the Pollock who once famously talked of being 'in' his paintings. Significantly, though, this impersonal formalism went hand in hand with changes in Greenberg's politics at the end of the 1940s. As John O'Brian notes, Greenberg's resignation from *The Nation* in 1949 was partly motivated by antipathy towards its Soviet sympathies, and in the early 1950s he became strongly anti-Communist, in line with McCarthyism, to the extent of helping to found the American Committee of Cultural Freedom (ACCF), later discovered to be funded by the CIA through a system of dummy foundations.[26]

With an almost utopian belief that capitalism could extend America's newly created 'middle-brow' culture to the masses, Greenberg gradually modified his earlier sense of the avant-garde's oppositional stance in relation to bourgeois culture. This critical turn-about obviously paralleled the ways in which Abstract Expressionism was manoeuvred to fit the class interests underpinning America's Cold War ideology. Yet what is particularly telling here is the way that, by the time of his seminal essay on 'Modernist Painting' of 1961,

Greenberg had seen fit to drop his earlier reliance on the idea of an artistic 'avant-garde' in favour of a key monolithic concept of 'Modernism'.

Greenberg's conception of 'Modernism' as synonymous with formal completion or inviolability (which could be seen as keyed to America's postwar imagining of its world position) was to fuel a mutually self-aggrandizing tradition of painting and art criticism in the 1950s and 1960s. Three of the principal painters concerned, Helen Frankenthaler, Morris Louis, and Kenneth Noland, were introduced by Greenberg in April 1953 when the two Washington-based male artists were taken by the critic to Frankenthaler's studio in New York. Her near-legendary painting *Mountains and Sea* (1952: National Gallery of Art, Washington) particularly impressed Louis in terms of its abandonment of the traditional build-up of brushmarks in favour of a process of 'staining' such that acrylic pigments were allowed to soak into large areas of unprimed canvas (a technique with which Pollock had briefly experimented in 1951–2). Given that colour here was literally at one with the weave of the canvas, rather than lying 'on top' of it, the technique tied in with the Modernist imperative towards flatness. Indeed, it achieved what Greenberg and his disciple Michael Fried were to describe as a supreme 'opticality' in so far as the colour—literally poured or spilled in plumes and rivulets onto the canvas in the case of Louis's aptly titled *Veils* of the mid-1950s [13]—not only formed an evenly textured 'field' but also gave an effect of luminosity.

In terms of the rigorous hair's-breadth distinctions of Greenberg's criticism, this represented a step beyond the 'all-over' abstractions of

Definitions of Modernism

In terms of its historical/critical usage, 'modernism' normally covers two impulses. The first of these involves the demand (first voiced self-consciously in the nineteenth-century French poet Baudelaire's critical writings) that the visual arts should reflect or exemplify broad processes of modernization and their societal effects. The second is bound up with the evaluation of the *quality* of works of art. Here works of art have to measure up to criteria of aesthetic innovation while being distinguishable from a set of indicators of 'non-art' status (the terms 'academic' or 'kitsch' being two such pejorative terms).

Greenberg's capitalization of the word 'Modernism' implies a formalization of the second of these definitions, whilst its subsequent elaboration as a theory implicitly downplays the consequences of the first definition, with which the notion of a socially disaffirmative 'avant-garde' is bound up. As explained by Greenberg in his key 'Modernist Painting' essay of 1961: 'The essence of Modernism lies ... in the use of the characteristic methods of a discipline to criticize the discipline itself, not in order to subvert it but to entrench it more firmly in its area of competence.' The warning against the 'subversion' of the discipline is included to rule out socially generated anti-art impulses, such as Dada and much of Surrealism, from the Modernist master-plan; Greenberg was notoriously opposed to the French proto-Dadaist, Marcel Duchamp.

Bojewyan is a small village near St Just in Cornwall, England. At the time of the painting local farmsteads were falling empty because they were uneconomic. Lanyon saw this as a serious threat to the region. His painting contains hints of a symbolic revival of fortunes. Several animal images and womb-like shapes are incorporated into the design. The Cornish landscape is suggested through rugged interlocking forms. (At the top left the curve of the coastline is legible.)

Pollock and Newman. However, this dour masculinist discourse of aesthetic one-upmanship obscures the fact that Louis's 'veils' may have 'feminine' connotations (a point worth contrasting with Pollock's very different understanding of 'veiling' as mentioned earlier). Feminist writers have persuasively argued that Frankenthaler's stained canvases have, in the past, suffered from being designated 'feminine' (and hence closer to the natural, the merely decorative, or the intuitive as opposed to the cultural) but interpreting Louis's work in this way suggests that social stereotypes regarding gender might equally be overturned within works by male artists.[27]

The fallout from Modernism: critiques of Greenberg

The critical parameters set up by Greenberg and Fried to legitimate Post-Painterly Abstraction had the effect of marginalizing other practices of abstraction, deriving from different conditions, in Europe. In Britain, the postwar atmosphere of austerity in London, presided over by a new, guardedly optimistic, Labour government, created the conditions for the emergence of an existentially tinged figuration (see the discussion of Bacon in Chapter 3). However, away from the metropolis, a group of its former residents—Ben Nicholson, Barbara Hepworth, and the Russian *émigré* Naum Gabo—had weathered the war years in and around St Ives in Cornwall, already a well-established artists' centre. Their geometric abstraction, which had won international recognition in the 1930s, had a decisive effect after the war on the painter Peter Lanyon. He began to reformulate his basic commitment to the Cornish landscape in terms of the post-Cubist space and interpenetration of interior and exterior volumes derived from their painting and sculpture respectively.

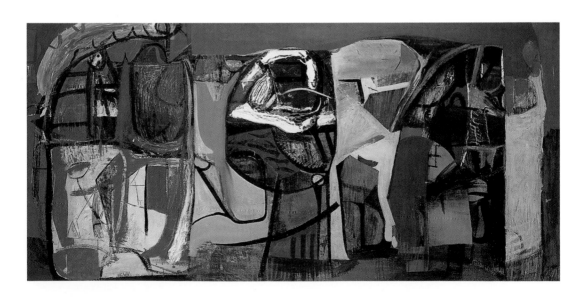

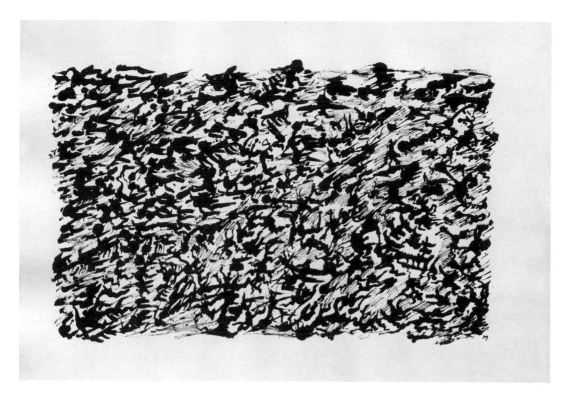

By the early 1950s Lanyon's work managed to reconcile the rural
nostalgia typical of 'Neo-Romanticism' (an important phenomenon of
the war years encompassing painters such as Graham Sutherland and
John Piper) with an expressionist handling and acknowledgement of
the picture plane in line with Abstract Expressionism [14]. It was not,
however, until the late 1950s that Lanyon and other St Ives-based
abstractionists such as Patrick Heron and Roger Hilton fully absorbed
the implications of recent American art. (A notable exception here is
Alan Davie, a Scottish-born painter connected with the Cornish group,
who had seen Pollock's works in Venice as early as 1948 and subse-
quently fused his gesturalism with primitivist and ritual allusions in a
series of uncompromising abstracts of the early 1950s.) For the other
painters, the Tate Gallery's 'Modern Art in the United States' exhibi-
tion of 1956 was something of a revelation, while the 'New American
Painting', backed, as noted earlier, by the International Program of
MOMA, consolidated America's Modernist supremacy in 1959.

Lanyon, who had already forged a style of his own, was to gain some
degree of commercial success in America in the late 1950s and to
develop personal links with Rothko in particular. His colleagues,
however, were generally deemed derivative by the American critical
establishment and further British responses to Post-Painterly
Abstraction by painters such as Robyn Denny and Richard Smith,
which culminated in two highly original environmentally conceived

exhibitions of 1959 and 1960 ('Place' at the ICA and 'Situation' at the RBA Gallery in London), seem hardly to have registered with Greenberg and Fried. In 1965 the latter opened his important essay in *Three American Painters*, the catalogue to an exhibition of Kenneth Noland, Jules Olitski, and Frank Stella at the Fogg Art Museum, Harvard, with the declaration: 'For twenty years or more almost all the best new painting and sculpture has been done in America.'

The painter and critic Patrick Heron leapt to the defence of British art, detecting a degree of 'cultural imperialism' on the part of America's art *cognoscenti*. Aggrieved that the Modernist critics had failed to acknowledge that the 'first invaluable bridgehead of approval' for Abstract Expressionism had been formed in Britain, he astutely recognized that the increasing tendency in (Post-Painterly) abstraction towards flatness, symmetry, and a 'centre-dominated format' was fundamentally at odds with 'European resources of sensibility.'[28] According to Heron, European abstraction tended towards a 're-complication' of the pictorial field, favouring a resolution of 'asymmetric, unequal, disparate formal ingredients' in terms of an overall 'architectonic harmony.'[29] (See, in this respect, the discussion of 'relational' and 'non-relational' art in Chapter 5.) Possibly Heron misconceived Greenberg's and Fried's view of Modernism as intrinsically progressive, pre-programmed to fulfil a historical logic. He demonstrates, however, that there were whole areas of European abstract art that fell outside the terms of the American critics. Histories of postwar art have, possibly correctly, disparaged much French abstraction, such as that of the *tachiste* Georges Mathieu, or Nicolas de Stael, for appearing fussy or 'tasteful' alongside, say, Pollock or Rothko. However, a figure such as the painter/poet Henri Michaux [15] can hardly be thought answerable to Modernist criteria, although his works have superficial visual links with Pollock's.

Its formal rigours aside, Greenbergian Modernism was primarily urban in tenor, an art of large metropolitan cultures. In this respect, Pollock, for all his Gothicism, excited Greenberg because he atttempted 'to cope with urban life' and with a related 'lonely jungle of immediate sensations, impulses and notions.'[30] In these terms, British abstractionsts such as Lanyon, working from landscape motifs in a tradition rooted in the eighteenth century, would have seemed anachronistic. (Something similar might be said of the American West Coast painter, Richard Diebenkorn, who produced powerful series of Albuquerque and Berkeley landscapes in the early 1950s.) Despite the fact that he had a strong stylistic influence on both Lanyon and Diebenkorn, and himself produced a sequence of paintings derived from landscape at the end of the 1950s, it was the Dutch-born Willem de Kooning, rather than Pollock, who produced the most distinctively urban-rooted Abstract Expressionist canvases. De Kooning had had a

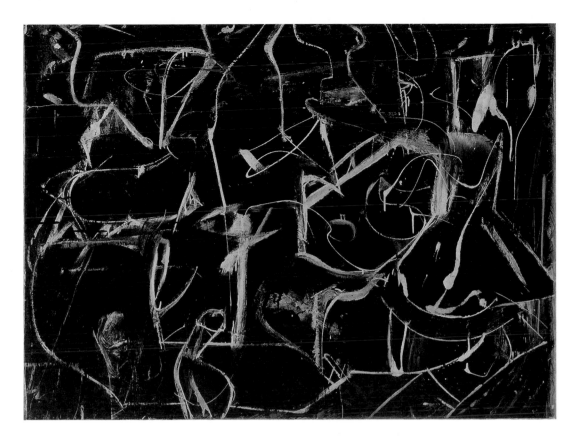

16 Willem de Kooning

Untitled, 1948–9

In de Kooning's black canvases the elimination of colour was conditioned as much by financial constraints as by the need to simplify pictorial problems in the spirit of Analytic Cubism. The deliberately artless use of shiny enamel housepaints (a strategy also adopted by Pollock at this time) evokes the wet night-time sidewalks of New York City, whilst disembodied lines, evocative of graffiti and other forms of signage, skid, loop, and zigzag across the canvas like reckless city drivers.

rigorous academic art training at the Rotterdam Academy. Consequently, for most of his career, the human figure remained his starting-point, whether tugged apart and assimilated to the infrastructure of Synthetic Cubism, as in the early 1940s, or bodied forth in Expressionist slashes and swipes of oil paint, as in the *Women* of the early 1950s [**23**].

De Kooning came closest to abstraction in the sequence of black-and-white canvases of 1947–9 [**16**], where pictorial planes lock together to produce an 'all-over' pictorial field analogous to Pollock's contemporary productions. However, references to body parts, buildings, and landscape, claustrophobically compacted together in a fierce collision of energies, can still be discerned. De Kooning's friend Edwin Denby recalled late-night walks with the painter during the Depression with the latter 'pointing out to me on the pavement the dispersed composition—spots and cracks and bits of wrappers and reflections of neon light.'[31] However much de Kooning's canvases insist on their post-Cubist formal austerity, they distil a *film noir* poetics which powerfully links them with the ideological reverberations of this genre noted in earlier discussions of the 'Modern Man' theme. In this sense, they resonate with the work of contemporary photographers such as Weegee [**58**].

It is perhaps not surprising that, in the final analysis, Greenberg found what he described as de Kooning's Picassoesque *terribilità* as disquieting as Pollock's Gothicism. He had little stomach for those 'practices of negation' which the art historian T.J. Clark pinpoints as lying at the heart of modernism.[32] Though he may well have understood Pollock, de Kooning, and the other Abstract Expressionists comprehensively, Greenberg represented them only partially and selectively. His critical legacy, based on the view, as reformulated by Clark, that 'art can substitute *itself* for the values capitalism has made useless',[33] had an undeniable grip on art up until the late 1960s. But other critical options were also on offer in the early 1950s. The critic Harold Rosenberg, whose reputation was largely overshadowed by that of Greenberg, produced a very different account of certain of the Abstract Expressionists. He wrote: 'At a certain moment the canvas began to appear to one American painter after another as an arena in which to act—rather than as a space in which to reproduce, re-design or "express" an object … What was to go on the canvas was not a picture but an event.'[34] This conception of a risk-laden 'encounter' between artist and work, although the starting-point for later caricatures of Pollock as paint-flinging existential hero, has been shown by the art historian Fred Orton to constitute a refusal to submit to that silencing of the American left in the later 1940s with which Greenberg's Modernist aesthetics seems to have been bound up. In Orton's analysis, Rosenberg's past Marxist affiliations meant that for him 'Action [was] the prerequisite of class identity' since 'all the relations of capitalist society forbid the working class to act except as a tool.'[35] On this analysis, a politics *was* still embedded in certain fundamental tenets of Abstract Expressionism, despite Greenberg's clean-up campaign.

The other implication of Rosenberg's essay was that, rather than being bound up with the contemplative processes of aesthetic decision-making and judgement, Abstract Expressionist painting was fundamentally 'performative'. Whilst this only fully applied to Pollock's 'drip paintings', it found an echo in a text of 1958 responding to the needs of a later, significantly different, aesthetic climate. Here the American organizer of 'Happenings', Allan Kaprow, saw Pollock as opening up two avenues within postwar art. One involved continuing in a Modernist vein. The other offered a radical option to artists; 'to give up the making of paintings entirely—I mean the single flat rectangle or oval as we know it … Pollock, as I see him, left us at the point where we must become preoccupied with and even dazzled by the space and objects of our everyday life.'[36] It remains to be seen which direction prevailed.

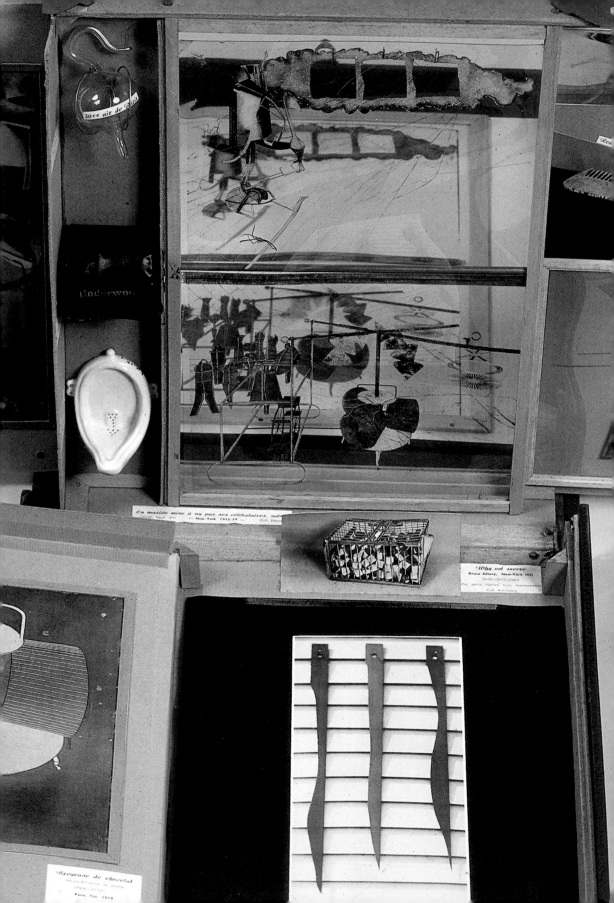

Duchamp's Legacy: The Rauschenberg–Johns Axis

2

The shift in art-world domination from Paris to New York in the postwar period is summed up by Marcel Duchamp's *Boîte-en-Valise* [**17**]. The work comprises a collection of miniatures and samples of the French-born artist's pre-1935 output. Included, for example, is a tiny version of *Fountain*, the re-titled men's urinal which emblematizes Duchamp's one-time involvement with the iconoclasm of Dada. Ever since the demise of the Dada movement in the early 1920s Duchamp had moved between Paris and New York. Based in France when a new European war seemed imminent, he had sensibly decided to 'pack his bags'.

The objects presented in the *Boîte* attested to cultural mutations. Early oil paintings by the artist were represented via reproductions. Objects which had once been 'readymades' (the term Duchamp applied to the mass-produced objects he had accorded art status) now had a paradoxically 'crafted' quality (the urinal is a case in point). The *Boîte* also spoke of commodification. Part of an edition (initially a 'de luxe' one of 24), it represented, in Duchamp's words, 'mass production on a modest scale.' Overall it had a dual function. It was a portable museum, regrouping the œuvre of an iconoclast. But it was also a travelling salesman's display case.

The *Boîte* exemplifies the transition between two worlds: the old Europe of the museum and the connoisseur, and the young America of the commercial gallery and the artistic commodity. Duchamp's acceptance that art should incorporate the dominant modes of social production was a radical alternative to Greenberg's Modernism as discussed in the last chapter. Greenberg had demanded that art remain true to its medium, purifying its means, maintaining aesthetic (and social) distance. For Duchamp, and those following in his wake, art's very identity was in question.

Marcel Duchamp

In the early 1940s Duchamp was installed again in New York, the location of his Dada activities between 1915 and 1923. Although his works

17 Marcel Duchamp

Boîte-en-Valise, 1941

Duchamp's *Boîte* 'unpacked' in such a way that certain sections slid out to become free-standing display boards, whilst a sheaf of folders and black mounts bore other reproductions of works from his output. In all, it contained 69 items. These included a miniature version of the *Large Glass* [**18**] on celluloid and, next to it, three tiny versions of earlier 'readymades'. These were, at the top, *Paris Air* of 1919 (a chemist's ampoule, emptied of its contents and then re-sealed by Duchamp); in the middle, *Traveller's Folding Item* of 1916 (a typewriter cover); and, at the bottom, *Fountain* (1917), the men's urinal which had originally been rotated 90 degrees to sit on a plinth but was here ironically restored to a 'functional' position.

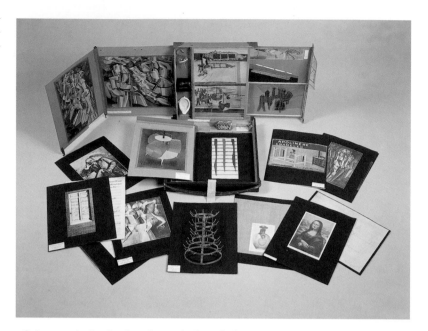

of that period, the 'readymades' and the enigmatic *Large Glass*, were legendary among a small community, Duchamp maintained a deliberately 'underground' profile. His *Boîte*, which was shown at Peggy Guggenheim's gallery in late 1942, poignantly spoke of the sense of cultural transplantation felt by many *émigré* artists from Europe. However, unlike the French Surrealists with whom he was friendly, Duchamp had little obvious appeal for the rising generation of Abstract Expressionist artists. He had renounced art which appealed solely to the eye, or, in his terms, 'retinal' art, as early as 1912. Two alternative paths had opened up for Duchamp. One was embodied in the conceptual challenge posed by the 'readymades'. The other involved the creation of a machine-age iconography, rendered in a dry, ironic, linear style. In the case of the *Large Glass*, he created a set of sci-fi mechanomorphs snagged in a complex machinery of human aspirations ranging from romantic love to scientific certainty [**18**].

Duchamp's likely attitude to Abstract Expressionism can be gauged from a small work of 1946, entitled *Wayward Landscape*, which was incorporated as an 'original' item in one example from the first, exclusive, edition of *Boîtes*. At first glance it appears to be an abstract painting. In fact it is a large semen stain on funereal black satin. Although it was essentially 'private', an unconventional parting gift for a lover, succinctly evoking the embalming of desire, it stands as one of the first examples of what, in the 1960s, became known as 'Body Art', that is, art directly linked to the body and to bodily identity. Beyond this, some knowledge of the rich iconography of Duchamp's *Large Glass*, properly titled *The Bride Stripped Bare by her Bachelors, Even*, yields another reading. It should be emphasized that this is indeed a

18 Marcel Duchamp

*The Bride Stripped Bare
by her Bachelors, Even
(The Large Glass)*, 1915–23

This work's technical
inventiveness matches its
iconographic density. It
consists of two panes of glass
set one above the other
(the work shattered in transit
in 1927 and was patiently
reconstructed by Duchamp).
The 'Oculist Witnesses' (lower
right) were produced by
meticulously scraping away a
section of 'silvering' applied to
that area of the Glass. Else-
where, random procedures
were utilized. The positions of
the nine holes representing
the Bachelors' 'shots' (upper
right) were determined by
firing paint-dipped match-
sticks at the work from a toy
cannon.

'reading' since it is largely based on Duchamp's notes, chiefly those
from the so-called *Green Box*. These were seen by him as integral to the
work. (Once again, Duchamp emerges as a pioneer of a new expressive
form, this time the text-related art of the 1960s.)

Turning to the *Glass* [**18**], at the left of their lower 'Domain', a
huddle of diagrammatized 'Bachelors' attempt to excite the 'Bride',

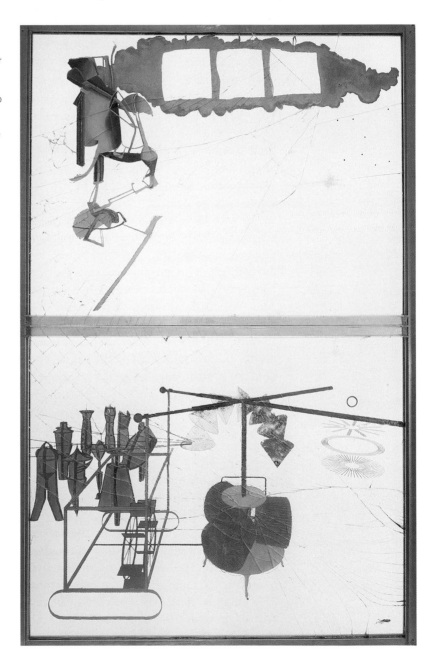

with her orgasmic 'blossoming', in the upper 'Domain'. Apart from triggering her 'stripping', the Bachelors' communal arousal produces 'love gasoline' which, once refined in the receptacles to which they are hooked up, is 'dazzled' into the Bride's orbit via a set of optical devices (the 'Oculist Witnesses' in the lower right of the *Glass*). Most of the droplets of love gasoline fall sadly short of their target in an area designated as that of the 'Shots'. This short description evokes something of the *Glass*'s bleak hilarity as a satire on sexual relations, but from it the significance of *Wayward Landscape* can be appreciated; it is one of the Bachelors'/Duchamp's 'shots'. As a comment on male express-ive/sexual urgency the gesture ironizes the new vogue for painterly bravado in American art linked to assertively 'male' artists such as Pollock, shortly to embark on his 'drip' paintings.

The reduction of the grand rhetoric of Abstract Expressionism to these terms is typical of Duchamp's deflationary 'anti-aesthetic' impulse and yet again prefigures an entire postwar attitude. It is also typical of Duchamp that, in the later 1940s, he made no overt display of his distaste for contemporary trends. In 1945 the Surrealist *émigrés*, in league with a few American writers, published a special edition of their art journal *View* containing a comprehensive range of accounts of Duchamp's activities, including André Breton's essay decoding the *Large Glass*. This ensured a gradual dissemination of his concepts. Meanwhile Duchamp himself had begun planning a new project. This, his final full-scale work, *Etant Donnés* ('Given …')—a title deriving from a cryptic note for the *Large Glass*—was begun in secret around 1946 and not revealed publicly until 1969, months after his death. Its full effects were thus programmatically postponed as if Duchamp, who was obsessed with chess, calculated his game with posterity in advance.

Etant Donnés is permanently installed in the Philadelphia Museum of Art. As such it is one of the first examples of the 'installation' genre which would flourish later. (The German Dadaist Kurt Schwitters's environmentally conceived *Hanover Merzbau* of 1923 was another important early installation.) *Etant Donnés* consists of a battered door through which the spectator peers via eye-holes at a floodlit tableau. This consists of a mannequin, representing a naked female, lying open-legged in a patently artificial landscape. She holds aloft a lamp, confounding an initial sense that she has been violated.

In a sense the work amounts to a hyper-real translation of the schematic ideograms of the *Large Glass* into grossly embodied form. It is as though the Bride who, for Duchamp, possessed unknowable, fourth-dimensional characteristics has fallen to earth in our measurable world. The door acts as a barrier between profane and spiritual domains, so that the spectators of the work become the Bachelors who, in the *Glass*, were constrained by perspectival and gravitational laws.

The (male) spectator's enforced viewpoint ensures that the shocking split-second view through the holes effectively brings about the Bride's 'blossoming'. The installation therefore endows sight with the power of an invisible erotic transmisson, as though investing Duchamp's bugbear, the sphere of the 'retinal', with a power untapped by conventional painting.

In 1957 Duchamp delivered an important lecture, 'The Creative Act', in which he argued that 'the work of art is not performed by the artist alone' and that the spectator's point of view affects the all-important 'transubstantiation' of inert matter into art.[1] The ritualistic, Catholic overtones here relate interestingly to *Etant Donnés*, but most important is the strategic belittling of the Modernist conception of the art object's internal self-sufficiency in favour of a sense of its dependence on contingent, external factors such as audience participation. Indeed, Duchamp's concern with the *spectator*'s share, to say nothing of his interest in the gendering of the relationship between spectator and artwork, would hover as a conceptual aura around much of the ambitious anti-Modernist art produced elsewhere in his lifetime.

The spectator's share: Cage, Rauschenberg, and assemblage

The prime mover in disseminating Duchamp's ideas in America was not the man himself, but John Cage. Having trained as a musician with Schoenberg, the Californian-born Cage was gradually establishing his avant-garde credentials with his 'prepared piano' when, in 1942, he first met Duchamp. His later interest in the Zen Buddhist philosophy of D.T. Suzuki, with whom he studied in 1945, led him to harness Duchamp's love of paradox and gratuitous humour to a more evangelical conception of the need to abolish watertight distinctions between art and life. In line with Zen doctrines of passivity, Cage saw the imposition of mind or human will as the enemy of creation; art consisted in 'purposeless play', charged with the imperative of 'waking us up to the very life we're living'.[2] The main Duchampian model here was undoubtedly that of the 'readymade' which, in the case of *Fountain*, miniaturized in the main section of the *Boîte* [17], had challenged the spectator to 'find a new thought for that object' through the elimination of authorial intervention.[3]

In the early 1950s Cage's utilization of chance in his own musical compositions, reinforced by the publication, in 1951, of Robert Motherwell's pioneering Dada anthology, *The Dada Painters and Poets*, strongly appealed to visual artists oppressed by the relentless interiority of Abstract Expressionism. The fulcrum for this shift of emphasis was Black Mountain College in North Carolina, where Cage occasionally taught.

Among Black Mountain's students, a pre-eminent figure was the Texan-born painter Robert Rauschenberg, whose first solo exhibition

Black Mountain College was a small but progressive art school with a strong community ethos, the opening of which, in 1933, had signalled a trend towards greater humanities and arts provision in American higher education. In that year a victim of the Nazis' dissolution of the Dessau-based Bauhaus, the abstract painter Josef Albers, was invited to join the college staff, subsequently becoming head. Albers's analytic attitudes towards colour interaction, along with other principles linked to Bauhaus teaching, thus became incorporated into US art education. His avowedly apolitical position and tendency to downplay European tradition made him a suitably liberal and diplomatic figurehead during a period of international tensions. Various influential practitioners taught summer schools at the institution in the late 1940s and early 1950s including John Cage and his collaborator, the choreographer Merce Cunningham, and the poet Charles Olson, who was to succeed Albers as director in 1952.

Cage had admired in New York in 1952. Rauschenberg's intuitive appreciation of Cage's Dada-derived ideas led to a spontaneous interdisciplinary 'happening', to which several faculty members contributed, in the summer of 1952. Looking back to the Dada provocations recounted in Motherwell's book, but also anticipating the performance genre that developed in the 1960s (see Chapter 6), the event involved the participants carrying out simultaneous actions. John Cage read texts such as the American Bill of Rights from a stepladder; Rauschenberg played scratchy Edith Piaf records; and the dancer Merce Cunningham danced in and around the audience, who were strategically decentred by being seated in a sequence of square or circular formations. However, aside from the 'purposeless play' of the performers' actions, the surest indications of the importation of Cage's Zen aesthetics into a visual/performing arts context were Rauschenberg's *White Paintings* of 1951, which hung in cross-formations from the ceiling as part of the environment. These pictures, usually consisting of several modular white-painted panels abutted together, reflected a pronounced discomfort with Abstract Expressionist bombast; they were passive receptors, awaiting events rather than prescribing sensations. As markers of an artistic *tabula rasa* they were not completely unprecedented. The Russian artist Malevich had produced his *White on White* paintings in 1918 as an outcome of different metaphysical preoccupations. However, Rauschenberg's pictures broke decisively with Modernist assumptions of aesthetic self-containment. They questioned whether art experiences should actually be sought from 'within' objects. Cage responded in appropriate Zen style. His notorious *4′33″* of late 1952 involved a concert audience being enjoined to 'listen' to a piano piece consisting of three sections. Each section consisted of silence.

The spirit of Duchamp hovered behind much of this but the Cagean emphasis on Eastern philosophy arguably repressed the

French artist's bodily preoccupations. These eventually resurfaced in Rauschenberg's work, but it is necessary first to chart his early career in some detail. For a time Rauschenberg oscillated in mercurial fashion between Dadaist/Duchampian and Abstract Expressionist principles. The *White Paintings* were succeeded, dialectically, by all-black ones, in which matt or gloss paint was applied to bases covered with fabric or crumpled paper. Whereas their 'all-overness' followed the new pictorial orthodoxies of Newman and Rothko, their blank, crackling resistance to optical pleasures parodied Greenbergian injunctions. Constantly alert to metaphor, Rauschenberg gradually introduced extra-artistic materials into his painting. The Cubists had pioneered the use of collage fragments within pictorial constructs earlier in the century, and the Dadaist Kurt Schwitters had taken the non-hierarchical implications of this further by incorporating rubbish into his *Merz* assemblages in the 1920s and 30s. Partly in the spirit of Schwitters, Rauschenberg incorporated newspapers into the bases for his work. In 1952 he produced *Asheville Citizen*, a two-part painting in which a whole sheet of newspaper, lightly brushed with brown-black paint evoking scatological associations, was very much the picture's 'subject'.

The consequences of this were far-reaching. As the critic Leo Steinberg later wrote in his important essay 'Other Criteria', Rauschenberg appeared to be implying that 'any flat documentary surface that tabulates information is a relevant analogue of his picture plane', with the implication that his work 'stood for the mind itself ... injesting incoming unprocessed data to be mapped in an overcharged field'.[4] In subsequent works Rauschenberg assimilated the gridded variegation of text and photography in newspaper layout to a new conception of the pictorial ground as, in Steinberg's terms, a 'flatbed' or work surface on which to pin heterogeneous images. An early example of such a practice was *Rebus* of 1955 in which fragments from different 'worlds'—a printed reproduction of a flying insect, photographs of runners, a reproduction of Botticelli's *Birth of Venus*, a page of comic-strip imagery—were laid out in a line, punctuated by daubs of paint, as though constituting some indecipherable 'message'.

By the early 1960s Rauschenberg had developed the technique to the extent of stacking up a whole array of divergent forms of information [**60**], reflecting the fact that throughout the 1950s America had seen a dizzying expansion in consumerism and the mass media. For instance, as a sign of things to come, receipts for television sales on Madison Avenue in New York escalated from 12.3 to 128 million dollars between 1949 and 1951.[5] According to the critic Brian O'Doherty the perceptual adjustments involved in responding to this proliferating 'image culture' led Rauschenberg to develop an aesthetic of the 'vernacular glance'.[6]

Rauschenberg's inventiveness took a further turn in his so-called 'Combines'. Here the full repertoire of Duchamp's 'readymades' (which, as well as unitary objects, had included poetic or unexpected combinations of objects as in the 'assisted readymade', *Bicycle Wheel*, of 1913), were brought into a realignment with fine art practices in constructions fusing everyday objects, painting, and sculpture. In the case of one of these 'Combines', the notorious *Bed* of 1955 [19], the move from a horizontal to vertical orientation in the object's upright placement sets up an anthropomorphic counterpoint to Pollock's floor-based 'action paintings'. In being placed in the 'vertical posture of "art"'[7] the object sheds its normal links with our sleeping and dreaming, and thus with the notion of psychic revelation synonymous with Pollock's practice.

These bodily associations go deeper, however; from the outside to the inside, so to speak. As with a short flurry of red canvases of 1953-5, *Bed* appears to equate paint with bodily fluids, as though making palpable the violence that Willem de Kooning acted out on the bodies of his contemporaneously produced *Women* [23]. Violent associations aside, stained bed-sheets inevitably have sexual connotations and, given that Rauchenberg had decribed his *White Paintings* to one of his first curators as being 'presented with the innocence of a virgin',[8] it is tempting to think that he might have seen *Bed* as a counter-proposition to these in the spirit of the Dadaist Francis Picabia, who, in 1920, had blasphemously titled an ink splash *Sainte Vierge*. Picabia had been a close friend of Duchamp, and it becomes clear that with *Bed* Rauschenberg came close to recapitulating their scurrilous bodily repartee.[9]

Whatever the precise bodily associations of *Bed*, and a polymorphously perverse co-mingling of blood, semen, and faeces may certainly be involved,[10] the way in which such flows are brought into counterpoint with the geometrical symmetry of the quilt produces an over-arching 'gendered' dialogue. Paint, which ultimately connotes the fine art tradition, is anarchically set against a product of the handicrafts or applied arts. The 'male' sphere of cultural production intrudes into the 'female' sphere of domestic labour. This transgression of categories also mobilizes deep-seated notions of purity and defilement, and encourages speculation about the way societies make use of taboos regarding bodily 'pollution' for purposes of social containment, a topic later studied by the anthropologist Mary Douglas.[11] Earlier, in 1953, Rauschenberg had symbolically equated materials with incompatible cultural 'value' in his concurrently produced *Dirt Paintings* and *Gold Paintings*, the former consisting of compacted earth in shallow boxes, the latter of gold leaf overlaid on collage bases.

There are implicit democratizing impulses at work here, but the socio-political resonances of Rauschenberg's practice would not fully

19 Robert Rauschenberg

Bed, 1955

Critics at the time darkly remarked that *Bed* looked as if an axe murder had been committed in it. Rauschenberg saw it differently. His greatest fear, he once confided, was that somebody might try and crawl into it.

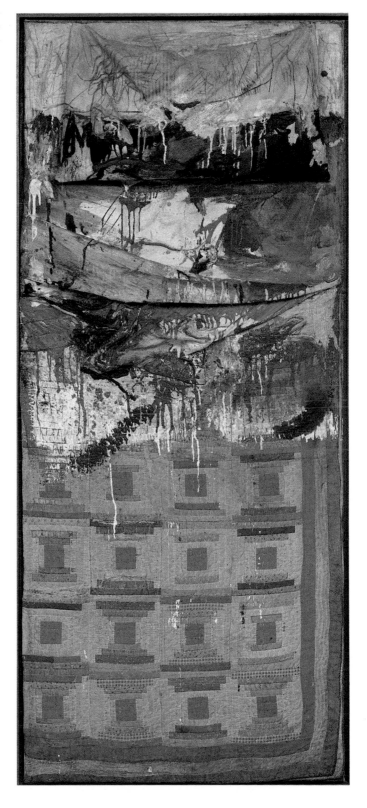

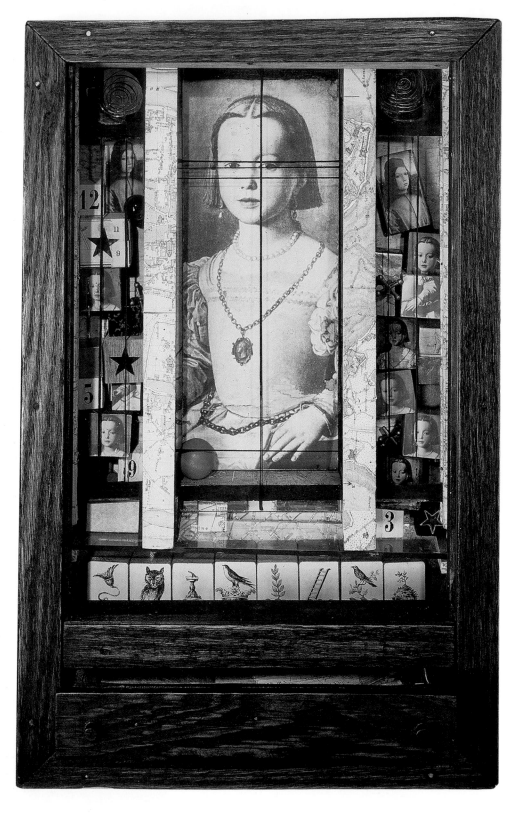

emerge until later. In 1958–9 critics began to codify the evident Duchampian disrespect for aesthetic boundaries, in both Rauschenberg's work and that of a growing body of fellow practitioners including Rauschenberg's ally Jasper Johns, in terms of a notion of 'Neo-Dada'.[12] But if such work embraced provisional structures and hybrid juxtapositions, it was hardly openly nihilistic, as was often the case with Dada. Consequently the term 'assemblage' quickly came to replace it. This genre reached its apotheosis in William Seitz's exhibition 'The Art of Assemblage', held at MOMA, New York, in 1961.

Seitz's curatorial recognition of what was dubbed a newly aestheticized 'urban collage environment' led to several artistic rehabilitations in his catalogue for the show. A late Picasso sculpture, *Baboon and Young*, of 1951, in which a toy car's body brilliantly doubles for the ape's features, now stood as a precursor of current preoccupations. In the exhibition itself, though, Picasso was downplayed in favour of Duchamp. Particularly significant was the inclusion of the reclusive Joseph Cornell, one of the few Americans to have responded inventively to Surrealism before the war. Over the years, Cornell had patiently constructed boxed miniaturized environments [20]. Their claustrophobic interiors, brimming with allusions, from French Symbolist poetry to Hollywood film, echoed his lifestyle in the New York suburbs caring for a demanding mother and a crippled brother. Cornell's boxes represented a new artistic genre and were spiritualized counterweights to Duchamp's more materially oriented *Boîte-en-Valise*. However, Cornell was not as otherworldly as is sometimes suggested. By 1949 he had insinuated himself into Charles Egan's gallery in New York where the young Rauschenberg, soon to show there, quickly absorbed his poetics of confinement, as did Jasper Johns somewhat later.

In stark contrast to Cornell's late Romantic sensibility, Seitz's catalogue also alluded briefly to West Coast American tendencies in the constructions of Ed Keinholz and Bruce Conner. These artists mobilized vernacular idioms and outright ugliness to mock social hypocrisies (see Chapter 4). Such developments led Seitz at one point to define assemblage as a 'language for impatient, hyper-critical and anarchic young artists'.[13] This instancing of youth culture affiliations is significant. In the 1950s America had witnessed the emergence of 'Beat' culture, as exemplified by writers such as Jack Kerouac and the poet Allen Ginsberg. The latter produced nightmarish urban visions of 'angelheaded hipsters burning for the ancient heavenly connection to the starry dynamo in the machinery of the night'.[14] His image-saturated open-form incantations, partly deriving from ideas of 'Projective verse' developed by the Black Mountain professor Charles Olson, have broad analogies with Rauschenberg's collaged surfaces. But, technicalities aside, Ginsberg was articulating the disaffection of a generation

born under the signs of Hiroshima and Nagasaki. (John Cage's promotion of Japanese philosophy has a socially-critical inflection in this context.) There was much in American culture at large for the ethically sensitive to feel uneasy about.

McCarthyism and masculinity

In the early 1950s the Cold War was at its height. The Korean conflict, entered by America to combat an imagined global expansion of Communism, had ended inconclusively in 1953. At home President Truman's 'loyalty order' of 1947, whereby government workers had been investigated for Soviet sympathies, had led to the Alger Hiss trial in 1950 in which dubious secret documents eventually secured the former State Department official's conviction for spying. The years 1950–4 saw the inexorable rise of Senator Joseph McCarthy, backed by the return of a Republican government in 1952 headed by President Eisenhower. McCarthy's reign of terror, which involved all manner of spurious accusations being levelled at suspected Communists, eventually ended in November 1957 when he was officially censured.

In such an atmosphere, artists with leftist instincts understandably felt vulnerable. To what extent did Rauschenberg reflect the 'Beat' writers' distaste for American chauvinism? In late 1952 and early 1953 he had travelled extensively in Europe with a close friend of the period, the painter Cy Twombly. Their desire to absorb European culture had symbolic weight at a time when American painting was relatively

21 Alberto Burri

Saccho H8, 1953

The sacks used in these canvases often displayed stencilled letters relating to their commercial origins. This suggests some link with the German prewar Dadaist, Kurt Schwitters who made collages from printed waste paper. However, Burri, unlike Rauschenberg, dissociated himself from the Dada spirit. He also played down the evident biologistic associations of the works, emphasizing their abstract materiality.

22 Cy Twombly

School of Athens, 1961

The classical setting and celebration of intellectual probity evoked in the title's reference to Raphael's *School of Athens* (*c*.1510–12, Vatican, Rome) are offset by markings evoking bodily excess and the smearing of faeces. The corporeal stainings of Rauschenberg's *Bed* [**19**] have become improbably crossed with an emblem of Renaissance humanism.

inward-looking. Italy, and Rome in particular, proved revelatory, and Rauschenberg twice visited the studio of the Rome-based painter Alberto Burri, whose *Sacchi* [**21**] of the early 1950s, consisting of patched and stitched burlap bags mounted on stretchers, were part of an *informel* movement paralleling that in France.

Italian *informel* had its own distinctive character, particularly in the paintings of Lucio Fontana, who powerfully rearticulated the spatial dynamism of early twentieth-century Italian Futurist art by opening up his picture planes via punctures and slashes. But Burri's work, like that of his French contemporaries, had sadistic bodily associations. Tears and bursts in the sacking of certain works appeared to be linked metaphorically to their blood-red colouration [**21**]. These must surely have affected Rauschenberg's contemporaneous red paintings, to say nothing of *Bed*. Burri's achievements have tended to drop out of

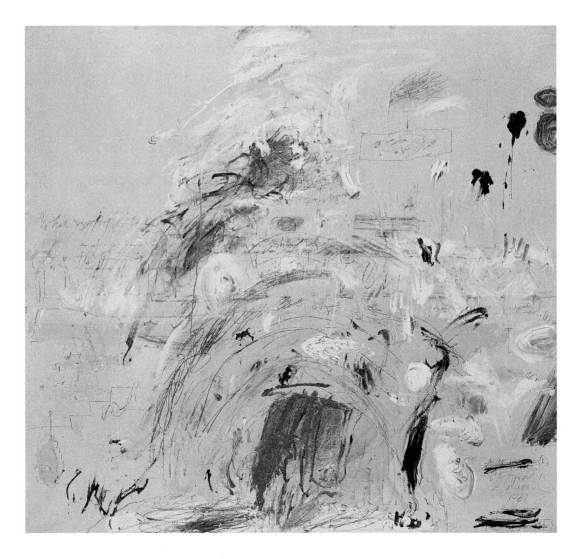

general accounts of postwar art but he was clearly influential internationally. He had several exhibitions in New York in 1953–5 and was accorded a role in Seitz's 1961 assemblage exhibition.

Rauschenberg's travelling companion Twombly also took elements from *informel* art, this time Dubuffet's graffiti vocabulary. Eventually he was to produce paintings marrying the gesturalism of Pollock and de Kooning to inchoate scribbles evoking the splotches, revisions, and erasures of childish script. His commitment to the sensuality of Mediterranean culture, which would lead to his settling permanently in Rome in the early 1960s, is conveyed by an ambivalent tribute to Raphael's Vatican fresco of the *School of Athens* [22].

In their embrace of Burri and Dubuffet, Rauschenberg and Twombly were staking out new territory, considering that American critics such as Greenberg, whilst extolling Dubuffet's achievements, nevertheless stressed the superior virility of American art. In this sense the artists might be seen as strategically importing the private or the visceral into a more stoical or 'manly' avant-garde climate. By 1964 Rauschenberg had been taken up by the American critical establishment, to the extent that its political maneouvring may have contributed to his winning the prestigious Grand Prize at the Venice Biennale, whilst Twombly was virtually written off by American critics for appearing too 'European'.[15] However, in the early 1950s they both implicitly aligned themselves with the bodily indulgences of *informel* aesthetics. The chauvinism of McCarthy's politics would have been reflected for them in the assertively macho challenge presented by their artistic elders, the Abstract Expressionists.

In 1953–54 it was de Kooning more than anybody else who epitomized the male-centredness of Abstract Expressionism. He was now producing semi-figurative images of women [23] which responded, possibly ironically, to Dubuffet. Whatever his personal attitude may have been—and he talked of savouring the 'fleshy part of art' encapsulated in the tradition of the European nude but of simultaneously wishing to get beyond it to the 'idea of the idol' —such aggressive images could hardly avoid upholding macho stereotypes.[16] This was reinforced by the well-known predilection of certain Abstract Expressionists for hard drinking and domestic violence.

For younger artists who felt ill at ease with such overbearing masculinism, defiance could take forms that were already sanctioned in structures of male avant-garde succession. This is encapsulated in a Duchampian gesture Rauschenberg carried out after his return to America in 1953 implicating de Kooning in an Oedipal scenario. Rauschenberg persuaded the older artist to donate a drawing to him for the purpose of erasure. Whilst de Kooning retained some authority by ensuring that the drawing he supplied was stubbornly greasy, the eventual ghostly trace was designated *Erased de Kooning* and signed

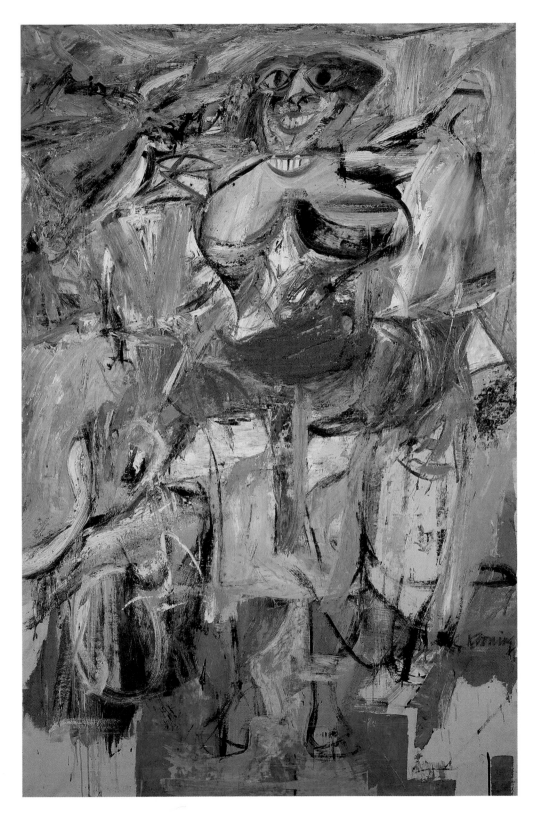

24 Lee Krasner

Bald Eagle, 1955

Lee Krasner was a central figure of Abstract Expressionism. She trained in the late 1930s with Hans Hofmann, the German painter whose teaching transmitted many of the principles of Modernist abstraction to the New York painters. She was employed on the Federal Art Project and in 1936 met Jackson Pollock, whom she was to marry in 1945. Early accounts of her career emphasized the extent to which she was 'overshadowed' by Pollock. Her work is now beginning to be examined in its own terms.

'Robert Rauschenberg'. This added a twist to the denial of authorial 'presence' in his earlier *White Paintings*.

However, this gesture symbolically effaced not just the 'paternal' signature but also something of the heterosexual masculinity attaching to it. Although briefly married at the start of the 1950s, Rauschenberg had come to recognize that his sexual orientation was bisexual. The social climate was hardly conducive to this. McCarthyism explicitly correlated homosexuality with Communism to the extent that, during

The masculine exclusivity of Abstract Expressionism is made especially clear when considering the effects it had on female artists attempting to work within it. The case of Jackson Pollock's wife, Lee Krasner, is particularly interesting here. The art historian Anne Wagner has shown that, during the height of Pollock's fame in the late 1940s, her response to his work, the so-called *Little Images* of 1946–9, involved a deliberate muting of his painterly heroics, a kind of self-abnegation necessitated paradoxically by the need to *preserve* her sense of self. (At the time she apparently worked in the cramped conditions of a converted bedroom, whilst Pollock occupied the main studio in their home.)

In the year before Pollock's premature death, Krasner made powerful collages, possibly drawing on the huge semi-abstract 'paper-cuts' that the veteran French Modernist Henri Matisse was producing around this time. In one of these collages she made use of off-cuts from her husband's canvases, as if rehearsing the problematics of retaining a separable identity [24]. Later on, at the end of the 1950s, she ironically allowed herself to develop the kind of expansive Abstract Expressionist style she had earlier needed to suppress. The upshot of this account is to show that, as in earlier instances in twentieth-century art, the structural position of female artists, as underwritten by socially and culturally determined frameworks of male–female relations, frequently placed female practitioners in a position of compromise with regard to career interests. This situation was naturally exacerbated, and made acutely vivid, when, like Krasner and Pollock, the artists were married.

its purges, more homosexuals than Communists ended up losing their jobs in the Federal government. In 1954, the young painter Jasper Johns replaced Twombly as Rauschenberg's artistic ally. This was simultaneously the beginning of a romantic relationship between them which, given the sexual mores of the period, quite apart from Abstract Expressionism's obligatory masculinism, would only be expressed through a highly coded pictorial syntax. Duchamp's use of oblique bodily metaphor and authorial indeterminacy again provided a model here. But it was to be Jasper Johns who followed it most closely.

Metaphors of sexual identity: Jasper Johns

Johns's earliest works, which are veritable icons of postwar art, appeared *sui generis*, the artist having destroyed much of his preceding output. He acquired critical success when the art dealer Leo Castelli, invited by Rauschenberg to their shared studio, bought up his entire production, exhibiting it, before Rauschenberg's, in early 1958. Looking at images such as *Target with Plaster Casts* and *Flag* of 1954–5 [**26**, **28**], it is apparent that, quite apart from inheriting Rauschenberg's dissolution of painting/object distinctions via the use of 'readymade' subject-matter, Johns's use of compartments in the former owes something to Cornell. His use of public emblems has a more esoteric source in earlier American artists such as Marsden Hartley and Charles Demuth. The latter's painting *I Saw the Number 5 in Gold* of 1928 was essayed in Johns's *Number 5* (1955) and later numbers pictures [**29**].

25 Marcel Duchamp
Belle Haleine, Eau de Voilette,
1921
The text on the label punningly
translates as 'beautiful breath/
veil water'. Duchamp's female
alter ego, Rrose Sélavy, peers
out from above it.

Hartley and Demuth had both been homosexuals, and the latter an
associate of Duchamp in the New York Dada days. From this Johns's
identification with a specific artistic lineage becomes clear. Among
Duchamp's strangest gestures had been the creation of a female alter
ego, Rrose Sélavy (a verbal pun on 'Eros, c'est la vie'). This figure,
whose visual manifestations consisted of photographs by the American
artist Man Ray of Duchamp in drag, appeared on the label of the
perfume bottle *Belle Haleine/Eau de voilette* [**25**]. A Dada skit on the
cosmetics/hygiene industry, this was simultaneously a succinct formu-
lation of Duchamp's understanding of art as (feminized) consumption
as opposed to (masculinized) production, as later exemplified by the
Boîte-en-Valise. Duchamp's sexuality, whilst ostensibly heterosexual,

was obviously put into question by this gesture. At the same time, his dandyish persona, involving an aristocratic disdain for what he deemed the 'splashy' side of painting, to say nothing of its retinal associations, won him many gay sympathizers.

In *Target with Plaster Casts* [**26**] Johns seems subtly to have invoked Duchamp. This painting/sculpture sets up a perceptual/conceptual interplay between an 'exposed' (but numberless) target below and a set of closeable boxes above containing casts of body parts, which, in certain cases, such as that of the green-painted penis third from right, blatantly signify as 'male'. The allusion seems to be to the Bachelors firing their 'shots' at the Bride in the *Large Glass* [**55**]. More broadly the imagery may dramatize the insecurity of gay identity at a time when homosexualiy was virulently proscribed, mobilizing metaphors of sexual 'outing' and 'closeting' or invoking social 'targeting', as symbolized by the fragmented body parts. In spite of its reticence, it appears to speak volumes about a society obsessed with fantasmatic inner demons and their expulsion. This relates it to Rauschenberg's *Bed* [**19**] as discussed earlier, and reprises the apocalyptic urgency of the Beat writers, several of whom were gay.

A more intriguing Duchampian parallel is with *Etant Donnés* which, as explained, involved directing the spectator's vision not at a male but at a female sexual organ. Johns must have been aware that, late in 1953, Duchamp had exhibited an enigmatic cast of a body part in New York entitled *Female Fig Leaf*, a 'positive' cast obtained from the pudenda of the 'nude' in *Etant Donnés*. It is unlikely that he knew of Duchamp's secret work on the installation, although John Cage, who was close to both Rauschenberg and Johns, may have known something of it. However, Johns appears to have tracked Duchamp's thought like a detective. Although he did not meet his spiritual mentor until 1959 (the year, incidentally, when the first book on Duchamp, by Robert Lebel, was published) he could have divined a great deal from the 1940s edition of *View* mentioned earlier. In 1954 much of Duchamp's output, assembled by the collector Walter Arensberg, went on show at the Philadelphia Museum of Art.

If *Target with Plaster Casts* does indeed transpose the dynamics of gendered looking from the *Large Glass* and *Etant Donnés* into homoerotic terms, a coda to this dialogue is provided by a slightly later work of art. The American sculptor Robert Morris's *I-Box* of 1962 [**27**] was produced at a yet further stage in the iconographic unravelling of Duchamp. The latter's notes for his *Large Glass* were now available in English (the translation came out in 1960) whilst Johns's *Target*, an echo of a work as yet invisible to the art community, could be construed as virtually predicting the trajectory of Duchamp's activities. In his voyeuristic *I-Box* Morris surely had the boxes at the top of Johns's *Target* in mind, but their fragmented contents were seemingly recon-

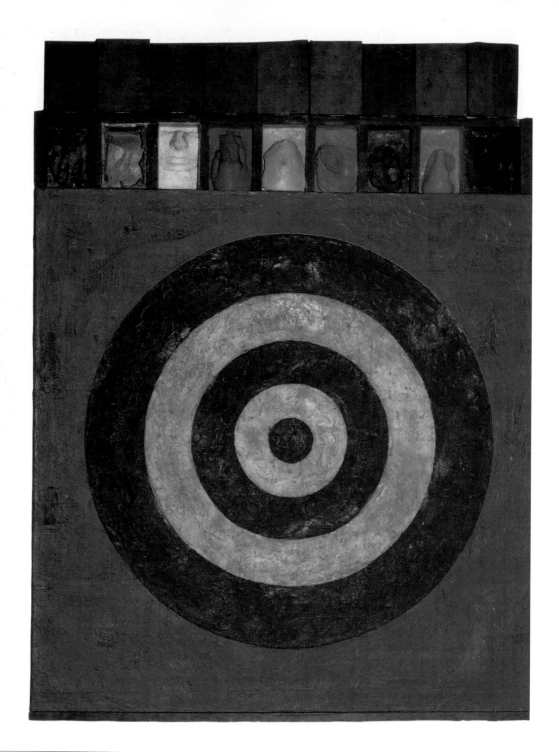

26 Jasper Johns

Target with Plaster Casts,
1955

27 Robert Morris

I-Box, 1962

Here Morris presented a small rectangular structure with a door shaped as a letter 'I'. When opened the door gave on to a photograph of the artist, his phallus rhyming with the 'I' connotative both of the viewers' looking (eye) and the artist's identity.

stituted in the image of a self-confident and possibly heterosexual male. The latter point is made tentatively since much depends on the sexual orientations Morris imagined himself addressing. And, whilst *I-Box* appears to reverse the terms of *Etant Donnés*, to what extent may the latter, materializing slowly elsewhere, have responded to Morris or Johns? There is no clear historical resolution to any of this. What is clear, though, is the sheer elasticity of the gender metaphors Duchamp put into play.

The aesthetics of indifference

The Duchampian model also appealed to Johns, as it did to Rauschenberg, for its anti-Modernist potential. Once again, de Kooning becomes pivotal here. His return to the figure in the early 1950s [**23**], a return paralleled in the work of numerous contemporaries

dubious about the faith Newman or Rothko placed in abstraction's ability to embody 'content', was seen by Modernist critics, notably Greenberg, as a failure of aesthetic nerve. Greenberg eventually coined the poetic phrase 'homeless representation' to describe de Kooning's adaptation of 'descriptive painterliness ...to abstract ends'.[17]

Looking at Johns's *Flag* [**28**], in which the American flag is taken as the 'subject' for a painting/collage, one sees his response to the discontents brewing in the Greenberg camp. Quite simply, it is impossible here to separate out the representational 'content' of the image from its insistence on functioning as a flatly 'abstract' Modernist painting. The paradox is set up by Johns's use of a pre-designed, two-dimensional sign as his subject. He would subsequently move on to making use of letters and numbers, generically described by him as 'things the mind already knows'. Such entities might be thought to have some substantial 'existence', but in fact hover somewhere between physical and conceptual states. They are, in this sense, 'homeless'. Johns therefore established that it *was* possible to make 'homeless' representations, subtly pre-empting Greenberg's difficulty with late Abstract Expressionism, although hardly, in terms of his banal subject-matter, endorsing de Kooning.

If *Flag* reintroduced a kind of phantom-like conceptual 'subject-matter' into the Modernist painterly 'field', while simultaneously preserving the 'all-over' integrity of it, Johns further ironized matters by supplying the image with an encaustic 'skin'. As with other paintings by Johns of this period, *Flag* utilised an unusual technique in which encaustic (pigment mixed with hot wax) was laid over a base of torn newspaper fragments. The use of a painterly medium which quickly solidified as the wax cooled ensured that the autographic mark was effectively frozen before it could achieve its full expansiveness.

Johns would have been aware that chance was one of Duchamp's principal means of short-circuiting his aesthetic habits, or introducing curbs on his expressivity. Duchamp had, for instance, permitted dust to build up on the lower section of his *Large Glass* [**18**] to determine part of its colouration (indeed the *Glass* in its entirety became for Duchamp a 'delay in glass' rather than a consolidated art object). It seems, then, that Johns also used a principle of 'delay' to interrogate the spontaneity of the Abstract Expressionist mark. In a painted construction of 1960 entitled *Painting with Two Balls*, this critique was allied to a scornful disdain for Abstract Expressionism's masculinism. Two small wooden balls were inserted into a gap manfully prising apart a canvas filled with embalmed painterly gestures. Johns thereby communicated an anxiety that, at any minute, the Modernist 'field' might snap shut.

A further point occurs in relation to *Flag*: this is the evident sense of concealment arising from the use of a newspaper base. Here and there suggestive bits of newspaper show through the encaustic as though contemporary events were metaphorically being screened out.[18] Given that 1950s America was obsessed with concealment and exposure, Johns's procedures seem entirely apt. It is revealing, though, that Johns replicated the social evasions of the period when, in later interviews, he accounted for the genesis of *Flag*. He said that the idea for it came to him 'in a dream', as though downplaying his volition and relegating its origins to the unconscious, the province of Surrealism. This might seem disingenuous. The American flag could hardly have been more charged with political significance than it was at the height of the Cold War, and Johns's work appears to encode a mute ambivalence towards its authority. However, the flag was surely an active symbol in the 'collective' or 'national' unconscious. This generates precisely the kind of ambiguity regarding his artistic intentions that Johns relished.

Johns's indeterminate position with respect to the imposition of aesthetic or social readings from the outside has been shown by the art historian Moira Roth to arise from an 'aesthetics of indifference' uniting Johns, Rauschenberg, and John Cage. Unlike Abstract Expressionists such as Newman or Motherwell, these artists' fascination with Duchamp's dandyism predisposed them to avoid overt political alignments.[19] The sheer ambiguity cultivated by Johns in this

respect is exemplified by a series of works from the late 1950s onward in which innocuous sequences of numbers were put through a series of painted and drawn variations [**29**]. The sequences were stepped such that they read horizontally, diagonally, and often vertically. They thus replaced the arbitrary subjectivity embodied in the Abstract Expressionist painted surface with a self-evidently 'logical' means of getting from one side of the pictorial field to the other. With such a system in place, Johns paradoxically freed himself to work around the numbers, courting the picture surface as devotedly as de Kooning. Roth emphasizes, however, that one could easily see the numbers as obliquely keyed to McCarthyism. Numerical sequences often acquired occult significance in the trials for spying, where 'codes were constantly on the verge of being cracked'.[20] It becomes clear that the numbers resist being counted, so to speak, on either interpretative side. They work, as Fred Orton has said of *Flag*, precisely 'in the space of difference', failing to confirm either one reading or another.[21]

There were, however, flickers of overt political comment in the larger artistic environment in New York. It tends to be overlooked that in 1953 another painter concerned with realigning subject-matter with abstraction, Larry Rivers, produced a small critical storm with his *Washington Crossing the Delaware*. Painted in an irresolute, sketch-like manner, it loosely referred to a kitsch, academic icon of patriotism of the same title produced by Emanuel Leutze in 1851. This episode demonstrates that not all avant-garde practice in this period projected a paralysis of political will. Although figurative and more conservative formally than Johns's work, Rivers's image conveyed a polemical disrespect for a picture which was ubiquitous in America's schoolrooms.

It also gets overlooked that Duchamp, however aloof from worldly affairs he appeared, had similarly produced a work on the subject of George Washington. This was a collage entitled *Allégorie de genre* which *Vogue* magazine solicited for a competition to produce a cover portrait of George Washington for their 'Americana' edition of February 1943. Duchamp's solution conjured the images of Washington's profile and a map of America from a section of shrivelled bandage gauze. This had been stained with iodine, to evoke dual connotations of wounds and the stripes of the American flag, and studded with a scattering of disconsolate fake stars. Given that the gesture appeared to reflect on America's entry into the Second World War, it was, unsurprisingly, rejected. Duchamp, it seems, had come too uncomfortably close to anti-patriotism for the America that was eventually to adopt him as its own (he took up citizenship in 1947). Johns may easily have seen Duchamp's collage since it was reproduced in *VVV*, an American Surrealist magazine, in 1944. Perhaps Johns forgot it. Twelve years later his *Flag* painting embalmed criticism of the State in ambiguities.

Readymades and replications

In 1960, as part of a then ongoing sequence of small-scaled sculptures, Johns produced *Painted Bronze (Ale Cans)*, in which casts taken from two beer cans appear on a plinth. This represented a new phase in Johns's reception of Duchamp, which now centred more squarely on the implications of the 'readymades'. Rauschenberg and, to a lesser degree, Larry Rivers had long ago ushered commodified imagery into art, reflecting America's postwar consumer boom, but Johns's beer cans were more essentially esoteric. By succinctly turning the readymade or mass-produced back into art, as symbolized both by the 'pedestal' on which the objects stood and by the utilization of the time-honoured sculptural process of bronze casting, Johns raised conceptual conundrums about the relationship between uniqueness and sameness. This is further dramatized by the way that the labels of the twinned objects were hand-painted to emphasize differences between them. In addition, one of the cast cans was 'opened' whilst the other remained 'sealed'.

Such gestures were seemingly reciprocated by Duchamp's own attention to issues surrounding readymades and replication in the 1960s. Showing some annoyance with the recent cult for 'Neo-Dada', he wrote, in 1962, to an old Dada ally, Hans Richter, complaining about the aestheticizing of his readymades. They had, he asserted, been

30 Sherrie Levine

Fountain / After Marcel Duchamp, 1991

Levine had pursued her dialogue with Duchamp in another direction in an installation of 1989 at Mary Boone's New York gallery entitled *The Bachelors (After Marcel Duchamp)*. Small frosted-glass versions of the Bachelors from Duchamp's *Large Glass* [**18**] were placed in a series of vitrines. Duchamp had conceived of his Bachelors as 'moulds' waiting to be filled. By transposing his diagrammatic prototypes into three-dimensional terms, Levine poignantly emphasized their 'emptiness' and isolation.

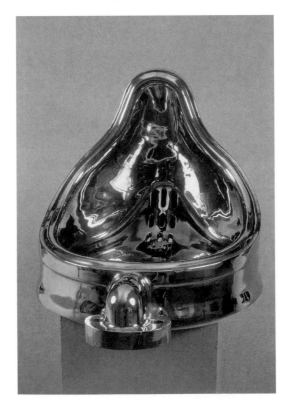

31 Robert Gober

Two Urinals, 1986

These highly stylized, non-utilitarian versions of plumbing fixtures evoke complex psycho-sexual concerns surrounding issues of hygiene and male bonding. At the same time, they participate in a witty dialogue with Jasper Johns's famous bronze cast of two ale cans, *Painted Bronze*, of 1960. Johns's cans themselves referred both to Duchamp and to the macho drinking culture of Abstract Expressionism. Gober thus brings an entire dialogue concerning male social/artistic camaraderie full circle

thrown into the public's face in a spirit of defiance. However much interpreters felt he had 'elevated' everyday objects to the status of art, he now declared that the readymades had been selected in a spirit of absolute indifference. Their whole anti-aesthetic rationale turned on the fact that they lacked 'uniqueness'.[22] He may well have been reformulating past attitudes here to keep ahead of developments around him. However, questions relating to the paradoxical 'originality' and 'reproducibility' of the readymades had preoccupied him earlier. In a series of notes of the 1930s on a pseudo-scientific category called 'infra-thin' he had speculated, in almost metaphysical fashion, on infinitesimal differences or thresholds between physical states. One example reads: 'The difference / (dimensional) between / 2 mass produced objects / [from the same mould] is an 'infra thin'.[23] Without knowledge of this note, Johns paralleled it with his cans.

Duchamp pushed the consequences of reproducibility to a perverse conclusion when, in 1964, he authorized the Galleria Schwarz in Milan to produce limited editions (of eight signed and numbered copies) of

14 readymades, each an 'original' from the same mould. There was probably a connection in Duchamp's mind here between the ironic 'individuality' of mass-produced items and other examples of the 'infra-thin' interface between moulds and casts such as the strange 'positive' cast, taken from the pudenda of the *Etant Donnés* mannequin, mentioned earlier. (Johns in fact acquired a version of this cast.) Quite apart from examples in Johns's work, the 1960s was to see many artists taking up body casting, exploiting all the poignant indexical traces or imprints of 'life' created by such processes. These included the American sculptor George Segal and the French artist Yves Klein, who will be discussed later.

It was not until the 1980s, however, that artists registered the full consequences of the Duchampian concern with replication. The American Sherrie Levine, who specialized in 'appropriating' pre-existing works of art by male 'Masters', made subtly ironic comments on the in-house 'masculinism' of the Duchampian tradition by 'feminizing' its imagery. In 1991 she produced a whole series of urinals with polished bronze surfaces, wittily re-enacting Johns's translation of the readymade principle back into art. At the same time she made sophisticated allusions to the polished modernist sculptures of Constantin Brancusi, whose work Duchamp had helped sell, thereby projecting a combined aura of sex and commercial gloss onto what now seemed a rather dour 'original' urinal [**30**]. Another 1980s artist, Robert Gober, produced a sculpture of two urinals side by side [**31**]. The fact that Gober's imagery often alluded to homosexuality had the effect of re-claiming Duchamp for masculinity, but a masculinity, of course, closer to that of artists such as Duchamp's arch-mediator, Jasper Johns, whose twinned ale cans Gober echoed.

Such metaphorical fine-tunings to the tradition of the readymade have turned into a rather monotonous end-game. Perhaps, more sympathetically, the process could be linked to the notion of 'genre'. In Holland over the course of the seventeenth century, still life came to be constituted as a genre, a category of subject-matter which painters could knowingly manipulate. The tradition of the readymade may have analogies. But the larger agendas set for postwar art by Duchamp, such as the concern with the 'gendered' relation between the object and the spectator or the probing of the relationship between the 'original' and the 'replica', hardly constitute genres in certain fundamental respects. They are not attached to specific kinds of objects, subjects, or techniques. Instead they rely on the dynamics of conceptual innovation. It is in this elusive area, resistant to conventional aesthetic criteria, that Duchamp had the greatest historical impact.

The Artist in Crisis: From Bacon to Beuys

3

The image of the artist bequeathed to the postwar avant-gardes was a fundamentally heroic one. Whether Picasso's mercurial shifts of style, Duchamp's cerebral dandyism, or Mondrian's universalizing abstract vision were taken as benchmarks, the modernist artist was broadly understood to possess a superior sensibility. This model largely persisted after 1945. Photographs of Jackson Pollock by Hans Namuth depict him as haunted and brooding, a prototypical non-conformist. But societal changes slowly modulated the sense of the artist's special status. The cultural value attaching to the concept of 'uniqueness', for instance, was insidiously eroded by commodity production and the rise of reproductive technologies. How did artists register such changes? This chapter aims to provide some answers.

Bound up with artists' sense of self was their sense of what it is to be human. The previous chapters have largely concentrated on how American avant-gardists navigated between the competing aesthetic positions of Greenberg and Duchamp. In the process overtly 'human' themes, alongside politics, often dropped out of their art. In general, it tended to be artists in European countries who reinvented humanist iconographies.

Humanism and individualism: British and French figuration in the 1950s

In Britain at mid-century the work of the sculptors Barbara Hepworth and Henry Moore had secured the country an international art profile it had lacked since the nineteenth century. Moore's figurative sculptures in particular managed to combine a universalizing rhetoric with a deep-rooted English inwardness and insularity. The best of his work, exemplified by the *Working Model for Reclining Figure* of 1951 [**32**], looked outward to the lessons of previous European avant-gardes and their 'primitivist' models, although the formal risks of late Constructivist sculpture, or Picasso's barbaric bodily distortions, were softened by a classically derived vision of bodily equilibrium. By contrast it looked inward to the reassertion of 'timeless' national

32 Henry Moore

Working Model for Reclining Figure (Internal and External Forms), 1951

In formal terms, this sculpture manages to harmonize the claims of an aspiring, organic element within and the protective, enveloping characteristics of an outer casing. This is achieved via Moore's signature 'holes'.

values—particularly those supposedly embodied in the English countryside—required by a country both victorious and depleted after the war. In tune with much 'Neo-Romantic' imagery in British culture of this period, Moore evoked the archetypes of an island-bound race: rocks eroded by the tides, crustaceans emerging inquisitively from their shells. But if he spoke metaphorically of resilience and native caution, he was capable, at his worst, of blandness. The outdoor *King and Queen* sculpture at Glenkiln in Scotland is perhaps a case in point.

Moore became the 'acceptable face of modernism' for the postwar British establishment whilst his commercial success was consolidated in New York with a retrospective at the Museum of Modern Art in 1946. His public sculptures—large, chunky semi-abstractions, cast in bronze, raised on plinths—ironically connoted 'tradition' located in front of Bauhaus-style buildings. However, his liberalism and sense of public duty, which probably compromised the quality of later productions, might be seen as reflective of the egalitarian ethos of the Labour government of the immediate postwar years. On the basis of the Beveridge Report of 1942, this administration laid the foundations for the Welfare State with the National Health Service as its centrepiece. The Arts Council of Great Britain was formed in 1946. Moore's civic humanism, his capitulation, as a modernist, to the cultural liberalism of centralized state socialism, can be contrasted starkly with the

intense introspection of the painter Francis Bacon. In 1946 Bacon's *Three Studies for Figures at the Base of a Crucifixion* received its public debut at the Lefevre Gallery, London. Depicting three Picassoesque hybrids united, in John Russell's words, by a 'mindless voracity ... a ravening undifferentiated capacity for hatred',[1] it represented the antithesis to Moore's magnanimity.

Unlike Moore, Bacon extracted a violent, anti-humanist message from Surrealism, mainly by turning, like certain *Informel* painters in France, to the example of one of its dissident figures, Georges Bataille. In texts published in the journal *Documents*, copies of which Bacon later owned, Bataille had established a sense of the human as not so much elevated above, but rather co-existent with, the bestial. 'On great occasions,' he wrote, 'human life is concentrated bestially in the mouth ... the stricken individual ... frantically lifts up his head, so that the mouth comes to be placed ... in the extension of the vertebral column, that is to say the position it normally occupies in the animal constitution.'[2] As Dawn Ades has shown, Bacon's recurring images of the wide-open mouth in paintings from 1948 to 1955, deriving also from Eisenstein's film *Battleship Potemkin* and Poussin, encapsulate this viewpoint.[3] However, this quotation equally illuminates Bacon's remarkable animal depictions, which tend, ironically, to receive less attention than those of humans [33]. Preferring photographs to actual models—often from the late nineteenth-century photographer Muybridge—Bacon followed Futurist or Duchampian precedents in incorporating motion into these images. Photographic traces of spasmodic animal movement were translated into flicks or flurries of paint.

Paradoxically, though, Bacon was a traditionalist, painting with the bravura of Velasquez or Rembrandt in an age increasingly attuned to media imagery. In interviews he elaborated on the brinksmanship required to 'trap' images, often via photographic mediation, at the point where they encoded the very pulse of nervous energy. This desire, as he said, to 'return the onlooker to life more violently'[4] should be distinguished from his occasional use of explicitly violent subject-matter, reflective of post-Holocaust human pessimism. In later paintings such as *Study for a Portrait of Lucian Freud (Sideways)* (1971), intensities of paintwork, articulating or cancelling the figures they represent, are located in large swathes of Matisse-like colour or raw canvas, crossed by elegant linear arcs, which read as schematized interiors. Sparse props, often incongruously streamlined furnishings, accompany Bacon's figures. He had been a successful designer of modernist tubular steel chairs and rugs in the 1930s. However different his intentions to Moore's, his figures are frequently offset against the utopian uniformities of high modernist abstraction and design. On this level at least there may be a residual humanism.

As a painter of the isolated figure, Bacon also evinced a fiercely

individualist artistic position. In this he was similar to the younger Lucian Freud, who, eschewing Bacon's reliance on photographs or memory, opted for an unremitting painterly interrogation of the live model. His hyper-realist style, partly reliant on the *Neue Sachlichkeit* (new objectivity) of German art in the 1920s, can be seen in his 1951 *Interior in Paddington* [**34**]. His razor-sharp, hallucinatory realism was inherently at odds with left-wing injunctions towards forms of socially committed realism; such a position in any case seemed untenable to many, and Albert Camus's *The Rebel*, translated into English in 1953, helped foster anti-bourgeois convictions in artists, in the

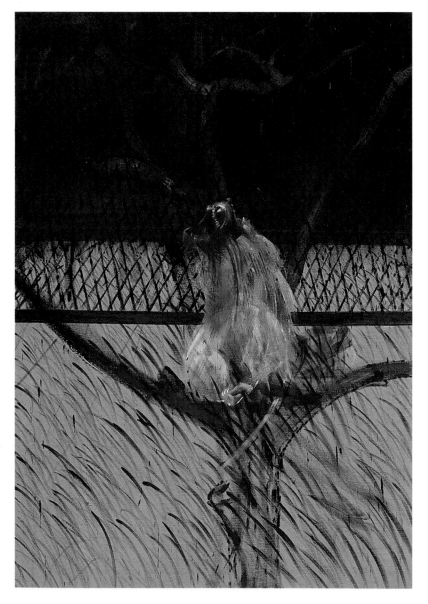

35 Alberto Giacometti

Standing Nude, 1955

This drawing, which at nearly three feet in height is very large for Giacometti, is one of an enormous number that he produced throughout his life. His sculptures and paintings of the figure, similarly attenuated, are far better known, but drawing for Giacometti had its own very specific virtues. Here, for instance, parts of the figure have been smudged or erased, reinforcing suggestions of transparency or of shimmering.

absence of political faith in Communism. By 1959 the critic John Berger, who had previously supported socially oriented art, acknowledged that an individualistic revelation of the real constituted in itself ideological opposition towards the *status quo*.[5] Like the Expressionist-oriented painters Frank Auerbach and Leon Kossoff, who emerged in London in the late 1950s, Freud became increasingly immersed in the pragmatics of a perceptual and emotional struggle with the motif. An underlying respect for hard-won observational skills and a basic suspicion towards the modernist cult of innovation went hand in hand with disdain for the public 'message'.

The individualist ethics of the 'School of London' were rooted in the reception of existentialist principles from France. These were mainly transmitted to artists through the work of Alberto Giacometti, a Swiss-born sculptor who had been a Surrealist up until the mid-1930s and then converted, dramatically, to working from life. Giacometti's mythical status was founded on legends of his driven persona as much as his anxiety-laden work. Whereas Moore's sculpture essentially derived from carving, Giacometti was a modeller who obsessively kneaded and whittled his spindly clay figures until they distilled complex or contradictory spatial apprehensions. His influential interpreter from 1941 onwards, Jean-Paul Sartre, described this process: 'he knows that space is a cancer on being, and eats everything; to sculpt, for him, is to take the fat off space'.[6] Implicitly questioning the reassuring givens of perspective, Giacometti repeatedly attempted to express the fragile contingency of his perceptual relations to his models, describing, for instance, how a model in his studio 'grew and simultaneously receded to a tremendous distance'.[7] The immobility of the figure in a drawing of 1955, in which lines bind the joints of the body like wire [35], indicates that Giacometti's thinking was also inflected by Maurice Merleau-Ponty's *Phenomenology of Perception* (1945). Writing much later, the psychoanalyst Jacques Lacan might almost be registering the frozen, hieratic look on this figure's face when, glossing Merleau-Ponty, he describes 'the dependence of the visible on that which places us under the eye of the seer … this seeing to which I am subjected.'[8]

The period 1948–53 saw Giacometti establishing himself with dealers in both Paris and New York, and his British reputation, largely an outcome of the critic David Sylvester's advocacy, was consolidated with an Arts Council exhibition in 1955. In that year another French sculptor, Germaine Richier, achieved considerable critical impact in London with an exhibition at the Hanover Gallery. The 'masculine' qualities of her bronzes—their unabashed dialogue with Rodin's full-scale figures, their rugged, scarred surfaces and violent deformations—troubled critics, in Britain as in France, not least because of set assumptions about the imagery expected of women artists [36].

36 Germaine Richier

L'Orage (The Storm), 1947–8

Having originally been taught by a pupil of Rodin and by the Paris-based sculptor Antoine Bourdelle, Richier produced work in a classical vein before the Second World War. After the war her work changed markedly. Her figures appeared traumatized. Often they seemed to be emerging from a larval condition. Their limbs looked strangely amphibian.

However, the work Richier produced in the late 1940s and early 1950s possibly had a greater formal impact on others than that of Giacometti. The latter's angst could be appropriated, but hardly his style. By contrast, Richier's morbid allegory, and the anti-humanist implications of her animal and insect imagery, had some take-up in the spiky, skeletal

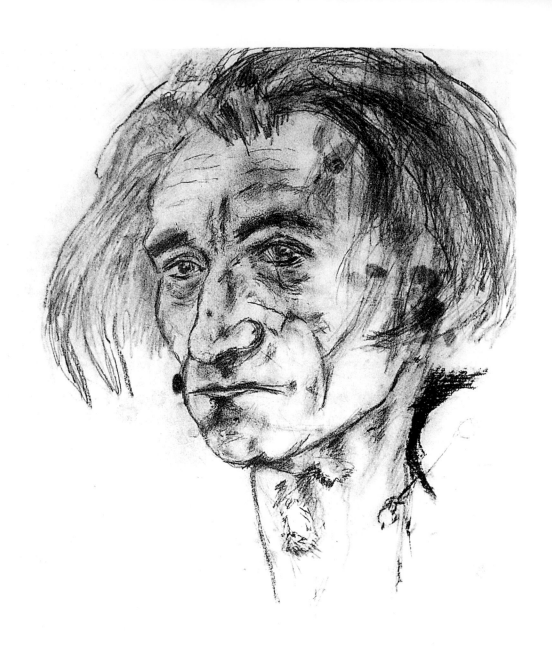

forms of British sculptors such as Lynn Chadwick, Reg Butler, and Eduardo Paolozzi. Exhibiting collectively at the Venice Biennale of 1952, they were said to manifest a 'Geometry of Fear' by the veteran critic Herbert Read. This was an evocative coinage. Britain acquired nuclear weapons in that year, following the example of the Russians in 1949.

Whether European figuration of the 1950s saw man as embodying the principles of existential choice, popularly available in Sartre's pamphlet 'Existentialism and Humanism' (1946), or of bestial irrationality, as in the Bataillean concerns of Bacon, this period saw the demise of a related notion—the artist as tragic genius. Certainly, isolated or eccentric figures abounded. In many ways the frenetic late drawings of the former Surrealist Antonin Artaud, produced just after the war had ended and comparable to works by Fautrier or Wols discussed in Chapter 1, had set the tone for this apotheosis of the *artiste maudit*. Hospitalized at the psychiatric asylum at Rodez in France during 1943–6, Artaud identified himself with Van Gogh, producing self-images manifesting a fierce desire to burst the bounds of identity. Asserting the rights of the body over the mind, Artaud wrote: 'the human face is temporarily, / and I say temporarily, / all that is left of the demand, / of the *revolutionary* demand of a body that is not yet and was never in keeping with this face'.[9] Frantic, he gouged out the eyes of one self-image, in the attempt to reach his internal 'other'.[10] A slightly later self-image, its surface bruised and blotched from reworkings, exudes a hard-won dignity [**37**].

Artaud's drawings, linked as they were to his writings, have only recently gained recognition. However, by the end of the 1950s, when MOMA in New York surveyed the figuration of the period in its 'New Images of Man' exhibition, intense subjectivism was beginning to look dated. Peter Selz, in the exhibition catalogue, asserted that 'the act of showing forth these effigies takes the place of political and moral philosophy'.[11] Forgetful of the fact that Abstract Expressionism's glory and failure had rested on these terms, and seemingly insensitive to the difficult moral decisions that had recently informed European individualism, he made figuration look complicit with America's neutralized political status quo. A few years later, in France, one of the doyens of post-Structuralist philosophy, Michel Foucault, was to claim that the humanist notion of man, on which Selz's claims had ultimately rested, was merely an outcome of bourgeois liberal ideology. 'Man', Foucault claimed, 'is an invention of recent date. And one perhaps nearing its end.'[12] The notion of a deep-rooted artistic subjectivity was similarly in crisis.

Art and commodity: New Realism

In the late 1950s France changed dramatically. The Algerian uprisings of mid-1954, leading to the independence of that country in 1962, signalled the end of French colonial power. Simultaneously American financial aid, under the Marshall Plan, set in motion a massive acceleration of state-led modernization, hand in hand with a new consumer ethos. By American standards the boom in consumption was modest: in 1961 one in eight people in France owned a car, compared to three in eight in America, but cinema in particular propagated images of the luxury-filled utopia to come. The literary theorist Roland Barthes was among the first to respond to the plethora of semiotic codings operative within this new advertising-led culture. His *Mythologies* of 1957, a collection of previously published essays, wittily discerned deep-seated social prejudices and aspirations at work in mass imagery—the latest detergents, women's magazines, margarine, the face of Garbo. Artistic responses were ambivalent. The idea of appealing to an increasingly mobilized and class-variegated audience spoke to an anti-elitist avant-garde dream. At the same time artists had to compete with a fast social turnover of imagery and a decline in their audience's attention spans. Galleries could hardly compete with cinemas.

The *Nouveau Réaliste* (New Realist) movement partly responded to this, although the group as a whole was of less consequence than its individual members: Yves Klein, Arman (born Armand Fernandez), Jean Tinguely, and Daniel Spoerri pre-eminently. Group solidarity was briefly achieved when their main critical advocate, Pierre Restany, issued a manifesto in April 1960 asserting that, since easel-painting was moribund, a 'passionate adventure of the real' was called for. Broadly speaking, this constituted a long-overdue French reassessment of Dada, particularly the Duchampian readymade. In 1959 Duchamp, on a visit to France, met Tinguely and Spoerri. Subsequently his spirit presided over a cluster of international exchanges between the New Realists and the American 'Neo-Dadaists', Johns and Rauschenberg. It was in America that several of the New Realists cemented their reputations (French galleries were slow to respond to new trends), but their name was quickly appropriated, and their achievements assimilated into America's burgeoning 'Pop' tendency, when they were shown alongside the likes of Warhol at 'The New Realists' exhibition at Sidney Janis's New York gallery in 1962. (They had also been represented in 'The Art of Assemblage' at MOMA the previous year.) After this, and in the wake of Klein's premature death in June 1962, the group gradually dissolved. However, their responses to consumerism were prescient, not least because they reflected a wariness of the tokens of capitalism.

Representative examples were Arman's series of *Accumulations*—boxes filled with identical readymade objects in various states of wear and tear, which responded to issues of overproduction and built-in

38 Arman

In Limbo, 1962

Whilst implicitly acknowledging the Surrealism of Cornell [20], Arman possibly evokes Barthes's mournful vision of commodified toys as expressed in the latter's book *Mythologies* (1957). Barthes wrote that in the consumerist era, rather than becoming worn through affection, the mechanical doll disappears 'behind the hernia of a broken spring'.

obsolescence, distilling a poetics of premature ageing and flawed uniformity [**38**]. In dialectical fashion Arman offset his *Accumulations* with his *Poubelles* ('trash cans') consisting of transparent containers filled with garbage. This trash, incidentally, found its own level through the anti-aesthetic utilization of gravity as an organizing principle, but neverthess had exact social origins; titles included *Household Rubbish* (1960) and *Small Bourgeois Trash* (1959). In October 1960 Arman and his friends filled Iris Clert's Paris gallery with refuse. The work's title, *Le Plein* ('Full Up'), astutely responded to an equally notorious and carefully stage-managed event of two years earlier by Arman's friend, Yves Klein. This consisted of an emptying and whitewashing of the same space, under the title, *Le Vide* ('The Void'). Klein's mystical gesture was a manifesto of immateriality, a concept central to his thinking. Arman countered this with the all-too-material detritus of mass production.

A materialist poetics was further manifested in the output of Daniel Spoerri. Combining the readymade principle with a respect for the laws of chance stemming from Dada, Spoerri began to produce *Tableaux-pièges* ('Snare-pictures') in the late 1950s. These pieces, initially reflecting his own impoverished lifestyle, dealt with consumption of a rudimentary kind. The leftovers of a (usually modest) meal on a table top—plates, cutlery, as well as crusts and so on—would be permanently affixed in position, and the entire ensemble hoisted vertically to hang on the wall. In 1962 Spoerri adapted the principle to book format in *An Anecdoted Topography of Chance*. At the back of the book, an elaborate numbered diagram maps the debris on a table in his hotel room on 17 October 1961. Using this, the reader reconstitutes the histories of humble objects, aided by the author's associations and a series of footnote annotations by Spoerri's associates in the Fluxus movement (see Chapter 4). The entry for a pin begins: 'Pin from a spectacularly folded new grey sports shirt, bought at the Uniprix on the Avenue GÉNÉRAL LECLERC for 20 francs, after being insulted by the salesgirl because I didn't know my size.'[13] This may be a humorous harbinger of taxonomic practices within Conceptual art. However, Spoerri's attention to the minutiae of human waste constitutes an obliquely critical response to his times. Underlying this there is a certain nostalgia, which bypasses the harder realities of art's changing relation to its public.

The commodification of spirituality: Yves Klein

Of all the New Realists Yves Klein most acutely registered the inexorable changes in art's societal role. He was a mixture of self-appointed messiah and self-aggrandizing showman. Like Salvador Dali, he set out to sell himself. That he appeared to sell off the hard-earned freedoms of avant-gardism, not least its spiritual reserves, has troubled many commentators.

Klein was almost childishly romantic, a lover of cults and rituals. Aged 20, he became devoted to Rosicrucianism, having contacted a Californian sect immersed in the principles of Max Heindel's *The Rosicrucian Cosmo-conception* (1937). Their beliefs—which were only tangentially related to those of the hermetic seventeenth-century Rosicrucian Brotherhood—emphasized an evolution from the current materially bound epoch to a future age of pure spirit. They saw 'empty' space as spiritually replete, whilst matter constituted crystallized space. It was the responsibility of initiates to enlighten their brethren. Klein thus conceived of himself as the prophet of a liberating 'immateriality'. His *Le Vide*, mentioned earlier, obviously embodied the notion of a spiritually energized emptiness. (Zen Buddhism, which he became aware of on a trip to Japan in 1952–3, similarly embraces 'nothingness'. Cage and Rauschenberg, it will be recalled, were utilizing Zen principles in America at this time.) Similarly, Klein's late photo-manipulation *The Painter of Space Hurls Himself into the Void* [**39**] pictured the artist as the avatar of human potentiality: Heindel's followers envisaged an age when men would levitate. To add to all this, Klein loved Catholicism and religious fetishism; he was a lifelong devotee of Saint Rita of Cascia.

Conversely, Klein loved fakery and the artificial. Like Duchamp and the post-Abstract-Expressionist generation in the US, he distrusted the arbitrary 'integrity' of the Expressionist gesture. He encapsulates a growing tiredness in France with the existentialists' rhetoric of 'authenticity'. The space in *Le Vide* was thus liberating rather than physically oppressive, as in Giacometti's sculptures. As someone nonetheless wishing to communicate 'truths', he cultivated an aesthetic predicated on dandyish equivocation. Towards the end of his life, stung by American criticism that his work was 'corny', he turned this into a virtue, asserting the need for an "'EXACERBATING AND VERY CONSCIOUS ARTIFICALITY" with a touch of DISHONESTY'.[14] A similar show of duplicity had underpinned his strategic entry into the art world. Having dabbled intermittently with monochrome painting, Klein had brought out a small booklet, 'Yves Peintures', in 1954. It purported to illustrate works of 1951–4 produced in various cities. In fact the plates were not photographic reproductions of pre-existing paintings but sheets of commercially inked paper.

There is an open play on authorial 'presence' and reproducibility in this gesture. However, when Klein actually started to produce his fully fledged *Monochrome* paintings in 1955 the verbiage of spirituality came to the fore. Having experimented with various colours, he stuck permanently with the colour which would be connotative for him of the 'boundlessness of space'—ultramarine blue. The single-colour canvas was undoubtedly innovatory, although Malevich's Suprematist abstractions were forerunners, whilst Rauschenberg had recently produced his

White Paintings in New York. Klein conceived of his use of pure colour as a kind of 'victory' over the competing claims of line, thus reviving a classic seventeenth-century French debate between the 'Rubenistes' and the 'Poussinistes'. Simultaneously he claimed that he refused 'to bring [colours] face to face in order to make such and such an element stronger and others weaker', thereby adumbrating a doctrine of the 'non-relational' which would be espoused later by American abstractionists (see Chapter 5).[15] He also pioneered new techniques such as the use of a house-painter's roller, and the use of a binder to impart a powdery quality to his chromatic surfaces, thus greatly enhancing their optical expansiveness. However, the fact that this blue quickly became Klein's trademark—he patented it as 'I.K.B.' ('International Klein Blue'), saw it as ushering in his 'Blue Period' (*à la* Picasso), and took to

calling himself 'Yves the Monochrome'—reintroduces the notion of charade, or, more precisely, self-commodification.

In 1957 Klein had a key exhibition at the Galleria Apollinaire in Milan. He showed 11 blue monochromes, all unframed and uniform in size and facture. They were sold at variable prices, established after Klein's consultations with individual buyers. Klein was to argue that the purchasers had discerned qualities unique to the works, mystically registering the levels of 'pictorial sensitivity' imbued in each by the artist. However, there is again a complex switching between seemingly irreconcilable positions: the idea of the 'authentic' expressive/spiritual exchange between artist and viewer and an acceptance that art objects are material commodities. The implications of the latter position would be succinctly expressed in a 'Pop' context in 1962 when Andy Warhol showed 32 images of Campbells soup cans at the Ferus Gallery, Los Angeles, identical but for labels conforming to the available range of flavours. Unlike Klein, he priced them all the same. Clearly Klein epitomized a prior historical juncture where the theologically related model of the creator-artist began to conflict with a technologically based model reflective of changing social modes of production. His principles shifted to gratify a new audience primed to expect that their unique desires—their spiritual needs, even—would be assuaged by standardized products.

It is here that critics discern Klein's bad faith. In later ritualistic performances of 1959 he signalled a shrewd economic sense. He set up transactions where wealthy buyers purchased not paintings but 'Immaterial Pictorial Sensibility' itself, for which they paid in gold leaf. Having received printed receipts from Klein they were enjoined to set fire to them, since, as the artist frequently asserted, outward manifestations were merely the 'ashes of his art'. Hence the buyers ironically attained literal immateriality—a fairly standard 'product', it might be argued—whilst Klein kept half of the gold. Thierry de Duve sees Klein as committing a crime against his avant-garde legacy—in Marxist terms, substituting 'exchange-value' for 'use-value'.[16] However, if we absolve Klein from being entirely mercenary, he exemplifies a kind of hysterical reaction—both to art's interface with a commodity culture and to a decline in the notion of the artist as someone able to speak, disinterestedly, 'for mankind'.

Symptomatically, Klein wanted to renounce individuality and 'sensitize' the interpreter/consumer, yet retain the authorial mystique of the artist. His 'performances', which help to announce a new genre of postwar art, exemplify this. The *Anthropometries of the Blue Age* [**40**], performed at the Galerie Internationale d'Art Contemporain in Paris in March 1960, both parodied and confirmed the inflation of the creative ego, seen as linked, inextricably, with masculinity. While a chamber orchestra played his Cage-influenced *Monotone Symphony* (a

40 Yves Klein

Anthropometries of the Blue Age, performance, 9 March, 1960

This performance exemplifies Klein's participation in the masculinist tradition of the dandy. The self-contained male, renouncing biological productivity (symbolized by the 'fecundity' of the paint-covered women launching themselves at virginal paper surfaces), ultimately reproduces 'cleanly' via art.

The death of the author: the rise of French Structuralism

Yves Klein's vacillation between a messianic and self-commodifying stance paralleled a demotion, in French intellectual life, of the status of artistic agency. This was consolidated in Roland Barthes's essay 'The Death of the Author', first published in *Aspen* magazine in America in 1967. Barthes's ideas followed a trend in French Structuralist thought that had been current since the early 1950s. Building on Freud, Jacques Lacan's psychoanalytic notion of the 'mirror stage', formulated fully in 1949, had indicated that the formative stages of human identity formation, involving the dawn of a self-consciousness in which the subject experiences itself as 'other', disproved the idea of a unified 'core' to subjectivity. Barthes, and other thinkers such as Michel Foucault, Jacques Derrida, and Julia Kristeva, polemically wielded related concepts in the 1960s to destabilize bourgeois liberal belief in an essential, unchanging 'human nature'. The figure of the author (or artist), popularly thought to enshrine these values, had to be dethroned. Barthes argued that 'a text is not a line of words revealing a single "theological" meaning (the "message" of the Author-God) but a multidimensional space in which a variety of writings, none of them original, blend and clash'. Thus it became possible to empower the interpreter or 'reader': 'the birth of the reader must be at the expense of the Author'.

These ideas became enormously influential later when they broke loose from their academic moorings, eventually underpinning postmodernism. However, Duchamp had touched on such notions by asserting that the spectator 'completes' the work of art, and Cage had transmitted equivalent doctrines to Rauschenberg. It has been argued that, in the French context, these principles actually suited the needs of a new technocracy. In the 1950s the philosopher Henri Lefebvre maintained that Structuralism, in downplaying human agency, paralysed people's sense of autonomy. In this sense it could be seen as unwittingly complicit with the expansion of market capitalism and symptomatic of a crisis among the French Left after 1956, the year in which, in the wake of his death, the full extent of Stalin's atrocities came to light, and the Soviets invaded Hungary. Yves Klein, whose political views were, incidentally, deeply reactionary, perhaps functions as a kind of barometer for this changing cultural climate.

work consisting of one note held for 20 minutes), Klein, wearing a tuxedo, instructed several naked female helpers, described by him as 'living paintbrushes', to imprint their paint-smeared bodies onto paper laid on the floor. Klein made much of not 'dirtying' his hands with paint, and officiating at the 'birth' of his work. No doubt he was ironizing Pollock's ejaculative 'action paintings', which were also horizontally oriented and avoided 'touch'. (Hans Namuth's dramatic photographs of Pollock painting were widely circulated in the 1950s.) Closer to home, Klein had reason to mock the showy public painting demonstrations of the 'Lyrical Abstractionist' Georges Mathieu, who, in 1956, had produced a 12-foot by 36-foot painting, full of expressive bravado, at Paris's Théâtre Sarah-Bernhardt. By appropriating the indexical traces of his models, which he predictably saw as embodying life-energy, Klein instigated a new non-autographic mode of artistic production. Rauschenberg had, however, experimented with the indexicality of photography around 1950, producing life-sized 'photograms' of the body of his then wife, Sue Weil, on blue-print paper. (These were reproduced in *Life* magazine in April 1951.)

Klein's penchant for fakery remains puzzling. His most striking performance gesture, *The Painter of Space Hurls Himself into the Void*, was an exercise in contrivance. Presciently recognizing the crucial role played by photography in the way a time-bound performance comes to be 'constructed' for posterity, Klein got his collaborator, Harry Shunk, to create three photographic montages which skilfully transformed a relatively safe jump into a tarpaulin manned by judo friends into an awesome ascension. One of these was published as part of a brilliant spoof newspaper produced for one day only—Sunday 27 November 1960 [**39**]. Although this newspaper was only placed on a few news stands for photographic purposes, its production establishes that Klein was happy to assimilate his spirituality to the logic of mass circulation.

The body's economy: Piero Manzoni

If the ostensible 'spirituality' of much of Klein's output appears compromised, it is useful here to look to an artist who, in many ways, acted as Klein's shadow, producing unambiguously acidic materialist counter-propositions to the French artist's excesses. Piero Manzoni was a Milan-based artist who, in the mid-1950s, was deeply affected by the work of that city's senior avant-garde presence, Lucio Fontana. Manzoni inherited Fontana's liberation from aesthetic constraints, symbolized for instance by the latter's innovatory environmental installations of the early 1950s utilizing looping neon light fittings. He also made alliances with like-minded younger artists in the *Gruppo Nucleare* (Nuclear Group). In early 1957 Manzoni saw Klein's Milan *Monochrome* exhibition, described above, and began a series of *Achrome* paintings in which he bled the mysticism, along with the colour, out of

41 Piero Manzoni

The Artist with 'Merda d'artista', at Angli Shirt Factory, Herning, Denmark, 1961

This provocative image of Manzoni with one of his cans of excrement could be seen as a rejoinder to photographic images of tormented artists at work in their studios. Hans Namuth's photographs of the intense-looking Jackson Pollock at work on his 'drip' paintings would have been well known to Manzoni.

Klein. He aimed, as he said, to purge space of any image whatsoever, to arrive at a point zero. Notwithstanding the link, again, to Rauschenberg's *White Paintings*, Manzoni's *Achromes*, whilst being uniformly colourless, assumed many guises: bread rolls in regimented rows or outgrowths of fibreglass mounted on board, squares of canvas machine-stitched together, straw miraculously piled in a box-shaped mass. Frequently they were mummified in kaolin (porcelain clay) and therefore vaguely reminiscent of Jasper Johns' contemporary embalmed emblems. (Johns had produced all-white *Flags*, *Numbers*, and *Alphabets* which were shown in Italy in 1958–9.)

Manzoni's 1959–62 output became increasingly self-referential. Like Klein he dealt with the anomalies of god-like creativity in the commodity era, but internalized these effects with analytical precision. His art correlated exactly with his abbreviated, peripatetic existence. On his travels between European cities he signed others as 'Living Sculptures', providing mock-bureaucratic certificates of 'authentification'. His *Lines*, begun in 1959, constituted lines of varying lengths, the maximum being 7,200 metres, painted on scrolls of paper or card and then placed in cardboard tubes or canisters with descriptive labels. One of these labels, pasted on a solid wooden cylinder, announced a 'line of infinite length'—a parodic invitation to sublime reverie and a clear exemplar for later Conceptual Art. Manzoni also drew ruthlessly on his body resources. He produced a number of *Artist's Breath* works consisting of balloons filled with his 'divine pneuma'. Attached to wooden bases, they poignantly deflated. He made plans to preserve his blood in phials. Most notoriously he filled 90 cans of *Merda d'artista* (artist's shit) in 1961.

Closely related to Duchamp's provocative readymades (especially the urinal), these cans of excrement possibly respond to the French iconoclast's absurd, scurrilous equation: 'ahhre est à art ce que merdre est à merde' (art/ahh is to art as 'shitte' is to shit) in which a verbal pun on 'les ahhres' (meaning 'down-payment' in French as well as aurally connotative of relief) was probably intended.[17] They suggested that, socially, art objects were on a par with supermarket commodities, a reading strengthened by a remarkable mock-advertising photograph in which Manzoni posed with one of his 'products' ready-canned on the 'factory floor' [**41**]. Italy, it should be noted, underwent its 'economic miracle' between 1958 and 1961.

Manzoni stipulated that his cans were to be sold by weight according to the current price of gold, referencing Klein's use of gold leaf in the *Rituals for the Relinquishment of the Immaterial Pictorial Sensibility Zones* described above. He thereby invoked the alchemical transubstantiation of base matter into gold, but stripped of Klein's romanticism. In the *Merda d'artista* Manzoni's incipient mysticism was also undercut by the body's economy. Freud had talked of children,

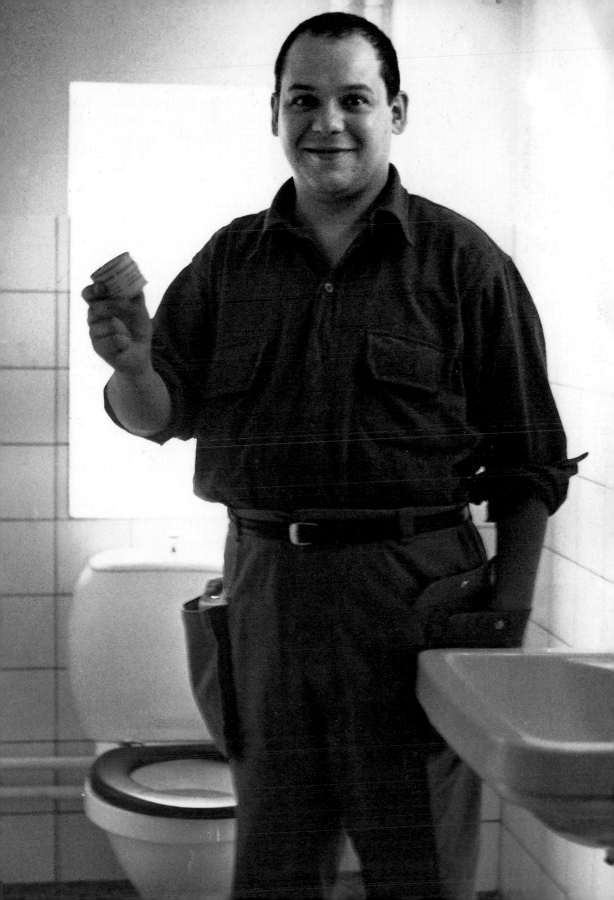

during the 'anal stage', withholding their faeces or bestowing them like gifts on their parents. This clearly correlates with the anti-aesthetic nature of Manzoni's gesture—its unresolved relation to a parent culture. On one occasion, however, Manzoni came close to Klein's love of Catholic ritual. On 21 July 1960, in Milan, he conducted a pseudo-eucharistic performance in which an audience was invited to consume hard-boiled eggs which had been marked with the artist's thumbprint (he consumed one himself in a form of symbolic self-absorption). This probably had social implications. After the election of Pope John XXIII in 1958 there was a push for Roman Catholic revival in Italy, fuelled by falling church attendances. But the subtle interrelations in Manzoni between Catholic/alchemical imagery, the iconography of body remnants/souvenirs, and a broader testing of society's aesthetic tolerance again argue for a deep-rooted affinity, beyond the work of Klein, with that of Duchamp.

It will be recalled that Duchamp had used a transubstantiation metaphor, consolidated in *Etant Donnés*, to convey his sense of a new reciprocal exchange between the work of art and its spectator. Like Manzoni, Duchamp had mined his body's resources, and art historians have argued that he possibly had alchemical interests; it is far from coincidental that the most notorious proponent of this view, Arturo Schwarz, opened a bookshop in Milan in 1954 (and later a gallery) which Manzoni frequented. All in all, the European Catholic back-grounds of Duchamp, Klein, and Manzoni equipped them with an ambivalent switching between irreverence and respect for the 'theology of matter' in an age of brute materialism. They mapped out a different route from the Modernist art object from American artists such as Johns and Rauschenberg, although Duchamp's presence in New York was crucial for the latter pair. For Europeans the changing status of the artist, and the birth of a new contract between artist and audience, could quickly assume a metaphysical dimension. Images of martyrdom and rebirth were liable to be invoked. The example of Joseph Beuys in Germany is a case in point.

The artist-hero: Beuys and West German art

In performance events of his later career such as *Coyote* [42] Joseph Beuys was to outdo Klein by presenting himself as a shamanic figure, communing with an animal formerly deified by the American Indians in order, symbolically, to recover a lost relationship for the materialist West. In this he set himself apart from ordinary humanity. He, too, assumed divine status.

He stood apart also from the broad line of development of postwar art in West Germany. Separated from its ideologically opposed other half, West Germany emerged slowly from conditions of outer devastation and inner demoralization. The tradition of avant-gardism had

42 Joseph Beuys

Coyote, performance, 1974

Beuys saw this week-long 'dialogue' between himself and the coyote as symbolically facing up to the genocide perpetrated by White America on its indigenous peoples. Beuys's movements were repetitive and ritualized. His walking-stick and felt blanket had a range of connotations : basic human needs, survival, the attributes of a shepherd. Each day of this New York performance copies of the *Wall Street Journal* were bought into the space and spread on the floor. The animal duly urinated on them.

been obliterated. The Nazis had favoured a debased classicism and hidden or destroyed the 'degenerate' art of modernism. The legacies of the Bauhaus, or Dada and Surrealism, were slowly rediscovered; Kurt Schwitters's Hanover retrospective was held in 1956, Max Ernst's in Cologne in 1963. There was some take-up of *informel* and *tachiste* currents, mainly from France, in the early 1950s, notably in works by Ernst Wilhelm Nay. However, when, in 1959, Kassel put on its second 'Documenta' exhibition (the first of these important events, dedicated to forging a new dialogue with European and American art, had taken place in 1955), Nay's work was programmatically placed next to Jackson Pollock's rather than that of French painters. The exhibition director, Arnold Bode, no doubt wished to assert comparability in terms of aesthetic power, but the power was unequal in other respects. Under NATO (the North Atlantic Treaty Organization, formed to counter the Soviet bloc), West Germany was increasingly beholden to America for the delicate matter of its military rebuilding, quite apart from general economic recovery. Unfortunately, Nay, like other European abstractionists, ended up looking second-rate alongside the Americans. From this point on, West German artists became involved in a complex struggle to recover their identities as modernists.

On the one hand there was a desire for internationalism, a need to shake off the recent past and to assert a new idealism. The Zero Group,

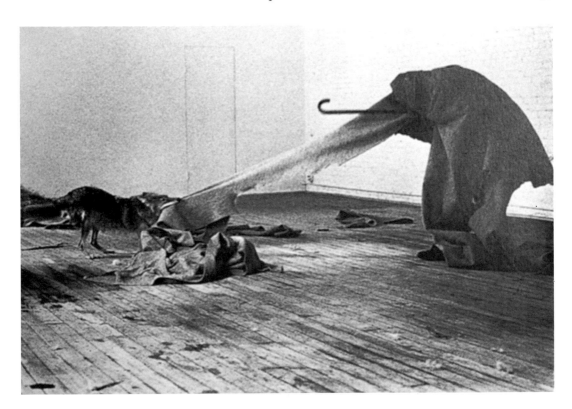

which fully emerged in Düsseldorf in 1958, formed close links with European anti-*informel* trends; Klein was an important contact. Similarly, in the early 1960s locations symbolically distanced from the previous cultural centres—Wiesbaden, Wuppertal, Darmstadt, as well as Düsseldorf and Cologne—saw the establishment of experimental Fluxus events in which younger German musicians and artists mingled with visiting Americans to develop interdisciplinary Cage-inspired practices (see Chapter 4). However, it might be argued that the painful questions of national reappraisal, which in any event were rendered problematic by pre-war nationalism, were merely postponed in such instances. A certain turn towards figuration in Berlin, to be discussed shortly, possibly faced up to immediate anxieties. The most distinctive alternative, however, was provided by Beuys, not least in terms of his anachronistically heroic pose. The fact that Beuys had a highly ambivalent relationship to America, and it to him, was bound up with this.

Based in Düsseldorf, where he became Professor of Sculpture at the Academy of Art in 1961, Beuys first came to prominence in the course of Fluxus events of 1962–4, a context which suited his impatience with aesthetic formalism and desire for dialogue. However, when the latter turned to confrontation, as at Aachen Technical College in 1964 when he was assaulted by right-wing students, Beuys decided on a quasi-religious path. Having trained academically as a sculptor, he had taken to using unorthodox materials by the early 1960s: battered hunks of wood or metal, industrial relics, disused batteries, wax, and felt. Time-scarred surfaces and organic matter reflected the range of his speculations, which were resolutely anachronistic. Beuys had no truck with consumerism; he saw humanity as out of touch with itself. He was fascinated by natural history, mythology, alchemy, Paracelsus, and particularly the thought of Rudolf Steiner, the founder of 'Anthroposophy', who had previously influenced Kandinsky's spiritualized abstraction.

Steiner's 1923 lectures 'About Bees' provided Beuys with an idiosyncratic aesthetic starting-point. Steiner had seen the bee colony as a model for human development. Its ability to generate the molten fatty material of wax and thence to produce the crystallized system of honeycombs became a trigger for Beuys's process-oriented sculptural theory which involved an interplay between fluid and fixed principles, governed by permutations of heat. This in turn would reflect for him the transformative potential of human beings and inform his later utopian concept of 'social sculpture' in which public dialogue itself became the means of dissolving cold, entrenched forms. His 'lectures', involving convoluted diagrams scrawled on blackboards, would eventually constitute the core of his practice.

In physical terms, his thought is well illustrated by *Filter Fat Corner* of 1963 [**43**]. In what is essentially an installation, the ambient room temperature is enlisted as the means of potentially liquefying a mass

Filter Fat Corner, 1963

The work consisted of a triangular gauze filter stretched across a corner into which lumps of fat had been packed. Apart from alluding to physical metamorphoses brought about via osmosis, processes of refinement and purification were evoked. In a sense, Beuys continued to investigate the implications of Duchamp's *Large Glass* [**18**] In his notes for the *Glass*, Duchamp had imagined subtle transformations of energy and matter occurring as his mechanical entities interacted.

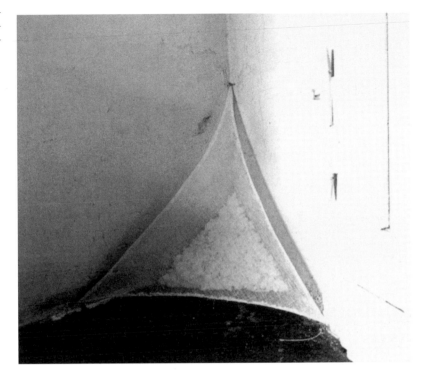

wedged into an inescapable geometric structure. The symbolism may seem literal but Beuys's inventiveness as a sculptor should not be underestimated. In the 1960s the American Minimalist Robert Morris was to revisit the same formal dynamic in his move from geometry to 'Anti-Form' (see Chapter 5) and the *Fat Corner* also found an echo in a Morris installation [**69**]. Beuys's visual language was not, however, unprecedented. The Italian sculptor Medardo Rosso had used beeswax in the late nineteenth century and the Russian Constructivist Tatlin had designed constructions to utilize corners. Beuys's famous *Fat Chair* (1964), in which a potentially unstable mass of fat is banked up on a fixed geometric base, stucturally shadows Duchamp's *Bicycle Wheel* of 1913 which consisted of a movable upper element and a stable readymade 'pedestal'. The principle of the readymade pervaded Beuys's art generally, but with his slogan of 1964, 'The Silence of Marcel Duchamp is Over-rated', Beuys asserted that Duchamp, now out of the avant-garde mainstream, withdrew aristocratically from the democratizing possibilities of his readymades. By contrast, Beuys appropriated an old utopian rallying cry: 'Everyone an artist'.

Beuys has been brought to task here for misunderstanding Duchamp. The art historian Benjamin Buchloh claimed that, for all his rhetoric of social emancipation, Beuys's artistic position was deeply conservative, reactionary even. Far from altering the status of the object within art discourse, as Duchamp had, Beuys had subscribed to the most 'naive context of representation of meaning, the idealist

metaphor: *this* object stands for *that* idea, and *that* idea is represented in *this* object'.[18] Beuys's iconography was certainly narrowly codified, not least according to autobiographical factors which encouraged spectators to excavate his intentions rather than consider his broader allusions. Apart from borrowing from Steiner's ideas, his use of fat recalled a plane crash experienced while flying for the *Luftwaffe* in the Crimea in the winter of 1942–3. Beuys claimed that he had been saved by a nomadic tribe of Tartars who, sympathetic to the Germans after persecution by the Soviets, 'covered my body in fat to help it regenerate warmth, and wrapped it in felt as an insulator to keep the warmth in'.[19] In fact this episode was fabricated, partly on the basis of a dream. Photographs published later showed Beuys standing relatively unscathed next to his aircraft, recalling Klein's contrivances. There had also been precedents in German art for the creation of rebirth myths: Max Ernst claimed to have 'died' with the start of the First World War, resuscitating in 1918. Whatever the truth of the matter, the materials that had facilitated this 'rebirth' were invoked constantly by Beuys as metaphors for spiritual healing. One of his most compelling sculptures, *Infiltration-Homogen for Grand Piano* (1966), consisted of a piano completely covered in felt. Part of a larger performance or 'Action', it was an oblique tribute to children deformed as a result of their mothers' use of the anti-nausea drug thalidomide. Eloquently speaking of the inner reserves of suffering, it cleverly humanized John Cage's *4'33"*.

In further 'Actions' of 1963–5 Beuys's signature materials acted as props in pseudo-rituals. In *The Chief* (1963–4), performed in galleries in Copenhagen and Berlin, he lay for nine hours in a felt roll with two dead hares attached to his head and feet, the felt supposedly insulating him from external concerns and facilitating a shamanistic 'communication' with the animals. The hare, mythologically linked to notions of transformation and thought to have special access to the earth's energies, reappeared in *How to Explain Paintings to a Dead Hare*, performed at the Schmela Gallery, Düsseldorf. With his head covered in honey and gold leaf, connotative of alchemical change, Beuys spent three hours in 'conversation' with a dead hare, since 'even a dead animal preserves more powers of intuition than some human beings with their stupid rationality'.[20] Beuys's arrogation of superior telepathic powers reached its high point in *Coyote* [**42**], as noted earlier. Here, during a week-long interaction between man and animal at René Block's New York gallery, a 'psychological trauma point' was supposedly tapped into.[21]

Whether Beuys's audiences, and particularly his American one in this case, felt the benefit of his shamanism is a moot point. His invocations of primal regeneration, as expressed by himself as charismatic mediator, raised suspicions that, rather than tending to West Germany's recent historical wounds, he was unconsciously recycling

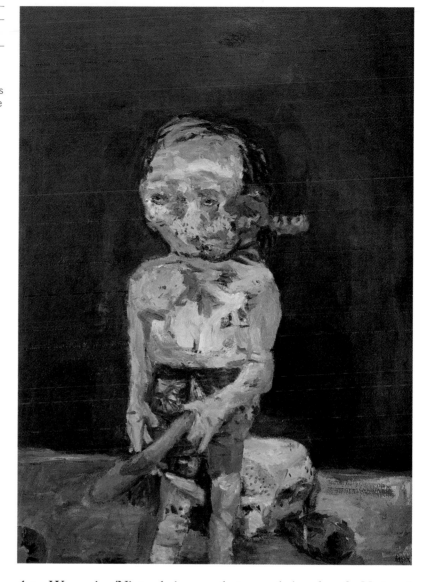

the Wagnerian/Nietzscheian archetypes beloved of National Socialism.[22] Beuys's politics, however fundamentally impractical, were far removed from this. His social libertarianism led to his dismissal from his professorship at Düsseldorf in 1972 due to a policy of unlimited admission of students, and in 1974, he and the writer Heinrich Böll instigated the 'Free International University'. Further concerns with ecological issues, paralleling the rise of the Green Party in West Germany in the early 1980s, were expressed in the initiation of *7000 Oaks*, a symbolic 'urban greening' project, begun at Kassel as part of Documenta 7 in 1982. The widespread planting of trees, next to basalt column markers, took five years to complete, although Beuys himself died in 1986.

Such idealism won him a big following, but his reception in America, where his metaphysics fell foul of native pragmatism, was never secure—a situation ironically registered by Beuys in his subtitle for *Coyote*: 'I like America and America likes me.' Although he made strenuous efforts to win favour in the US (he received the accolade of a Guggenheim exhibition in New York in 1979), Beuys was mistrustful of American materialism. He spoke for a generation of middle Europeans whose self-determination (a key Beuysian concept) was undermined by the imposition of alien values before they were able properly to rediscover their own. Artistically, Beuys virtually equated American materialism with 'formalism'—a kind of Modernist aesthetic 'packaging' shorn of the symbolic density he favoured. (Once again, Morris's dislodging of Beuys's forms from their meanings may bear this out.) The upshot of this was that, ironically enacting the 'rebirth' of the artist, in an era broadly pledged to witnessing the 'death of the author', Beuys was a conduit for the rediscovery of their identities, *vis-à-vis* American cultural hegemony, by artists working in West Germany. In Düsseldorf particularly, where his teaching was massively influential, he was a formative, if eccentric, influence on the likes of Gerhard Richter and Sigmar Polke (see Chapter 4).

Whilst Düsseldorf was responsive, however ambivalently, to New York, Berlin in the early 1960s looked back to the German Expressionist legacy, with its emphasis on the autographic mark. Antipathetic towards abstraction and *tachisme*, artists turned the powerful impact of MOMA's 'New American Painting', shown in Berlin in 1958, to their own advantage. The gestural aggression of Pollock was wedded to a treatment of the figure derived from sources such as *Die Brücke* and Max Beckmann. In a city which saw the creation of the Berlin Wall in 1961, artists felt alienated and deeply mistrustful of political ideologies. Georg Baselitz, who had moved from East to West Germany in the mid-1950s, exemplified this in grotesque, dismembered images of the body, implicitly repudiating both the armoured body-type of official Fascist art and the heroic worker-images endorsed under the 'Socialist Realism' of East Germany. The provocative obscenity of early pictures such as *Die Grosse Nacht im Eimer* (The Great Piss-Up) [44] led, in 1963, to a West German attorney having paintings removed from Baselitz's first one-man show. The savagely apocalyptic *Pandemonium Manifesto*, produced by Baselitz in 1961 in collaboration with the painter Eugen Schönebeck, dredged up images from a disturbed collective psyche: 'the sacrifice of the flesh, bits of food in the drains, evaporations from the bedclothes, bleeding from stumps and aerial roots'.[23]

Later works by Baselitz, and fellow Berlin painters such as Marcus Lüpertz, would be read in the 1980s as signs that, despite successive attacks on the authorial 'voice' in the art of the 1960s and 1970s, to say

nothing of attacks on art as an institution, the heroic, internally divided image of the artist was still intact. In that sense they perpetuated the angst-ridden humanism of Artaud discussed earlier. However, these conditions could only legitimately persist in the light of Germany's unique historical position. Elsewhere the dynamics of postwar history, as we shall see, meant that the implications of mechanical reproduction, consumer-oriented markets and changing artist–audience relations irrevocably altered the terms within which not only art, but also 'the artist', could be conceived.

Blurring Boundaries: Pop Art, Fluxus, and their Effects

4

By the late 1950s consumerism and mass culture (film, television, advertising) were all-pervasive. For Modernism's advocate Clement Greenberg this was profoundly negative, amounting to an onslaught of 'kitsch'. As explained earlier, he believed that, to retain their integrity, the arts had to protect themselves against the debased variants on their accomplishments that advanced capitalism generated for the masses.

It is significant, however, that when he wrote 'Avant-Garde and Kitsch' in 1939, Greenberg's elitist opposition of 'formal culture' to 'kitsch' was motivated by the spectre of totalitarian uses of mass propaganda in Germany and Russia and the suppression of avant-gardes. In an important essay Thomas Crow argues that Greenberg appreciated that the emergence of the avant-garde had necessarily been tied to the birth of mass culture in the nineteenth century and that, although he chose to privilege the former, he saw them as mutually defining. Following the logic of this, Crow establishes that the avant-garde had always sought a 'necessary brokerage' between 'high' and 'low' cultural forms, borrowing images from popular culture and relocating them both to reinvigorate its own idioms and to forge alliances with other subcultures, often with different class loyalties.[1] In the US, Rauschenberg and Johns had used mass-produced imagery in ways that destabilized Greenberg's Modernism and, on occasions, signalled illicit gay affiliations. However, they did not theorize their position *vis-à-vis* 'high' and 'low' forms. By contrast, the London-based Independent Group (IG) had, as early as 1952–3, established the criteria for what became a fully fledged 'Pop' aesthetic, openly embracing 'kitsch'.

'Pop' culture and mechanical reproduction: the Independent Group

The IG came together in London through the ICA (Institute of Contemporary Arts). Founded in 1946 by British advocates of Surrealism such as Roland Penrose and Herbert Read, this institution was identified with mainland European experimentation as opposed to the Neo-Romantic and realist currents in 1950s British art. The IG

Detail of 55

45 Eduardo Paolozzi
Evadne in Green Dimension,
*c.*1952

In this collage elements such
as Charles Atlas and the
diagrammatized penis were
pasted over a female 'art' pin-
up (the 'Evadne in Green
Dimension' of the work's title),
as though allegorizing the
artist's arousal.

constituted a loose alliance of artists, architects, photographers, and art
and design historians who, with the ICA's encouragement, organized a
highly eclectic programme of lectures in 1952–5 on topics such as heli-
copter design, science fiction, car styling, advertising, and recent
scientific and philosophical thought.

The IG's academic latitude was underpinned by a radical belief that
'culture' should connote not the heights of artistic excellence but rather
a plurality of social practices. They therefore identified themselves
with capitalism's cultural consumers. The main critic in the group,
Lawrence Alloway, argued against humanist-led values of uniqueness
in favour of a 'long front of culture' characterized by a continuum of
artefacts from oil paintings to 'mass-distributed film and group-orien-
tated magazines'.[2] This openness to culture at large informed the first

46 Independent Group

Parallel of Life and Art, photograph of exhibition installation, ICA, London, September–October 1953

In this early Independent Group exhibition photographs of varying sizes were attached to the gallery walls. Others were suspended by wires from the ceiling. Analogies were set up between various structures deriving from technology, science, art, and the natural world. Revisiting the spirit of the 'New Vision' photography of the 1930s, which had been associated pre-eminently with the Bauhaus teacher László Moholy Nagy, the exhibition helped broaden attitudes towards visual culture in Britain.

IG usages of the term 'Pop' around 1955. (Alloway was to move to America in 1961 and to champion a more narrowly painting-based 'Pop Art', as discussed shortly, but it is important to appreciate the sociologically inclined origins of the term.)

The IG's breadth of reference was dramatized in two early events. The first, now accorded an originary mythic status, was a Surrealistic epidiascope lecture delivered in 1952 by the Scottish-born sculptor Eduardo Paolozzi which galvanized colleagues with its flood of heterogeneous imagery from pulp and commercial sources. The materials shown, a set of collages with the generic title 'Bunk' [**45**], were not even considered 'art' by Paolozzi until 1972 when they were incorporated into silkscreen designs. The second event was the exhibition 'Parallel of Life and Art', the beginning of an important sequence conceived by IG members, installed at the ICA in 1953 by Paolozzi in collaboration with the architects Alison and Peter Smithson and the photographer Nigel Henderson. This consisted of dramatic non-hierarchical juxtapositions of photographs from sources as diverse as photo-journalism and microscopy [**46**]. Although Fine Art images were included (Pollock, Dubuffet, Klee), they were clearly reproductions, submitted to a form of cultural levelling by means of a common grainy texture.

This exhibition subordinated the authentic artistic gesture to the principle of reproducibility. It therefore dramatically expanded art's

parameters while fuelling the destabilizing of authorial agency noted in the last chapter. The IG's immediate inspirations were books such as Amedée Ozenfant's *Foundations of Modern Art* (1928) or Siegfried Giedion's *Mechanization Takes Command* (1947) which were prized for their photographic juxtapositions of art and technology rather than their modernist rhetoric. However, the IG's acknowlegement of photography's ubiquity brought them close to the conclusions of the Marxist critic Walter Benjamin, who, in the 1930s, had analysed photography's societal role in undermining authorial 'origins'. In his seminal essay, 'The Work of Art in the Age of Mechanical Repro-duction', Benjamin argued that the 'auras' art objects once possessed by virtue of their specific locations or 'cult value' had 'withered away' in mass society at the hands of reproductive technologies. (He also believed that, in substituting 'a plurality of copies for a unique exis-tence', mechanical reproduction created the conditions for a politicized (socialistic) art for the masses.)[3]

The IG were not alone in recognizing that the visual sphere had been colonized by technology; Rauschenberg was simultaneously presenting traditionally 'artistic' imagery (brushstrokes, reproductions of artworks) as part of a continuum of culturally produced signs, although he did not commit himself solely to photographic imagery until the early 1960s [**60**]. Steinberg's critical interpretation of Rauschenberg, discussed earlier, bore similarities with Benjamin in suggesting that whereas works of art had once seemed to be 'natural' analogues for human experience, Rauschenberg's 'flatbed' pictures declared themselves to be synthetic 'cultural' constructs. That Steinberg characterized this shift as 'post -Modernist' marks a signifi-cant historical moment, with far-reaching consequences, as will be seen. In the case of the IG, a proto-postmodern attitude underpinned their departure not only from the humanism of ICA elders such as Herbert Read but from contemporary British painters who were also reliant on photography, such as Francis Bacon. From the 1960s onwards artists who saw photography as indexed to shifts in the cultural functioning of images would increasingly question humanist/individualist positions.

'The aesthetics of plenty': Pop Art in Britain

If the IG implicitly accepted Benjamin's cultural prognosis they hardly followed his political agenda. With the exception of Henderson, they belonged to the first working-class generation of artists, and were commercially or technically trained rather than grammar-school-educated. Nevertheless, whilst the British writer Richard Hoggart argued for a reaffirmation of vernacular British working-class culture in the face of 'decadent' Americanization in his 1957 book *The Uses of Literacy*, the IG openly celebrated Americana, avoiding political side-

47 Richard Hamilton

$he, 1958–61

Hamilton's housewife muse is conjured from a winking eye (the small plastic object attached at the top left), a shape in shallow relief suggestive of an apron, and a sinister toaster-cum-vacuum-cleaner, its functioning obligingly indicated with dots (an allusion to both advertising conventions and Marcel Duchamp's early mechanistic paintings). She hovers next to a fridge whose contents are schematically represented. Glamorous denizens of the kitchen such as Betty Furness, the 'Lady from Westinghouse', were television celebrities in the US.

taking. In Alloway's terms, they endorsed an 'aesthetics of plenty' at a time when Britain was attuned to scarcity; postwar rationing was not lifted until 1954 and packaging on goods was uncommon. In this dour climate it is understandable that they looked to the consumerist diversity of a post-Depression culture. Broadly speaking they welcomed the shift in power from the state to the marketplace, but it was unclear at times where their sympathies lay. For instance, in 1960 the artist Richard Hamilton argued controversially that the mass audience should be 'designed' for products by the media rather than the other way round.[4] However, whilst the IG's advocacy of American-led consumerism separated them from the wary Europeans discussed in Chapter 3, they did not lack irony.

In this respect Duchamp was again a formative influence, on both Hamilton and Paolozzi. Although Hamilton admiringly mimicked the 'presentation techniques' of design stylists in images such as *Hers is a Lush Situation* (1958), in which elements of a Cadillac advertisement fuse with painterly allusions to female anatomy, a key resource was Duchamp's more sinister vision of woman/machine conflations in the *Large Glass* [**18**]. Hamilton was later to make a replica of the shattered original, but his *$he* of 1958–61 [**47**] inherits not only its diagrammatic organization from the *Glass* but also its ambivalence to socially

constructed femininity. *She*'s fragmentary images evoke the American housewife of the period. Hamilton asserted that his aim was to update 'art's woman', who was 'as close to us as a smell in the drain ... remote from the cool woman image outside fine art'.[5] His targets were de Kooning or Dubuffet [9] but his 'cool' aproned alternative is far from 'liberated': the toaster suggests routine mechanical copulation, and there is blood on her shiny floor. In certain of Paolozzi's collages male sexuality is interrogated [45]. Brawn triumphs over machine as Charles Atlas holds a car aloft. The car in turn connotes Henry Ford, whose verdict on history, recalling Paolozzi's generic title for such collages, was that it was 'bunk'. Ultimately male sexuality, as linked to technological 'progress', appears to be debunked.

This wavering between affirmation and parodic foreboding is further dramatized by an exhibition normally thought to epitomize IG ideas concerning interdisciplinarity between areas of art practice— 'This is Tomorrow' of 1956, consisting of 12 'pavilions' set up in the Whitechapel Gallery by artists/designers. Strictly speaking, it was not an IG manifestation, since several pavilions involved contributions by artists/designers working in Constructivist or abstract modes. However, two pavilions clearly expressed the polarities in IG attitudes. The first of these was designed by Hamilton in collaboration with John McHale and John Voelcker. It assaulted the senses, anticipating the environmental 'Happenings' shortly to emerge in America. Outside the pavilion a 16-foot 'Robbie the Robot' (from the film *Forbidden Planet*) was juxtaposed with an image of Marilyn Monroe. Inside, spongy floors emitting strawberry-scented air-freshener, a jukebox, and a reproduction of Van Gogh's *Sunflowers* (then the best-selling postcard at London's National Gallery) vied for attention. This celebratory side of Hamilton incidentally informed his famous collage, *Just What Is It That Makes Today's Homes So Different, So Appealing?* (1956), a cornucopia of consumer dreams crammed into a living room, which was reproduced in the catalogue of the exhibition. The word 'pop', wittily incorporated into the collage on a lollipop held by Charles Atlas over his 'bulge', momentarily connoted sensual gratification. (Hamilton wrote a famous letter to the Smithsons enumerating the qualities possessed by popular art such as sex, expendability, and glamour.[6] It is ironic perhaps that his subsequent output as a 'Pop' artist would often be allusive and intellectualized.)

By contrast, the second distinctive IG pavilion in 'This is Tomorrow', by Paolozzi, Henderson, and the Smithsons, was a poignantly desolate affair. It consisted of a rudimentary living-space-cum-garden-shed, far removed from Hamilton's dream-home, presided over by an extraordinary photo-collage by Henderson conforming to his interest in a human image 'stressed' by photographic manipulations (and linked stylistically to Paolozzi's ravaged-looking

48 Nigel Henderson

Head of a Man, 1956

Henderson is rarely accorded
much status in accounts of
postwar art but he was a
formative influence on
members of London's
Independent Group,
especially Paolozzi and
Hamilton. In the late 1940s
and 1950s he photographed
shop fronts and café windows
around Bethnal Green, East
London, working as a cultural
anthropologist. Traumatized
by his war experiences, he
developed a mode of collage
using fragments of
photographs distorted by
darkroom manipulations.
Head of a Man, a one-off
masterpiece, is an icon of
postwar human pessimism.

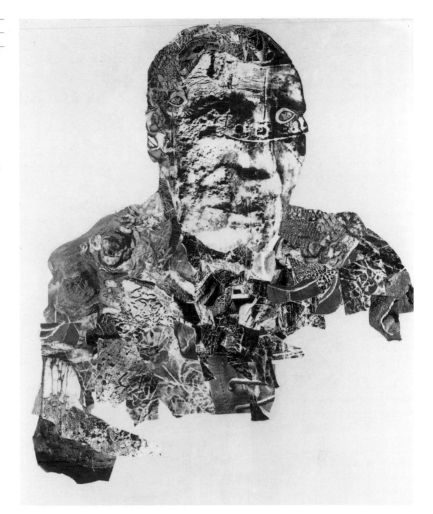

'Brutalist' sculpture of the period) [**48**]. The floor was ironically spread
with tokens of family life—a rusted bicycle, a battered trumpet—
whilst littered stones and clay tiles reminded Rayner Banham, the
design historian of the IG, of excavations after a nuclear holocaust.

The disparity between the pavilions points up two ways of reading
the IG. Dick Hebdige sees them as devoted to a democratizing 'politics
of pleasure' and thereby (to recall Crow) signalling subcultural affinities
with those who regularly consume culture rather than loftily contem-
plate it. Alternatively, the art historian David Alan Mellor points out
that in many ways the IG's iconography of robots and science fiction
was complicit with the 'Tory Futurism' of the period.[7] A Conservative
government had been returned to power in Britain in 1951, and by the
late 1950s their propaganda of 'The Leisure State' was inextricably
bound up with bright images of a technological future, backed up by a
nuclear arms programme. The flip side of popular pleasures, it seemed,
was catastrophe.

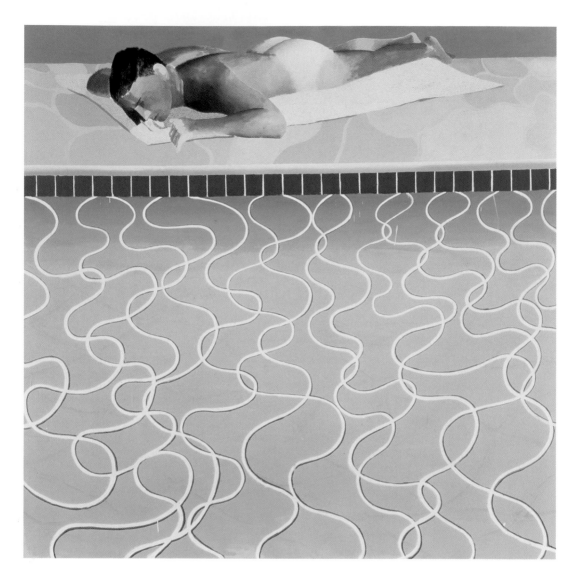

Hamilton taught at London's Royal College of Art in the late 1950s, where Peter Blake and Richard Smith produced figure-based and abstract 'Pop' variants respectively. In 1961 Royal College products such as David Hockney, Derek Boshier, Patrick Caulfield, and the older, American-born R.B. Kitaj came to prominence at the 'Young Contemporaries' exhibition. Hockney, brought up in working-class Bradford, exemplified the freedoms of expanded educational provision as well as the growing affluence of the early 1960s. Unconcerned with the semiotic analyses of IG forebears, he imported their ethic of surface style into his painting, but kept to personal or domestic themes. Paintings of 1960–2, in a *faux naïf* style deriving from Dubuffet, dealt openly with his homosexuality at a time when it was criminalized in Britain. Like Hamilton, he looked to America, moving to California

49 David Hockney

49 David Hockney
Sunbather, 1966
Hockney was originally attracted to Los Angeles by John Rechy's homoerotic novel, *City of Night* (1963). Hockney subsequently celebrated its homosexual subculture in images of naked men emerging from, or basking next to, swimming pools. At a submerged level the eerie stillness of these images may communicate some unease with the good life. Frank Perry's 1971 film *The Swimmer* examined the despair underlying aspects of California's sunny swimming-pool culture.

in 1963, but his libidinal liberation went hand in hand with fey stylizations which could appear vacuous, as in the tourist-brochure eroticism of *Sunbather* (1966) [**49**]. Lawrence Alloway was to set such tendencies in British Pop against the superior 'density' and 'rigour' of New York's burgeoning Pop aesthetic.[8] Whilst Caulfield's work later stood up to the formal resolution of American art, Hockney's feyness was part of a 'camp' discourse set in motion by Johns and Rauschenberg (and subsequently Warhol) to deflate a 'hard' masculinist Modernism via the domestic or decorative. His ubiquitously reproduced *A Bigger Splash* (1967) wittily ups the stakes in the attack on the Abstract Expressionist mark, lamely asserting a northern English 'virility'.

Hockney's sexual openness was at one with the experimental lifestyles of 1960s youth culture in Britain. The birth control pill, invented in 1952, radically affected sexual morality, although sexist attitudes prevailed among men, to be countered by the rise of feminism. (The American feminist Betty Friedan's *The Feminine Mystique* of 1963 and Germaine Greer's *The Female Eunuch* of 1970 were highly influential publications.) Allen Jones notoriously explored sexual fetishism in a Pop idiom (e.g. *Girl Table*, 1969) whilst Pauline Boty, a recently rediscovered female Pop artist, parodied 'permissiveness' in *It's a Man's World II* (1965–6), with its painted fragments from soft-porn magazines.

When Harold Wilson's Labour government came to power in late 1964 the mythology of 'Swinging London' was born. In this climate 'high' and 'low' cultural forms increasingly cross-fertilized, as symbolized by the cover of the 1967 LP record *Sergeant Pepper's Lonely Hearts Club Band* by the Beatles. Designed by Peter Blake, in collaboration with his first wife Jann Haworth, it fuses the nostalgia for British folk culture (fairgrounds, circuses, etc.) of his early Pop paintings with the druggy countercultural iconography of the period. If, in 1962, the

Art education in Britain

The Independent Group, and the exhibitions associated with them, were important exemplars for British art education. The two stylistic impulses showcased in the 'This is Tomorrow' exhibition—its Pop and abstract/Constructivist sides—eventually converged in the development of new notions of art-school training. Bauhaus-derived ideas of 'basic design' (emphasizing analytic investigations of visual stuctures and materials) were fused with an openness to photography and mass-media imagery. The 1944 Education Act had extended art training to talented working-class students, initiating a massively expanded professionalization of the visual arts. In the mid-1950s Richard Hamilton, working alongside his Constructivist-oriented colleague Victor Pasmore at King's College Durham (later the University of Newcastle-upon-Tyne), set up a pioneering one-year 'Foundation Course', followed by Tom Hudson and Harry Thubron at Leeds College of Art. This quickly became standard practice in art colleges. IG attitudes to culture also helped broaden higher education conceptions of art history, paving the way for 'cultural studies' programmes in British polytechnics in the late 1970s.

German Marxist Adorno, in line with Greenbergian Modernism, could assert 'politics has migrated into autonomous art',[9] some forms of art had blithely migrated into the sphere of mass-produced pleasure.

'The gap between art and life': Happenings, Fluxus, and anti-art

British assaults on high/low cultural distinctions were paralleled in America during 1958–64 by attempts to close what Rauschenberg once described as the 'gap' between art and life. These took the form of experimental 'Happenings' and Fluxus manifestations, pledged to artistic interdisciplinarity in defiance of conventional painting and sculpture. As further extensions of a performance genre dating back to the Black Mountain 'happening' of 1952 (see Chapter 2) and thence to Dada, both were committed to Cage's 'decentring' of the artist's ego, favouring 'live' artist–audience interaction as opposed to the aesthetic closure of Greenberg's aesthetics. Future adherents attended Cage's unorthodox classes on music at the New School for Social Research, New York, in 1958–9. They included Allan Kaprow, the ideologue of 'Happenings', and George Brecht and Dick Higgins, who were to throw in their lot with a further devotee of avant-garde music, the Lithuanian-born George Maciunas, the future promoter of Fluxus events.

Whilst they shared a desire to reconfigure artist–audience relations through disorienting transgressions of media boundaries, the tendencies differed fundamentally. 'Happenings' such as Kaprow's seminal *18 Happenings in 6 Parts* (1959) were put on in New York by visually trained artists whose experimentalism was tied to the promotional concerns of specific venues, notably the Judson Memorial Church, with its pioneering *rapprochement* between religion and modern art, and the Reuben Gallery, where *18 Happenings* took place. 'Happenings' therefore took the form of complex sensory environments, bordering on theatre in terms of vestigial narrative content and the use of 'props', but soliciting spectator participation. Jim Dine's *Car Crash*, a response

50 Jim Dine

The Car Crash, 1960, 'Happening'

In a darkened room, Dine, acting the part of 'car' in a silver-sprayed cap and raincoat, swerved to avoid 'hits' from the raking 'headlights' attached to fellow performers. The lights went on and off amid clatterings and amplified collision noises, while a girl on a stepladder recited disjointed phrases. Dine later unrolled paper towels, emblazoned with the word 'help', from a washing-machine wringer, distributing them among the audience.

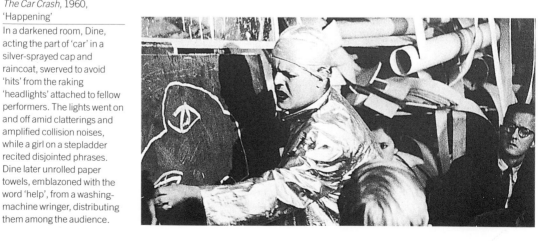

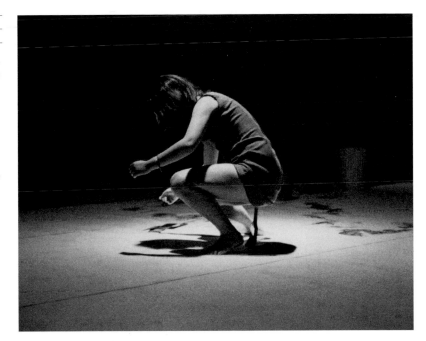

51 Shigeko Kubota
Vagina Painting, 4 July 1965
Retrospectively this performance reads as a proto-feminist riposte to Yves Klein's usurpation of the female 'trace' of five years earlier [**40**]. Kubota's Japanese compatriot Yoko Ono performed another Fluxus event dealing with culturally determined gender imbalances entitled *Cut Piece* (1964). Ono's audience was invited to cut away portions of her clothing in a disturbing mix of vulnerability and self-abuse.

to a spate of car accidents in which friends had died, reactivated trauma via a barrage of poetically allusive actions, images, and sounds [**50**].

Such activities represented an extension of Rauschenberg's 'Combines' (Rauschenberg himself was involved in performances, often in league with Merce Cunningham's dance company, during this period) wedded to a reinterpretation of Pollock (see the end of Chapter 1). By contrast, typical Fluxus performances such as Emmett Williams's *Counting Song* (1962), in which he simply counted the audience, were predicated on the itinerant performance patterns of musicians or poets. They usually dispensed with fussy 'staging' and centred on rudimentary experiences, recalling Cage's advocacy of silence. Fluxus also inherited his mysticism. The term, as elaborated in Maciunas's 'Manifesto' of 1963, recalls the Greek philosopher Heraclitus in endorsing the principle of flux: 'Act of flowing: a continuous moving on or passing by ... a continuous succession of changes.' George Brecht thus devised sparse, open-ended 'event scores' courting elementary or indeterminate processes; *Three Aqueous Events* of 1961 consisted of three words: ice, water, steam.

Alternatively, Fluxus events could be behaviourally or socially challenging. In 1962, in a concert in Wiesbaden, West Germany, the Korean-born Nam June Paik performed *Zen for Head*, an interpretation of a 'composition' by the experimental musician La Monte Young which involved him drawing a line on a strip of paper placed on the floor using his head and necktie dipped in ink and tomato juice. Three years later Shigeko Kubota, one of several female participants in Fluxus, translated this event's bloody connotations into female flows with her

Vagina Painting, implicitly counterposing the body's productivity to the intellectualism symbolized by Paik's use of his head, although she in fact employed a brush attached to her underwear [**51**].

Fluxus had no fixed aesthetic agenda. It was precariously held together by Maciunas's organizational zeal. Whereas 'Happenings' constituted a 'local' phenomenon, responding to New York's in-house art debates, Maciunas had international ambitions for Fluxus. Having come up with the logo while assisting with a publication of La Monte Young's scores and running his AG Gallery in New York in 1960–1, he moved to Wiesbaden in West Germany to work as a designer for an American airforce base, quickly rallying like-minded talents to his cause. The first event to take place under the Fluxus banner, the 'Fluxus Internationale Festspiele Neuester Musik', therefore occurred in Wiesbaden in September 1962, when Paik performed the action described above. This was followed by a number of densely packed festivals throughout Europe. The resultant international co-minglings, recalling the structural dynamics of the European-American Dada alliances of 1916–23 and providing a model for Conceptualism to follow slightly later, led to the establishment of various outposts centred on charismatic practitioners/publicists (e.g. Ben Vautier in Nice, Willem de Ridder in Amsterdam, Wolf Vostell in Cologne). In autumn 1963 Maciunas's return to New York shifted the emphasis back to America. By the end of 1964, however, the network's fragile unity was ruptured when Maciunas supported Henry Flynt's picketing of a New York concert by the German composer Karlheinz Stockhausen on the grounds that, as 'Serious Culture', it was fundamentally imperialistic.

Flynt's passionate conviction that 'Serious Culture' was predicated on forms of cultural exclusion was bound up with his sympathies for America's Civil Rights movement, dedicated to raising public awareness of the oppression of black Americans, and brought to a head with the march on Washington headed by Martin Luther King in August 1963. Flynt and Macunias's activist responses to social inequality were further exemplified in a *Fluxus Policy Newsletter* of the previous year in which Maciunas had advocated civil disruption.[10] However, such hardline approaches alienated Fluxus members such as Brecht who saw the movement as consciousness-changing rather than interventionist, whilst Kaprow, from the 'Happenings' camp, deemed them 'irresponsible'.[11] Although Fluxus nominally continued into the 1970s, it now became factionalized. Its oppositional tendencies nevertheless introduced a powerful note of anti-(art)institutional negativity into the 1960s (a legacy once more from Dada). Whilst destruction was the subject of formative Fluxus events (for instance Paik's notorious *One for Violin Solo* (1961) in which, having slowly raised the said instrument overhead, he slammed it down with full force), iconoclasm surprisingly had a distinct flowering in Britain.

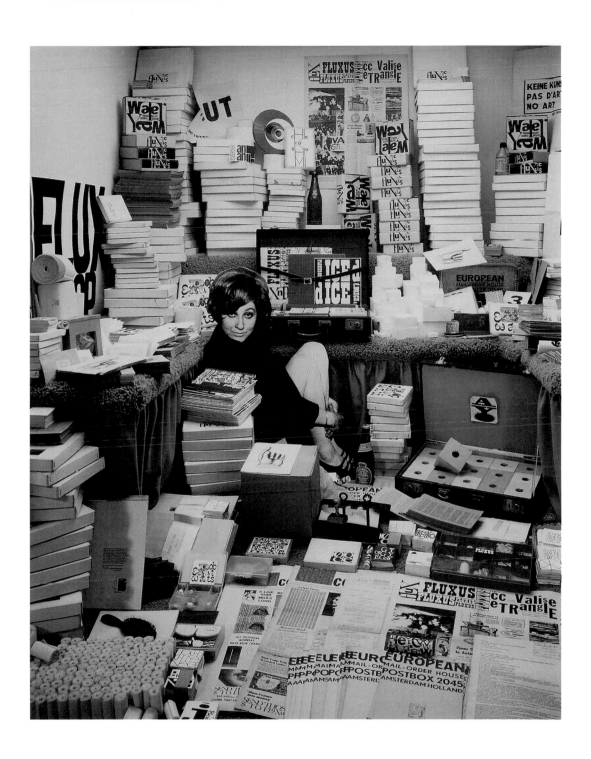

The anti-art mood in Britain was to be memorialized by an enig-matic suitcase, a distant relation to Duchamp's *Boîte-en-Valise*. Produced by John Latham, an assemblage artist who achieved brief international success early in the 1960s with his sprayed book ensem-bles, it contained the physical remains, and the documented consequences, of a strange ritual entitled 'Still and Chew'. Latham's students from St Martin's School of Art in London were invited to his home in August 1966 to communally chew up the pages of Clement Greenberg's *Art and Culture* (1961), borrowed from the college library. The resultant pulp was then 'brewed' and bottled before being returned to the library, after which, unsurprisingly, Latham lost his job. Anti-social or not, the gesture clearly made a point, not least in relation to the Modernist aesthetics then embodied at St Martin's in the works of Anthony Caro's successors (see Chapter 5). *Art and Culture* contained essays by Greenberg such as 'Avant-Garde and Kitsch' which, as explained earlier, endorsed aesthetic exclusivity. By parodically testing it against bodily needs, Latham encapsulated a generational shift towards inclusiveness.

An ally of Latham, the German-born Jewish immigrant Gustav Metzger, followed this up a month later with his 'Destruction in Art Symposium', attracting nearly one hundred international iconoclasts to London, many with Fluxus links. However, histories have tended to ignore British iconoclasm in favour of a single orgy of destruction, Jean Tinguely's *Homage to New York*. This massive agglomeration of comically auto-destructive machinery, set up in the sculpture garden of MOMA in March 1960 as the French New Realist's dramatic *entrée* into New York's 'Happenings' scene, consumed itself in flames before being extinguished by the city's fire brigade. However, compared with subsequent Fluxus gestures and their British counterparts, it now appears overblown and socially detached.

If Fluxus advocated anti-art, it also, paradoxically, commodified itself. Its acolytes patented a remarkable variety of multiple-edition objects which Maciunas, a one-man cottage industry, then manufac-tured, issuing exhaustive price lists filled with quirky typefaces. On offer were small boxes such as *Water Yam* (1963) containing Brecht's 'event scores', or *Flux Clippings* (1966), containing Ken Friedman's toenail/bunion clippings. Alternatively Robert Watts's sheets of 'Flux-stamps' (1963) subverted the official postage system, as well as functioning as covert propaganda. In 1964 Maciunas set up a 'Fluxshop' in his Canal Street loft in Manhattan. Although spectacularly unsuccessful, it spawned European offshoots such as Willem de Ridder's *European Mail-Order House/Fluxshop*. An installation based on a photograph advertising this [52], complete with a female 'commodity', shows the quantity of 'Fluxkits' and 'Fluxus Year Boxes' that came to be produced. All in all, such ventures amounted to a Marxist recognition that the

dynamics of commodity circulation needed to be addressed if art's finance-based institutions were to be challenged. Ironically, of course, much Fluxus 'mass-production' was pledged not to profit-making but to the elimination of artistic 'auras', to reprise Walter Benjamin's terms.

A telling corollary to this aspect of Fluxus can be found by returning to 'Happenings'. In 1960–2, Claes Oldenburg, a Yale-educated artist with wealthy Swedish origins, made New York's impoverished Lower East Side the site of a kind of self-analysis. He constructed an environment, *The Street* (1960), which, in its Reuben Gallery showing, consisted of shards of stiffened cardboard and burlap hanging from the ceiling, evoking urban detritus. This then became the location for a 'Happening' titled *Snapshots from the City*: a sequence of vignettes, briefly illuminated, in which he enacted psycho-dramas, identifying with city bums. Oldenburg next created an *alter ego* for himself, a meta-morphic transvestite character whose name, Ray Gun, came to evoke Oldenburg's repressed phallic desires for a further creation, 'The Street Chick'. These characters, allegorizing Oldenburg's longing for class mobility, appeared in performances of the 'Ray Gun Theater', itself an offshoot of an attempt to infiltrate Lower East Side life in the form of the 'Ray Gun Manufacturing Company', otherwise known as *The Store*, with premises at 107 East Second Street.

This in effect became Oldenburg's challenge to capitalist modes of art distribution. In its back room he produced a profusion of roughly

crafted plaster sculptures, approximating to consumer desirables such as clothing or food, splashily painted *à la* Abstract Expressionism. These were then sold by the artist at the front at prices not far above those of their real-life equivalents [**53**]. In a familiar tale of assimilation, rather than selling to baffled locals, they attracted shrewd buyers such as MOMA and the offer to move the *Store* up-town to Richard Bellamy's Green Gallery, whose advance payment soaked up Oldenburg's net losses on the project. By the mid-1960s Oldenburg's work was also undeniably up-town, the epitome of Pop chic. His homages to consumer fantasies such as the kapok-filled hamburgers with their Magrittean enlargements of scale were kitted out first in canvas 'ghost' versions, then in sexy vinyl. Reminders of a harder New York, such as the *Soft Drainpipes* of 1967, obeying a libidinal logic, went flaccid. And the prices naturally escalated.

Pop Art in America: Lichtenstein and Warhol

Fluxus's *rapprochement* between aesthetic and everyday experience went hand in hand with attempts to circumvent the workings of the market. By contrast, American Pop's contemporaneous merging of elite and mass culture was underwritten by the business acumen of dealers riding a booming economy. The movement emerged suddenly in 1962 when

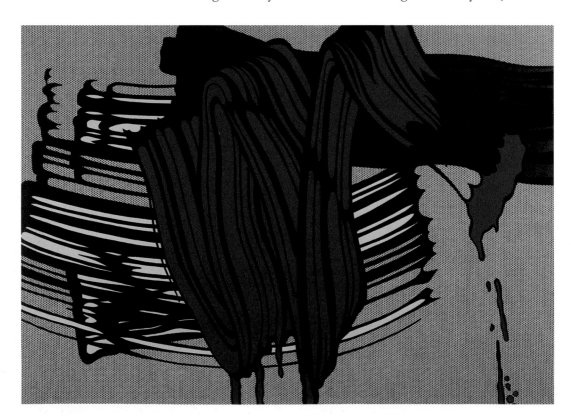

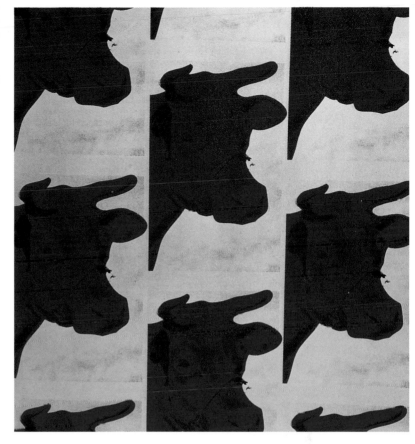

critics such as Gene Swenson, attuned to an iconography of urban signage by Johns and Rauschenberg, seized on Lawrence Alloway's earlier 'Pop' coinage to characterize paintings in a spate of exhibitions by James Rosenquist, Roy Lichtenstein, and Andy Warhol. The movement was not so much self-generated as market-created by dealers such as the Italian-born Leo Castelli. Its birth was also accompanied by the phenomenon of instantaneous accreditation by museums, Alloway's 'Six Painters and the Object' at the Guggenheim Museum in 1963 being particularly prescient. By 1964, whilst the careers of individual participants flourished, the movement as such was over. Heralded by mass-circulation magazines such as *Time* and *Life*, it had generated a new media-led hunger for artistic novelty.

Turning to the art itself, New York Pop stepped up Johns's and Rauschenberg's critique of Abstract Expressionism's bombast through a cool impersonality. Rauschenberg's early 1960s silkscreen paintings [**60**] appear convoluted alongside the colourful, emblematic images of Lichtenstein and Warhol. Borrowing the compositional clarity of contemporaneous abstraction [**65**], they employed single images, ready designed from pre-existing commercial sources, in enlarged or

56 Andy Warhol

Five Deaths Seventeen Times in Black and White, 1963

The use of serial repetition here, as in other early Warhol works, relates interestingly to Minimalist uses of repetition (see Chapter 5). The reciprocally ironic relation between Warhol and the Minimalists came to a head in 1964. Warhol exhibited a series of *Brillo Boxes*, consisting of large wooden boxes covered with silkscreened commercial logos, at the Stable Gallery, New York. He must have been aware of Robert Morris's anonymous cubic structures of the period. Late that year Morris exhibited his austere geometric forms at the city's Green Gallery [**69**].

The makings of Pop: the American art market

The Italian-born dealer Leo Castelli, assisted by his talent scout Ivan Karp, was pre-eminent in marketing American Pop Art. Having already snapped up Johns and Rauschenberg for his gallery (see Chapter 2), Castelli took on Lichtenstein in 1961, followed by Rosenquist and Warhol three years later. He extended his operations to Europe via a collaborative deal with his ex-wife Ileana Sonnabend, the daughter of a wealthy Romanian industrialist, who opened a Paris gallery in 1962.

When Rauschenberg won the Grand Prize at the Venice Biennale in 1964, aided by a string of strategic European exhibitions and Castelli's promotional machinations before the event, it was clear that the art world's financial capital was now New York. Wealthy collectors set the pace; Ethel and Robert Scull, their fortune based on a taxi empire, reportedly payed $45,000 for Rosenquist's multi-panelled *F-111* of 1965. When, in 1973, their collection was sold, at several thousand per cent profit, a dizzying escalation in postwar art prices was established.

repeated formats [**55**]. Lichtenstein's brushstroke paintings of 1965–6 [**54**] upstaged Johns's earlier parodies of Abstract Expressionist painterly largesse, translating its spontaneous flourishes into a formulaic graphic design idiom and turning 'expression' into one culturally mediated sign among others. His comic-strip images of the 1960s explored the stock signifiers of American mass culture. Square jaws connoted maleness, blonde hair and tears femininity. Gender roles were further demarcated into the spheres of combat (Lichtenstein's men are often at war in unspecified Asian locations, hinting at American involvement in Korea or Vietnam) and the domestic bedroom (women invariably agonize over love affairs). Skilfully transferring the Ben Day dots of the printer's screen and the stylizations of comic-book graphics into more satisfying 'abstract' designs, Lichtenstein asserted that his aim was to 'unify' his source materials visually, thus appeasing Modernist detractors scornful of debased 'copying' from 'kitsch'.

By contrast, Warhol mercilessly debunked Modernist protocols. Whilst his homosexuality was not widely acknowledged until after his death, he blithely used the related sensibility of Camp as his main weapon. Defined by Susan Sontag in a famous essay of 1964 as 'love of the unnatural: of artifice and exaggeration', a 'good taste of bad taste', it had permeated Warhol's earlier output as a successful illustrator in the 1950s.[12] He had, for instance, produced stylish gold-leaf collages of shoes specially personalized for celebrities, before moving from the commercial to the fine art sphere. His first exhibition of works in the latter idiom was decidedly 'camp'. In 1961, paintings derived from commercial graphics were displayed behind a scattering of fashionably clad mannequin 'shoppers' in the window of Bonwit Teller's, an up-market women's clothes store. The ensemble teasingly fused the dynamics of (male) 'high art' production and (female) mass-culture consumption, such gender connotations having been in place since the

mid nineteenth century, and persisting in Greenberg's art/kitsch opposition, according to Andreas Huyssen.[13]

In 1962 Warhol embarked on his iconography of consumerism—the screen-printed rows of dollar bills and Coca-Cola bottles on large canvases or the paintings of individual Campbell's soup cans that were shown at his first solo exhibition at Los Angeles's Ferus Gallery (see Chapter 3). The 'stacking' of his 'products' in rows implied a submission to the routinization of supermarket-era shopping as well as mimicking the techniques of mass-production. In line with this, he turned mechanization's threat to artistic autonomy into an aesthetic rationale, talking of wanting to be a machine, and pursuing the industrial metaphor to the extent of employing assistants to print his silkscreens in his 'Factory'. This essentially 'masculine' managerial stance, which updated art-historical workshop practices (e.g. Rubens), sat oddly alongside his 'camp' position.

Through aligning himself with 'female' consumption, Warhol came close to Duchamp, who had represented himself in drag on a perfume bottle [25], but Warhol's taste was more flamboyantly vulgar, especially when it came to opposing Abstract Expressionism's 'virility'. His *Cow Wallpaper* [55], its ungainly bovine profiles appearing incongruously rural alongside his urban subjects, repudiated a whole lineage of 'bullish' imagery in twentieth-century art ranging from Picasso's *Guernica* to Motherwell's *Elegies* [12]. At the same time, in producing 'wallpaper'—the very incarnation of the domestic and decorative—he parodied the broodings of Modernists over where abstract paintings ended compositionally, revelling in the philistine perception of such works as 'wallpaper'. (The American critic Harold Rosenberg once denigrated certain forms of Abstract Expressionist art as 'apocalyptic wallpaper'.)[14]

Warhol's anti-Modernist position informed his most celebrated subjects, Marilyn Monroe and Elizabeth Taylor. These celebrities were as much gay icons as objects of male heterosexual desire, not least because of their publicized sufferings in heterosexual relationships, and in his silkscreen-printed 'portraits' of 1962–3 the garish inks virtually functioned as make-up, creating 'drag-queen' connotations. Warhol was plagued by personal cosmetic insecurities. An early painting called *Before and After* (1960) was adapted from a newspaper advertisement dramatizing the transformation of a woman's nose from 'aqualine' to 'ski-slope' via plastic surgery; Warhol himself had had a 'nose job' in 1957. Applying silkscreen inks like cosmetics, he ironically attended to Modernist painting's 'complexion'—its concern, in Greenberg's terms, with maintaining surface integrity. Warhol famously asserted that to 'know' him, his audience simply needed to look at the 'surface' of himself or his work; there was nothing more.

In cosmeticizing Modernism Warhol brilliantly replayed certain conditions surrounding the foundational construction of the 'modernist' artist (for the two usages of the term see Chapter 1). In his essay 'The Painter of Modern Life' (1863), the French art critic Charles Baudelaire had argued that what distinguished the (male) artistic advocate of 'modernity' was a marrying of the aristocratic spirit of the 'dandy' with that of the *flâneur* in the desire to 'distil the eternal from the transitory' out of urban flux. In a section entitled 'In Praise of Cosmetics' he extolled the artifice of make-up as an analogue for his aesthetic credo. Its ability to 'create an abstract unity in the colour and texture of the skin' was said to approximate 'the human being to the statue, that is to something superior and divine'.[15] Warhol's Marilyn was turned into a divinity in precisely these terms, although his *Gold Marilyn* of 1962, consisting of a solo head placed on a gold-painted field, also evoked Byzantine icons. The fact that Warhol was a fervent Catholic suggests a mobilization of fetishistic religious impulses equal to Klein's or Manzoni's. Certainly Warhol's carefully distanced persona and the voyeuristic establishment of a 'freak show' of hangers-on at his 'Factory' positioned him as Pop's 'dandy' *par excellence*.

Warhol's voyeuristic tendencies surfaced most clearly in the *Disasters* series (1962–4). The *Marilyns*, produced shortly after her suicide, anticipated these works in dramatizing how mass culture threads private tragedy through its machinery. (The repeated 'frames' of the *Marilyn Dyptich* [1962], some with the image over-inked or virtually invisible, connoted film, a medium to which Warhol turned in 1963.) Deriving initially from a stark newspaper headline '129 die in Jet' (the subject of a 1962 painting) the *Disasters* series ironically revived an important genre of Neoclassical 'history painting': the heroic death. Warhol, however, programmatically placed allusions to 'celebrity' deaths, such as Monroe's or President Kennedy's registered through the grief on his wife Jackie Kennedy's face, on a par with those of 'unknowns'—the harrowing *Suicide Jumps* and *Car Crashes* [**56**]. The latter constituted dystopian reflections on the symbol of American affluence in the wake of Jim Dine's earlier 'Happening' [**50**]. Other works in the series, the *Electric Chairs* and the *Tunafish Disasters*, dealt with 'unknowns' who momentarily achieved fame precisely through death. All in all, death was presented as a social leveller.

Democratizing processes were often the subject of Warhol's fey pronouncements. He noted approvingly that when Elizabeth II drank the Coca-Cola offered by President Eisenhower it tasted the same to her as to the man in the street. In a famous utterance he conflated the conformities of commodity culture with an alien political credo: 'I want everybody to think alike ... Russia is doing it under government ... Everybody looks alike and thinks alike, and we're getting more and more that way'.[16] The conflation reflected the way American media

representations of ideological rivalry between the US and Russia hinged on the supposedly egalitarian benefits of capitalist commodity output (as in reports of the 'kitchen debate' between America's Vice-President Nixon and Russia's President Krushchev in 1959). But Warhol's embrace of sameness potentially had moral valency. In an important essay Thomas Crow argues that the restatement of identical images in the *Disasters* series reminds us, poignantly, of the daily repetitiveness of tragedy.[17] It might equally be asserted, in line with Warhol's observation that 'when you see a gruesome picture over and over again, it doesn't really have any effect', that he was commenting on the affective numbing brought on by repeated exposure to the mass media.[18] Alternatively, critics have seen Warhol as cynically capitulating to alienation effects. Hence the disjunctive coloration (and titling) of certain images—*Lavender Disaster* (1963), for instance, in which multiple electric chairs appear in toilet-roll hue—possibly amounts to his commodifying of voyeurism, rendering it 'decorative'.

Whatever one's viewpoint, Warhol's re-runs of media intrusions shadow structural changes in American national consciousness brought about through the mass witnessing of traumatic 'spectacle' on TV (the filming of Kennedy's assassination in 1963 was a vivid demonstration of this new 'collective' phenomenon).[19] In this sense his recognition of technology's increasing mediation between the public and private spheres was exemplary, and his wholesale importation of photographic processes into the Fine Art arena, symbolized by the decision to 'paint' using photographic stencils just before Rauschenberg's move in the

58 Weegee

'Sudden Death for One …
Sudden Shock for the
Other …', photograph first
published in the New York
evening newspaper *PM Daily*,
7 September, 1944

The freelance newspaper
photographer Arthur Fellig,
better known as 'Weegee', was
notorious in New York in the
late 1930s for being the first to
arrive at any scene of crime,
arrest, or tragedy. Generally he
worked late at night or early in
the morning and his images
are characterized by the use of
photographic 'flash'. At the
turn of the 1940s he
occasionally lectured at New
York's 'Photo League', forging
links with the 'art photography'
world.

same direction [**60**], represents a key historical juncture. It implicitly underlined Benjamin's sense of photography's sociocultural destiny, as discussed earlier, creating a precedent for later conceptually oriented art. In the latter respect, Warhol's utilization of a 'low' journalistic photographic genre can be correlated with the more resolutely amateurish, or deadpan, uses of photography in the work of a 'Pop' contemporary from Los Angeles, Ed Ruscha. In *Twentysix Gasoline Stations* (1963) [**57**], the first of a series of self-published books, Ruscha undercut the rarefied *livre d'artiste* tradition via the creation of an artless visual itinerary of the petrol stations on Route 66 between Los Angeles and Oklahoma, a forerunner of the Bechers' later taxonomies [**93**].

Ruscha's book also presented a cool take on the poeticized mythology of the American highway synonymous with Jack Kerouac's 1950s 'Beat' novels and Robert Frank's related 'art' photographs. Warhol's recoding of 'reportage' photography into 'Fine Art' terms probably played off earlier photographic history. In the 1940s the New York photographer Weegee, hailing from a similar working-class immigrant background to Warhol, had made his name in the commer-

cial arena, opportunistically photographing grisly car accidents for newspapers, before being turned into an 'art photographer' when MOMA bought and exhibited his work in 1943. In the late 1940s, when Warhol first lived in New York, Weegee's book *Naked City* was a best-seller, heralding its author's later self-promotion as 'Weegee the Famous'. The recoding of his morally ambiguous work, to say nothing of his negotiation of the interface between commerce and art 'stardom', may well have provided Warhol's model. Crow notes that images from Warhol's *Disasters* series often possess a dark *film noir* aura, such that we might well be witnessing events of the 1940s, and the image of a suicide victim used in *1947 White* (1963) actually dated from the year in that title. Interestingly, certain of Warhol's commercial logos were nostalgically anachronistic. His Coca-Cola lettering derived from early in the century.[20]

Weegee's intrusive photographs often exploited the traumatized 'blanking out' of accident victims in a state of shock [58]. Warhol in fact used 'blanks' in a more literal way, accompanying several of his *Disasters* with monochrome panels [56]. Frequently overlooked in analyses, these acknowledged the contemporary abstractions of Ellsworth Kelly or even Barnett Newman (by the mid-1960s Warhol's work was in dialogue with contemporaneous abstraction, especially Minimalist repetition; see Chapter 5), while providing a form of antithetical stasis or 'blanking out' in relation to the images. They may well be metaphors for the 'sublime'—the experience of awe in the face of overwhelming external forces that the Abstract Expressionists Newman and Rothko, drawing on eighteenth-century aesthetics, talked of wishing to evoke in their abstract 'fields'. For once, it seems, Warhol may have seen some virtue in Modernism. However, his 'sublime', as we shall see, was intrinsically 'postmodern'. He calls for further reappraisal, not just as a prophet of the author's 'disappearance' behind codes of representation (although, ironically, Warhol's authorial 'presence' actually increased as surely as the 'auras' of his images decreased), but as a moralist of sorts, or even a therapist, anaesthetizing us against the effects of traumas to come.

Pop and politics: the US and West Germany

In general, American Pop luxuriated in the abundance of the Kennedy era (1960–3), as exemplified by Tom Wesselmann's and Mel Ramos's paintings juxtaposing glamorous nudes with brightly packaged foodstuffs. But James Rosenquist, like Warhol, occasionally registered its shallowness. He had trained commercially as a billboard artist, working close-up on enormous advertising hoardings which later predisposed him towards the use of abstracted fragments of imagery. In *Painting for the American Negro* [59], a response to Civil Rights issues, a slice of cake, connotative of consumer pleasures, is given a

59 James Rosenquist

Painting for the American Negro, 1962–3
Rosenquist's paintings made use of bizarre, filmic jumps in scale and content, hinting at buried 'narratives'. In the top left corner the lower half of a seated businessman is depicted in an illustrational mode. His feet, possibly awaiting the services of a 'shoe shine' boy, are firmly planted on the head of an illusionistically painted negro. Further along, an enlarged head (perhaps that of a black activist or the car's chauffeur) is rendered anonymous by the slice of sandwich cake in the final frame.

political inflection: it seems to hint at the social stratification implied throughout the painting. Cake had made another appearance in Rosenquist's earlier *President Elect* (1960–1). This time it was proffered by a ghostly hand emerging from the newly elected President Kennedy's face and emblematizing what Rosenquist feared would be 'empty promises'—cake for the masses, to recall Marie Antoinette. By contrast, Rauschenberg lauded Kennedy's vigorous statesmanship in several 'silkscreen paintings', as exemplified by the repetition of the pointing hand in *Retroactive 1* [**60**].

As the American dream soured during the 1960s, Rosenquist encapsulated the changing mood in *F-111* (1964–5), a 51-panel 'mural' in the tradition of Picasso's politically motivated *Guernica*, depicting images of doom (an atomic explosion) and desire (yet more cake) intercut with an ominous image of an F-111 bomber. Planes of this type were instrumental in America's increasing involvement in the Vietnam War, as overseen by Kennedy's successor Lyndon Johnson. In fact they proved expensive design failures and thus appropriate symbols for an escalating Cold War conflict, ostensibly fought to uphold the freedom of Southern Vietnam against neighbouring Communist aggressors, but

evolving into an unwinnable war of attrition, which dragged on until 1973. Despite the equation it drew between political expediency and economics (Rosenquist commented that the prosperous lives of American arms-industry workers were predicated on death), Rosenquist's bomber was seductive enough to be installed in an entire room of Castelli's gallery and to be sold to fashionable collectors (see textbox on the American art market).[21]

If Rosenquist's politics were compromised by his Pop gloss, a more abrasive form of social commentary was conducted throughout the 1960s by the Los Angeles-based assemblage artist Ed Keinholz. Keinholz had helped consolidate West Coast Pop's distinctive 'funk' idiom with the establishment, in 1957, of Los Angeles's important Ferus Gallery, in collaboration with the curator Walter Hopps. By the turn of the 1970s his response to nearly two decades of racial tension, epitomized by riots in Los Angeles's Watts district in 1965 and in hundreds of other cities in 1967 and 1968, was a stark tableau first shown at Documenta 5 in Kassel, Germany, in 1972. It consisted of life-sized mannequins and related props. Its imagery was nightmarish. Lit by the headlights of their parked cars, six white men, their faces hidden

60 Robert Rauschenberg

Retroactive 1, 1964

Rauschenberg's silkscreened canvases bearing images of Kennedy were produced after the president's assassination, although Rauschenberg had ordered the screens before the event. Kennedy's populist rhetoric of space conquest (in 1969 the US was to put the first man, Neil Armstrong, on the moon) thus becomes elided with an image of his deification; the parachuting astronaut at top left doubles as an angel.

61 Ed Keinholz

Five Car Stud, 1969–72

Ruthlessly forgoing aesthetic or metaphorical niceties, Keinholz's grotesquely theatrical scenario compels the viewer to witness what he termed a 'social castration'.

by rubber Hallowe'en masks, systematically emasculated their black victim, while his white 'date' cowered, vomiting, in the truck from which he had been dragged [**61**].

By 1970 America's domestic troubles had become compounded by proliferating anti-war protests. These reached a peak when President Johnson's Republican successor, Richard Nixon, decided to bomb North Vietnamese bases in neutral Cambodia. Pop had long been supplanted as a movement, but it is significant that its idioms could still be mobilized by an 'outsider' commenting on the US's dangerous international power game. This was the frequently overlooked Brazil-born artist and poet Öyvind Fahlström, who was to settle in Sweden, but spent much of the 1960s shuttling between that country, Italy, and America. His *World Politics Monopoly* [**62**] of 1970 wittily dramatizes Cold War tensions. If Keinholz aimed to outrage his viewers, Fahlström invites them to 'play'. The magnetic 'pieces' on his 'board' are movable, thereby positing some degree of social/political autonomy. With Warhol in semi-retirement after the trauma of his shooting by Valerie Solanis in 1968, few home-grown exponents of Pop, whatever their commitment to a vernacular art, had any such stomach for sociopolitical comment.

If Fahlström implicitly criticized American Pop's political silence from within, two Germans conducted a different dialogue with it

from afar. Gerhard Richter and Sigmar Polke had moved to West Germany from the East before the erection of the Berlin Wall, settling in Düsseldorf, where, apart from assimilating Fluxus's anti-formalist ethos, they saw reproductions of 'Pop' works by Lichtenstein and Warhol around 1962-3. These offered alternatives to a set of restrictive aesthetic options: the 'Socialist Realist' modes in which they had originally been indoctrinated, the abstraction that was being touted as West Germany's aesthetic corollary of American Modernism's 'freedoms', and the atavistic return to quintessentially 'German' Expressionist roots favoured by Berlin artists. Predisposed by their backgrounds to assume the hidden hand of ideology in art's productions, they gravitated towards Pop's intrinsic irony, its distanced appraisal of the way cultural information is processed. Nonetheless, an early manifestation of their position, the performance event *Life with Pop—A Demonstration of Capital Realism*, makes it clear that they were more intrinsically self-reflexive than their American counterparts.

The 'Capital Realism' (which later became 'Capitalist Realism') of the above event's title succinctly posited a German Pop idiom which was not so much the liberated converse of Socialist Realist academicism as the reflection of another ideology. The event itself, which took place in a furniture store, consisted of Richter and a further collaborator Konrad Lueg (later to run a gallery as Konrad Fischer) sitting in a mock living-room in which both they and a range of bourgeois living accessories were raised on pedestals. Surrounding objects included Winston Churchill's recently published memoirs and a television broadcasting a programme on the Adenauer era. (The performance took place on 11 October 1963, the date of Konrad Adenauer's resignation as West Germany's chancellor.) In an adjacent space spectators passed by *papier mâché* figures of Kennedy and the art dealer Alfred Schmela. All in all, the artists ironically presented themselves as complicit with the complacency engendered by Adenauer's 'economic miracle'.

In subsequent paintings by Polke, deliberately inept versions of American Pop techniques ironically signalled West Germany's 'secondary' cultural/economic status *vis-à-vis* America. In his *Rasterbilder* works he subverted Lichtenstein's stylization of printer's dots by exploding his photographic motifs into molecular fields. The elements of these fields achieved a distracting autonomy—some dots were half-formed, others merged. In the case of *Bunnies* [63] this atomizing of the image implied a critique of capitalism's marketing of female sexuality: the closer the (male) spectator peers at these Playboy 'Bunnies', the more they 'break up', their mouths dispersing in red showers. Commenting on his dots, Polke amusingly linked their perverse behaviour to his personality, acknowledging an obvious pun on his name: 'I love all dots. I am married to many of them. I want all

dots to be happy. Dots are my brothers. I am a dot myself.'[22]

Less anarchic by nature, Richter similarly used photographs as ready-made subjects, often working from family snapshots, although *Eight Student Nurses* (1971), the images of eight victims of a Chicago murderer, drew on Warhol's investigations of media-induced morbidity. Unlike Warhol, however, Richter produced painted simulations of photographs, blurring the outlines of their imagery to create out-of-focus effects, as though thematizing irresolution, both in terms of memory, as befits a response to photographed subjects, and in terms

of the distinction between painting and photography. In the latter respect, his later paintings from photographs of dead members of the Baader–Meinhof gang, a group of terrorists who committed suicide in Stammheim prison, Stuttgart, in 1977 after the attempted hijacking of a plane by their supporters had failed [**111**], function dialectically in relation to Warhol's memorializations of heroic death (see above). For Richter it was precisely *painting's* continuing ability to embody historical consciousness, in the light of *photography's* usurpation of the business of recording, that was at issue.

Such concerns, which will be further explored in Chapter 7, show Richter departing from Pop, but it is relevant here to anticipate another aspect of his later career—the split in his work between 'photo-realist' images, which in the Baader–Meinhof works have an obliquely ironic relation to the heroicizing public imagery of 'Socialist Realism' (the terrorists were Communist opponents of the West German regime), and 'abstractions' [**113**]. It is as if this split in his work reproduced the historical rift between 'Socialist Realist' and abstract Modernist positions, hinging on the question of art's 'public' responsibility, that he had been compelled to negotiate through moving to the West.

Recalling the start of this chapter, Greenberg's horror of 'kitsch'—the principle which Pop so fervently embraced—had initially been bound up with an abhorrence of the aesthetic consequences of Stalinism, namely propagandist art for the masses: 'Socialist Realism'. In a sense, then, Richter's eventual response to Pop was to retreat from its embrace of kitsch, recovering the historical conditions from which it, as the antithesis of Greenberg's Modernism, had grown. In doing this he, and Polke also, return us to the central premises of postwar avant-gardism, discussed in Chapter 1. However daring Pop's levelling of 'high' and 'low' cultural distinctions, its aesthetics were ideologically rooted: it was as 'American' as Greenberg's Modernism. In that sense, it constituted 'Capitalist Realism', as far as Polke and Richter were concerned; a form of propaganda, as the case of Rosenquist demonstrates, for values it was not always comfortable with.

Modernism in Retreat: Minimalist Aesthetics and Beyond

5

Clement Greenberg's Modernism was a source of antagonism for most of the artists discussed in the last three chapters. Their weapons of opposition were the bodily, the readymade, the mass-(re)produced, the 'kitsch', and the aesthetically hybrid. At the turn of the 1960s Modernism's rhetoric of aesthetic 'purity' had reached a pitch. However, it could only be comprehensively discredited if, as well as being set against the social realities it spurned, it was found wanting in its own abstract terms. Aesthetic dilemmas demanded solutions. This chapter will show how practices of abstraction mutated from the early 1960s onwards, gradually recovering vestiges of figuration and human content.

The non-relational: Reinhardt, Stella, Judd

In America the output of two painters of the early 1960s, Ad Reinhardt and Frank Stella, manifested telling ambiguities from a Modernist standpoint. Ad Reinhardt, the senior of the two, with a career stretching back to the late 1930s, carved out a particularly intractable position for himself. On the one hand, he possessed the hallmarks of a staunch Modernist. He deplored any confusion between art forms, fiercely advocated a philosophy of 'art as art' predicated on relentlessly negativistic itineraries of all the things art was not,[1] and in his 'black' paintings of 1955–67 practically banished compositional incident from a sequence of unyielding monochromes. On the other hand Reinhardt had no time for Modernism's avatars, the Abstract Expressionists. He regarded their paintings as impure marriages of abstraction and Surrealism and satirized their Jungian sympathies in the title and imagery of one of the polemical 'cartoons' he published in the art press in the 1950s [64]. This jibe notwithstanding, Reinhardt was deeply sympathetic towards various forms of mysticism. The sombre iconicity of the 'black paintings', from which Greek cross structures slowly emerge against faint bluish or reddish 'haloes', attests to this.

Detail of 73

64 Ad Reinhardt

A Portend of the Artist as a Yhung Mandala, 1955

Ad Reinhardt's satirical cartoons, which contrasted sharply with his practice as a painter, dated back to the 1930s and 1940s. His strong Communist sympathies during that period had informed a series of cartoons for left-wing journals. By the 1950s he was more concerned with exposing the politics of the art world. It is presented here in the form of a Tibetan mandala—a maze of buzz words and cant, shot through with capitalist decadence.

Reinhardt's art world purges were given impetus by the lukewarm reception he received from Clement Greenberg. In the early 1960s this Modernist critic was wary of the uninflected object-like quality of Reinhardt's 'black' canvases. Having previously espoused values of painterly 'all-overness' and 'flatness' (as discussed in Chapter 1), Greenberg was now retreating from their logical extremes, observing that 'a stretched or tacked-up canvas already exists as a picture—though not necessarily as a successful one'.[2] In line with his advocacy of painters like Morris Louis, he increasingly stressed the optical incident within the pictorial field rather than its overall cohesion. Yet it was precisely the latter self-referring quality which younger artists in New

York, such as Don Judd, Sol LeWitt, and Frank Stella, prized in Reinhardt. Stella's own 'black paintings' of 1958–60, which set his career in motion, were almost calculated to confirm Greenberg in his critical reorientation.

Stella's works took the critic's earlier dogma of formal self-containment to a deadpan conclusion. Expunging any residues of Abstract Expressionist emotionalism and seizing on Johns's use of systematic pictorial rationales [29], Stella deduced the internal logic of paintings such as '*Die Fahne Hoch!*' [65] from their nature as objects. The unvarying 2-inch-wide bands of black that filled the canvases were thus derived from the width of their stretchers. The slivers of bare canvas that were left behind paradoxically functioned as 'drawing', echoing the framing edges of the supports and setting up centrifugal or centripetal 'ripples'. Such images seemed to obey structural necessity rather than aesthetic whim. But Stella, of course, made minimal decisions as to how to extract necessity from his formats. This flew in the face of the Modernist idea that painting imposes a fixed set of aesthetic limitations.

In subsequent sequences of work Stella dramatically moved from 'painting' in a Modernist sense towards 'objecthood' (to pre-empt Michael Fried's later terminology). In the aluminium-coated 'shaped canvases' of 1960 the paintings' reverberative internal patterns were dictated by notches cut into the corners or sides of the supports, or by holes puncturing the centres. Their aluminium surfaces encouraged the art historian Robert Rosenblum to characterize them as 'irrevocably shut metal doors',[3] an association underlining both their self-containment and the artist's stated desire to 'repel' attempts to 'enter them' visually.

In the face of such drastic metamorphoses, the Modernist critic Michael Fried, torn between loyalties to Greenberg and to Stella (he was a close friend of the latter), attempted to cast such works in Modernist terms. He claimed, for instance, that the reflected light from the aluminium canvases counterbalanced their tendency to function as objects by creating an optical shimmer.[4] He and other Modernist commentators such as William Rubin were spared further explanatory acrobatics when, having pursued his end-game with painting to the extent of producing polygonally shaped canvases in 1963, in which the redundant centres of the paintings were completely removed, Stella changed direction. His enormous *Protractor* paintings of 1967–8 now reintroduced complex internal relationships between arcing bands of colour. For a time at least he appeared to have entered the Modernist fold, alongside other 1960s exponents of 'hard-edge' abstract colour painting such as Ellsworth Kelly. However, in the 1970s his surprising turn to a kind of parodic or baroque gestural painting established him as terminally ambivalent.

The resolution with which Stella squeezed both content and formal rhetoric out of his works temporarily diverted any discussion of his emotional investment in them. The titles of his early 'black paintings' have led, however, to considerable speculation concerning hidden agendas. '*Die Fahne Hoch!*', for instance, translates as 'Raise the Flag!', a phrase from a Nazi marching song which doubles as an ironic nod towards Jasper Johns [28], and, given Stella's imputation of aggressive motives to those pictures, it has been argued that they encode a fascination with fascistic forms of domination.[5] *En masse*, however, the titles catalogue so many connotations of 'blackness' (for instance references to jazz hangouts and a transvestite club in Harlem) that they probably simply reflected Stella's identification with New York's seamier side. He was at emotional 'rock bottom' when the works were produced, and may well have seen them as continuous with a tradition of 'black' paintings deriving from the gritty, *noir* ambience of 1940s film and photography [16]. In this, Stella was a precedent for the Warhol of the *Disasters* [56]. This comparison may be extended to another similarity between these apparently dissimilar figures—a conception of art output as akin to industrial production.

It is here that readings of Stella as preoccupied by metaphors of domination gain some purchase. Basically, it has been argued that, as the 1960s progressed, Stella's works, whether Modernist or anti-Modernist in orientation, came to acquire the impersonal clarity of corporate logos.[6] This argument may not be as reductive as it appears. Moves by American corporations from international to multinational status during this period may have insidiously informed the way ambitious artists, conscious of America's new-found hegemony in the Western art world, seized the advantages of having instantly identifiable 'brand identities' within an expanding art market. It is revealing perhaps that Leo Castelli, Stella's dealer, once characterized his shiny aluminium canvases as 'cash registers'.[7] Certainly by the late 1960s Stella, like Warhol, had embraced a 'managerial' ethos, employing assistants to cope with the demand for his wares and effectively splitting artistic creativity into 'executive' and 'production' modes.

Whether or not Stella is to be seen as a cipher for larger economic forces, it is interesting that when he, along with fellow artist Don Judd, theorized the move to a new impersonal aesthetic, in an important interview of 1966, the rhetoric of American cultural supremacy played its part.[8] It is necessary here to say something about Judd. Initially a painter, Judd had come to believe, in the wake of Stella's productions, that both painting and sculpture were inherently illusionistic and should be superseded by the creation of what he called 'specific objects' in literal space.[9] His production of this new artistic genre, which took the form of single or repeated geometrical objects, was part of a broader move towards 'Minimalism', to be discussed

shortly. The objects, which were uninflected, 'hollow', and occasionally subdivided internally according to part-to-whole ratios, were fabricated by workmen at factories, according to his specifications, in materials ranging from cold-rolled steel to Plexiglass [**66**]. In articulating their position, Stella and Judd made much of the fact that their new works were 'non-relational'. This meant they were structurally self-evident and pragmatically ordered according to a principle of 'one thing after another', thereby shaking off the fussy 'relational' characteristics of much previous art.

What they took to be 'relational' was epitomized by the work of the British sculptor Anthony Caro, currently being promoted by Greenberg and Fried in a notable softening of their pro-Americanism. Caro had transferred his loyalties from Henry Moore to US Modernism in the late 1950s by absorbing the example of the American sculptor David Smith. In the 1940s and 1950s Smith had utilized the industrial process of welding to produce imposing steel or other metal structures, thereby establishing the practice of construction, pioneered by artists such as Picasso and the Russian Constructivists earlier in the century, as the pre-eminent postwar sculptural principle. Revitalizing British sculpture through the importation of Smith's techniques, Caro boldly dispensed with the American's assumption that sculpture should be oriented vertically from a base. Smith's links to an older Abstract Expressionist generation had predisposed him towards residues of figuration, even in his most apparently abstract works [**67**], but Caro made a radical shift to horizontally oriented abstract sculptures. Occupying large areas of ground, they were painted in the bright colours of American Post-Painterly Abstraction in order to counteract

67 David Smith

Lectern Sentinel, 1961

Smith's series of *Sentinel* sculptures, which were begun in 1956, were placed in the landscape surrounding his studio at Bolton Landing in upstate New York. Given their clear figurative associations they appeared to 'survey' or 'guard' the terrain. In this example, the overlapping and angling of the welded stainless-steel plates brilliantly hint at the classical motif of *contrapposto*, whereby the body is slightly 'twisted' through the employment of a resting and a supporting leg.

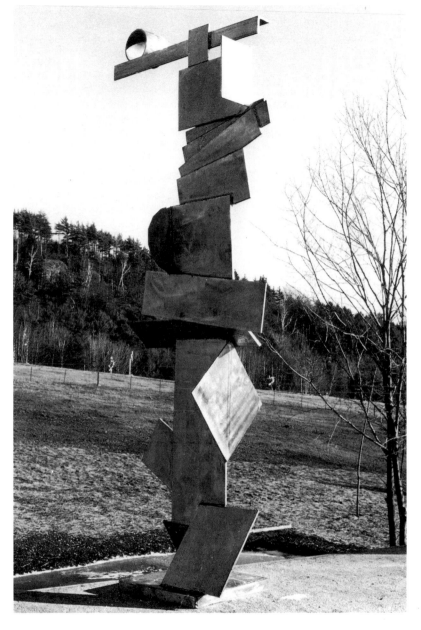

their weight and make their elements 'hover' above the ground. Fried in particular lauded Caro for achieving a purely non-referential Modernist sculptural 'syntax' in which part-to-part relationships were orchestrated to cohere, as the spectators circled the works, in moments of optical exultation [**68**].

It was this balancing of 'relational' parts that Stella and Judd disliked. Judd's own objects acknowledged construction as a technical paradigm, but completely rejected a 'composed' or 'arty' look. For

Stella and Judd 'relational art' was intrinsically Modernist, but it was also seen as tethered to European sensibility, which is where the aforementioned cultural chauvinism enters in. Thinking largely of European geometrical abstraction, Judd asserted in the 1966 interview with Stella and himself that European art was 'over with': the new American art was characterized by a direct and powerful presentation of 'whole things' whereas European art was 'rationalistic'. However ambivalent he was about Modernist values, he was flexing America's art-world muscle in the way that Greenberg and New York's MOMA had in the 1950s.

If the above appears to tilt the discussion in favour of Judd's pristine 'objects' embodying the 'technological sublime' (in other words an awed capitulation to the sheer authority of America's spreading technological and corporate might), it is worth investigating Stella and Judd's claim that 'non-relational' works of art were in some way a release from 'rationalism'—a principle that might, initially, appear to be synonymous with authoritative exposition and clarity. By looking now to the wider Minimalist milieu, a rather different picture emerges.

Minimalism and anti-rationalism

The 'Minimalist' tag was derived from the title of a 1965 essay on the withdrawal of manual effort from aesthetic output by the British philosopher Richard Wollheim.[10] Its connotations of reductive 'paring down', however, were rejected by all of the key figures who came to be identified with it after a spate of solo shows in 1963–4: Don Judd, Robert Morris, Carl Andre, and Dan Flavin. Other labels such as 'Literalism' or 'Primary Structures', the latter the title of the key exhibition of these artists at New York's Jewish Museum in 1966, were no

more helpful. As Judd asserted, the reductionist interpretation of Minimalist art was predicated on what was thought to be missing from the objects when works such as his were kept uncomplicated precisely in order to isolate specific and positive qualities. Reduction alternatively implies a calculated attempt to reach an essential 'core'. In this respect the work of many Minimalists implicitly denied any 'rationalist' or 'idealist' accession to 'meaning'. Judd's ordering systems were anti-rationalist, he claimed, because the logic of 'one thing after another' obviated the need for aesthetic 'decisions'. In the case of Robert Morris, though, the principle of anti-idealism went deeper.

In the early 1960s Morris had been involved with the moves towards a simplified, task-oriented style of dance which his then wife, Simone Forti, and dancers such as Trisha Brown and Yvonne Rainer developed at New York's Judson Memorial Theatre. In its openness towards interdisciplinarity this tendency paralleled contemporaneous Merce Cunningham/Rauschenberg and Fluxus performances. In sculptures of the period Morris explored Duchampian preoccupations with the body and gendered identity [**27**], as noted earlier. These concerns naturally found their way into the fairly elaborate dance events he organized between 1962 and 1965 such as *Site* (1964, with Carolee Schneeman) and *Waterman Switch* (1965), but the convergence between sculpture and dance had been economically suggested in Morris's first performance, *Column*, at the Living Theatre in New York in 1961. The 'performer' in the piece was a grey-painted 8-foot plywood column which stood on an empty stage for three and a half minutes. Manipulated externally by strings, it then fell to the floor, where it remained for the same period before the performance ended. The piece conflated anthropomorphic allusions to male sexuality (as subsequently explored in *I-Box*) and current moves in sculpture from a (virile) verticality to a stress on horizontality [**67, 68**]. In 1964–5, Morris began to use such geometrical forms in the context of Minimalism, but his sense of their metaphorical possibilities clearly separated him from Judd.

This is not to say that Morris was unconcerned with the problem of maintaining the sense of the 'wholeness' of his geometrical forms. However, in his contemporaneous *Notes on Sculpture* he evinced an interest in how such 'whole objects' were actually perceived by spectators, playing off the concept of the 'good gestalt' (a term used by psychologists to designate the 'whole' or regular structures we are predisposed to search for in visual configurations) against the fact that our bodily based experience of objects, even the most regular ones, is inevitably partial or contingent. We may be able to conceptualize 'cubeness', but we can only experience actual cubes in time from certain angles and distances. We oscillate, as Morris put it, between the 'known constant and the experienced variable'.[11]

69 Robert Morris

Installation at the Green Gallery, New York, December 1964

Spectators were implicitly asked to test their height in relation to the arch-like 'table' at the left of this photograph or the form suspended at eye level at the right. Expectations concerning the format of the gallery were modified by the 'corner piece', a sculptural concept derived from Joseph Beuys, but adapted to a different end.

In real terms, this led Morris to the controlled perceptual conditions involved in works like *Untitled (Three L-Beams)* of 1965. These large, identical L-beams were placed in sitting, lying, and balancing postures, like three Platonic Graces. The spectator's experience of them as visually 'different' had to be reconciled with the fact that their natures were identical. Much has been made of Morris's interest at this time in Merleau-Ponty's *Phenomenology of Perception* (1945), in which the philosopher was at pains to strip the body's 'primordial' apprehensions of spatial, temporal, or sensory stimuli from the tyranny of predetermined axiomatic truths. Morris's Green Gallery exhibition of 1964–5 [**69**] might almost be described as a phenomenological gymnasium, its aesthetic 'apparatus' designed to 'tone up' its audience's eyes, bodies, and minds. What is clear is that Morris's work '[took] relationships out of the work and [made] them a function of space, light and the viewer's field of vision'.[12]

In moving from Judd's 'non-relational' interests to Morris's 'phenomenological' ones, a split within Minimalism has emerged between a desire to see art objects achieve ultimate self-sufficiency (thereby pushing the Modernist credo to its limits) and a desire to see

such objects defined by their ambient conditions.[13] The latter position, which Morris partly inherited from the Duchampian emphasis on the role of the spectator, constitutes a radical break with Modernist assumptions, undermining the autonomy previously claimed for works of art. Minimalism here becomes deeply relativistic, supportive of the view that 'art' can only acquire value or worth in relation to external factors, such as its social or institutional setting. Such a view sets distinct limits on the artist's ability to control meaning, recalling Barthes's theorization of the loss of authorial agency.

This issue of loss of agency can be differently exemplified in the art historian Rosalind Krauss's reading of the anti-rationalism of another artist associated with Minimalism, Sol LeWitt. Discussing his *Variations of Incomplete Open Cubes* (1974), a modular structure composed of 122 wooden units demonstrating all the permutations produced by systematically removing the various sides of a cube, she shows how an apparent logicality flips into obsessive compulsion.[14] Although LeWitt's productions clearly responded to Minimalist preoccupations, such that this project echoes Morris's play on the 'known constant' discussed above, he was to present himself as one of the first practitioners of Conceptual Art in articles of 1967 and 1969 with statements such as 'The idea becomes a machine that makes the art'.[15] This principle informs the 'wall drawings' that LeWitt embarked on from 1968 onwards. Revealing a Minimalist predilection for impersonality, they were designed for specific locations but were frequently carried out by draughtsmen on the basis of succinct instructions from LeWitt—for instance 'circles, grids, arcs from four corners and sides' [70]. Strict adhesion to such prescriptions, with no clear sense of how they would unravel *in situ*, led the interpreters to produce unexpectedly labyrinthine or eccentric visual structures. Again, the strange co-existence within Minimalism of authorial removal and aesthetic autonomy is touched upon.

LeWitt's abandonment of control, his deployment of pragmatic systems to undermine rationality, would appear to argue against the earlier points made about Minimalism's tacit complicity with America's power base. However, the loss of agency which he seems glad to submit to may be read as the symptomatic underside of that coin. In this sense, Minimalism emerges as the autistic child of booming industry and mass production, its fixations on strong *Gestalts* and repetitive systems bespeaking a pragmatism internalized and, in many cases, gone awry. Forcing Modernist aesthetics to breaking point, Minimalism vacillated between an awe for the totality of power and a sense of powerlessness. In the latter respect it was closer to America's disaffected countercultures of the mid-1960s than might be supposed.

In the early 1960s LeWitt had
largely devoted himself to
producing modular open cube
structures made from wood.
His 'wall drawings'
represented a continuation of
his interest in pushing systems
to their limits, but also made a
radical contribution to the
history of drawing. Drawing
has traditionally been thought
a peculiarly private activity for
artists, a way of trying out
ideas, preparing for more
'finished' works in other
media. LeWitt both removes
himself from its production,
providing it with a conceptual
basis, and turns it into a public
art. In a sense these works are
variants on fresco paintings.

'Art and Objecthood': Fried and his detractors

In June 1967 the critic Michael Fried published an essay of pivotal
importance entitled 'Art and Objecthood', which staunchly defended
the Modernist cause against Minimalism (he called it 'Literalism' in
the essay).[16] Greenberg had already disparaged the Minimalist object
two months earlier for being too gratuitously 'far-out' and intellectual-
ized, no more readable as art than 'a door, a table, a sheet of paper'.[17]
Essentially Fried expanded this view that Minimalist works did not
distinguish themselves sufficiently from mere objects, arguing that the
real test of a work of art was that it 'suspend its own objecthood'.
Modernist art was now charged with the strenuous task of 'compelling
conviction' pictorially, which meant overcoming the limitations of
literal shape through the mystique of 'opticality'. (We saw earlier how
he attempted to make this stick in the case of the recalcitrant Stella.)

Thinking mainly of Robert Morris [69], Fried asserted that
Minimalism committed the cardinal sin, from a Modernist viewpoint,
of borrowing another discipline's effects. In the case of Minimalism,
theatre appropriately supplied the 'effects'. Minimalist objects were
said to rely for their uncanny anthropomorphic sense of 'presence'
precisely on being like presences waiting to be met (and 'completed' as
artworks) by spectators entering the gallery space. Theatrical 'staging'
and duration, Fried argued, were integral to their functioning, and in
danger of usurping their *raison d'être* entirely. Whilst the 'presence' of
such objects made spectators conscious of their own physicality, the
superior Modernist works of Caro possessed an absorbing 'present-
ness', momentarily freeing spectators from self-awareness. One effect
was profane, the other transcendent. Horrified that the turn to
Minimalism might threaten the idealist values bound up with the
latter, Fried famously declared that Modernist art and 'theatricality'
were 'at war'.

They had been skirmishing for years, and Chapter 6 will demon-
strate that 'theatricalities' of various orders won out in the 1970s. But
Fried was correct in recognizing that a great deal stood to be lost. If
factors such as the height or position of a spectator became entangled
with the functioning of a work of art, how could secure, universally
valid value judgements be made about its success or otherwise? Too
many variables were in play. New criteria for legitimating art's societal
status would follow and the cultivated humanist art criticism, predi-
cated on the possession of a 'good eye' that Fried practised, would be in
jeopardy. Clearly there was an ideological basis to Fried's fears. This
point can be further elaborated by considering the Minimalist Carl
Andre.

Andre's sculptural aesthetic was heavily indebted to the early twen-
tieth-century Romanian sculptor Constantin Brancusi, particularly
his *Endless Column* (1937), in which modular zigzag elements were

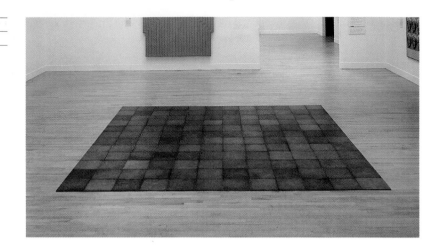

71 Carl Andre
Magnesium Square, 1969

71 Carl Andre
Magnesium Square, 1969

stacked vertically, implying infinite extension both upwards and downwards. Andre similarly employed standardized units in sculptures from the early 1960s onwards, utilizing prefabricated elements such as sheets of metal or bricks and arranging them, as did his friend Frank Stella, in self-evident, numerically determined stuctures. In *Lever* of 1966, which consisted of a line of 139 abutted fire-bricks, he claimed to have brought Brancusi's column down to earth: 'Most sculpture is priapic with the male organ in the air. In my work, Priapus is down on the floor.'[18] This enactment of the 'fall' of sculpture logically led him to consider the terrain it covered. His *Floor Pieces* [71] were thus compressed pedestals from which spectators, who were encouraged to walk on them, could look beyond art. In 'Art and Objecthood' Fried discussed an anecdote recounted by the sculptor Tony Smith in which, driving along the New Jersey Turnpike, the artist had sensed a kind of elation at the endlessness of the experience. Smith's yearning for an experiential state that could not be 'framed' not only epitomized the lure of 'theatricality' for Fried but betokened the art object's complete dissolution. And, although he did not say as much, if the object disappeared, so would its role as item of exchange-value.

This leads on to the politics embedded in the physical aspects of Andre's *Floor Pieces*. The artist asserted that part of his intention was to sensitize his spectators to gravity. The properties of the materials he used—lead, copper, aluminium, and so on—would thus be transmitted through his audience's feet. This bias towards physically based sensations extended to a materialist conception of art itself. He clamed that his work was 'atheistic, materialistic and communistic', the last because its non-hierarchical structures, based on bringing 'particles' into alliance rather than corralling parts into a whole via processes such as welding, were somehow 'accessible to all men'.[19] It is ironic that Andre's works later aroused widespread hostility. In 1976 the revelation that the Tate Gallery in London had bought part of Andre's brick work

72 Agnes Martin
Flower in the Wind, 1963
In her consistent use of grids Agnes Martin participated in a tradition in twentieth-century art stretching from the Cubists and Mondrian to her Minimalist contemporaries. The grid was a non-hierarchical and non-referential structure. It asserted the flatness of the picture plane, echoing its framing limits while implying an indefinite structural extension of the picture beyond its limits. For Martin this had metaphysical connotations, whereas for the Minimalists its associations were essentially literal and pragmatic.

Equivalents I–VIII, as orchestrated by Britain's popular press, led to philistine attacks on the spending policies of Britain's public galleries from general public and art establishment alike.[20] But the Marxist/materialist ideology informing Andre's aesthetics separated him, and many of his artist associates, from Fried's conservative humanism, however surely his works later became items of exchange-value. The politicization of the late 1960s avant-garde will be discussed in the next chapter, but Andre's role in the formation of the Art Workers' Coalition in 1969, which subsequently protested against the art establishment's tacit assent to war in Vietnam, should be noted in passing.

Materialist ideologies by no means pervaded all of the art associated with Minimalism. The American painter Agnes Martin, who became

identified with the movement when her works were exhibited in the 'Systemic Abstraction' show at New York's Guggenheim Museum in 1966, sought spiritual absolutes. An enormously self-reliant artist, from a Presbyterian background, she produced taut but tremulous graphite lattices on lightly painted fields. These were intended to evoke luminescence or immateriality and lighten the 'weight' of the squares that enclosed them [72].[21] Martin's mystical denial of ego ran the risk of conforming to prevalent stereotypes of female passivity, but it also prevented critics from reducing her work to the 'personal' or biographical, as will be seen to have happened in the case of Eva Hesse.

Martin's quietism provides a striking contrast with another female abstractionist who emerged in the late 1960s, in the context of the British response to Modernism, namely Bridget Riley. Sculptural abstraction in Britain had been galvanized, in more senses than one, by the 1965 'New Generation' show at London's Whitechapel Gallery, which established Caro's painted constructions as paradigmatic for a generation of sculptors, notably Phillip King. In terms of abstract painting, however, London rather lagged behind New York's example, despite the initial promise of Robyn Denny's and Bernard Cohen's paintings in the wake of the 1960s 'Situation' exhibition. Minimalist aesthetics were likewise slowly assimilated. Riley, however, carved out a profoundly distinctive path with her assertive, optically disorientating paintings.

Although her work had superficial parallels with the formulaic illusion-inducing paintings of the Hungarian Victor Vasarely, the basis of Riley's work in naturalistic starting-points (such as the effects of wind in long grass) or in physical sensations provided her work with greater metaphorical range. The invasive energy of certain images [73] quickly led to threatened male critics complaining of unfeminine 'aggression'. She achieved international prominence in 1965 when she was featured, alongside her compatriate Michael Kidner, in the 'Responsive Eye' exhibition at New York's MOMA, following this up by winning the

Minimalism and the masculine

The abstractionist Agnes Martin's desire for what she once described as 'impotence' might be seen as implicitly criticizing Minimalism's flirtation with power, reminding us that, however radical its anti-idealist rhetoric, Minimalism was fundamentally a male movement. In this respect the art historian Anna Chave has noted a preponderance of phallic metaphors among its male practitioners. The sculptor Dan Flavin's breakthrough to his signature use of fluorescent tubes was thus the *Diagonal of May 25th 1963*, a strip light, angled at 45 degrees, which corresponded, as the artist once averred, to the 'diagonal of personal ecstasy'. Carl Andre's claims that his works brought Priapus down to earth seem relevant here, but it could well be maintained that, as with Robert Morris's *Column*, discussed in the last section, a parody of sculptural 'virility' was involved, presaging new conceptions of male artistic identity.

prize for painting at the 1968 Venice Biennale, but her work often aroused suspicion.

This was partly due to the way Riley became synonymous with the fashionable cult of 1960s 'Op Art'. Arriving in New York for the 'Responsive Eye' exhibition, she was appalled to see how quickly her motifs had migrated onto dresses in shop windows, and attempted unsuccessfully to sue for copyright infringement. More damaging was the vitriol of American critics. Incensed that the curator of 'The Responsive Eye', William Seitz, had had the temerity to place the likes of Riley next to American abstractionists such as Morris Louis, Rosalind Krauss, a critical ally of Fried, asserted that Riley's species of 'opticality' was pure gimmickry in comparison with the superior Modernist variety, no more worthwhile than exercises in perceptual illusion produced by students.[22]

Krauss's hierarchy of 'opticalities' has its ironies. Following a shift of allegiance to a counter-Modernist position in the 1970s, she would eventually champion the historical importance of Duchamp's path-breaking experiments with optical illusion, in the form of his *Rotorelief* disks of 1935. When rotated on a machine, certain of these set up pulsatile oscillations between inward and outward expansion. Krauss therefore came to see them as exemplifications of an impulse

74 James Turrell

Sky Window, 1975

While producing works like this, Turrell also embarked on a major project in 1972 which involved purchasing, and subsequently modifying, an extinct volcanic crater located in northern Arizona. This 'Roden Crater' project has connections with Land Art (see Chapter 6). However, Turrell's modifications, which involved him in cutting tunnels and adjusting the crater's bowl, were ultimately geared towards orchestrating awesome effects of light and space. Such god-like manipulations distinguish him from Land Artists such as Robert Smithson though not perhaps from Walter De Maria.

in twentieth-century art away from Modernism's lofty disembodied 'visuality'—which made no attempts to meet spectators' visual 'desires'—and towards the gratification of somatic fantasies.[23] Riley's illusions were not pledged to undercutting the sovereignty of 'retinal art' in quite the same way as Duchamp's, and a trend towards 'Kinetic Art' in the 1960s would take up, in its own quasi-scientific terms, his exploration of actual movement. Her contribution to challenging Modernist proprieties has, however, been obscured by the vagaries of critical debate.

In America the promotion of Modernist 'opticality' on the East Coast also deflected attention from work dealing with the mechanics of perception by West Coast artists. Robert Irwin and James Turrell's 'Light and Space Movement', formed in Los Angeles in the late 1960s, was dedicated to sensitizing spectators to the mysteries of natural light. Such effects took some stage-managing and Turrell eventually dedicated himself to creating *Sky Window* installations throughout the 1970s and 1980s, consisting of rectangular apertures in the ceilings of

rooms, through which ineffable changes in the sky's luminosity or chromatic density could be experienced in relation to controlled lighting conditions [**74**]. Works such as these are intended to engender experiences of ethereal otherworldliness rather than carnal excitation or convulsion. But it is clear, not least from Krauss's change of direction, that aberrant forms of 'opticality' would eventually join forces with 'theatricality' in rendering Fried's stringent Modernism insensitive to changing needs, and hardly as 'timeless' as he imagined.

Anti Form and body metaphors: Hesse and Bourgeois

In the mid-1960s Minimalism functioned as a kind of purgative, ridding sculpture of surplus aesthetic and metaphorical baggage, but its austerity almost begged to be challenged. In 1968, therefore, Robert Morris published a text, titled 'Anti Form', which was widely taken to signal a refutation of Minimalism's assumptions. That a short article by an artist possessed such clout is symptomatic of a widespread acceptance of artists as theoretical legislators in the later 1960s. This went hand in hand with a changing sense of art's academic status. Artists increasingly moved between humanities disciplines. Morris, for example, had studied psychology and philosophy in the early 1950s; Don Judd, who published extensively as an art critic, had studied philosophy at Columbia University.

In 'Anti Form' Morris argued that rather than being preconceived, sculpture should follow the dictates of process. Seriality should be abandoned in favour of randomness and materials should be allowed to find their own forms in response to principles such as gravity.[24] Renouncing geometry, he himself scattered materials such as threads or metal scraps in amorphous masses on gallery floors or, having cut strips into large sheets of felt, hung them from hooks so that the strips cascaded to the floor. Given that he and Carl Andre had regarded their practices as imbued with anti-virile metaphors, this change of tack might be interpreted as a means of softening Minimalism's hard masculinist edges. (It is far from coincidental that Morris illustrated 'Anti Form' with one of Oldenburg's 'soft sculptures'.) Dissolution was a cultural condition in 1968. As we shall see, the gallery system was under attack, and Morris was pledged to undermining its rigidities, as well as his own. However, if Morris 'feminized' his practice, it is ironic that a female curator, Lucy Lippard, had already set the 'desublimation' of Minimalism in motion.

In 1966 Lippard had curated an important exhibition entitled 'Eccentric Abstraction' at New York's Fischbach Gallery, dedicated to work which addressed the tactile or the visceral rather than the cerebral. Under this rubric she particularly promoted the work of the German-born artist Eva Hesse. Familiar with Minimalist ideas through her friendship with Sol LeWitt, Hesse had recently begun

exploring the underside of the movement's fetishization of unyielding surfaces and systems. In 1967, for instance, she produced two versions of *Accession*, consisting of perforated Minimalist cubes threaded with thousands of pieces of plastic tubing which provided them with bristling interior 'lives' [**75**]. These pieces had obvious bodily connotations, but the dialectic of mutually defining principles that they embodied clearly pre-empted Morris's move to 'Anti Form'.

The biological associations of Hesse's work invariably existed in counterpoint to her emphasis on the literal nature of materials. Lippard underlined this, observing that in 'eccentric abstraction', 'a bag remains a bag and does not become a uterus, a tube is a tube and not a phallic symbol. Too much free association on the viewer's part is combatted by formal understatement.'[25] Hesse in fact stressed that absurdity was often her most pressing theme. This was exemplified by *Hang Up* of 1966, in which an enormous loop of metal wire, extending from a frame 'bandaged' in cloth, flopped out into the viewer's space as though paradoxically disgorging the frame's emptiness.

Whatever existential dilemma it embodied, *Hang Up*'s figuring of emptiness nevertheless begs to be interpreted in emotional terms, and psychoanalytical accounts of Hesse's work have posited the death of her father in the year it was produced, which reactivated memories for her of her mother's suicide, as a key determinant.[26] However, such analyses tend to construct Hesse as a peculiarly 'inward' artist, more attuned to psychological nuances, by virtue of her sex, than her male peers. These accounts are given piquancy by the fact that Hesse died tragically young from a brain tumour, but interpretations which see her

work as mired in morbidity, such that her use of cheesecloth dipped in latex has been said to evoke diseased skin, have served her badly. Hesse's success stemmed from her ability to seize educational opportunities such as a scholarship to Yale University, which in turn allowed her to surmount contemporaneous social taboos against women departing from the domestic sphere. Her journals bear witness to the pressures of maintaining a dual identity as a woman and an artist : 'I cannot be something for everyone … Woman, beautiful, artist, wife, housekeeper, cook.'[27]

Biographical drama tends to detract from Hesse's historical significance. In many ways she maintained a more frank and inventive relation to the history of sculpture than her male counterparts. Hesse's breakthrough to a mature style was partly a response to seeing Beuys's process-oriented works during a period spent in Germany in 1964–5. By contrast, Morris virtually repressed his debt to Beuys (although it resurfaced in his utilization of felt). Similarly, Hesse implicitly acknowledged that, just as Pollock's painting had spawned a genre of performative art, so it now stood as exemplary for sculpture. Although Morris's 'Anti Form' article significantly reinterpreted Pollock's 'drip' paintings as being about the behaviour of materials rather than Modernist 'opticality', it was Hesse who, in her last *Rope Pieces* of 1969–70, translated Pollock's painterly skeins into two highly evocative hanging sculptures. One, utilizing fibreglass over string, had the delicacy of a spider's web, whilst the other, in latex, threatened to absorb the spectator in its tangles.

If Hesse's formal originality got overlooked, her reintroduction of body metaphors into abstract sculpture initially overshadowed the contribution of an older French-born artist, Louise Bourgeois. She

76 Louise Bourgeois

Double Negative, 1963
Whilst Bourgeois's sculptures frequently connote male and female body parts, this piece also has landscape associations. Mounds or mushrooms are evoked, as is a relationship between 'above' and 'below' ground.

had been using a material that became associated with Hesse, liquid latex, to create visceral, biomorphic sculptures in the early 1960s [**76**]. But although Lippard showed her work alongside that of Hesse in 'Eccentric Abstraction', Bourgeois remained relatively unappreciated until the early 1980s. Before leaving France for America in 1938 she had been affected by Surrealism's emphasis on psychoanalytic investigation. Whereas Hesse publicly made little of the psychological content of her work, aware perhaps of the dangers discussed above, Bourgeois gradually revealed that a complex psycho-biography informed her output. Such openness went hand in hand with the increasing politicization of women artists, accompanied by changed aesthetic values, in the 1970s (see Chapter 6).

The troubled early history that informed Bourgeois's work involved the fact that her father had installed his mistress in the family home, systematically undermining the self-esteem of his wife and daughter. Bourgeois's intensely ambivalent feelings towards him would be given expression in disturbingly direct works such as the installation *Destruction of the Father* (1974), a conglomeration of globular forms both sprouting from and overhanging a long 'table', based on a cannibalistic patricidal fantasy. In smaller carved or modelled sculptures she developed a lexicon of mutating 'part objects'—split-off parts of the body, neither securely male nor female, active or passive, onto which feelings of seduction or repulsion, pain or pleasure, could be projected. Her persistence in using a relatively anachronistic sculptural language, partly rooted in Surrealist reworkings of 'primitivist' sources, seemed increasingly pointed in the 1980s and 1990s as the Modernist imperative towards formal innovation lost its grip. She was understood as speaking in the subversively unsublimated bodily terms which (masculine) Modernism, with its abhorrence of Surrealist eroticism, deemed extra-aesthetic.

Minimalist legacies: sculpture, film, public art

In December 1968 Robert Morris organized an important exhibition under the 'Anti Form' aegis called '9 at Castelli's' in the warehouse of Leo Castelli's gallery. Although Hesse was included, the successes of this exhibition were Richard Serra and Bruce Nauman, whose works explored relationships to their bodies that were more mechanistic and cerebral. Serra's use of industrial materials to carry out actions such as rolling, folding, and splashing drew on the working-class industrial roots he shared with Carl Andre, exhibiting a pronounced masculinist ethos. In *Casting*, carried out *in situ* at Castelli's, Serra threw molten lead into the angled junction between the floor and wall of the space, pulling the resultant castings away when they hardened and repeating the action to produce a series of 'waves'. This concern with physical operations led him to examine the way forces were brought into equilibrium by rudi-

77 Richard Serra

From the film *Hand Catching Lead*, 1968

This 3-minute 30-second film, like others produced by Serra in the same year, related to a famous 'verb list' which he compiled in 1967–8. The verb involved in this instance is 'to grasp' but the list also included ' to roll, to crease, to fold, to store, to bend, to shorten, to twist, to dapple, to crumple, to shave' and so on (see Richard Serra, *Writings/Interviews*, Chicago, 1994, pp. 3–4). Such pragmatic instructions informed much of Serra's process-oriented art of the period.

mentary leaning or propped structures. In *Corner Prop* (1969) a 2-foot-square cube of lead was supported against a wall, over 6 feet above the ground, by means of a slender lead pipe. With such heavy materials problems of 'balance' were decidedly literal rather than 'pictorial', and the sense that the works might collapse provided spectators with an uncomfortable *frisson*, directly addressing their bodily presences.

Time was an active principle in Serra's work and he therefore made several short films such as *Hand Catching Lead* (1968) [**77**], in which repeated images of a hand attempting to catch a falling piece of lead create a hypnotic rhythm, making the spectator conscious of the filmic process. Film's intrinsic qualities as a medium rather than as a vehicle for narrative had been explored earlier in the century by artists such as Hans Richter and Man Ray. However, it was not until the turn of the 1960s, largely as a result of the advocacy and commitment of the Lithuanian-born critic and film-maker Jonas Mekas in New York, that the 'underground' films of figures such as Stan Brakhage, Bruce

Conner, and Andy Warhol came to represent an alliance between film and experimental practices in other artistic media. By the late 1960s the 'abstract' possibilities of the medium were being explored in the 'structuralist' films of the American Hollis Frampton and the Canadian-born Michael Snow. The latter was a friend of Serra, and his film *Wavelength* (1967), consisting of a continuous zoom through his apartment lasting 45 minutes, heavily affected the sculptor, who promoted it vigorously on a trip to Europe in 1969. This kind of cross-fertilization between artists, which further extended to Serra's friendship with the 'minimalist' composer Philip Glass, was typical of the times, paralleling a questioning of disciplinary boundaries that had been given impetus by Fluxus.

Bruce Nauman, based in Los Angeles, also turned to film (and videotape), although more as a means of recording a sequence of performances, carried out in the isolation of his studio, that examined sculptural, conceptual, and bodily interactions. In one he bounced two balls between the floor and ceiling of his studio. Another showed him walking, with hands clasped behind his neck, towards and away from the camera along an uncomfortably narrow 20-foot-long corridor. In a third he staked out the perimeter of a square marked on the floor with balletic steps dictated by a metronome's beat [**78**].

Nauman's interrogation of his bodily identity owed much to a heady cocktail of reading. Samuel Beckett and the *Gestalt* psychology and phenomenology that had affected Morris were formative influences. So was the philosophy of Wittgenstein, with its scepticism as to language's ability to broker between 'public' and 'private' systems of

meaning. In a sequence of sculptural objects, partly indebted to Duchamp, whose example for West Coast artists was particularly vivid after his retrospective in Pasedena in 1963, Nauman sent language's metaphorical and descriptive functions spinning into collision. Its role as name (and identity) was submitted to the principle of anamorphosis in a work consisting of neon tubing, *My Last Name Exaggerated Fourteen Times Vertically*, of 1967 [**79**]. Stretching out the implications of his signature with the detachment of a laboratory investigator Nauman succinctly articulated a male artist's self-alienation in direct counterpoint to what has been said about Hesse's or Bourgeois's ability to metaphoricize their bodies/identities within their objects.

Nauman's use of neon was not unprecedented. The Minimalist Dan Flavin was an obvious reference point. The Conceptualist Joseph Kosuth had also investigated Wittgensteinian tautologies regarding language and representation in neon works such as the self-descriptive, blue-lit *Five Words in Blue Neon* (1965). However, Nauman's ironic allusions to the numinous connotations of light put him more in line with European contemporaries such as the Italian *Arte Povera* artist Mario Merz, who revivified assemblages of mundane objects through the insertion of neon tubes. Neon also connotes the public dimension, via advertising, and in later works of the 1980s Nauman ironically brought it into proximity with 'private' erotic imagery. *Hanged Man* (1985) once again deals with male sexuality. Two overlapping neon circuits alternately flash on and off. One represents a live hanging

79 Bruce Nauman

My Last Name Exaggerated Fourteen Times Vertically, 1967

This relates to another work of 1968, *My Name As Though It Were Written on the Surface of the Moon*, also in neon. The latter, slightly more legibly, reads: 'bbbbbbrrrrrruuu uuucccccceeeeee'. It has been suggested that it may have been a response to photographs sent back to earth by five lunar orbiters launched by the US between 1966 and 1968.

stick-man with enormous limp phallus; the other depicts him hanged, with an erection. Such sadistic (or masochistic) allusions to games and torture, coupled with the theme of surveillance, would further dominate the video works Nauman produced in the late 1980s and 1990s.

It is clear that Nauman's cluster of body-related metaphors increasingly eluded a fixed artistic medium. More than Serra, therefore, his concerns in the late 1960s crossed over from sculpture into the spheres of Conceptual and Performance art, which will be discussed shortly. Modernist aesthetics had reached a cul-de-sac, compromising the expressive resources of sculpture and painting, whilst the logic of Morris's Minimalism pointed beyond traditional forms. Breathing-space had to be sought in less heavily colonized visual practices. This situation persisted until well into the 1970s, and sculptural metaphor, as investigated by the likes of Hesse and Bourgeois, would be revisited on the back of a return to figuration. This development can briefly be indicated by looking at British sculpture.

In the late 1960s Anti Form's main exponent in British sculpture, defying all that Caro stood for, had been Barry Flanagan, who produced quirky ensembles of rope and sand-filled hessian sacks. In the 1970s Richard Long kept post-Minimalist principles alive through his informal placement of stones or sticks in landscape locations. In an earlier work, *A Line Made for Walking* (1967), which was recorded in a photograph, he hardly intervened as a maker, simply treading a mark into a field. But these works ultimately embodied a romantic desire to escape aesthetic confinement. It was not until the end of the 1970s, in the work of a new generation of sculptors including Tony Cragg, Richard Deacon, Anish Kapoor, and Bill Woodrow, that the sculptural object as such, in relation to human or urban themes, reassumed importance.

This group came to prominence in a key exhibition of 1981, held in London and Bristol, entitled 'Objects and Sculptures', which paralleled contemporaneous exhibitions of painting signalling a new *Zeitgeist* (see Chapter 7). Their work varied considerably. Kapoor, an Indian-born artist, reflected something of Britain's ethnic diversity in the 1980s in exotically shaped moulded objects, placed on the floor and covered with brilliantly coloured chalk powder redolent of his country of origin. Cragg and Woodrow were drawn to the industrial landscape. The latter's *Twin Tub with Guitar* (1981) involved him cutting out and constructing a metal 'guitar' from a twin tub washing machine, to which it remained, umbilically, linked. In a form of post-Minimalist Surrealism, he instituted alliances between unrelated objects via an industrial/consumerist logic. Less taken with overtly social themes, Deacon evoked poetic associations between ears, eyes, and animal forms in open structures constructed from girders of laminated strips of wood. The 'skins' of his large shell-like structures were often visibly

patched together with materials such as sheet metal, corrugated iron, or linoleum [**80**]. This fusion of aesthetic form and metaphor would have been unthinkable without precedents such as Robert Morris or Eva Hesse. (Deacon frequently invoked Don Judd and Carl Andre.)

In the 1990s Rachel Whiteread was to carry out a more overt reassessment of the Minimalist inheritance in very different terms. Her casts of the negative spaces surrounding objects with strong human associations such as baths or bathroom sinks had a precursor in one of Bruce Nauman's enigmatic sculptures, *A Cast of the Space Under My Chair* (1966–8) However, Whiteread pushed the emotive connotations of casting through myriad variations of material and colour, registering the poignancy of the dialectic between presence and absence. Her remarkable *House* (1993) [**81**] was cast from the inside of a house in Bow, London, from which the exterior was subsequently peeled away. The house had been the sole survivor of a line of Victorian terraced houses, slated for demolition, which symbolized the last vestiges of a working-class community now dispersed among housing schemes. Although it had never been envisaged as a permanent fixture, Whiteread's ghostly monument to the former dwelling spoke eloquently of the erasure of human and social memory and aroused mixed but intense public controversy before its removal by the local council.

A loose connection exists between this case and the controversial demolition of an earlier site-specific sculpture, Richard Serra's *Tilted*

81 Rachel Whiteread
House, 1993

Rachel Whiteread's *House* revived a taste for outrage previously brought to the fore in Britain by the Tate Bricks saga. Before its completion in October 1993 it had attracted little press interest. In November of that year, however, a combination of Whiteread winning the Turner Prize and the decision by the Neighbourhood Councillors of Bow that the work should be demolished led to a massive dispute. Defenders of the work argued that an English taste for iconoclasm, dating back to the sacking of the monasteries, was being rekindled.

Arc (1981). In that instance Serra's 120-foot-wide steel-plate wall had been commissioned for a civic location on New York's Federal Plaza, a pedestrian area flanked by government offices. Serra's provocative intervention in the space, which compelled pedestrians to change direction and follow his sculpture's trajectory, led to a court case in which the government body that had commissioned the work secured its removal. The critic Douglas Crimp drew attention to aspects of the state's case against *Tilted Arc*, which claimed that it ran the risk of deflecting explosions onto government buildings opposite and impeded adequate surveillance of the area beyond. Such, he noted, were the state's expectations of the public.[28]

Two of the most challenging post-Minimalist sculptures sited in the public domain have thus been destroyed. Whilst public sculpture has taken diverse forms since the 1960s, in several American and European cities Claes Oldenburg's upscaled Pop icons, such as the 1976 *Clothespin* in Philadelphia, have displaced Henry Moore's reclining figures as the most acceptable compromises between civic aspiration and artistic avant-gardism. In the cases of Serra and Whiteread it appears that the metaphors left in play once Modernist aesthetics had been discredited proved too plainly redolent of the insecurities that social modernization, symbolized by the notoriously dysfunctional housing estates and soulless city centres of the 1960s and 1970s, had wrought in the social psyche. If Minimalism had once proved ambivalent about technology and state power, as argued earlier, it had engendered the metaphorical resources to question such monolithic principles.

The Death of the Object: The Move to Conceptualism

A curious photograph shows 'sandwichmen' walking through the streets of Paris [82]. They are bearing signboards displaying the stripe motifs of the French artist Daniel Buren. The image suggests directionless protest. Modernist abstraction had reached an impasse in the mid-1960s and Buren was one of many artists who felt that the entire 'framing' or institutional conditions for avant-garde art needed to be redefined. Buren's seemingly innocuous 'abstractions' were therefore part of a strategy. Inserted in various environments, the stripes would assert that, for all its vaunted aesthetic autonomy, Modernist art is defined by context. Paintings, especially Modernist ones, normally rely on the museum, or gallery, for their 'visibility'. Out on the streets of Paris such objects become vulnerable, invisible even. Or so Buren, envisaging the 'end of painting', hoped.[1]

The sandwichmen's impotent militancy was doubly ironic. The year was 1968, now fabled as a time of political dissent across Europe and America. Over the next few years artistic tendencies such as *Arte Povera*, Land Art, Conceptualism, and Performance Art interrogated not just aesthetic but social and cultural preconceptions. In dealing with them in this chapter, it makes sense to begin by examining a strand of politicized art linking the immediate post-1945 years to 1968 and its aftermath.

1968: political radicalism and counterculture

Although the artistic avant-garde was hardly central to the radicalism of 1968, it was certainly part of the foundations for it, particularly in France and neighbouring countries. In this respect the model of prewar Surrealism, with its international networks and Marxist commitments, was of key significance and its activist legacy needs to be plotted. From 1948 to 1951 certain artists sympathetic towards Surrealism's politics had joined forces as CoBrA, a name derived from fusing the opening letters of Copenhagen, Brussels, and Amsterdam, the cities where its members worked. This group included the Danish-born Asger Jorn, the Belgian Christian Dotremont, and the Dutch

82 Daniel Buren

Untitled, 1968

This is an early example of Buren's use of stripe motifs in a public context. He has continued the practice to the present. For instance, in 1997 in Munster, Germany, his contribution to a festival of site-specific sculpture consisted of lines of red-and-white-striped triangular 'flags' strung across the main streets of the town above the heads of pedestrians. The flags thus appeared to function as civic decoration. Whether this had the political bite of the earlier work shown in this photograph is questionable.

artists Karel Appel and Constant (Constant Anton Nieuwenhuys). Their output as painters relied heavily on the ealier 'automatism' of Surrealists such as Joan Miró, but what made them distinctive was a collectivist group dynamic which saw the establishment, for instance, of a commune in Bregnerod, outside Copenhagen, in 1948–9. For a brief interlude before the onset of the Cold War their ideals of communal free expression represented a utopian alternative to the heroic individualism of American Abstract Expressionism and the conformism of pro-Stalinist realism.

In France, Surrealism's idiosyncratic blending of revolutionary rhetoric and aesthetic innovation found its most spirited postwar echo in an incendiary movement called Lettrism, active from around 1950 and led by Isidore Isou, a self-promoting Messiah of radicalism. However, in many ways this movement's emphasis on anarchic fragmentations of language was closer to Dada, which had helped pioneer experimental typography and 'sound poetry' over 30 years earlier. Lettrism is perhaps best seen as an instance of countercultural provocation, a bridge between Dada and the youth cults of the 1960s and 1970s.

Lettrism's assaults on language linked it to another French movement, *Nouveau Réalisme* (see Chapter 3), and particularly to the practice of *décollage* developed by the likes of Raymond Hains and

Jacques de Villeglé. *Décollage* involved tearing sections from compacted layers of posters or billboard advertisements to bring about collisions of imagery and lettering. It could be seen as a symbolic form of urban vandalism, a declaration of solidarity with those anonymous authors of graffiti markings and defacings who had earlier inspired Brassai [10]. Implicit was a critique of the way public space was being rationalized to facilitate the passive consumption of advertising and other imagery by a mass audience. In this sense, its perpetrators were pledged to undermining the burgeoning culture industry soon to be celebrated by certain Pop artists.

Similar impulses percolated through various left-wing art formations and were finally given theoretical advocacy by a group integrating aesthetics and politics called the Situationist International, founded in 1957. The main theorist of that group was Guy Debord. Departing from the classical Marxist emphasis on the primacy of production, he argued that everyday life, with its alienating work routines and stultifying restrictions, needed to be interrogated as rigorously as class relations. Once again this placed him in the tradition of Surrealist thought.

The Situationists denounced the myths of social freedom and satisfaction promoted by forms like advertising, asserting that such representations merged into a monolithic 'spectacle'. (Debord's key book, published in 1967, was titled *The Society of the Spectacle*.) They devised two strategies for undermining its control. One was the playfully disruptive principle of *dérive* (drift), which might involve Situationists mapping alternative routes through the city in accordance

83 Asger Jorn

Le Canard Inquiétant, from *Modifications* series, 1959

Modifications such as this were only one aspect of Jorn's output. During his early CoBrA period he produced raw, expressionistic paintings bearing scrawled imagery relating to child art. The *Modifications* attest more clearly to his political beliefs. They recall, yet again, an aspect of Duchamp's practice—this time his 'adaptation' of the *Mona Lisa* (or rather a reproduction of it) via the incorporation of the letters 'L.H.O.O.Q'. However, despite the visual dislocations Jorn brought about, he implictly valorized the work of 'unknown' artists.

with their desires rather than civic prescriptions. The Surrealists had similarly followed the dictates of what they called 'objective chance'. The other, *détournement* (diversion), involved the rearrangement and derailing of existing routines and sign-systems. The latter principle informed works by two artist associates of the group, the Italian Giuseppe Pinot-Gallizio and Asger Jorn, formerly a member of CoBrA. Pinot-Gallizio hijacked the principle of the production line to create 'industrial paintings' by the yard. Jorn's *Modifications* consisted of scrawled interventions on banal second-hand oil paintings [**83**]. Celebrating kitsch, Jorn simultaneously revitalized hackneyed aesthetics. He wrote: 'Painting is Over. You might as well finish it off. Detourn. Long live Painting.'[2]

By 1962 Debord had steered Situationism away from its artistic alliances, although he himself had produced films and worked collaboratively with Jorn on experimental books. The aesthetic sphere was now disparaged as merely another branch of 'the spectacle'. Politics took centre stage and the group played some part in mobilizing the French student strikes in 1968, particularly at Nanterre University, where, aware of precedents in Germany and Italy and exasperated by poor conditions and an antiquated administration, the students first took militant action. In May their colleagues were to be joined by striking workers in bringing much of Paris to a standstill, forcing President de Gaulle's government to a point of crisis.

In these circumstances it is hardly surprising that art's very nature and underlying assumptions were questioned. Daniel Buren, whose stripes, borne by 'sandwichmen', opened this chapter, was part of international Conceptualism, an art movement then at its height. His stripes, standardized at a width of 8.7 cm and printed on varying surfaces, reflected its prioritization of idea over process, to say nothing

The late 1960s: counterculture and protest

The discontents of 1968 were by no means confined to students. Throughout Europe and America youth acquired an unprecedented sense of its own autonomy. The politically astute came to question the foundations of capitalist freedoms, whilst many flirted with psychedelia and non-Western cultural forms. America's involvement in Vietnam stimulated international solidarity in defiance of the strictures of politicians schooled in Cold War diplomacy. In his 1965 song *Subterranean Homesick Blues*, Bob Dylan had sung 'You don't need a weatherman to know which way the wind blows'* as activist groups, affiliated to the New Left, started springing up. These would include the Provos in Amsterdam and the Yippies in the US. Unity of purpose had been symbolized in October 1967 in a massive march on the Pentagon in Washington, when hippies placed flowers in the barrels of soldiers' guns. Increasingly open sexuality and the principle of play became political issues. Situationist ideas, fused with those of libertarian philosophers such as Herbert Marcuse, gradually entered popular consciousness.

* from *Bringing It All Back Home*

of its radical questioning of art's dependence on notions such as authorial origins and institutional placement. But Conceptualism was largely formalized in America and Britain and will be discussed in those contexts in due course. As a French artist, Buren was partly working in the tradition of Situationism, as he later confirmed.[3] One photograph shows one of his works on a billboard, partially obscuring a flyer relating to Nanterre's 1968 eruptions. In many respects he stands alongside two apparently different artists from mainland Europe whose outputs, however much they became annexed to Conceptualism, ultimately stemmed from European activist roots, although not specifically Situationist ones—Marcel Broodthaers and Hans Haacke.

Institutional critique: Broodthaers and Haacke

Marcel Broodthaers, based in Belgium, took up visual art in 1964 having previously been a poet. His relations to it were to be profoundly ambivalent. He had been involved in a spin-off group from CoBrA and the Belgian Communist Party in the 1940s and 1950s and was critical of the commercial motivations of much 1960s avant-gardism, particularly American Pop. For him the Marxist notion of 'reification' (the illusory sense that social relations or values are immutable, which extends to capitalism's implantation of abstract values in material goods) was art's defining principle. His characteristic works involved esoteric exposés of the arbitrary relationships between objects and signs, in the tradition of the Belgian Surrealist René Magritte's famous depiction of a pipe with the words 'This is not a Pipe' inscribed beneath. In 1965, for instance, he took two human femur bones, one male and one female, and painted them the colours of the Belgian and French flags respectively, obliquely commenting on the way national characteristics are thought, like gender, to be innate.

In 1968 Broodthaers participated in a sit-in by artists at the Palais des Beaux-Arts in Brussels. This inspired his most explicitly political project—a sardonic dismantling of the notion of the museum and its functions. It took place between 1968 and 1972 in a series of enigmatic events and installations manifesting different 'sections' of a fictitious museum. Possibly the most elaborate 'section', the 'Department of Eagles', displayed in the Kunsthalle in Düsseldorf in 1972, consisted of vitrines containing diverse representations of eagles, produced in art, craft, or commercial contexts and dating 'from the Oligocene to the present' [84]. The objects were accompanied by signs asserting 'This is not a work of art'. Acknowledging Magritte as well as Duchamp's readymades, the declarations implied that museums obscure the ideological functioning of images via the imposition of spurious value judgements or taxonomies. Eagles have often symbolized the transcendence of material reality but, like certain museum collections, they have also signified imperial might.

Whilst Broodthaers posed complex questions about cultural meaning, the German-born Hans Haacke revealed his socialist affiliations more unambiguously in his institutional interventions. Given the dramatic nature of America's Republican backlash in the immediate post-1968 period, it is not surprising that he carried these out in New York. The year 1968 had been a turning-point in left-wing hopes in America with the assassinations of Robert Kennedy and Martin Luther King. In Chicago Mayor Daley ordered brutal police reprisals against demonstrators protesting the pro-Vietnam position adopted by the Democratic Party. In 1970 President Nixon pushed on with the war, extending it to Cambodia. This time opposition was met with the killing and wounding of student demonstrators by the National Guard at Kent State University and Jackson State College. Haacke's response to all this was to install a visitors' poll as his contribution to an exhibition entitled 'Information' at New York's MOMA. It directly asked museum-goers whether they would vote for Nelson Rockefeller as Republican governor of New York State if he supported Nixon's military actions. The majority answered in the negative. Rockefeller was a prominent trustee of the museum.

American artists also targeted New York's museums. The Art Workers' Coalition, which Carl Andre helped to form in 1969,

mounted two anti-Vietnam demonstrations in MOMA, whilst in May 1970 Andre and Robert Morris headed an 'Art Strike' against the powerful Metropolitan Museum of Art, demanding that it close for one day to draw attention to recent atrocities. Although the museum resisted, other institutions supported the cause. Yet however much reactionary politics cemented international bonds among avant-gardists, it took a spate of intense wrangling between the combined forces of Haacke, Buren, and Broodthaers and America's art establishment to delineate ideological rifts most clearly.

The wrangling centred on the Solomon R. Guggenheim Museum. In 1971 it staged the sixth in a series of international exhibitions designed to demonstrate a liberal responsiveness to avant-garde developments. Daniel Buren was invited to exhibit. Part of his contribution consisted of a huge stripe painting hung from the skylight inside the building so that it plunged down the central well encircled by the famous spiral ramp of the gallery. It thereby drew attention to what Buren perceived to be the peculiarly coercive and mesmerizing effects of the architecture, which he felt diverted people's attention from the works on display. On this occasion it was necessary to compete with the museum itself to make his work 'visible'. In the event the Guggenheim's administration physically removed the work. This was ostensibly because it impeded the viewing of other site-specific work by American Minimalists, but given that New York's press had started to buzz with conservative fears about the anti-institutionalism condoned by liberal arts organizations, the museum probably simply used this as a pretext. Buren had touched a sensitive nerve.[4]

This was confirmed when Haacke's forthcoming exhibition was cancelled. It was to have included documentation that the artist had unearthed in the New York County Clerk's Office relating to the corrupt dealings of the Shapolsky family, slum landlords who owned large quantities of Manhattan real estate. Although Haacke's exhibition was subsequently shown elsewhere, its cancellation provoked Marcel Broodthaers to withdraw from a Guggenheim show of European artists in 1972 and to send an elliptical 'open letter' to fellow contributor Joseph Beuys criticizing him for continuing to participate.[5] In 1974 Haacke delivered a parting shot. He exhibited listings of the corporate and business interests of the Guggenheim Board and Trustees in a group exhibition held in the Stefanotty Gallery, New York. As with much of his future output, the interests underpinning art's supposedly 'neutral' institutions were systematically exposed in a dry, pseudo-bureaucratic presentational style. All in all, this amounted to open warfare. In the revealing words of the Guggenheim's director Thomas Messer, Haacke's Shapolsky project had represented 'an alien substance that had entered the art museum organism'.[6] Perhaps what was at stake was a 'return of the repressed'. The European refusal to separate art from poli-

tics was infiltrating the very networks which had once groomed Modernism for export.

The above narrative suggests that, whilst Surrealism has now become assimilated into the system it opposed, its activist postwar heirs have provoked significant moments of crisis. The art theorist Peter Bürger has been damning in his assessment of artistic radicalism since 1945, arguing that, whereas avant-gardes of the early twentieth century sought to dissolve distinctions between art as a specialized sphere and other areas of social life, postwar tendencies such as

American 'Neo-Dada' merely professionalized non-conformism,
turning the avant-garde itself into a social institution.[7] Buren,
Broodthaers, and Haacke at least modify this view.

A coda is provided by the work of the American Gordon Matta
Clark (the son of the Chilean Surrealist Roberto Matta), who carried
out quasi-Situationist incursions into the city's fabric up until his death
in 1978, literally cutting into and piercing condemned buildings. This
'anarchitecture' involved him, on one occasion, in slicing a building in
two halves, revealing, like an anatomist, the inner processes of one of
the 'suburban and urban boxes' that he deemed responsible for
'insuring a passive, isolated consumer' addicted to privacy and private
property [85].[8] There is no doubting what Matta Clark opposed, but
the alternatives were less clear. After the 'Prague Spring' had been
crushed by the Russians in late 1968, Communism looked more repres-
sive than capitalism. Chinese Maoism, although popular in the 1960s
with some leftist intellectuals, was similarly discredited.

In 1971 Matta Clark co-founded 'Food', a co-operative restaurant in
New York, as both an artwork and a social facility, anticipating the
personal and local politics of that decade. In line with the thought of
French post-Marxist thinkers such as Louis Althusser and Michel
Foucault, ideology increasingly came to be seen as all-pervasive, at
work in the very institutions in which human beings are socialized. As
left-inclined artists began to examine their assumptions about gender,
race, or ecology, there developed an increasingly nuanced sense of 'the
system' to which they were opposed. Political options seemed less
black and white.

Art into life: *Arte Povera*

Europeans like Buren and Haacke raised doubts about the liberalism of
New York's art establishment, but they worked within it, implicitly
accepting its central position in the art world. In Europe the pull of
American aesthetics continued to be resisted in certain quarters. In the
mid-1960s Italian artists who were to become grouped under the *Arte
Povera* (Poor Art) umbrella tended to regard Minimalism as narrowly
prescriptive. Anticipating the way Minimalism would itself open up
issues of context and 'anti-form' and looking back to the precedents set
in their own country by Lucio Fontana and Piero Manzoni, figures such
as Michelangelo Pistoletto and Jannis Kounellis set about challenging
their nation's tradition-bound view of aesthetics. Pistoletto produced
large, polished stainless-steel sheets which incorporated the reflections
of spectators within partially filled-in painted scenarios. (*Vietnam* of
1965 inserts the viewer between demonstrators carrying an anti-war
banner.) Kounellis's *Untitled* installation of 1967 featured a live macaw
sitting on a perch in front of a monochrome abstract painting, its
colours outstripping those of art.

86 Luciano Fabro

Italia d'oro (Golden Italy),
1971

Fabro made his first sculpture
in the *Italia* series in 1968.
Dozens of variations followed
in subsequent years. Another
theme established in 1968
was that of 'Feet'. This
involved the artist in
producing a series of bizarre
sculptural installations in
which large 'feet' or 'claws',
often in glass or polished
metal, functioned as the bases
for free-standing fabric
'stockings', frequently made of
silk. Fabro may have been
commenting obliquely on the
Italians' well-known
predilection for elegant and
expensive clothing.

In 1967 this trend was seized on by the critic Germano Celant, who codified it as *'Arte Povera'* in an exhibition in Genoa. He would subsequently promote it internationally. In prose bristling with vitalist metaphors, he argued for the distinctively heterogeneous, non-didactic nature of the new Italian art. The artist was seen as someone who 'mixes himself with the environment, camouflages himself ... enlarges his threshold of things' and who, unlike his over-theorized American counterparts (although that was not actually stated), 'draws from the substance of the natural event—that of the growth of a plant, the chemical reaction of a mineral ... the fall of a weight'.[9] In many ways the exemplar for this neo-Romantic construction was Joseph Beuys, and the German artist's symbolically energized fragments of stone and lumps of wax or metal would find their way into works by *Arte Povera*'s main practitioners: Pistoletto, Kounellis, Gilberto Zorio, Giovanni Anselmo, Mario Merz, and Luciano Fabro.

It is important, however, to see *Arte Povera* as reflecting a set of specifically Italian circumstances. Between 1967 and 1969 confrontations in Italy between students and police were far more numerous and violent than those in France. In late 1968 the chaos was compounded by protracted industrial disputes. Terrorist bombings by groups such as the Red Brigades punctuated the early 1970s. Amid such events *Arte Povera*'s forms gain a particular poignancy. Motifs and materials

connoting a rich cultural heritage were often juxtaposed with objects suggestive of social disparity or hardship. In his *Venus of the Rags* (1967), for instance, Pistoletto forced a classical statue into confrontation with an enormous mound of rags. A particularly suggestive image is Luciano Fabro's *Golden Italy* of 1971, one of a series of hanging sculptures representing a map of Italy hung upside down by its 'leg', like a carcass [**86**]. Industrial expansion in the wealthy north of Italy had seen mass migration from the poorer south in the 1960s, reinforcing the traditional polarization of the country's two halves. Fabro's work in gilded bronze seems, symbolically, to reverse regional fates.

Fabro's *Golden Italy*, with its suggestions of a transmutation from base matter into gold, has thematic links with Jannis Kounellis's alchemical imagery. This artist's desire to transform the material conditions of art would produce spectacular gestures such as the temporary housing of 12 live horses at the Galleria L'Attico in Rome in 1969 [**87**], but in other installations he used veiled alchemical allusions such as propane gas flames, setting up historical links with Klein and Beuys (see Chapter 3). Fabro's metaphorical reversal of his native land's 'fortunes' also suggests parallels with Mario Merz. The latter's 'igloos', dating from 1968, consisted of hemispherical metal-ribbed structures covered with materials ranging from broken glass or slate to branches. They evoked nomadic lifestyles, sustained by the land's basic resources. As such they embodied what Germano Celant described as a 'moment that tends towards deculturization, regression, primitiveness … towards elementary and spontaneous politics'.[10] Far removed from the

Marxist analyses of Haacke, they connoted a similar distrust of galleries and aesthetic confinement.

Primordial returns: Smithson, Land Art, and language

As already stated, many exponents of *Arte Povera* eyed American Minimalism with suspicion. However, one US artist schooled in Minimalist principles shared their concerns with organic meta-mophoses and the interrelations of landscape and history, namely Robert Smithson. As one of the first exponents of Land or Earth Art, he was committed to working with the spaces, materials, and fluctuating conditions of the physical world. In this he represented the apotheosis of all that the Modernist critic Michael Fried, with his warnings of art's surrender to 'theatricality', had feared.

Smithson had strong political motivations and, in line with Haacke or Buren, he talked in 1972 of wishing to explore the 'apparatus' he was 'threaded through'.[11] By this he meant the gallery system with its hunger for artistic 'commodities', but he saw this as merely an extension of the larger post-industrial phase of capitalism. Whilst he fell in with American sculpture's orientation towards 'anti-form' or process, in dialogue with Minimalism's fixed structures, his synoptic viewpoint prevented him from perceiving this as simply another aesthetic step 'forward'. If anything, it represented a move backward. Process for him was annexed to entropy, the principle whereby ordered systems undergo exponential deterioration or unravelling. Minimalism's geometries were thus placed under an ecological spotlight. In order to feed the needs of increasing consumer turnover, the industrial order that Minimalism had fetishized sanctioned the despoliation of more and more land. Smithson's response was to create impermanent earthworks in sites blighted by industrial waste, drawing attention to cyclical interactions of order and disorder. Reversing *Arte Povera*'s alchemical logic, he nurtured a vision of a return to base matter, a reassertion of nature's rights over man's.

His most famous work, *Spiral Jetty* (1970), embodies these entropic principles. It grew out of wasteland at the edge of the Great Salt Lake in Utah where unsuccessful attempts had been made to extract oil from tar deposits. At a cost of about 9,000 dollars, provided by New York's Dwan Gallery, a crew of workmen with trucks extended a strip of the mainland into the lake's pinkish water, forming a spiral measuring 1,500 by 15 feet. Photographs foster the impression that the structure still exists, but it is now submerged. In any case its location was never physically accessible to spectators.

This was a paradox which Smithson exploited. He underlined the fictive dimension of the piece by reconstituting it in various registers ranging from written and photographic documentation to a film [88]. The fact that spectators were obliged to reconstruct the piece conceptu-

ally opens onto a related aspect of Smithson's output, his punningly
titled 'non-sites'. These mainly consisted of metal bins containing
mineral samples which, when located in galleries, made available to
'sight' deposits from external 'sites'. This dialectic would be echoed by
the British land artist Richard Long, who, from the late 1960s onwards,
created geometrical formations from materials such as rocks, sticks, or
mud on gallery floors or displayed maps and photographs, inviting his
audience's imaginative reconstruction of his activities in the landscape.

In his 'non-sites' Smithson ironically situated his work at a midway
point between 'presence' and 'absence'. As information was given, so it
was drained away. The dissolution informing his practice was at times
virtually apocalyptic. He was a prolific writer, producing numerous
essays before his tragic death in a flying accident in 1973. In an account
in which he recalled the filmic ideas provoked *in situ* by *Spiral Jetty* he
described a sunstroke-induced vision: 'Following the spiral steps we
return to our origins, back to some pulpy protoplasm ... My eyes
became combustion chambers ... the sun vomited its corpuscular radia-
tions.'[12] This kind of atavistic regression on Smithson's part seems, as
with several previously discussed artists, to have direct resonances with
the thought of the French writer Georges Bataille. In an essay of 1930
entitled 'Sacrificial Mutilation and the Severed Ear of Vincent Van
Gogh' Bataille had talked of Van Gogh's insanity as bound up with an
obsession with staring at the sun. It is perhaps no coincidence that, as
part of his sun-blasted vision, Smithson fantasized 'Van Gogh with
his easel on some sun-baked lagoon.' Elsewhere this radical sense of

dissolution fed into a view of language as liable, like geological structures, to fissuring: 'Words and rocks contain a language that follows a syntax of splits and ruptures. Look at any word long enough and you will see it open up into a sea of faults, into a terrain of particles.'[13]

As will become clear later, Smithson's apprehension of the disjunctions between linguistic signifiers and their referents places him with Rauschenberg or Warhol, at a point of transition from a Modernist paradigm, predicated on aesthetic (and experiential) 'essences', to a 'postmodern' one. However, the importance he accorded to language also links him to contemporaneous Conceptualist trends and, more broadly, with the 'concrete' and performance poetry of the 1960s. 'Concrete poetry', involving explorations of the 'abstract' visual possibilities of language, had been pioneered in 1956 by the Swiss poet Eugen Gomringer and would be realized most fully in three-dimensional terms by the Scottish artist Ian Hamilton Finlay. In *Wave Rock* (1966) Finlay made palpable Smithson's disintegrative pairing of landscape and language. Sandblasted onto glass, words visually enact the principles of fixity, fluidity, and erosion to which they are semantically

90 Walter De Maria

Lightning Field, 1971–7
One of the ironies of the anti-market strategies of certain Land Artists was that to view their works other than via photographs spectators had to travel large distances. This could be costly, especially when specialized transport was required. Spectators of *Lightning Field* could observe the work from a log cabin located in suitable viewing range. But even then, of course, the work could not necessarily be guaranteed to 'perform'.

tied, whilst the fluctuations of light through the object reinforce the theme that is 'written' into it [**89**]. At this time 'sound poetry', with its roots in Dada and French Lettrism, was also being variously developed by the likes of Henri Chopin in France and Bob Cobbing in Britain. Such linkages help indicate how, at the end of the 1960s, artistic disciplines themselves were continually dissolving and merging.

Despite thematic parallels with Smithson, Ian Hamilton Finlay was to develop a very different mode of land-based art in 'Stonypath', the garden in Lanarkshire, Scotland, that he began in 1967 and continues to develop. At war with modern philistinism, Finlay looks back in his garden to both the iconography and the intellectual probity of French Revolutionary Neoclassicism, maintaining that 'certain gardens are described as retreats when they are really attacks'.[14] Although Finlay's garden incorporates disconcertingly modern conceits such as a stone bird-table in the form of a battleship, it is largely populated by allusive epigrams inscribed on buildings or stone tablets. In many respects it embodies the eighteenth-century principle of the 'picturesque', borrowing its construction of the 'pastoral' from paintings by Poussin or Claude Lorrain, with their classical 'follies' offset by open vistas and secluded copses. In eigh-

teenth-century aesthetics the 'picturesque' was routinely counter-posed to the notion of the 'sublime', which involved uncultivated nature being passively experienced as something overpowering and unfathomable. Since, as mentioned earlier, the 'sublime' had its place in Abstract Expressionism, it is not surprising to find it reappearing in the American Land Art of Smithson's contemporaries, providing a sharp contrast not only with Finlay, but with much British Land Art.

It should be noted first, though, that American Land Art differs from British variants simply in terms of the quantities of land available to it. One non-American artist who exploited this was the Bulgarian-born Christo. Associated with French *Nouveau Réalisme* in the 1960s, he subsequently became famous for collaborating with his wife Jeanne-Claude in the 'wrapping' of sites ranging from part of the coastline of Sydney, Australia (1969) to the Reichstag in Berlin (1995). In 1976 he produced *Running Fence*, in which he ran 18-foot-high sections of white fabric along metal runners that snaked for $24\frac{1}{2}$ miles along the north Californian landscape before plunging into the ocean in Marin County. The American artist Michael Heizer worked on a similar scale, supervising the removal of thousands of tons of earth in *Double Negative* (1969–70) to produce two 'cuts' facing each other across the chasm of the Mormon Mesa in Nevada. However, scale alone does not produce 'sublime' effects. The American Walter De Maria demonstrated what could be done with his *Lightning Field* of 1971–7 in which 400 stainless-steel poles were planted in an area of approximately one square mile near Quemado, New Mexico, a location noted for its high incidence of electric storms. De Maria thus coaxed these forces into 'completing' his work [**90**]. There is perhaps a sense, though, of a coercive appropriation of power, an enactment of fantasies which Smithson had resisted.

It is interesting to note finally that, as his contribution to the 1977 Documenta exhibition in Kassel, Germany, De Maria hired a Texan drilling rig to sink a metal rod (or rather 167 20-foot rods screwed together) into the earth to produce his *Vertical Earth Kilometer*. Afterwards the top of the rod, flush with the ground, was all that marked the spot. This might be said to invoke a kind of conceptual vertigo, a sense of the invisible 'sublime' in the tradition of Manzoni's *Line of Infinite Length*. However, its invasive, technocratic dimension was pointed up by the British performance artist Stuart Brisley, who had originally been allocated the site which De Maria occupied. Recapitulating previous instances of European artists' unease with America's aesthetic hegemony, Brisley excavated a pit nearby, living 'on site' in rudimentary fashion for two weeks. His digging yielded up bones and rubble from the Second World War. Meaning was elicited from below rather than imposed from above.

Dematerialization: Conceptual Art

Walter De Maria's *Vertical Earth Kilometer* typifies a conviction, pervasive by the mid-1970s, that thought was as much an artistic material as any other. Critics certainly perceived the 'conceptual' to be the dominant *Zeitgeist*. In her important chronicle of the period 1966–72, Lucy Lippard saw it as unifying practices such as Land Art and 'anti-form' in a wave of 'dematerialization', predicated on resistance to galleries and the market.[15] Wholesale applicability aside, the term 'Conceptual Art' had been specifically employed by the Fluxus artist Henry Flynt in 1961 and by Sol LeWitt (see Chapter 5). Its full ratification came, however, in an essay of 1969 by the American Joseph Kosuth entitled 'Art After Philosophy'. Here Kosuth identified Duchamp as a historical pivot. Art before him, he claimed, had been hampered by its physical embodiment. After the Duchampian readymade, advanced art's quest consisted in posing 'analytic propositions' as to what art might be. Its essential nature was therefore conceptual.[16]

Kosuth was making a bid to raise the theoretical stakes in the aftermath of Minimalism. He also took the opportunity to place himself, alongside the British artists Terry Atkinson and Michael Baldwin, as the first producer of authentically 'analytic' Conceptual Art in 1966. Certainly his *Art as Idea as Idea* series (1966–8), comprising photographically enlarged dictionary definitions of words such as 'meaning', were among the first works of the 1960s to assert a strict identity between verbal concept and artistic form. However, his reading of Duchamp was narrowly focused on the issue of nomination (the conferral of art status). It might be argued that, in reducing artworks to tautologies (self-definitions), he was simply reiterating a Modernist credo of formal autonomy. Conceptual purity now stood in for optical refinement.[17] He thus ignored questions of art's relations to spectators, institutions, or dominant modes of production that had led to a more politicized post-Duchamp sensibility elsewhere. As will be shown, it was not until the early to mid-1970s that Anglo-American Conceptualism fully caught up with the political mood of 1968.

This should not detract from the uncompromising nature of many of the 'propositions', whether strictly analytic or not, generated by late 1960s American Conceptualists. The dethroning of the art object bred a kind of puritan iconophobia. Written declarations or documentary information were offered to audiences in lieu of sensual pleasures. Lawrence Weiner's short statements gave open-ended instructions for sculptures that did not require actual realization; 'A square removed from a rug in use' (1969) is one example. In certain instances, literal 'dematerialization' was practised. Douglas Huebler announced, in the catalogue to an exhibition curated by Seth Siegelaub to be discussed below, that since the world was full of objects, to which he pointed his audience using maps and diagrams, he would not add more. The same

year John Baldessari's *Cremation Piece* (1969) declared that the artist had 'cremated' his accumulated art production, adding the assurance that he felt better for it, and Robert Barry sent out announcement cards to the effect that 'March 10 through March 21 the Gallery will be closed'.

Questions naturally arose about how such recalcitrant gestures should be distributed. Dan Graham's strategy of placing his art productions in commercial magazines such as *Harper's Bazaar* offered an important exemplar. In *Homes for America* (1966)—inserted in *Arts* magazine—he produced a documentary-style survey of postwar housing, which at the same time could be read as an oblique reflection on aesthetic (Minimalist) standardization and its social corollaries. Publications increasingly became outlets for conceptual proposals. Seth Siegelaub's key curatorial venture in New York, 'January 5–31 1969', consisted simply of a catalogue which gallery-goers were invited to read. As far as the critic Lucy Lippard was concerned, such modes of dissemination gave art an unprecedented fluidity. She extended this to artists themselves. No longer reliant on 'belated circulating exhibitions', they could carry their wares in their heads or pockets. With improved transcontinental travel, this provided a way of 'getting the power structure out of New York'.[18] An international art community based on the free exchange of ideas fleetingly emerged. As with Fluxus (see Chapter 4), satellites to New York such as Art & Language in Britain or Jan Dibbets in Holland established themselves, although Conceptualism had broader repercussions, with strongholds becoming established in Latin America, Japan, and Australia. However, by the early 1970s it was becoming clear that the markets had caught up. Robert Barry, seemingly the least recouperable artist, found his ephemera being collected by Herbert and Dorothy Vogel in New York.[19] Similarly, Conceptualism became museum art. Harold Szeeman's innovatory exhibition 'When Attitude Becomes Form' at the Kunsthalle, Berne, in March–April 1969 began a process which was further consolidated by 'Information' at MOMA, New York, in 1970 and 'The New Art' at London's Hayward Gallery in 1972.

Much as Conceptualists railed against such assimilation, they were curiously attracted to bureaucratic language. The redundant aesthetic formulas of Modernism were transformed into a babble of systems and statistics. On 4 January 1966, for instance, the Japanese-born On Kawara started to produce 'date paintings' on an almost daily basis. As tokens of his continuing existence they took the day's date as their subject-matter [**91**]. He also produced a ten-volume book which listed one million years counting back from 1971, the year it was produced.

The case of the British Art & Language group is particularly interesting in relation to this tendency. Its founding members Terry Atkinson, Michael Baldwin, David Bainbridge, and Harold Hurrell

felt that the increasingly discursive nature of art obviated the need to produce objects. Theory about art could in itself be considered art. They therefore produced a journal, *Art-Language*, first published in 1968, which set about dismantling Modernist rhetoric. Its vocabulary was perversely obscure in order to resist cultural commodification and to test the 'competencies' of readers rendered intellectually flabby by a surfeit of 'opticality'. But to whom exactly was it addressed? An air of intellectual sanctimony clung to it. Information theory was newly in vogue around this time and avant-garde art naturally experimented with its idioms. In the summer of 1968, while Paris was witnessing the return of barricades, the ICA gallery in London put on a show entitled 'Cybernetic Serendipity' which explored computer applications within the arts. The year 1972 saw Art & Language, now expanded to include a New York contingent, install a computational system of sorts entitled *Index or* as their contribution to the Kassel Documenta exhibition. It consisted of eight metal filing cabinets on four grey blocks surrounded by walls papered with an index. Spectators were invited to cross-reference some 350 texts assembled by group members to detemine levels of logical congruence or discrepancy. They thus participated in the group's sifting of ideological cant.

It could be argued that *Index or* was insufficiently ironic in its replication of the structures of state administration. The art historian Benjamin Buchloh has detected a kind of double-think at work in such projects. Whatever their working-class roots and Marxist sympathies, he argues that artists such as Art & Language were unwittingly establishing their radical kudos using the signifiers of the (middle) managerial class to which they had in fact acceded.[20] On the alternative view, as cultural producers Art & Language dissolved their status as individual artist-geniuses in a model of collectivity, while radicalizing an audience habituated to passive contemplation.[21] In the latter respect Art & Language were particularly influential in placing theory on the agenda in Britain's notoriously conservative art schools, having pioneered a controversial course at Lanchester Polytechnic, Coventry, in 1969–71. From this point on, few self-respecting art tutors or students could persist in seeing art as unmediated expression.

The rise of semiotics: Burgin and Conceptualism

Other British Conceptualists saw Art & Language's allegiance to analytic philosophical procedures as verging, like Kosuth, on covert formalism. Victor Burgin in particular saw photography as a means to a more productive social engagement. He was aided in this by the French writer Roland Barthes's *Elements of Semiology*, published in English in 1967. Barthes's contribution to literary theory had partly consisted in adapting the findings of the Swiss linguist Ferdinand de Saussure whereby, in language, the relation between 'signifier' (word or

What does possession mean to you?

7% of our population own 84% of our wealth

The Economist, 15 January, 1966

utterance) and 'signified' (the thing to which it refers) is shown to be fundamentally arbitrary. To give a simple illustration, 'cat' refers to a feline animal in so far as it differs from 'bat'. Meaning is constituted via a shuffling of available linguistic components. It is in no sense innate in things, but 'constructed'. This means that it can also be permeated by changing ideologies. In one essay, Barthes analysed a photograph of a black soldier apparently saluting the French flag. Beyond signifying patriotism, he saw it as encoding a second order of signification arising from its placement on the cover of the conservative magazine *Paris Match*. In this context it connoted 'imperialism', reassuringly implying black assent to French rule at a time when the Algerian conflict had destabilized France's colonial position.[22]

The assimilation of such ideas led to an easing of the Conceptualist embargo on visual imagery, and 'representations' now stood to be investigated as repositories of social information. In this respect, Burgin partly conceived his role in educational terms. Along with theorists from disciplines such as film studies and sociology, he helped pioneer 'cultural studies' as an alternative to 'art history' in British polytechnics. The prevailing assumption was that 'Fine Art' productions were no more worthy of analysis than other cultural artefacts. Burgin gave such principles practical emodiment. *Possession* of 1976 [92] was a mock advertisement, produced in an edition of 500 and fly-posted around Newcastle-upon-Tyne. It deftly redeployed the genre's linguistic and photographic tropes to show how the longing for 'possession', on which advertising plays, assumes incompatible economic and gender relations.

For Burgin, then, photography was primarily a social sign system whose operations needed to be 'exposed'. This attitude was shared by the Californian Conceptualist John Baldessari, who, having gradually moved from text- to photo-based work through the 1970s, produced photo-assemblages in the mid-1980s which disrupted the integrity of photographic space or narrative by recombining or reshaping images from sources such as films or newspapers, deleting areas, and adding colour overlays. Such active inroads into visual currency echo the Situationist-style institutional interventions that were discussed earlier. Baldessari was not overtly political, but other Conceptualists based in California in the early 1970s, such as Martha Rosler and Allan Sekula, eventually embarked on stringent critiques of photographic reportage conventions from a left-wing standpoint. Burgin's practice

Photography and Conceptualism

Conceptualism provided photography with a long-sought-after centrality within 'Fine Art', but privileged its normally downgraded 'amateur' or 'documentary' modes over its 'pictorialist' attempts to appear 'arty'. The German artists Bernd and Hilla Becher thus utilized a 'documentary' look in their suites of photographs of industrial building such as blast furnaces, mine-heads, or cooling towers [93], unifying individual types within classes via a standardized frontal presentation and low horizon line. They appeared to be creating pseudo-scientific taxonomies in a specifically German photographic tradition extending back to August Sander. However, their play on variations within a category also suggests a parody of the Minimalist interplay between the 'known constant' and the 'experienced variable' (see Chapter 5).

The Bechers were to have an enormous impact on German photographers such as Thomas Ruff, who, in the late 1980s, subtly nudged their 'documentary' idiom back towards 'pictorialism'. In this way Conceptualism channelled its iconophobia (its disdain for the insistent visual/authorial 'presence' in much Modernist art) back into forms which, while being powerfully 'visual' once more, could nevertheless invoke photography's claims to social 'transparency'. As will be seen, Jeff Wall's work, in particular, consolidated this tendency in the late 1980s [124].

93 Bernd and Hilla Becher

Typology of Water Towers
(one of six suites of nine
photographs), 1972

The Bechers' photographs of
industrial structures, which
they began in 1959, belong to
the genres of documentary
photography, sculpture, and
industrial archaeology
simultaneously, as well as
having status as Conceptual
Art. Although resolutely sober
in format, the suites of images
often contain a surprising
humour. Standing next to their
peers, unpromising industrial
structures acquire distinct
'personalities'.

should also be seen as broadly informed by the trades union militancy
in Britain in the period 1970–4. Given this climate of left-wing
activism, one notable feature of *Possession* was its author's unusual
embrace of mass distribution (although Dan Graham's earlier *Homes
for America* could also be recalled). In terms of Conceptualism's overall
trajectory, Burgin was effectively rematerializing art in public space
after Daniel Buren had symbolically dissolved it [**82**]. Ironically his
mock adertisement's unmasking of societal mechanisms remained
similarly 'invisible' given that, in a survey, only one person in seven
claimed to understand it.[23]

Burgin came to feel in the late 1970s that works such as *Possession*
failed because they assumed that it was possible to speak ironically
from a vantage point that was 'outside' ideology. In line with Barthes's
doctrine of the demise of the author, he came to perceive the author-
position not so much as stable, a fount of social insight, as constituted
out of a plurality of socially determined assumptions. This point of
view led him, in the late 1970s, to explore his own gender position in
works which double back on their dominant 'masculinist' cultural
viewpoint. However, in acknowledging the socializing and encultur-
ating 'voices' that both formed and informed his practice, Burgin
implicitly posited an audience willing to make an investment in
reconstituting his role as 'author'. This paradox persisted through
much of the full-blown 'postmodernist' art production that Burgin's
work presaged.

Gender positions: feminism and art

Victor Burgin's male self-questioning paralleled the rise of radical
feminism. As the 1970s progressed, women powerfully contested the
cultural stereotypes attached to traditional childbearing or domestic
roles. In many ways Burgin's work responded to that of Mary Kelly, an
American artist based in Britain, whose work systematically used
Conceptualist devices to probe the social foundations of gender condi-
tioning. However, Kelly's work departed significantly from overtly
separatist feminist practices. These, as exemplified by the Californian
Judy Chicago, celebrated the rediscovery of an essential 'feminine'
consciousness. To understand first what Chicago stood for it is worth
examining *The Dinner Party* [**94**].

This enormous installation, which drew record crowds when first
exhibited at San Francisco's Museum of Modern Art in 1979, consisted
of a triangular table with places set with ceramic vulvas and embroi-
dered 'runners' for 39 imaginary female guests. These, along with 999
additional female invitees, whose names were written on floor tiles as
part of the installation, were mainly artists and writers from the past.
The work had two central functions. It rehabilitated talents overlooked
or disparaged in male-oriented constructions of history, tying in with a

reorientation of art history in the 1970s associated with writers such as Linda Nochlin in America and Griselda Pollock in Britain. At the same time its emphasis on 'applied arts' productions drew attention to women's frequently anonymous cultural participation, questioning aesthetic hierarchies.

Male critics responded rather predictably. Robert Hughes, for instance, described the work as 'mainly cliché … with colours worthy of a Taiwanese souvenir factory'.[24] The point was that decorative excess, bordering on kitsch, was being deliberately flaunted in the face of a renunciative 'masculinist' modernism. 'Sisterhood' replaced the image of the alienated male outsider. Along with the artist Miriam Schapiro, Chicago set up a Feminist Art Program at the University of California in 1971, which led to 'Womanhouse', a collaborative project in which teachers and students occupied an abandoned house, creating environmental works exploring domestic creativity. At the same time artists such as Faith Ringgold, a black American whose feminism was also informed by racial marginalization, contributed to the continuity of folk practices such as quilt-making. However, it should be noted that, although *The Dinner Party* was realized with the aid of numerous helpers, Chicago retained sole authorship of it. She diligently displayed her co-workers' names, but kept certain hierarchies in place.

A controversial aspect of the work was its vulvic iconography. This was part of a genre of 'central-core' imagery, promoted by critics such as Lucy Lippard, which aimed to dislodge the cultural primacy of the phallus, rehabilitating the sign of women's biological 'lack' (to invoke Freud's discredited terms) as the symbol of their creativity. The work possibly echoes Louise Bourgeois's cannabilistic installation *Destruction of the Father*, discussed in Chapter 5, which was shown in New York in 1974, the year *The Dinner Party* was begun. But there is a sense in which Chicago turns Bourgeois's symbolic consumption of the patriarch into celebratory female self-consumption, which clearly has erotic undercurrents. The nature of the work's address thus becomes ambiguous. Indeed, many women found it reductive, implicitly returning them to biology.

This was certainly Mary Kelly's view. Her *Post-Partum Document*, produced between 1973 and 1979, was concerned with recording her relationship with her son during his weaning, but pointedly renounced corporeal imagery in favour of 135 framed items such as diagrams, texts, and traces from the body (faecal smears on nappy liners) [95]. Polemically countering the 'essentialist' view that gender is biologically determined, *Post-Partum Document* grew out of Kelly's participation in a London women's group dedicated to examining the sexual division of labour. With child-rearing as her theme, she became deeply affected by Juliet Mitchell's book *Psychoanalysis and*

Feminism (1974), which introduced English speakers to post-Freudian accounts of the dawning of gendered subjectivity. Most influentially it explained how the French psychoanalyst Jacques Lacan had reinterpreted Freud's unconscious 'rite of passage', the Oedipus complex, as allegorizing the unequal accession of boys and girls to patriarchal language. He had thus made socializing forces of Freud's notorious anatomical markers of sexual identity—penile 'possession' and 'lack'. The phallus became symbolic rather than literal. Using such ideas, Kelly produced a painstaking record of maternal separation. After a pre-Oedipal phase during which mother and child were united, her son's linguistic initiation gave him a 'positive' relation to the phallus while she was returned to the condition of 'lack' originally inscribed by her gender.

Kelly's work brilliantly tracked gender's linguistic basis. One of the six sections of the work records early 'conversations' between mother and child. Shown his own reflection in the mirror, the child introjects the paternal position: 'da/da-/da-da'. Elsewhere the work raises fascinating questions about the relation between creativity and procreativity. Interrogating the psychoanalytic platitude that, in raising babies, women compensate for their phallic lack, Kelly hypothesized a form of female fetishism, turning her child's imprints, clothes, or gifts into compensatory tokens which were exhibited in taxonomic style. These fetishes asserted that, far from succumbing to imaginary identifications, women could attain symbolic distance from procreation, becoming cultural as well as natural producers.

Apart from provoking feminist objections that it capitulated to male-centred theory, Kelly's work was considered dauntingly abstruse. Her defenders appealed to the Brechtian ideas promoted in Britain in the 1970s by *Screen*, a politicized journal dedicated to film theory. In the 1930s Bertold Brecht had mounted Marxist arguments for an anti-realist art which, rather than 'naturalizing' societal norms, which were profoundly 'unnatural', made its audience conscious of its devices.[25] However the Kelly-inspired 'scripto-visual' art that followed such precepts, showcased most prominently in the exhibition 'Difference: On Representation and Sexuality' at New York's New Museum of Contemporary Art in 1984, could be seen as having a moralizing undercurrent. Visual pleasure, associatively linked to a world where men traditionally did the looking whilst women's bodies were 'objectified', was considered suspect.[26] This 'politically correct' attitude tied in with Kelly's moritorium on bodily depictions.

A broader undermining of 'humanist' content in late 1970s art was fuelled by English translations of writings by the French post-Structuralist philosopher Jacques Derrida.[27] Derrida saw a 'metaphysics of presence' as endemic to Western thought. His 'deconstructive' strategy, aimed at eroding the bourgeois certainties bound up with this,

consisted in revealing how the self-sufficiency (and authority) of many concepts is illusory. In defining themselves against their opposites, concepts often contain residues of what they refute. Meanings are never stable, but in continual 'slippage'. The notion of 'presence' in itself provides a good candidate for deconstruction, since 'presence', in defining itself against 'absence', admits to a lack (in this sense 'lack' inheres in all human subjectivity). In line with these ideas, Kelly's work, like that of Victor Burgin, turned the author into a phantom-like entity, never fully available to the viewer. At the same time, functioning as Burgin did in a critical capacity, she argued against the reliance on 'presence', now deemed symptomatically 'modernist', in 1970s Body Art.

95 Mary Kelly

Post-Partum Document: from Documentation 1: Analysed Faecal Stains and Feeding Charts, 1974

One of the oldest themes of Western art, mother and child, was ironically made compatible with Conceptualism's iconophobia in Kelly's complex, multi-part work. As in Duchamp's *Large Glass*, the textual component of the work was of equal importance to its visual appearance. In this respect, Kelly's book, *Post-Partum Document* (London, 1983) is an indispensable resource for appreciating the work.

Questions of 'presence': Body Art and Performance

The concept of Body Art, which had first been articulated (as 'body work') in an article of 1970 by the critic Willoughby Sharp,[28] ostensibly designated a genre of live performance, following modes established by precursors such as Yves Klein or the Fluxus performers, in which artists used their bodies as their materials [**51**]. Mary Kelly asserted that such apparently radical activities compensated audiences for the dematerialization being practised elsewhere. The comforts of artistic 'presence' were provided in abundance, she argued, however transient the context.[29] In effect, the form relied, like Land Art, on photographic mediation. Examples range from Bruce Nauman's recordings of his audience-less 'performances' [**78**] to the films in which the German artist Rebecca Horn investigates the possibilities of peculiar body extensions, cross-fertilizing nineteenth-century medical prosthetics with the nursery terrors of Heinrich Hoffmann's *Struwwelpeter* [**96**]. However, even in photographic form, Kelly felt that the literal

96 Rebecca Horn

Scratching Both Walls at Once, 1974–5

Rebecca Horn's early performances involved her strapping surreal prostheses to her body or wearing elaborate costumes. The allusions to fairy tale and myth were unmistakable but rarely specfic. Since then she has produced a wide range of poetically charged sculptures and installations. In certain of them, groups of everyday objects such as stilletto shoes or binoculars, attached to gallery walls by prongs or hung from wires, are set in spasmodic motion.

presence of the artist heralded a newly 'auratic', and commodifiable, art. Whatever the truth of this, it could be argued that photographic documentation, precisely by being 'after the fact', dramatized the insufficiency of the sense of 'presence' that performance was able to summon up both for artists and their audiences. As a genre, performance oscillated between being experientially 'available' and poignantly 'lacking'. It therefore placed identity in a Derridean 'gap'.

An interesting instance of this involves Rudolf Schwarzkogler, an artist linked with one of the earliest groups of 'body artists', the Viennese Actionists. Aiming to unblock the repressed emotions underlying Austria's post-Fascist amnesia, the Actionists owed much to the influential doctrines of the French Surrealist Antonin Artaud's *The Theatre and its Double* (1964) in which he had called for a cathartic theatre, overcoming the form's past reliance on text through ritualistic gestures and vocal exertions (Derrida naturally saw this as haunted by a nostalgia for 'presence').[30] From late 1962 onwards the group's key members, Herman Nitsch, Günter Brus, and Otto Mühl, staged Dionysian ceremonies which frequently involved disembowelling animal cadavers. Schwarzkogler, however, mainly appeared in harrowing photographs, notably ones which apparently showed him bandaged in the aftermath of a self-castration. It is clear now that such scenarios were contrived. Schwarzkogler mocked up his experiential agonies with a collaborator's body as his stand-in.

Kelly's worries about Body Art mainly derived from masochistic or

narcissistic female versions, where women could be seen as unwittingly submitting to patriarchal oppression or courting male 'objectification'. In the case of the Paris-based Gina Pane, who inflicted wounds on her body, turning it into an emblem of suffering, such concerns may have been justified. However, in that of the American Hannah Wilke, who defied what she termed 'Fascist Feminism' by posing in photographs according to media stereotypes of desirable femininity, it may be that she was parodically 'acting out' femininity as a form of masquerade, exposing the artifice of gender.[31] Such strategies rendered objectification impotent, bereft of a suitably passive 'object'. Adrian Piper, an African-American artist, addressed interpersonal social assumptions from a different angle, dressing up as a man in her *Mythic Being* performances of 1975 in order to explore, in the course of walking New York's streets, how black males were themselves made into objects of racism. The distortions of self-image brought on through racial stereotyping were pointedly expressed in a self-portrait by Piper of 1981 [**97**].

97 Adrian Piper

Self Portrait Exaggerating My Negroid Features, 1981

As an African-American who is able to pass as 'white', Piper has written eloquently of the social and institutional prejudices that surface when she divulges her racially mixed identity. In a text entitled 'Flying' of 1987 she wrote: 'I am the racist's nightmare ... I represent the loathsome possibility that everyone is "tainted" by black ancestry. If someone can look like me and sound like me who is unimpeachably white?' (quoted in *Adrian Piper*, Ikon Gallery, Birmingham, 1991, p. 26).

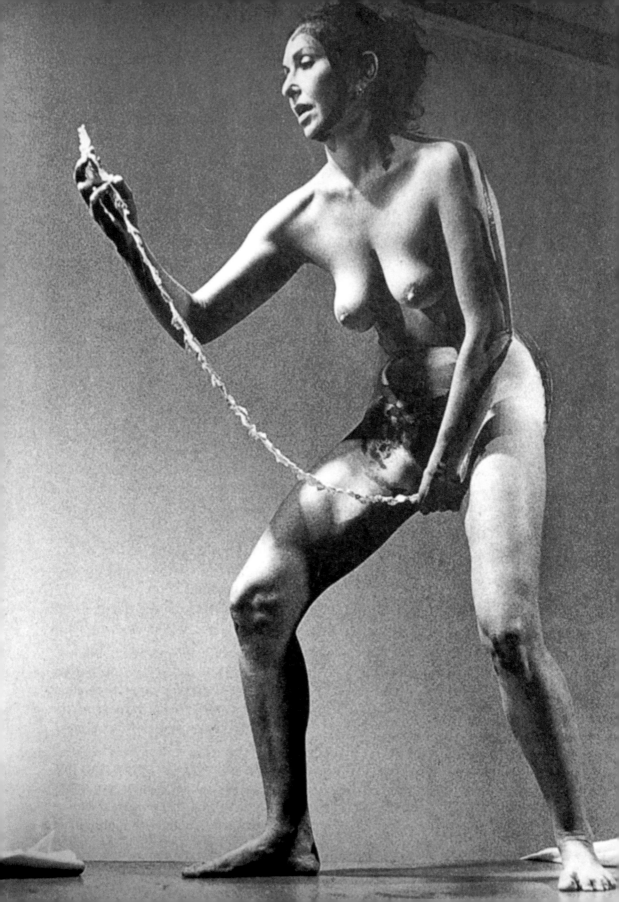

Carolee Schneemann, an American artist whose 1960s performances such as *Meat Joy* (1964) had contributed decisively to the translation of 'action painting' into performance terms, developed an aesthetic out of the active as opposed to the passive female body. Her *Interior Scroll* [**98**], first performed in Long Island, New York, in 1975, involved her standing before an audience and gradually unravelling a scroll from her vagina. From this she read a parodic account of a meeting with a 'structuralist film maker' who had criticized her films for their 'personal clutter' and 'persistence of feelings'.[32] In a sense Schneeman's performance dealt with the internalization of criticism, but it could also be aligned with an 'essentialist' feminist interest in *écriture feminine* (female writing). This form of French feminist theory, espoused by writers such as Hélène Cixous, posited female access to a pre-Oedipal (hence implicitly anti-patriarchal) 'language' of bodily pulsations. The painter Nancy Spero produced a number of frieze-like paintings on paper bound up with this notion in the 1970s, alternating texts connotative of both 'male' and 'female' speech with repeated printed motifs of the female goddess figures who were being re-discovered by feminists. Other artists actively used bodily secretions or traces in the manner suggested, although not strictly accomplished, by Shigeko Kubota [**51**]. The Cuban-born Ana Mendieta, working in America, produced earthworkings (titled *Siluetas*) which poignantly suggested the imprint of her body on the landscape. The author's simultaneous 'presence' and 'absence' was again at issue.

Turning to Body Art by male practitioners, a prevalence of masochistic ordeals demonstrated that, at least by virtue of feeling pain, their authors most definitely existed. The Californian Chris Burden performed a number of carefully planned but self-endangering actions. In *Shoot*, performed at 'F-Space' gallery, Santa Ana, California, in 1971, he arranged for a male friend to shoot him, sustaining a deep arm wound. The New-York-based poet Vito Acconci produced less aggressive works. His *Step Piece*, performed for month-long periods in 1970, saw him stepping on and off a stool daily at the rate of 30 steps a minute for as long as he could manage. His progress was duly recorded [**99**]. Comparing male 'body works' with those by women, men often pitted themselves against themselves, metaphorically testing social expectations of invulnerability, whilst women challenged cultural conditioning head on, becoming active rather than passive.

A notorious work by Acconci reflects a gradual blurring of fixed gender positions. *Seedbed* (1972) involved Acconci masturbating under a ramp in a gallery. As he imagined his audience, his groans were relayed into their space by loudspeakers. Invisibly dominating the gallery space while simultaneously being (pleasurably) 'walked over', Acconci set up a fascinating interplay of empowerment and masochism, ironizing the dynamics of his 'masculine' creativity and control.

99 Vito Acconci

Step Piece, 1970

Acconci's rudimentary early pieces often involved him in exploring interpersonal relations or communication. In *Proximity Piece*, performed at the Jewish Museum, New York, in 1970, he moved from room to room in an exhibition, sidling uncomfortably close to the spectators so that they were obliged to move away. *Prying* of 1971 saw him attempting to prise open the eyes of his co-performer Kathy Dillon as she kept them tightly shut.

STEP PIECE (STEPS: STEPPING-OFF PLACE)
Apartment 6B, 102 Christopher Street,
New York City
1970
Activity/Performance
4 months (February, April, July, November);
varying times each day

An 18-inch stool is set up in my apartment and used as a step.

Each morning, during the designated months, I step up and down the stool at the rate of 30 steps a minute. Each day, I step up and down until I can't go on and I'm forced to stop.

Improvement, and the ability to sustain improvement, is put to the test: after the first month's activity, there's a one-month lay-off, then a two-month lay-off, then a three-month lay-off.

(*Announcements are sent out, inviting the public to come see the activity, in my apartment, any day during the designated months. At the end of each month's activity, a progress-report is sent out to the public.*)

100 Gilbert and George

The Alcoholic, 1978

Gilbert and George's presence in their photo-works can be seen as an extension of their early performance activities. They often stand apart from the other imagery in the pieces as though acknowledging the artifice involved. Moral conundrums are frequently raised. *The Alcoholic* seems essentially compassionate but in one notorious work, '*Paki*' of 1978, they flanked a young Asian man. Their images were flooded in red whilst he remained in black and white. Whether they were guardians or oppressors seemed unclear.

Works by male American 'body artists' rarely made overt social reference. Burden's performances can now be interpreted as mapping the brutalization of the social body onto the private one, but actual parallels with politically motivated instances of self-immolation, such as that of Jan Pallak in Prague in 1968, are tenuous. Social responsiveness was more the province of the British performance artist Stuart Brisley. His *10 Days*, first performed in Berlin between 21 and 30 December 1972, involved the artist sitting at a table daily at meal times and being served with food which he refused. The food was left on the table to rot. On the tenth day he crawled the length of the table through the debris, before presenting his 'new self' at a banquet for friends. Although no 'explanation' was offered, the event's response to Christmas festivities seemed pointed when Third World famine was constantly in the news.

By contrast, Gilbert and George, whose symbiotic partnership began in 1967 at London's St Martin's School of Art, showed a dandyish irresolution towards social protest. Their famous *Singing Sculpture* (1969) was riven with contradictions. Wearing anachronistic

suits, they posed as 'Living Sculptures' with a table as their 'pedestal'. Their gold-painted faces echoed Joseph Beuys's earler performance persona, but they had nothing of his shamanic idealism. As they circled robotically to the music-hall nostalgia of a recording of Flanagan and Allen's *Underneath the Arches*, they appeared to annex the dreamy resignation of its tramps to the futility of the characters in Samuel Beckett's influential play *Waiting for Godot*. In the mid-1970s, they began the sequence of large, multi-panelled photo-installations which continue to the present. Appearing in their works as besuited witnesses of social deprivation and intolerance, they seemed like donors in secular altarpieces or Victorian philanthopists visiting hell [**100**]. Like Warhol, they were *flâneurs* of a kind but lacked 'street credibility' and seemed unsure how to maintain social distance. In the 1980s this led to strange visual conjunctions. Homoerotic, religious, and nationalistic iconographies rubbed shoulders uneasily.

Another British artist trained at St Martin's, Bruce McLean, explored sartorial concerns in a more theatrical mode. Between 1971 and 1974 he and several friends presented themselves as 'Nice Style', the 'World's First Pose Band', a group dedicated to parodying the posing of rock stars. An obvious self-consciousness about the artificiality of performance, as filtered through mass media channels, was apparent. By contrast, the self-styled Genesis P-Orridge from Manchester participated, albeit warily, in Britain's late 1970s Punk Rock scene with his four-piece, electronically oriented band Throbbing Gristle. P-Orridge, along with his girlfriend Cosey Fanni Tutti, had mounted a provocative exhibition under the enigmatic 'Coum Transmissions' banner at London's ICA in 1976. Titled 'Prostitution', it included bloodied tampons and images of Tutti posing in pornographic magazines. Press outrage, in the wake of the 'Tate Bricks' scandal earlier that year (see Chapter 5), inevitably followed. Between 1975 and 1981 the lyrics accompanying Throbbing Gristle's pounding, discordant music further investigated unsettling and taboo subjects. 'Zyklon B Zombie', a 'single' of 1978, derived its title from the gas used by the Nazis in their extermination chambers.

Whilst Throbbing Gristle embraced the technologies bound up with the 1970s music industry, they were antagonistic towards the mass media at large. In America, Performance Art allied itself more wholeheartedly with technology and spectacle. This was the case with the elaborate 'operas' and multi-media productions of Robert Wilson and Laurie Anderson respectively. In the latter's *United States Parts I–IV* (1983), the author's voice, fed through an electronic 'harmonizer', mimicked the 'Voice of Authority'. The elliptical anecdotes it recounted succeeded in dissolving any secure sense of an authorial 'presence' behind the words. Back projections, tape recordings, and music further contributed to a seductively sinister *Gesamtkunstwerk*.

In other areas of 1980s art the longstanding dialogue between photography and performance tilted decisively in favour of the former, prioritizing performance's fictive nature over its capacity for 'presence'. This 'postmodern' turn is exemplified by Cindy Sherman, to be contextualized more fully later, who 'performed' herself acting out other female personae in photographs. Both 'Cindy Sherman' as author and the existence of any originary 'performances' were opened up to doubt [101]. A similar concern with 'masquerade' came to permeate much photography of the 1990s. A notable example is the work of Matthew Barney, whose persona, in terms of not just gender but also species identity, was shown to be manifestly 'constructed' [130].

If Mary Kelly had worried that Body and Performance Art would summon up a new artist-subject to gratify bourgeois needs, it seems that much of it succeeded in rendering this subject elusive and unfixed. However, whether the work mounted any real challenge to the artist's status within commodity culture remains open to debate. Much Performance Art of the 1970s, in line with the other tendencies discussed in this chapter, implicitly repudiated the art object's position within capitalism. But, as will be shown, rather than dematerializing itself further, art at the turn of the 1980s largely underwent a 'rematerialization'. It might be concluded from this that the post-1968 avant-garde project, however innovatory its forms, simply failed. In fact, as the next chapter explains, it had to weather a political and cultural sea-change.

Postmodernism: Theory and Practice in the 1980s

7

Historians generally regard the years 1973–4 as a turning-point in the postwar economic fortunes of Europe and America. After a 'golden age' which had lasted from 1950, an era of instability set in. Rising oil prices, in the aftermath of the Arab–Israeli war, caused Europe's economies to become inflated and to go into recession in 1973–4 and again in 1979–83. Different financial conditions led to changes in industrial organization. The previous Fordist model of integrated production began to give way to flexible (e.g. short-term) contracts, the decentring of output ('outsourcing' of plants), and increased mobility of capital across international markets. Companies expanded globally as service industries such as computing replaced the old manufacturing concerns. All in all, a phase of 'late capitalism' appeared to be underway. Whereas previous monopoly or imperialist phases of capitalism had been linked to cultural modernism, late capitalism was to be seen as synonymous with a 'postmodern' epoch.[1]

One of art's key changes was the loss of any overall sense of an avant-garde project. If this book has taken the self-referring Modernist aesthetics of Greenberg and Fried to be the horizon against which postwar avant-gardes defined themselves, the social and economic changes of 'postmodernity' bred a pluralist cultural ethos in which artistic practices proliferated without any agreed goals. Art objects became cultural products among others, rather than catalysts for social or aesthetic values. Some practices certainly maintained the opposi-tional stances of the period around 1968. But it became harder for art to achieve any adversarial distance from the social mechanisms into which it was merged. This chapter will frequently return to that struggle.

Theories of the postmodern

The notion of the postmodern had had some currency among cultural theorists in the early 1970s. The American-based literary critic Ihab Hassan applied the term to a swathe of artistic experimentalists ranging from Duchamp and Cage to writers such as Thomas Pynchon. By 1985 Hassan had established criteria for distinguishing 'postmod-

Detail of 117

ernist' works from their 'modernist' counterparts. For instance, the latter were said to privilege depth and determinacy whilst the former prioritized surface and indeterminacy.[2] Such crude oppositions are far from watertight. Recalling the dual definitions of modernism outlined in Chapter 1, indeterminacy could easily be seen as a 'modernist' concern, indicative of responses to social modernization. By the same token, it is 'Modernism' (capital M), as defined by Greenberg, which most clearly privileged origins or 'essences', whereas late 'modernists', such as Yves Klein, often undermined authorial presence. Whilst certain opponents of Modernism may certainly have been proto-post-modernists (Rauschenberg, as noted earlier, was perceived as such by Leo Steinberg in 1972), a more sophisticated model of cultural change is required to make the term meaningful.

Another early exponent of the notion was the British architectural critic Charles Jencks. In *The Language of Post-Modern Architecture* (1977) he announced grandly that modern architecture had 'died' in St Louis, Missouri, on 15 July 1972 at 3.32 p.m., when much of the noto-rious Pruitt Igoe housing scheme was dynamited.[3] Celebrating the demise of the austere 'functionalist' ethos of modernist architecture, he argued polemically for an eclectically 'postmodern' play of stylistic quotations cross-fertilizing modernist forms with previous historical idioms. His model was primarily aesthetic but by the 1980s it was linked to a neo-conservative rhetoric which trumpeted the virtues of increased choice in a less socially stratified society. The crucial shift from an aesthetic to a societal model of the postmodern came, however with the French philosopher Jean-François Lyotard's *The Postmodern Condition*, first published in 1979.[4]

Lyotard's book replaced the play of styles with a thoroughgoing cultural relativism. According to Lyotard, the 'grand narratives' that had informed Western societies since the Enlightenment (in other words since the eighteenth century, when European philosophers such as Kant and Rousseau had laid the intellectual foundations for modernism) could no longer sustain credibility. These abstract systems of thought, by which social institutions validated themselves, were infused with ideals of 'social perfectibility' or 'progress'. (In terms of modern art, Greenberg's aesthetic Modernism might be considered a 'grand narrative' of sorts.) Societies now generated a profusion of 'language games'. Institutions and businesses spoke to differing social interests, differing desires and concerns.

These ideas chimed in with the political changes of the period. The year 1979 saw Margaret Thatcher accede to power in Britain, followed, in 1981, by Ronald Reagan in America. This sharp swing to the polit-ical right heralded policies of economic deregulation and an allied relativization of values. Thatcherism, for instance, promoted the idea of an 'enterprise culture' predicated on personal (and entrepreneurial)

initiative rather than social cohesion. These were hardly Lyotard's politics. His philosophies derived from Marxist roots. Yet the bitter lessons learnt from 1968 and post-Stalinist repression had suggested to him that Marxism was unworkable. It was another unwieldy 'grand narrative'. Like the French philosopher Michel Foucault, he welcomed the dissolution of the Enlightenment legacy. The 'micro-politics' of groups such as ecologists or feminists seemed preferable to monolithic causes.

Lyotard's views ran counter to those of another influential philosopher of the Left, the German Jürgen Habermas. In a lecture of 1980 Habermas acknowledged that modernist ideals seemed unsustainable but argued nevertheless for a continuation of the Enlightenment project. For him, art, science, and morality had to remain as specialized 'narratives' while last-ditch efforts were made to create bridges between them.[5] In so far as the notion of avant-garde opposition to normative culture persisted in the years to come, Lyotard's and Habermas's positions broadly underpinned differences of standpoint. But if artists were to endorse either 'postmodernist' pluralism or 'modernist' totality, how were they to separate themselves from the historical process? If culture is in a 'postmodern phase', then art must inevitably be symptomatic of this. The American literary critic Fredric Jameson certainly thought so. His highly influential essay of 1984, 'Postmodernism, or the Cultural Logic of Late Capitalism', argued that culture's destiny was inextricably bound to capitalism's.[6]

Jameson asserted that aesthetic and commodity production had become indistinguishable. Technologies of reproduction (such as television) had replaced technologies of production. Art was increasingly sponsored by commercial companies, leading to a new interdependence of art and advertising. Subsequent commentators noted that avant-gardism was now a commercial signifier rather than a deeply rooted position. Social levelling had caused shifts in class values. The refined cultivation of the aristocracy or the principled militancy of the working classes, to which the avant-garde had once appealed, had become absorbed into an undifferentiated consumerist philistinism. Since enshrined academic principles and moral pieties also no longer posed any opposition, to whom could the avant-garde speak? As we shall see, gender and identity politics continued to be key issues for artists, but such concerns were socially decentred.

The main thrust of Jameson's analysis, however, was an account of the mind-set underlying the cultural products of postmodernism. Using Warhol as an early example, he talked of an emotional numbing or 'waning of affect' as characterizing postmodern subjectivity. Whereas modernism had frequently invoked the artist's inner 'depths' as a bulwark against an alienating external world, a 'new depthlessness' seemed to haunt recent art. Artists now manipulated visual surfaces

and codes, assuming that their sensiblities were formed out of representations rather than 'prior' to them in any sense. Most dramatically, Jameson adapted the thought of the French social theorist Jean Baudrillard to evoke the 'schizophrenic' effects of an autonomous sphere of social sign production where signifiers had become detached from their referents and existed in 'free play' as de-realized 'simulacra'.[7] Artists were left with a 'rubble of distinct and unrelated signifiers' and an accompanying loss of temporal coordinates.[8] A culture of 'retro' styles confirmed the loss of 'authentic' historical awareness. Similarly, whilst parody had been a weapon of the beleagured modernist, 'pastiche', described by Jameson as 'speech in a dead language', was now the order of the day.

This is apocalyptic stuff, more applicable perhaps to the experience of Los Angeles than large areas of Europe. When, slightly later, the theorist David Harvey related such effects to insidious forms of 'space-time compression', brought on, for instance, by the way global communications collapse space into an accelerated temporal dimension, they seemed slightly more feasible.[9] However, one way of testing Jameson's theories is to measure them against the art that directly preceded them.

The American artist Cindy Sherman, earlier described as 'postmodern', is relevant here. Emerging in New York in the late 1970s with Pop, Conceptualism, and Body Art as her expressive resources, her first important works, a sequence of 69 *Untitled Film Stills*, were produced between 1977 and 1980 [**101**]. Ideally they should be seen *en masse* since she appears in all of them, threading her persona through codes of clothing, lighting, setting, and composition filched from 1950s American B-movies. Appearing as a film-star lookalike, a flirtatious college student, a defiant housewife, she tips her hat to feminist debates, establishing femininity as a 'construct' rather than something 'innate'. But it is Sherman's assertion that representation itself is already pre-coded (via cinematic tropes in this instance) that seems to gel with Jameson's talk of pastiche, surface effects, and disconnected signifiers. Sherman's images are uncannily simulacral, referrable to no external 'origins'. Photography thus becomes the ideal postmodernist medium, freezing the ostensibly real as a sign.

Turning to painting, the postmodern epithet is frequently attached to Sigmar Polke, previously discussed in relation to German 'Capitalist Realism' [**63**]. Looking at *This Is How You Sit Correctly (after Goya)* [**102**] of 1982, it is possible to see how his earlier appropriations of mass-media imagery subsequently became intermingled with diverse 'high cultural' allusions. Against a background featuring a collision of two varieties of decorative fabric, one 'abstract', the other sprinkled with saccharine animal motifs (possibly for a child's room), Polke has overlaid fragmentary, irresolute linear 'quotations'. This mode of

101 Cindy Sherman

Untitled Film Still no. 6, 1977

Sherman poses as a woman daydreaming. She holds a mirror, a clichéd symbol of vanity, in one hand. Momentarily her blank stare triggers a disturbing 'double-take'. She becomes a victim of crime in a police photograph, 'killed' by the voyeuristic, mechanical gaze of the camera.

layering imagery was partly borrowed from the French Dadaist Francis Picabia, whose *Transparencies* of the 1920s, consisting of linear overlaps of disparate motifs, had a distinct vogue in the early 1980s. The American painter David Salle, who was directly affected by both Picabia and Polke, set elliptical fragments of 1950s textile design into grisaille fields of soft-porn imagery, floating nebulous and deliberately crude graphic notations from Old Master paintings over them. Polke's melding of 'public' and 'private', decoration and Fine Art, also harks

back to Rauschenberg's *Bed* [**19**]. However, whilst Rauschenberg's discursive jumps were mediated by a formal logic, Polke's cultural fragments seem irreconcilable. The effect is very much that of Jameson's 'rubble of distinct and unrelated signifiers'.

It seems clear, then, that postmodernist theory, or Jameson's at least, identified a shift of artistic mood. But to what extent *was* the art of the early 1980s merely symptomatic of a new cultural 'condition'? If, on Jameson's account, the loss of a 'depth model' in art reflected capital's deeper inroads into social formations, to what degree were

artists self-reflexive about such seemingly dire circumstances? One possibility, entertained by Jameson, is that postmodern sensibility was itself often experienced as a form of elation or euphoria, and his related notion of a 'postmodern sublime' will be dealt with in due course. For the moment, it can be asserted that postmodern art in the early 1980s broadly resolved itself into two camps. First there were those who were content to surrender to the 'free play of the signifier', even in its most lurid consumerist garb. Alternatively there were those postmodernists who set about reassessing modernism, utilizing Duchampian, Situationist, or Conceptualist strategies to open up fault-lines in the capitalist 'spectacle'.

The latter option posed certain difficulties. In theory Polke's dazzling mergers of 'high' and 'low' imagery ought to amount to a socially critical position because he was profoundly sensitive to the historical preconditions for cultural fragmentation. (His work would later incorporate the kind of alchemical allusions that Beuys and Kounellis had used as metaphors for a residual spiritual agency.) But if one characteristic of the postmodern is art's structural dissolution into the wider culture, Polke's mergers possibly replicate such assimilation. On this count, he would belong to the former camp. The question returns, how was art to attain oppositional distance?

The return to painting

The dilemma posed above was dramatized in the early 1980s through the interplay of painting and photo-related practices. Painting first demands consideration. Broadly speaking, it had fallen out of critical favour in the 1970s. The Modernist cult of abstraction had looked increasingly inappropriate to the times, although, as will be seen, important figurative painting was still being produced. By the turn of the 1980s a full-scale revival of figuration, informed by lessons learned from abstraction, was underway. Not only was it promoted in large exhibitions, but its return coincided with a temporary shift in art-world domination from America to Europe. The defining exhibitions were 'A New Spirit in Painting' at London's Royal Academy in 1981 and 'Zeitgeist' in Berlin in 1982. Their European curators made passionate claims for a reaffirmation of humanist concerns, sensing that Conceptualism's ascetic intellectualism had signalled the end of a historical trajectory. In the catalogue for the London show one of its organizers asserted that 'the subjective view, the creative imagination, has come back into its own'.[10]

One of the early 'discoveries' of this revival was Philip Guston, whose work had already provided a catalyst for what critics in late 1970s New York dubbed 'New Image' painting. Guston had initially been linked to Abstract Expressionism, shifting dramatically to figuration in the mid-1960s. Deciding that his previous output had been dishon-

estly geared to specious notions of 'purity', Guston spent the 1970s
setting down the insistent, graspable facts of his daily moods, obses-
sions, and insecurities. His lexicon of crude, idiosyncratic images
borrowed their stylizations from 1940s American cartoonists such as
Al Capp or Basil Wolverton (figures who also influenced the 1960s
'underground' comic-book artist Robert Crumb) [**103**].

Another rediscovered American painter was Leon Golub. Since the
1950s Golub had been developing a scarred and lacerated figuration,
responding to issues such as the use of napalm in the Vietnam War, but
his reputation was consolidated when he exhibited his *Mercenaries* and
Interrogations in 1982. Depicting a world of brutalized males, paid to
carry out human violations at the political margins, Golub avoided a
moralizing position. His mercenaries and interrogators swap banter
among themselves and gaze out of his pictures as though assuming our
complicity in their actions [**104**]. Sometimes a bound or gagged victim
is present. Golub painted the works on the floor, dissolving build-ups
of paint with solvents and then scraping the surface with a meat-
cleaver. Paint adheres in the weave of his canvases as though
corruption were etched into the creases of his protagonists' clothes, the
laughter lines around their eyes.

Although Guston and Golub became visible internationally, as did
Julian Schnabel, who will be discussed shortly, American artists did
not figure particularly prominently in the European promotion of the
painting revival. In many ways the phenomenon provided a means for

ambitious European curators to revenge themselves on two decades of American art-world hegemony. In 1982 the German Documenta 7 exhibition at Kassel, curated by Rudi Fuchs, was dominated by new figuration from Italy and Germany. The French critic Pierre Restany perceived an 'anti-American Kulturkampf' taking place.[11]

The new Italian painting was dubbed the 'Trans-avantgarde' by the critic Achille Bonito Oliva, who promoted it in a book of 1980, arguing that the presumption of 'difficulty' and singularity of purpose in avant-guardism had been supplanted by a cultural nomadism and eclecticism.[12] The perfect exemplar of this was the painter Francesco Clemente, who moved restlessly between Rome, New York, and Madras at the turn of the 1980s, incorporating a heterogeneous range of sources in his narcissistic and poetically allusive images. Clemente's style was broadly expressionistic but, like several contemporaries, his magpie borrowings from past and present art looked to the example of the early twentieth-century Italian painter Giorgio de Chirico, whose late output, with its bizarre amalgams of classicism and modernism, suddenly found favour. As noted earlier, Picabia's late work was also rehabilitated, whilst exhibitions of Picasso's final expressionistic paintings, produced between the late 1950s and his death in 1973, consolidated assumptions that, after phases of doctrinal purity, the

104 Leon Golub

Mercenaries II, 1979

Set against huge fields of red oxide on mural-sized, unstretched canvases, Golub's figures' frozen poses fleetingly echo those on Greek pottery, but they travesty classical faith in the body.

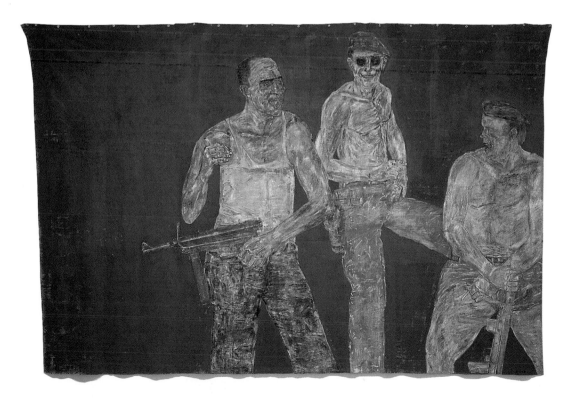

modernist masters had rekindled their creativity via idiosyncratic, excessive imagery.

It was in West Germany that a prevailing mood of eclecticism resolved itself into what most resembled a common painting style, with a brooding 'Neo-Expressionist' idiom becoming dominant. As noted at the end of Chapter 3, painters such as Georg Baselitz and Marcus Lüpertz had long been concerned with keeping German Expressionist traditions alive, but the younger Anselm Kiefer, a pupil of Joseph Beuys, drew on his teacher's example to deal self-consciously with Germany's recent cultural and political history. In his landscapes thick accretions of black paint, mixed with sand, straw, or ashes, simultaneously emblematized his own artistic desire to renew painting and referred to the way retreating armies burn land to render it unusable. Whilst American critics such as Donald Kuspit lauded Kiefer, alongside other German painters, for heroically 'lay[ing] to rest the ghosts… of German style, culture and history so that people can be authentically new',[13] German-born critics such as Andreas Huyssen were more cautious of the artist's apparent invocation of Teutonic myths linking the regeneration of the 'Volk' with the soil.[14]

Kiefer's evident fascination with Fascist architecture was similarly ambiguous, but in *Shulamite* (1983) [**105**] it served to evoke atonement. The title derives from a poem by an ex-concentration-camp internee, Paul Celan, in which Nazi and Jewish archetypes are juxtaposed in the repeated refrain 'your golden hair Margarete/your ashen hair Shulamith'. In the painting the blackened brickwork of the depicted interior, which was based on a Fascist architectural scheme honouring the 'Great German Soldier', transforms it metaphorically into an enormous oven.

Painting's new-found preoccupations with national identity and with recycling previous stylistic tropes were attacked in a polemical essay of 1981 by the art historian Benjamin Buchloh, who noted that regression to nationally distinct artistic modes in twentieth-century

The 1980s art market

The economic crises of the mid-1970s had precipitated big changes in market attitudes to art. Collectors, business corporations, and banks began to see it as a reliable means of acquiring assets. In 1985 the private sector in America contributed $698 million to arts sponsorship compared to the government's $163 million. Businesses developed policies of 'enlightened self-interest', realizing the benefits that could accrue from being associatied with art's universalizing and libertarian rhetoric. The prices of Old Master paintings soared. During 1987–8, 121 paintings and drawings topped the million-dollar mark in American auctions compared with 14 in 1979–80. (Jasper Johns's painting *False Start* (1959) set a record for a living artist in 1988 when it fetched $17.1 million.) But younger living artists who produced appropriate products also represented sound investments.

Sulamith

105 Anselm Kiefer

Shulamite, 1983

Kiefer used explicit references to Nazi architecture in several other works of this period. For instance, his *Interior* of 1981 was based on Hitler's Chancellery, designed by Albert Speer. In the painting the building was depicted as desecrated and smoke-blackened. Similarly *To The Unknown Painter* (1983) made reference to a courtyard from the same building. In the centre of it an artist's palette was placed on what resembled a microphone stand.

art, such as the classicizing *rappel à l'ordre* in French art in the 1920s, had often accompanied swings to the political right.[15] Buchloh's critique tended to gloss over anomalies. For instance, a German painter such as Jörg Immendorf, whose revivalism involved the 1920s *Neue Sachlichkeit* (New Objectivitiy) idiom of German painters such as George Grosz, clearly manifested an edgy unease with Germany's political divisions, as in his *Café Deutschland* series, rather than any yearning for national belonging. But Buchloh's analysis did draw attention to the way that, after an internationalist, left-oriented Conceptualist phase, the return to figurative, nationally identifiable styles suited an art market attuned to Reaganism.

National styles, tied to newly valorized painterly 'signatures', became highly desirable. In Europe the institutional triumphalism surrounding the 'return to painting' quickly dissipated as its commercial backers went global. In 1983 the Cologne dealer Michael Werner, who had helped to establish German Neo-Expressionists such as Baselitz and Lüpertz, cemented business links with Mary Boone, the New York dealer responsible for the success of their American counterparts. (The couple married in 1986.) It might be argued that invocations of national identity in, say, Kiefer, symbolized resistance to

such homogenizing global arrangements. But the sheer impetus of the early 1980s market meant that few ambitious artists could extricate themselves from the ideological paradoxes it generated. Many blithely played along. One outstanding example, to return to Mary Boone, was one of her protégés, the American painter Julian Schnabel.

When Schnabel's first exhibition sold out before its opening at Mary Boone's gallery in February 1979, it was taken by many to be an augury. An essentially derivative painter, Schnabel brashly revived the rhetoric of the macho artist–genius, specializing in painting fractured images over large surfaces covered with objects such as smashed crockery. His meteoric success owed much to Charles and Maurice Saatchi, the then owners of the global advertising agency Saatchi and Saatchi, with Charles, as art collector, becoming the embodiment of new patterns of commercial patronage. Bulk-buying the work of selected artists or movements, Saatchi strategically dropped them when necessary. A case in point was the Italian *Transavanguardia* painter Sandro Chia, whose career suffered accordingly. In the case of Schnabel, the fact that the Saatchis owned nearly all of the works shown in his significant Tate Gallery exhibition in 1982 raised doubts about their role in prematurely canonizing relatively undeveloped talents.[16]

The backlash against painting: photo-related practices

In 1983 Hans Haacke, previously discussed here in the context of Conceptualism, parodically turned his hand to oil painting. In *Taking Stock (Unfinished)* [106] he surrounded an image of Margaret Thatcher, one of the political enablers of the current art boom, with a décor connotative of her regard for 'Victorian values', framing the painting in appropriately grand style. Behind Thatcher the artist depicted a bookcase containing leather-bound volumes. These are shown to contain details of company reports, including those of the Saatchis. The heads of the brothers are further emblazoned on two cracked plates on the top shelf of the bookcase, signifying their links with Julian Schnabel. The Saatchis' agency had advised both the British Conservative Party and Thatcher on matters of public image before their election victories in Britain in 1979 and 1983. Haacke thus supplied the 'evidence' confirming the new painting's complicity with political and economic interests.

Haacke's implied criticisms were shared by a sector of New York's cultural establishment which had grown up with post-1968 Conceptualism. In 1976 the critics Rosalind Krauss and Annette Michelson had founded a magazine whose title, *October*, invoked the militancy of the Russian avant-garde after the 1917 revolution. Their commitments were broadly towards Conceptualist uses of photography, backed up by the heavy theoretical artillery of semiotics and post-Structuralist philosophy. Taking Barthes's notion of 'the death of the author' as a given,

106 Hans Haacke

Taking Stock (Unfinished),
1983–4

In this painting Haacke's use of allegorical detail has an ironic air of academic exactitude. For instance, the marble sculpture of Pandora, pointedly placed on the Victorian table next to Margaret Thatcher, is based on one produced in 1890 by the British sculptor Harry Bates and owned by the Tate Gallery, London.

Krauss theorized photographs, alongside other visual artefacts such as body casts, as examples of an 'indexical' order of signs, which constituted direct traces or imprints of reality. In this they differed from 'iconic' or 'symbolic' signs, which required the mediation of the artist's hand. Since Duchamp had shown a predilection for 'indexical' signs, he came to represent the historical touchstone for opposition to the nascent fetishization of the painterly mark.[17] Photography thus became

107 Jenny Holzer

Abuse of Power Comes as No Surprise (T-shirt modelled by Lady Pink), 1983

Holzer has used a diversity of means to disseminate her messages. These have included posters, plaques on buldings, T-shirts, bus tickets, park benches, baggage carousels at airports, LED screens in shopping malls or sports stadiums, television, radio, and billboards. In 1989 her slogans and statements appeared on LED strips following the circular motion of the spiral ramp at New York's Guggenheim Museum.

for the 1980s what the readymade had been for the 1950s and early 1960s in terms of antagonism to painting. In 1977 a further *October* collaborator, Douglas Crimp, curated a key exhibition of photographically produced works at New York's Artists Space gallery entitled 'Pictures'. Exhibitors such as Sherrie Levine and Robert Longo re-photographed and re-presented imagery from an increasingly invasive world of visual signs. Such strategies were again underwritten by post-Structuralist conceptions of the artist/author as someone who shuffles existing texts and signs, renouncing the possibility of creative originality.

By the early 1980s younger critics such as Craig Owens and Hal Foster had gravitated towards *October* and were arguing for an art that was strategically 'deconstructive' rather than symptomatically 'postmodern', like the new painting. These critics largely supported practices which echoed those of Situationist-influenced Conceptualists such as Daniel Buren. They therefore backed the American artist Jenny Holzer, who specialized in inserting highly ambiguous printed statements into the public domain. Her *Truisms* (1977–8) consisted of long lists of conflicting homilies or injunctions (such as 'An elite is inevitable' or 'Any surplus is immoral') which seemingly questioned the possibility that univocal viewpoints could issue from either an authorial or a public sphere. These lists were affixed to buildings or lamp-posts, whilst single statements subsequently appeared on T-shirts, their meanings dramatically modified in relation to the wearer's gender [**107**].

From 1982 onwards Holzer periodically paid to have messages flashed across electronic billboards. Hence, in 1985–6 the message 'Protect me from what I want' (part of her *Survival* series) hovered above Times Square. No doubt hurrying shoppers paused confusedly, as the voice of authority (or advertising) ventriloquized their insecurities.

Another American artist, Barbara Kruger, used similar strategies, recapitulating Victor Burgin's parodic advertisements with striking juxtapositions of photography and text echoing 1920s and 1930s political photomontages and typographics by John Heartfield and Alexander Rodchenko. Like Holzer's, her texts hijacked an authoritarian voice but levelled accusations at nameless adversaries from the viewpoint of the oppressed or marginalized. In *Untitled* (1981) a photograph of a carved female bust is captioned 'Your gaze hits the side of my face', cleverly reversing the Medusa myth to convey the immobilization of women in social spaces dominated by male looking. As this work implies, as Kruger took possession of the voice of power, so she, at some level, became 'possessed'. She inevitably became entrapped both in representation and in the mass media's machinations. This was dramatized in different terms in 1987 when she appeared on the cover of the magazine *ARTnews*. Whether Kruger was aware of it or not, this magazine had been carefully selected by a major American bank as a vehicle for advertising to potential clients with 'portfolios of $5 million or more'.[18] It seems, then, that oppositionally 'postmodern' artists, in ceding their agency to other 'voices', ironically fell prey to Jameson's postmodern merging of art into commerce.

The *October* critics nevertheless attempted to distinguish a 'postmodernism of resistance' from a 'postmodernism of reaction',[19] making ambitious claims for the former's departure from modernist assumptions. Craig Owens, for instance, perceived an 'allegorical impulse' at work in the way certain artists since Rauschenberg had effected crossovers between aesthetic mediums or appropriated cultural imagery to establish that meanings were contingent rather than fixed. Rosalind Krauss further argued for a decisive shift from modernist notions of 'authenticity' and 'originality'.[20] Krauss's thinking may well have been stimulated by the example of Duchamp's ironic play on the 'original' and the 'copy' in his editioned readymades of the 1960s. Certainly Sherrie Levine, an artist who came to prominence in Crimp's 1977 'Pictures' exhibition, became Krauss's protégé precisely by (almost literally) recasting Duchamp [**30**].

Levine also 're-presented' other works such as photographs by the American Depression-era photographer Walker Evans. Her apparently rudimentary strategy raised fascinating questions. For instance, Evans's 'documentary' aesthetics were partly predicated on a notion of

108 Richard Prince

Untitled (Cowboy), 1980–4

Prince's early 'appropriations' from advertising, of which this is an example, have interesting connections with his later practice. After 1985 Prince started to employ verbal jokes in his works. They were often silkscreened as texts across the centres of large, single-colour canvases alluding to Modernist abstractions. The character of the jokes, which usually reflected 1950s, middle American,'blue-collar' values, often had an undercurrent of malevolence. Many of them dealt with infidelity. From the evidence of his earlier appropiations, Prince himself was a fugitive, teasingly 'untrustworthy' artist.

'transparency' whereby the plight of the subjects of his photographs (the downtrodden Southern sharecroppers and their families of the 1930s) supposedly predominated over any awareness of the photographer's 'style'. In effect the opposite was the case: pragmatism and stoicism came to be identified with the name 'Walker Evans'. In usurping Evans's authorship, Levine ironically focused attention back on the 'subjects' of his photographs, making the images curiously 'transparent' again. Another artist concerned with appropriating imagery was Richard Prince. In 're-presenting' images of cowboys extrapolated from advertisements for Marlboro cigarettes, he effaced his authorial presence while obliquely preserving an ironically macho identification between himself, as artist, and the romantic outsider-figures of the cowboys [**108**].

All in all, Prince and Levine's 'decentring' of authorship, like that of Holzer or Kruger, spoke of the impossibility of being 'outside representation'. However, in terms of the workings of the art world, this translated into capitulation as much as 'resistance'. By 1986 Sherrie Levine followed the likes of Schnabel in showing at Mary Boone's chic New York gallery. Deconstruction of authorial presence did not lead to artists deconstructing their own authority. Indeed, postmodern authorship became an increasingly exotic affair, as audiences were enjoined to unpick authors from the codes in which they were camouflaged. This was backed up by a highly professionalized critical and academic discourse and a publishing industry quick to cash in on the inverted intellectual snobbery that 'critical postmodernism' often inadvertently engendered. In relation to Conceptualism's principled avant-gardism, 'oppositional postmodernism' often smacked of mannerism.

The 'postmodern sublime': permutations of photo-painting

If attempts to assert the moral superiority of photo-related practices over painting rang hollow, it was arguably when photography and painting converged that the most challenging forms of postmodern art resulted. In 1981 the artist and critic Thomas Lawson asserted that, whereas the art promoted by the journal *October* sometimes appeared smug in its marginality, painting, with its greater public visibility, perversely held out greater critical potential. Demanding a kind of blind faith, it could attain a degree of irony that photography's more straightforwardly declarative imagery lacked.[21] Lawson mainly cited the work of the American David Salle, but may easily have had in mind artists such as Malcolm Morley, Eric Fischl, and Gerhard Richter. In their different ways, they continued to affirm a discredited medium. However, rather than reviving past rhetorical strategies in the manner of the Neo-Expressionists, they acknowledged that painting had to interface directly with photography and its conventions.

This applies almost literally to Malcolm Morley. A British-born painter who had worked in America since 1958, Morley had pioneered a form of 'photorealism' (also dubbed 'hyper'- or 'super-realism') in America in the mid-1960s, producing images such as *SS Amsterdam in Front of Rotterdam* (1966) which were painstakingly transposed from photographs. In the early 1970s other artists achieved critical and commercial success from related practices. Painters such as Philip Pearlstein, Chuck Close, and Richard Estes translated the pictorial plenitude of photographs into glossy painted surfaces, densely encoded with visual information. At the same time the sculptor Duane Hanson made uncanny direct-cast replicas of live figures, painting them illusionistically and dressing them in actual clothes.

As photorealism became fashionable, however, Morley grew frustrated with his seamless surfaces. This is dramatized in *The Ultimate Anxiety* (1978) [**109**], in which a depiction of a train cuts incongruously across an image transposed from a postcard reproduction of a painting by the Venetian master Francesco Guardi. This work relates to other 'catastrophe' pictures Morley produced at this time such as *The Day of the Locust* (1977), in which a Pop-like replication of the cover of the *Los Angeles Yellow Pages* appears to be eaten away from the inside by swarms of imagery. Morley produces a refreshingly direct response to the cutural relativism of his times. But he also dramatizes the peculiar sense of dislocation which arises as different orders of representation intrude upon one another.

The American artist Eric Fischl's painterly realism might appear anachronistically descriptive but his works were also riven internally by divergent modes of representation linked to photography and film. The flat literalness of Fischl's paint handling, along with certain compositional devices, partly derived from the 1920s and 1930s

109 Malcolm Morley

The Ultimate Anxiety, 1978

Although resident in America, Morley was the first winner of the Turner Prize in 1984. Funded by the 'Patrons of New Art' affiliated to London's Tate Gallery, this prize was subsequently awarded annually for 'outstanding contributions' to British art. Conceived as an equivalent of the Booker Prize (for literature), it reflected something of the entrepreneurial spirit of 'Thatcher's Britain', attracting considerable publicity to the Tate, where shortlisted artists' works were exhibited. Winners have included Damien Hirst (1995) and Gillian Wearing (1997).

American realist painter Edward Hopper, whose work was widely exhibited in 1981. However, Fischl translated Hopper's poetic vision of Middle American *ennui* into an examination of suburban neuroses and repressions. Arresting narratives in mid-flow, he obliged his spectators to become entangled in morally ambiguous scenarios, anticipating David Lynch's film *Blue Velvet* (1986).

This sense of imminent implosion was closely informed by Fischl's pictorial strategies. Combining disparate figures derived from sources such as photographs taken on nudist beaches, he sought a 'seamless look constituted by fragments'.[22] In *The Old Man's Boat and the Old Man's Dog* of 1982 [110] Fischl revisited Théodore Géricault's famous painting *Raft of the Medusa* (1819), which had commented obliquely on corruption in early nineteenth-century French government. Its subject aside, Fischl's work communicates moral breakdown in the way its photographically derived, voyeuristic fragments almost fail to cohere. Unlike Gericault he cannot achieve a unified public statement. His realism is vitiated by technologies oriented towards visual distraction and discontinuity.

As pointed out in Chapter 4, the German painter Gerhard Richter similarly looked back mournfully on painting's loss of public function in his *October 18, 1977* (1988), a cycle of 15 paintings which mimicked the

appearances of blurred black-and-white photographs [**111**]. Richter had initially produced 'photo-paintings' just before Malcolm Morley in the 1960s. However, by contrast to Morley, his works frequently possessed a metaphysical cast which aligns him with a lesser-known American-based artist, the Latvian-born Vija Celmins. Celmins's drawings of the late 1960s and early 1970s dealt with issues of proximity and distance. Taking photographs of limitless phenomena, such as the ocean or the star-filled sky, as her models, she translated such ungraspable subjects into finite blocks of graphic description, which call for close-up inspection [**112**].

This oscillation between an informationally saturated surface and an elusive subject assumed a political edge in Richter's *October 18, 1977*. The cycle dealt with the apparent suicides, ten years previously, of members of West Germany's militant Red Army Faction. Having lived under a Stalinist regime in Eastern Europe, Richter abhorred ideological dogmatism. Nevertheless he felt some sympathy for the terrorists as misguided heirs of the idealism of 1968.[23] Aware that photographs had originally been instrumental in implanting ideologically tinged images of the terrorists in the German public's mind, Richter submitted such imagery to his painterly blur. As though reversing the terms of Fischl's reworking of Géricault, he filtered

111 Gerhard Richter

Dead from *October 18, 1977* series, 1988

photographic imagery through a former technology of public address (the depictions of dead terrorists echoed previous paintings such as Manet's *Dead Toreador* of 1864). At the same time, by obliging his spectators to adjust their positions in relation to his blurs (in order to 'focus' them), he implied that, just as painting and photography were making competing demands from within the same object, so ideology's claims were unresolvable. This might be linked to Fredric Jameson's influential essay on postmodernism, cited earlier, where its author drew attention to a peculiarly postmodern modality of the 'sublime', rooted in the philosopher Kant's thought, whereby representation appears stretched to inconceivable limits by technology.[24] Once a 'container' for public conscience, painting became replete with photography, a technology often employed to collapse critical 'distance'.

In the mid-1980s Richter produced abstract paintings [113] as well as realist 'photo-paintings'. As argued earlier, he appeared here to be recapitulating the ideological options underpinning postwar modernism in so far as his own transplantation from Eastern to Western Europe had been paralleled by an imperative to favour abstract artistic modes over realist ones. Significantly, in 1979–80 the British Conceptualist collective Art & Language, who had previously been opposed to the seductions of the painterly, physically merged Communist-style realism and abstraction in their series *Portraits of V. I. Lenin in the Style of Jackson Pollock* [1]. Their ingenious double-images, described at the start of this book, parodied the nascent return to (figurative) painting. Whilst the modernist project was widely being pronounced as *passé*, Art & Language demonstrated that history is deeply embedded in the forms that representation takes. This repudiated the prevailing pluralist ethos whereby historical modes were simply deemed 'available' for co-option.

Richter's abstractions also appeared to mock the modes of expressionist brushwork blithely revisited by Neo-Expressionist contemporaries. However, Richter complicated matters here by asserting that his abstractions were concerned with expressing the

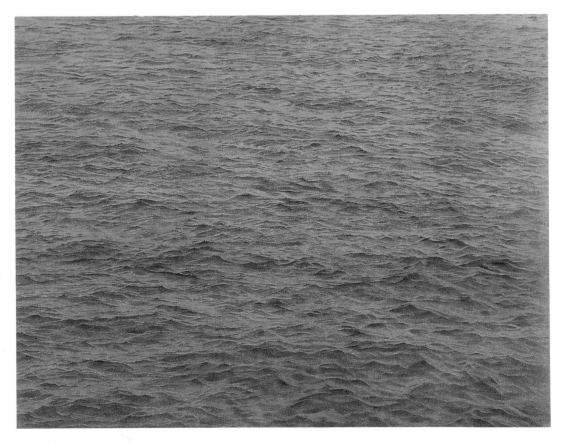

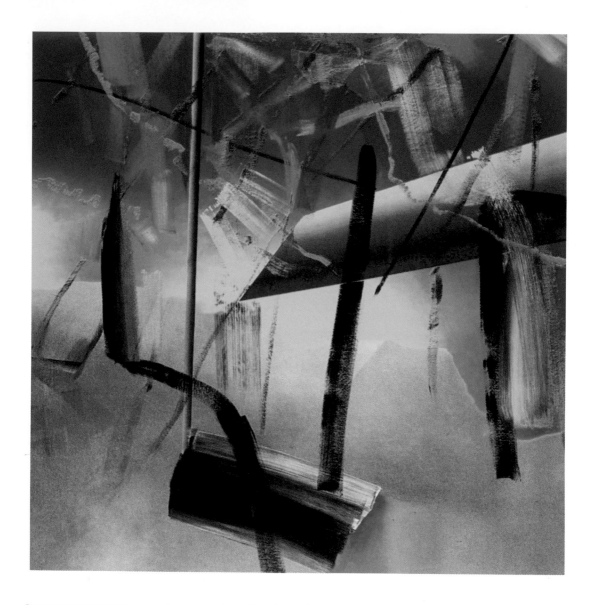

113 Gerhard Richter

July, 1983

'transcendental' or 'inexplicable'.[25] To clarify this, Jameson's notion of a 'postmodern sublime' might again be pertinent. Looking at *July* (1983) [113] one needs to be aware that Richter had painted related abstractions in the late 1970s from photographs of his own paintings, but by this point was overlaying free brushwork onto smooth, photo-derived, abstract grounds. The effect is that of looking into some form of photographically illusionistic space, in which brushstrokes, either directly applied or 'depicted' in incongruous scale, usurp the places of figures or landscape features. The Surrealist Salvador Dali once asserted that he wished to make 'hand coloured dream photographs'. However, rather than depicting dreams (which are impalpable) Richter

paradoxically depicts 'expression', locating it in the lurid photo-reality envisaged by Dali. We are given dizzying access into the very interstices of representation. As with Richter's realist 'photo-paintings', phases of recent art history appear to be conflated. Abstract Expressionist invocations of the 'sublime' and Lichtenstein's brushstroke paintings [**54**] are brought into collision with technology. In comparison with Art & Language's 'abstraction', the net outcome is hardly a historical dialogue. Instead a 'postmodern sublime' is envisioned.

Art and difference

The above suggests that, even at its most self-consciously historicist, painting of the 1980s sometimes succumbed to an apocalyptic sense of the postmodern (or what Jameson called an 'inverted millenarianism'). In this it ran the risk of appearing to languish, symptomatically, in a putative 'postmodern crisis'. This was compounded by the status of artists such as Morley or Richter, who, being male, white, and financially secure, could be interpreted as relatively immune from more pressing crises such as social marginalization or deprivation. This once more raises the question: to what extent could postmodern art claim any critical distance?

Among certain commentators, many of whom questioned the 'totalizing' tenor of Jameson-style theory, there was a tendency to identify the theme of difference as grounds for a more ethically oriented art practice. It is important to remember that, as far back as the 1960s, post-Structuralist conceptions of an internally divided, gendered human subject had undermined modernist assumptions that it is possible to invoke a 'universal' human nature. Theorists such as Barthes, and later Derrida, had demonstrated that verbal structures in occidental cultures are built around binary oppositions: positive/negative, presence/absence, masculine/feminine, black/white. Since, in each case, one term is privileged in contrast to its negatively tinged 'other', difference becomes something inscribed both linguistically and ideologically. We have seen how this realization informed the feminist art of, say, Mary Kelly or Barbara Kruger. But further permutations of difference affect people's subject-positions in European and North American cultures, notably class and race.[26] 'Identity politics' therefore constituted an arena for less self-referential forms of art.

Having parted company with the British Art & Language group in the early 1970s, Terry Atkinson had, by the mid-1970s, moved away from their stringent Conceptualism to explore his working-class heritage in a set of 'history paintings'. In his *First World War* series (*c*.1974–81) he reinterpreted photographs of troops taken during the Great War, using a strategically 'botched' drawing style and satirical captions. He thereby encoded a critique of the way working-class labour was mobilized for capitalist warfare. By 1984–5 such explo-

THE STONE TOUCHERS 1

Ruby and Amber in The Gardens of their old Empire
history-dressed men.

Dear Ruby and Amber,
Do you think God is a person?
If he is, is he a he?
If he is, is he black or white, or brown or yellow,
or pink or orange or blue or red, or green or purple.....?
What if he's a she?

Do you think God is a dissident? Or is he a South African,
Or an Argentinian, or an Anglo-Saxon, etc.?

Do you think he's the best knower?

If he is a she do you think all the he's would admit
she's the best knower?

114 Terry Atkinson

The Stone Touchers 1,
1984–5

Terry Atkinson, like David Hockney, came from a working-class background in Yorkshire, England. However, his affiliations when he eventually moved to London were with Conceptualism rather than Pop. Whilst Conceptualism had been international in orientation, his 1980s output, which dealt with subjects such as class identity and English attitudes to Northern Ireland, seemed to represent a deliberate return to 'local' issues.

rations of ideological undercurrents were brought to bear on family photographs. *The Stone Touchers 1* (1984–5) [114] incorporates an ironically diligent 'copy' of a photograph of Atkinson's children taken during a holiday in northern France. Intrigued by the rows of war graves, they are shown flanking a stone dedicated, according to the 'key' beneath the image, to a South African infantryman. In a mock-poetic caption Atkinson asks them: 'Do you think God is a person? If he is, is he a he? If he is, is he black or white … is he a South African, or an Argentinian … ?' Britain's faded imperialism had recently been rekindled by the Falklands War, and South African apartheid was a pressing issue. Atkinson thus presented his suntanned children as inextricably (if unknowingly) implicated in such events.

Cultural identity was perhaps more urgent for the large numbers of artists whose immediate predecessors had suffered under colonial rule. The increasing visibility and empowerment of artists of 'hyphenated' cutural identity (e.g. African-American, Asian-American) are often correctly perceived as triumphs of a 'postmodern' dispensation, but this process has barely begun. In 1984, in its '"Primitivism" and 20th Century Art' exhibition, New York's MOMA was still endorsing a relatively unreflective view of early modernism's reliance on appropriations from the West's colonial 'others'. By 1989 a large exhibition at La Villette and the Pompidou Centre in Paris, entitled 'Magiciens de la terre', promoted a determinedly 'multiculturalist' view of art, showing works by 100 artists from over 40 countries, many outside of the

115 Jimmie Durham

Bedia's Stirring Wheel, 1985
Durham's symbolic recoding of the imagery of modern America in the terms of its native Indians is interesting in relation to Joseph Beuys's use of Indian iconography for purposes of symbolic retribution [42]. As a modernist, Beuys assumed his work could possess a certain universality of meaning. By contrast, Durham's 'postmodern' gesture acknowledges ambiguities of translation in the way it treats its subject. Beuys, of couse, was European whilst Durham actually came from an American Indian background.

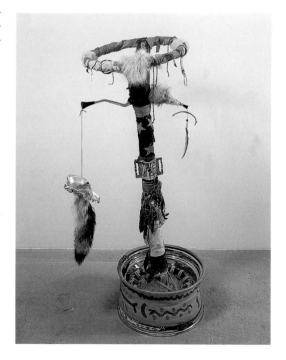

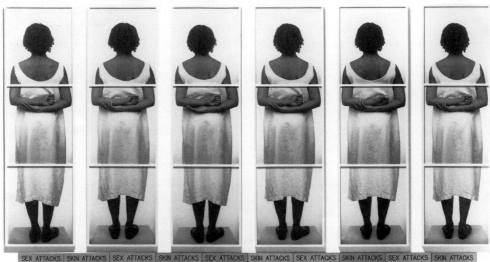

GUARDED CONDITIONS

116 Lorna Simpson

Guarded Conditions, 1989

The viewer of Lorna Simpson's works is compelled to shuttle between texts and images in order to construct meanings. The use of text–image conjunctions was a major component of 1980s photographic practice. In Britain Victor Burgin's teaching at the Polytechnic of Central London was particularly influential for a number of Simpson's contemporaries. These included Mitra Tabrizian, Karen Knorr, and Olivier Richon.

Western art ambit. It could be argued, however, that such well-meaning efforts at assimilation neutralized the specificities of cultural difference. The scars of ethnic diaspora, or 'subaltern' status, could hardly be dispelled via symbolic gestures. For artists of mixed racial origin there was an urgent need to discover their own voices.

An exemplary figure here is the Cherokee Indian artist Jimmie Durham. Actively involved in the American-Indian Movement during the later 1970s, Durham has since produced objects, performances, and installations which wittily expose the mingling of mythologization and historical disavowal that characterize white US attitudes towards North American Indians. In *Bedia's Stirring Wheel* (1985) [**115**] a car's steering-wheel is wrapped in hides and star-patterned cloth and embellished with animal trophies, producing an ironic hybrid of 'primitivist' ritual object and Western 'Conceptualist' readymade. A playful text accompanying the work proposes that it has been unearthed by a Cuban archaeologist, Jose Bedia, during an excavation of the 'White Planes' in 3290 AD. Bedia identifies the find as 'a symbol of Office for the Great White Father' who, standing behind it, made 'pronouncements and stirring speeches'. A form of symbolic revenge on the West's technological triumphalism is envisaged.

Racial assumptions are the butt of Durham's irony, but as Atkinson intimated, these are normally inseparable from ones involving class or gender. Depictions of African-Americans by two American-based artists prominent in the late 1980s demonstate the complexities that accrue from this. Robert Mapplethorpe, who achieved the unlikely

feat of making the 'pictorialist' Modernist photography of the likes of Edward Weston function in a postmodern ambience, did so by over-hauling that tradition's image of the male nude. In publications such as *The Black Book* (1986) he produced provocative, classicizing images of black males. Critics argued as to whether, as a white homosexual, he was objectifying his subjects or whether he was summoning up the spectre of a mythologized black potency to unsettle his predominantly white gallery-going audience. Whatever the case, the power of his images turned on the ramifications of 'visibility'. By contrast, Lorna Simpson, an African-American artist who employed text–image juxtapositions in a Conceptualist idiom, produced a haunting series of back views of a generic black female in a shift, her identity occluded. Clearly social invisibility was being figured here, whilst Simpson's textual captions produced ambiguous supplementary meanings [**116**]. Moving from Mapplethorpe to Simpson, different configurations of race, class, and gender result from shifting relations between the artists, their subjects, and their implied audiences. In viewing such works the critical appraisal of such permutations became an ethical prerequisite.

Simulation and abjection: the late 1980s

If identity-related art inherited something of the modernist avant-garde's claims to moral authority, an entirely antithetical tendency emerged in New York during the 1980s. Encompassing artists such as Ashley Bickerton, Haim Steinbach, and Jeff Koons, its forms relied heavily on Duchampian and post-Pop mergers between art objects and commodities. The label it acquired around 1986, 'Neo-Geo', was only really applicable to Peter Halley, a painter who coolly readjusted formal devices from Modernist abstractions to reveal latent technocratic metaphors. Halley, however, took it upon himself to theorize the tendency, partly placing it under the aegis of the French sociologist Jean Baudrillard, who, as noted earlier, perceived the ominous collapse of distinctions between 'reality' and 'simulation' as intrinsic to the market-led world of late capitalism.[27] With 'simulation' as its core principle, therefore, this art was bound to antagonize artists and critics concerned with the 'authenticity' of identity struggles.

Of all the simulationists Jeff Koons most offended against 'politically correct' proprieties. His blithe acquiescence to consumerism was first manifested in 1980 with the presentation of off-the-shelf vacuum cleaners, in Plexiglas vitrines, as seductive items of display in the window of New York's New Museum of Contemporary Art. After a period working, appropriately enough, as a broker on Wall Street, he achieved notoriety, and considerable market success, with a series of exhibitions showing batches of work with unmistakably ironic titles; 'Equilibrium' (1985), 'Luxury and Degradation' (1986), and 'Banality'

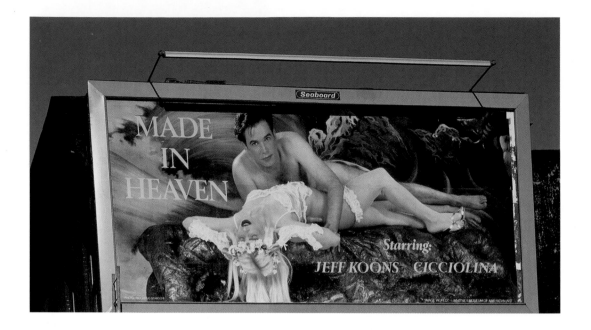

117 Jeff Koons

Made in Heaven, billboard
poster, 1989

Koons followed up this poster
with a series of explicit,
human-scale, photo-based
'paintings' of the couple
having sex. Characteristically,
Koons asserted that his
concerns were far removed
from pornography. He had
apparently gone through a
moral conflict in preparing for
the work, which, he claimed,
would initiate viewers into the
'realm of the Sacred Heart of
Jesus'. More probably he was
scurrilously testing such
boundaries as public/private
and aesthetic legitimacy/
erotic pleasure.

(1988). The works on show were now carefully replicated by hired craftsmen from readymade sources—*Michael Jackson and Bubbles* (1988), a porcelain figurine of the pop star with pet chimpanzee, being a notorious example.

Koons was a connoisseur of what the artist Barbara Kruger once termed 'the sex appeal of the inorganic': he eulogized over his vacuum cleaners' hermaphroditic ability to combine phallicism and sucking operations. Wittily turning the advocacy of kitsch into a crusade, he claimed to unburden the middle class of conditioned hypocrisies of taste. In 1989 he achieved a kind of sublimity when a billboard poster appeared which, although advertising an exhibition at New York's Whitney Museum, ostensibly advertised a film of the artist in the throes of sexual passion with his new wife, the Hungarian-born, Italy-based porn-actress and artist Ilona Staller (known as 'La Cicciolina' or, in English, 'Little Dumpling') [117].

In a sense, Koons was updating the moral conundrums of Andy Warhol. His sheer effrontery sits interestingly alongside rather different European responses to consumerism in the 1980s. In Britain, for instance, the sculptors Tony Cragg and Bill Woodrow, who were part of a sculptural revival discussed in Chapter 5, developed an iconography of recycling to counter the flagrant materialism of nascent Thatcherism. Cragg's *Britain Seen from the North* [118], an array of found plastic objects and fragments arranged to configure a person approaching a map of Britain, invokes widespread perceptions of an ideological rift betwen the country's north and south, subtly revising Luciano Fabro's *Golden Italy* [86]. By contrast, in West Germany in the

118 Tony Cragg

Britain Seen from the North,
1981

Born in Britain, Cragg moved
in 1977 to Wuppertal in West
Germany where he has
worked ever since. This
information adds a personal
dimension to this primarily
political gesture. In the early
1980s Cragg largely
concentrated on themes
relating to landscape and the
city, but his work changed
dramatically later in the
decade. He became more
interested in the relationships
between organic and man-
made forms and
experimented widely with
diverse materials.

later 1980s, Rosemarie Trockel added a feminist twist both to the post-Warhol aesthetic being flagged by Americans and to the influential mediations of Pop in works by senior male artists such as Sigmar Polke. Reclaiming Polke's use of fabrics for the purposes of 'feminine' production, she produced knitted balaclava helmets patterned with repeated motifs [119].

Trockel's works, and even Cragg's at a stretch, could answer the requirements of an oppositional postmodernism, but American critics in particular were outraged by Koons's symptomatically 'postmodern' flirtation with capital. The critic Hal Foster castigated Koons and others for cynically advocating the populist levelling of art and mass culture and then judiciously sidestepping the issue in favour of art's commercial advantages.[28] Furthermore, as Foster suggested in the course of an essay identifying the 'return of the real' as an emergent impulse of the late 1980s, brazen materialist excess, along with the institutional consolidation of America's political Right, appeared to elicit a kind of reflex action. This manifested itself in the re-emergence of the body in late 1980s art, not necessarily as a whole, integrated entity but as something evoked by corporeal fragments and physical residues. A surfeit of capitulations and cynicism was seemingly being ejected.[29] This process came to be identified with the concept of 'abjection'.

As theorized by the French writer Julia Kristeva, 'abjection' covers both an action, of abjecting, by which primordial experiences of the separation of inside and outside, or self and other, are re-experienced via bodily expulsions, and a wretched condition, that of being abject.[30] Its visual corollaries ranged from the sculptures of the American Kiki Smith, in which bodies were represented as eviscerated or leaking, to certain Cindy Sherman photo-works of 1987 depicting disturbing 'landscapes' made up of human viscera or vomit, broadly connotative of conditions such as bulimia. In California a vein of Performance and

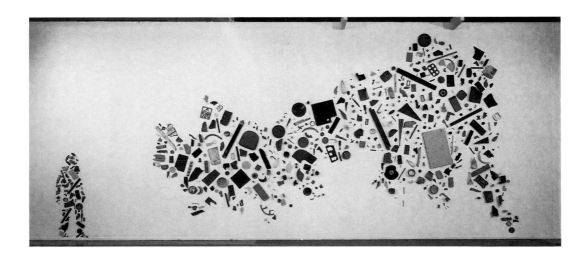

Installation Art courting related themes of bodily excess and social
malfunction had long been the province of artists such as Paul
McCarthy and Mike Kelley. The latter's iconography of adolescent
anomie, manifested in his tacky knitted hippy blankets or felt banners,
matched Koons's valorization of debased taste. However, the soiled
stuffed toys which he hung in claustrophobic clusters or scattered in
galleries were redolent of dysfunctional families or emotional surro-
gacy and thus read as direct ripostes to Koons's pristine replications of
toys [**120**]. Back in New York, the sculptor Robert Gober produced
similarly charged stand-ins for relationships and bodily needs in his
sealed plumbing fixtures, referencing Duchamp and Surrealism [**31**].
Here, however, a very specific set of contextual circumstances needs to
be supplied.

During the 1980s the spread of the AIDS virus had been responsible
for tragically destroying a sizeable proportion of America's male art
community. Many gay artists were therefore preoccupied with
expressing the polarities of desire and mourning. In New York such
representations ranged from the Cuban-born Felix Gonzales-Torres's
elegiac conceptually based billboards of 1992, showing poignantly

mute photographs of two adjacent pillows with indentations, to Gober's more overt wax sculptures of male body parts with phallic votive candles sprouting from them. In 1990 a touring retrospective of Robert Mapplethorpe's sexually explicit photographs, as described above, succeeded in provoking ringing accusations of obscenity from American conservatives. Mapplethorpe had died of AIDS in 1989 and the entire conjunction of circumstances led to a right-wing campaign against the imputed moral laxity of the arts, one outcome being a debate concerning the distribution of government funding by the US National Endowment for the Arts. It is clear, then, that the social determinants of late 1980s art were manifold.

Although nothing directly comparable could be found in Europe, the British artist Helen Chadwick echoed American concerns with the body's integrity and boundaries. Chadwick came to prominence in 1986 with the installation *Of Mutability* at London's ICA. Its main component was the 'Oval Court', a low, centrally-placed platform on which blue photocopies of parts of Chadwick's body, animal cadavers, and vegetable matter were jigsawed together to produce a representation of a 'pool' containing floating and swimming bodies. Chadwick made complex allusions to 'vanitas' emblems and Baroque iconography, showing herself, in multiple emanations, engaged in a sensual immersion in nature's cycles of fruition and decay.[31] By the early 1990s she was producing works such as *Loop My Loop*, a back-lit cibachrome photograph of a sow's intestines intertwined with braids of blonde hair [121]. Such works challenged conventional dualisms such as bestial and human, base and ideal, body and mind. Ultimately, the body's internal economy superseded the external, consumer-driven one. The impulse was perhaps solipsistic, or narcissistic, but it answered a yearning for experiential authenticity in the face of an increasingly mediated reality.

Installation as a paradigm

Many key works by Gober, Kelley, and Chadwick were installations. At the turn of the 1990s no one medium dominated Western art production, but installations were made by many practitioners at one time or another. The medium's history has been threaded through this book, with Duchamp's *Etant Donnés* and Robert Morris's Minimalist shift from a stress on the self-containment of the art object to its physical location as defining points [69]. Between 1987 and 1991 it served the needs of varying agendas. In 1987 the British artist Richard Wilson, who specialized in the medium, produced *20/50* [122], now permanently installed in London's Saatchi Collection, in which the viewer walks along a kind of enclosed jetty surrounded, at waist height, by an immense steel trough containing an expanse of impenetrable, glutinous sump oil. The effect is profoundly disorientating.

By contrast to Wilson's late modernist exploration of phenomenological paradox, 1991 saw a younger British artist named Damien Hirst produce a striking analogue for the relationship between aesthetic and lived experience. Wilson's installation had been designed for its location (site-specific), but Hirst's *In and Out of Love* [123], located in a makeshift gallery space in Woodstock Road, London, temporarily brought together a variety of disparate 'materials'. It also required the spectator's physical movement. In an upper room the cocoons of exotic butterflies were attached to large white canvases. Heat from radiators and plants in 'window boxes' at the bases of the canvases encouraged them to hatch and flourish briefly. In a lower room a myriad of

122 Richard Wilson
20/50, installation, 1987
The oil uncannily mirrors the ceiling of the gallery, leaving the spectator, figuratively speaking, in mid-air. Although currently installed in the Saatchi Gallery, the work was originally located in Matt's Gallery in East London. In that venue spectators had been able to view urban wasteland from the gallery's windows. The work's aura consequently seemed linked to the decline of manufacturing industries. This was lost in its later setting, where the effect was more streamlined and 'theatrical'.

gorgeous butterflies were embalmed on a set of brightly painted canvases. The butterflies' wings, in a curious mix of insensitivity and poetry, were lapped in paint.

What does the prevalence of installation art tell us about this period? As a medium, installation is defined by spatial location rather than by the materials that constitute it. Indeed, as the above examples indicate, its physical possibilities are virtually limitless. If its defining attribute is space, this necessarily implies horizontal extension—the occupation of 'sites'. From here we might move to an observation by the American critic Hal Foster. He asserts that a key structural transformation in Western art practice since the 1960s has been a shift from what he calls a 'vertical' conception of art, whereby artists investigate the disciplinary depths of a given genre or medium, to a 'horizontal' conception, whereby art activity is conceived of as a kind of terrain on which various areas of discourse are brought together. In Foster's words, it is now the case that 'many artists and critics treat conditions like desire or disease ... as sites for art'.[32] Installations such as Hirst's, with their urge to locate divergent feelings and issues rather than consolidate form, reflected this trend. But installation here should only

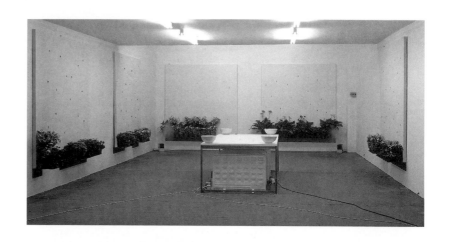

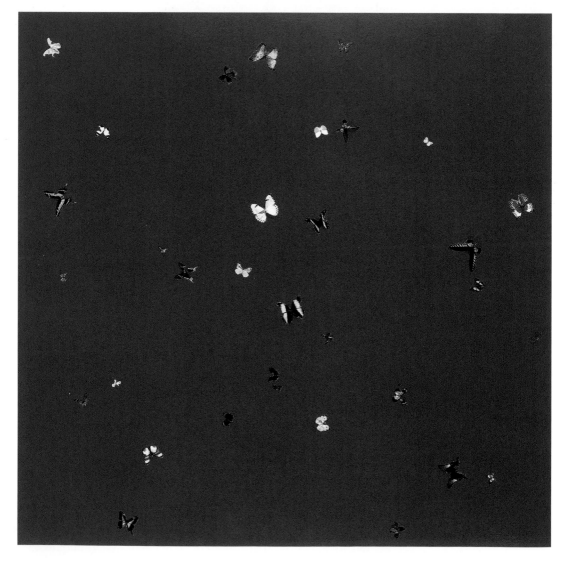

123 Damien Hirst

a) *In and Out of Love*, installation, 1991 **b)** *I Love You*, 1994–5

There was a lyrical quality to Hirst's use of butterflies' life-cycles, both in the 1991 installation *In and Out of Love*, and the related 1994–5 series of paintings, of which *I Love You* forms part. In other thematically related works Hirst used much more brutal imagery. In *A Thousand Years* (1990) a huge steel-and-glass vitrine contained a white painted box in which flies hatched from maggots. Emerging from a hole in the box, they flew around the vitrine, laying eggs on a cow's gruesomely flayed head sitting on the floor of the glass enclosure. Sooner or later the flies were destroyed by an electric 'fly-killer' hung from the ceiling of the vitrine.

be understood as a paradigm. In fact related principles of heterogeneity also held for photography, painting, or sculpture.

This talk of multiplicity inevitably recalls the larger theme of post-modernism, normally considered synonymous with pluralism. This chapter has acknowleged the stylistic revivalism and cultural relativism bound up with the subject. But it has mainly demonstrated that the underlying dynamic of the so-called postmodern era has been a tension, integral to art's practices and institutions, between a sense of historical entrapment, with all the 'symptoms' this involves, and the ethical injunction, inherited from modernism, of achieving critical distance. In a sense all the features of late 1980s art that have just been discussed could be seen as 'symptomatic'. Whatever its political commitments, identity-related art arose out of the lack of a social core; simulation art revelled in its lack of separation from the marketplace; abject art actually manifested itself in 'symptoms'. Possibly this argues for a sense of postmodernism as a 'cultural logic' which, at the turn of the 1990s, appeared both ongoing and inescapable. However, against this deterministic view, a proliferation of symptoms could, paradoxically, be understood to betoken health. All the signs were that Western art's critical frontiers were widening.

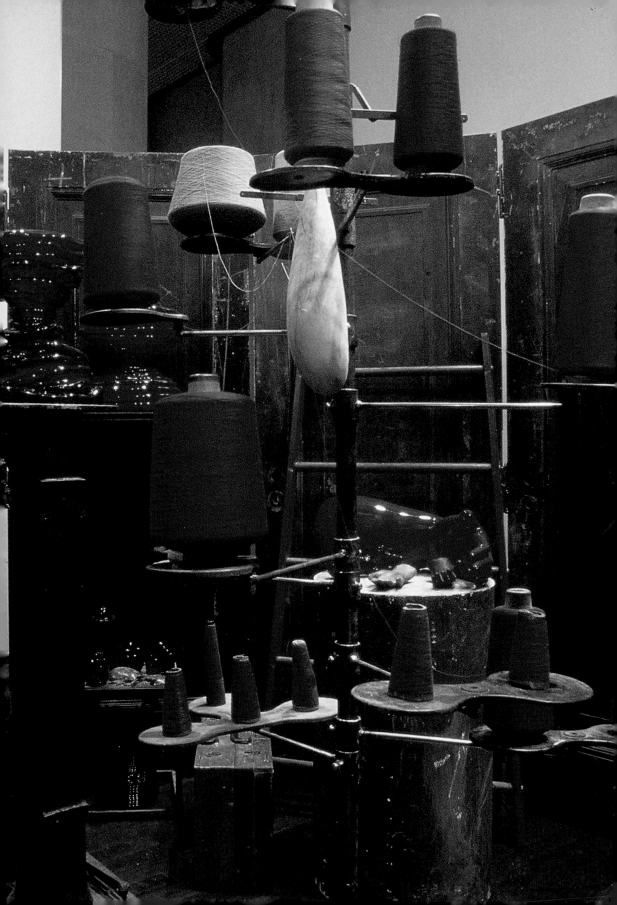

Into the 1990s

8

The Canadian artist Jeff Wall has been a central influence on recent European and American practice. In 1991–2 he produced a work entitled *Dead Troops Talk* [**124**]. Responding to a 1980s concern with the rehabilitation of 'history painting' [**111**] it allegorized not only the decline of the Soviet Union, whose unsuccessful involvement in Afghanistan echoed America's failed intervention in Vietnam, but also Europe's growing susceptiblity to religious or atavistic tendencies.[1] Whilst the Cold War opposition between capitalism and Communism had previously set the terms for post-1945 Europe, Russia's decline heralded the emergence of new historical forces.

In 1989 the Eastern bloc began splintering, reconfiguring Europe's political structure and opening the floodgates for factional struggles which are still underway. The most potent symbol of all was the dismantling of the Berlin Wall in November, presaging German reunification. Suddenly Eastern European artists became visible in the West, commenting on regimes they had left and underlining the West's complacencies. A leading figure here is Ilya Kabakov. One of an influential group of Moscow Conceptualists working in the 1970s and 1980s, he quickly gained notoriety in Western Europe for his installations. These included *The Toilet*, installed as an outbuilding at Kassel's Documenta 9 exhibition of 1992. It consisted of a full-scale replica of the dingy public toilets found in the Russian provinces, with the adjacent men's and women's sections turned into the living-room and bedroom of a typical Soviet two-room apartment. It thus commented sardonically on the way collectivism in Russia was giving way to privatization and on the dislocations of 'public' and 'private' involved for ordinary people.

Kabakov expressed himself in an ironic language familiar to Western art audiences. This was true also of Zofia Kulik, a Polish artist who received widespread exposure in the West. In elaborately constructed photo-works she explored images of masculinity, fetishistically juxtaposing naked men in heroic or martyr-like poses with military and religious emblems, and thereby interrogating the peculiar gender archetypes produced through the overlaying of official Communist

Detail of 129

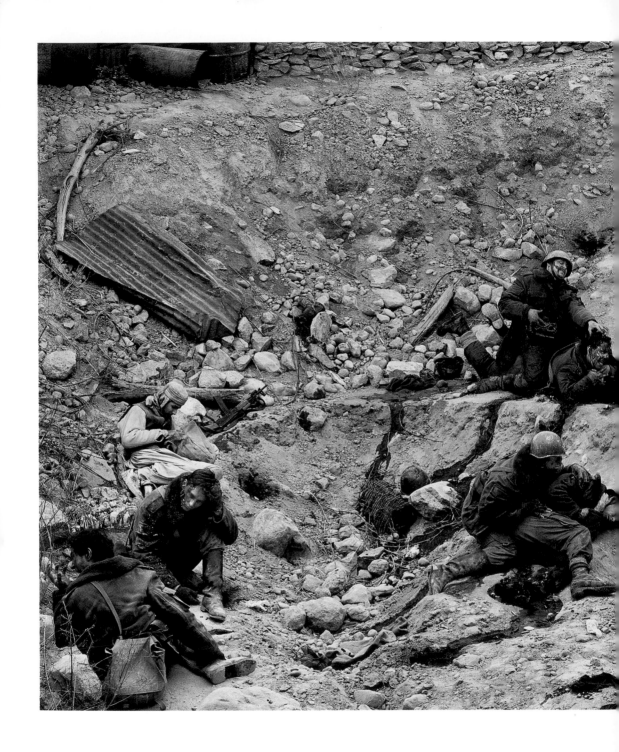

124 Jeff Wall

Dead Troops Talk (A Vision After an Ambush of a Red Army Patrol, Moqor, Afghanistan, Winter, 1986), 1991–2

This large, back-lit photographic transparency apparently shows soldiers killed in mid-action. The scene was actually mocked up by digitally manipulating images. In a tableau worthy of a ghoulish horror film, a young Moslem (centre left) searches a Russian soldier's possessions. He possibly emblematizes the Islamic Fundamentalism which the Russians were then attempting to counter in Afghanistan.

iconographies onto residual Polish Catholic ones [125].[2] Her works have superficial similarities to works by the British artists Gilbert and George, but their thematic premises are fundamentally different. In the 1990s Western European art happily assimilated practitioners who spoke its specialized language but, as with Kulik, many artists from former Communist countries were concerned with reconciling indigenous iconographies with late modernist/postmodernist forms, and thus were sceptical about the West's relatively deracinated artistic practices.

The turn of the 1990s also saw upheavals in the American art world, albeit much less radical ones. The stock market crashed in October 1987 and although this was followed by a short, spectacular art-buying boom, it was clear by the end of 1990 that the economic prosperity of the 1980s was over. At the same time, debates about American National Endowment for the Arts (NEA) funding, mentioned in the previous chapter, were particularly intense in late 1989 and early 1990. Conservatives in the US Senate (such as Jesse Helms) raised the disturbing spectre of state censorship.[3] A reproduction of the photographer Andres Serrano's *Piss Christ* (1987), an image of a crucifix immersed in urine, was actually torn up on the floor of the US Senate. The debate had the knock-on effect of raising questions about the relationship between 'alternative' arts practices and their assumed publics.

125 Zofia Kulik

From the *Columns* series: *Right Sword, Left Garland,* 1992

Between 1970 and 1987 Zofia Kulik carried out performances in her native Poland with fellow artist Przenyslaw Kwick. Her more recent photographic works contain a 'time-based' aspect in that, rather than constituting montages made up from separate images, they consist of images built up over time on a single sheet of paper, using a painstaking process involving stencils and techniques of masking. Her works normally deal with the iconography of power, whether linked to state or church.

The fact was that much politically motivated art of the 1980s shown in 'artist-run' venues supported by the NEA was actually seen by audiences who, far from having their assumptions 'disrupted', as the critical rhetoric claimed, were already committed 'non-conformists'.[4] By the mid-1990s anomalies like this led to a gradual withdrawal of US government arts support and a shift from public to private sector sponsorship. In Britain the introduction of a national lottery in 1993 became a means of offsetting an increasing disinclination to support the visual arts via public funds.

The British art revival

Paradoxically, Britain's traditional public indifference towards the visual arts had, at the start of the 1990s, provided the impetus for an artistic revival. In the face of limited outlets for their work, a group of students then studying at Goldsmiths College, London, decided to turn the entrepreneurial ethos of Thatcherism to their advantage. Late in 1988 Damien Hirst persuaded the London Docklands Development Corporation to allow him and his friends to use an abandoned building to stage a three-part exhibition titled 'Freeze'. As with later Hirst initiatives, such as *In and Out of Love* [123], this pragmatic bypassing of the regular professional procedures quickly attracted commercial

interest. With the help of London dealers such as Karsten Schubert and Jay Jopling, a roster of artists including Hirst, the sculptor/installation artists Sarah Lucas, Anya Gallaccio, and Mat Collishaw, and the painter Gary Hume attained international prominence under the 'yBa' (young British artists) banner. In Britain, artists associated with the trend became increasingly beholden to the voracious patronage of Charles Saatchi (see Chapter 7), thereby risking becoming typecast simply as 'Saatchi artists'. Part of Saatchi's collection of their work, bought cheaply en masse before prices soared, went on show in Britain in the Royal Academy's 'Sensation' exhibition in late 1997. The success of the yBas was consolidated by numerous international solo and group shows such as 'Brilliant: New Art from London', exhibited at the Walker Art Center, Minneapolis, in 1995. In 1996 the 'life/live' exhibition held in Paris demonstrated that artist-run spaces, underwritten as much by subcultural ties as by hard cash, were establishing new patterns of self-promotion by artists in Britain. This seemed to point to a wholesale adaptation to changing financial circumstances.

But was there anything distinctively new about 1990s British art? For many commentators works such as Hirst's notorious *The Physical Impossibility of Death in the Mind of Someone Living* (1991), a 14-foot

tiger shark preserved in formaldehyde in an enormous glass tank, or Sarah Lucas's *Au Naturel* [**126**], a bawdy assimilation of lovers' anatomies to the language of the playground or building site, simply rehashed American abject art or mindlessly recycled the tropes of Dada, Fluxus, or *Arte Povera*. British artists were not alone in reprocessing 1960s ideas. The Italian artist Maurizio Cattelan, an emergent talent of the later 1990s, was to make overt allusions to his country's *Arte Povera* idioms. In *Twentieth Century* (1997), for instance, a stuffed horse was suspended high above a gallery space as though signalling that the freedoms once symbolized by Jannis Kounellis's live horses [**87**] now seemed utopian. Critics in Britain also berated homegrown artists for tacitly capitulating to the market or to the chauvinism implicit in the promotion of their work abroad. However, it should be noted that several artists marshalled under the yBa banner, such as Mark Wallinger and Gavin Turk, were profoundly critical of Thatcherism's pro-nationalist legacy.[5]

By contrast to many among the critical intelligentsia, the critic John Roberts argued that the new British art, or at least the more localized working-class variants which he supported, possessed a number of distinctively new attributes. Most significantly it represented a reaction against the intellectual obscurantism of critical postmodernism, promoting strains of strategic 'philistinism' and proletarian 'disaffirmation'.[6] All in all, Roberts argued, a generation seemed to be emerging which, rather than forging worthy links between 'high' and 'low' cultural spheres like their postmodernist forebears, unselfconsciously accepted the pleasures of the demotic.

Whatever its street credibility, British art of the early 1990s often possessed a curiously anachronistic sensibility. Although Hirst's art, like that of his contemporaries Dinos and Jake Chapman, cultivated a deliberately 'laddish' disrespect for the politically correct attitudes of the 1980s, it simultaneously harboured a quasi-Victorian fascination with death and taxonomic specimens. Hirst's 'Victorianism' is emphasized in *Away from the Flock* (1994), where the single sheep preserved in formaldehyde is a distant cousin to the straying sheep in the British Pre-Raphaelite painter Henry Holman Hunt's *The Hireling Shepherd* (1851). This suggests that, like its nineteenth-century predecessor, the art of this *fin de siècle* had a rather morbid, backward-looking streak. Even the prevalence of video in the 1990s, which might suggest an openness to mass-media forms or technological adaptability, partly supports this.

Video art

The use of video as a medium was hardly new. The Fluxus artist Nam June Paik had experimented with television in the 1960s and the American Bruce Nauman, among others, had made artists' videos in

127 Gillian Wearing

Dancing in Peckham, video, 1994

The idea that art can provide access to an artist's inner being is amusingly, and pointedly, repudiated here. Wearing is completely immersed in her own world. In the video, no soundtrack accompanies her dancing. She has talked about her interest in fathoming people's inner motivations as being stimulated by a series of documentaries produced in 1964–77 for Britain's BBC/Granada television. Initially entitled *Seven Up*, they tracked the lives of a diverse group of people at regular intervals from the age of seven.

the 1980s. Its widespread adoption in the 1990s, however, may have been bound up with its narrative potential as a time-based medium (although straightforward narration was rarely involved), suggesting a retreat from the instantaneity or simultaneity courted in much twentieth-century art.

For instance, in his *24 Hour Psycho* (1993), the Glasgow-based Neo-Conceptualist Douglas Gordon sought to uncover the unforeseen 'micro-narratives' lurking in Alfred Hitchcock's classic film by slowing it down to approximately two frames per second. Working in London, the English artist Gillian Wearing explored the disparities between people's interior and exterior lives in works such as the 25-minute *Dancing in Peckham* (1994), where she presented herself dancing self-absorbedly to imaginary music in a shopping centre [**127**]. In other works she examined the hidden dynamics of relationships. In *Sacha and Mum* (1996) the video is played forwards and backwards so that the ambivalent relations between a mother and her daughter, involving the former's embraces flipping into disturbing acts of abuse, are rendered visible.

Video took widely divergent forms elsewhere in Europe and the US. The Americans Bill Viola and Gary Hill frequently invoked intense bodily or metaphysical experiences, paying close attention to the way their video installations, which typically employed multiple monitors or large screens, were set up in dramatically darkened spaces. In Hill's *Tall Ships* (1992), for example, the spectator enters a corridor where he or she is 'visited' by a series of projected human presences. Having first appeared as spots of light, they approach the spectator, as if soliciting contact, and then turn around to recede again. In marked contrast the Northern Irish artist Willie Doherty exploited video's associations with practices of social surveillance and reportage. In his *The Only Good One is a Dead One* (1993) the spectator is positioned uneasily between two projections, one produced by a static camera trained on a city street at night, the other produced by a camera tracking along a country road. An Irishman's voice on the soundtrack alternates between the viewpoints of a victim and an aggressor. The spectator thus re-experiences the personal anxieties linked to the doctrinal and ideological divisions of Derry, Northern Ireland, where Doherty works.

Individualism and globalization

Such a range of video practices attests to a strongly individualistic slant in 1990s art which can be contrasted with a much-touted trend in the period towards globalization. On the one hand, internationally acclaimed figures such as the French artist Sophie Calle continued to explore postmodern themes relating to authorial positioning. In her *Double Game* project, published in book form in 1999, Calle collaborated with one of the doyens of postmodern literature, the American novelist

How Does a Girl Like You Get to Be a Girl Like You? 1997

This work by Shonibare consists of three clothed mannequins standing on a low platform. Their stiff postures and high Victorian dresses, complete with petticoats and bustles, evoke British decorum in the Age of Empire. However, the busy patterns and bright colours of the cloth produce contradictory cultural associations. Notions of dress, ethnic status, museum display, and artistic value are brought into collision. Shonibare builds on discourses eroding distinctions between the fine and applied arts [**19, 119**] but inserts a dimension of cultural difference.

Paul Auster. In his *Leviathan* (1992) Auster had based a character, Maria, on Calle's peculiar 'performances' of the 1980s such as *Suite vénitienne* (1980), which had involved her surreptitiously following a partial stranger to Venice and documenting his movements photographically. In the 1990s she recomplicated these authorial switches by carrying out certain additional tasks Auster had assigned her fictional counterpart. These included strict adherence to a 'chromatic diet' involving eating foods of one specified colour per day.[7]

By contrast to such essentially solipsistic pursuits, many younger artists of the 1990s reflected new conditions of cultural hybridization and global cross-fertilization. The British artist Yinka Shonibare, who was born in England but brought up by Nigerian parents in Lagos, sought to contest the 'authentic' ethnic origins that had preoccupied many culturally displaced artists of the 1980s. Working with patterned fabrics which connoted 'Africa' but had actually begun life in their raw state in England or Holland, he produced dresses which bore witness to the cultural hybridities stemming from colonialism [**128**].

Shonibare's work implicitly endorses a forecast by the film historian and critic Peter Wollen to the effect that, on the evidence of the 1980s and 1990s, changing patterns of international migration and tourism, along with redistributed relations between urban centres and their peripheries across Europe and the Third World, will increasingly influence, and rejuvenate, cultural forms. Warning against a too

129 Louise Bourgeois

Red Room (Child),
installation, 1994

The colour red, connotative of
intense passion,
predominated in the two
cramped spaces forming this
installation. One important
theme here was regressive
psychological fantasy. But
there was also a sense that
ancient knowlege was being
recovered. The peculiar glass
bottles and flasks in many of
Bourgeois's early 1980s
installations related to
alchemy. Their scenarios also
seemed to conform to the logic
of fairy tales.

'Eurocentric' understanding of both modernism and postmodernism Wollen asserts that the future will see ever-greater cultural diffusion.[8] His prediction offers a dynamic vision of cultural renewal, but it could be seen as downplaying capital's controlling grip. As the 1990s art market became increasingly globalized, other critics saw a strategic need to shift the emphasis away from diversity towards the need for 'local' pockets of resistance to a market-led world system.

Psychic resources: memory and fantasy

Perhaps it is wisest to forgo the need for predictions. One way to conclude is to take a snapshot of the work of two artists of the 1990s who, although diverging in gender and age, embody a tendency to return to the resources of the psyche.

Louise Bourgeois, previously discussed in Chapter 5, was a presiding senior figure of the decade, exhibiting a series of small, room-like 'cells' between 1991 and 1994 filled with strange sculptures of body parts or symbolic 'furnishings', and constituting further explorations of the role played in her psychic life by her parents. In 1994 she exhibited two *Red Rooms* at Peter Blum's gallery in New York. One was designated as that of a parental couple, the other that of a child. The parents' room was impeccably neat, with a closed instrument case placed on the bed and a

130 Matthew Barney

Still from *Cremaster 4*, video, 1994–5

This book has contained a diversity of constructions of artistic identity since 1945 [**37**, **39**, **41**, **79**, **97**, **117**, **127**]. Here the artist aspires to a metamorphosis which hints partly at mythology, partly at science fiction. However, with mock pathos, Barney's floppy ears and dual kiss curls inadequately match up to the four horns of the ram which the video's plot establishes as his ideal.

strange, misshapen object hanging ominously above the bed. The child's room, by contrast, was dominated by numerous spools and enigmatic glass ornaments [**129**]. Bougeois's mother had been a tapestry restorer and had previously been invoked by the artist via spindle-like forms. In this context the vast quantity of thread seemed to signify the amount of unwinding and mending in store for the child as, growing up, it was obliged to recapitulate its origins.

Working at the end of the 1990s, Bourgeois asserted the irreducible, ongoing primacy of human memory and the unconscious. Her art looks backward. By contrast, the work of the younger American artist, Matthew Barney, looks forward ambivalently, conjuring up futuristic technological fantasies.

On the whole, the technologies of the 1990s have not had a major structural impact on art. Digitalization has become widespread in photography and film, but the Internet, although potentially the means of generating a new pool of creative energies in the manner of 1960s Conceptualism, has yet to yield up much of consequence. Barney makes full use of the technologies available, but he concocts a lush vision of a world where technology has become not so much a tool as something invasive.

His series of generically titled *Cremaster* videos has involved enigmatic narratives steeped in bizarre imagery. In *Cremaster 4* (1994) the plot revolves around a hybrid satyr-cum-dandy (played by Barney) whose ambition, it seems, is to achieve the more impressive hybridity of the Loughton Ram, one of a four-horned species of ram from the Isle of Man [**130**]. The hero finally attains the ram's realm (the Isle of Man itself) via a peculiar descent into the sea followed by a journey along a form of uterine passageway (possibly symbolizing rebirth). His libidinal metamorphoses are meanwhile symbolized by the futuristic image of two teams of motorbike and sidecar riders, in matching yellow and blue leathers, who rapidly circuit the island in reverse directions.[9]

What does Barney's strange conjunction of sportswear fetishism, technological streamlining, and surreal camp add up to? It could certainly be an elaborately humorous parody of masculine aspirations. Many have seen a crisis of masculinity, tied up with the social shifts arising from women's empowerment, as endemic to the 1990s. It seems more likely, however, that it dramatizes the desire to transcend human givens, to achieve bio-mechanical syntheses. This has a a real resonance with 1990s concerns with issues such as cloning and genetic engineering and, in this sense, Barney's work offers an appropriate note on which to finish. This book began by describing an atomic explosion. It ends with a satire on hubris.

Notes

Introduction

1. Adorno, 'On Commitment', as reprinted in Charles Harrison and Paul Wood, *Art in Theory*, Oxford, 1992, p. 761.

Chapter 1. The Politics of Modernism: Abstract Expressionism and the European *Informel*

1. First published in translation in *Partisan Review*, vol. IV, no. 1, New York, Fall 1938, pp. 49–53.
2. Mark Rothko and Adolph Gottlieb, letter to the *New York Times*, 7 June 1943.
3. See Michael Leja, *Reframing Abstract Expressionism*, Yale, 1993, chs 2–4. Links to *film noir* are made on pp. 109–14.
4. Arthur Schlesinger: *The Vital Center*, Boston, 1962, p. 57. (Originally published Boston, 1949.)
5. See Leja, *Reframing*, p. 198.
6. See Serge Guilbaut, *How New York Stole the Idea of Modern Art*, Chicago, 1983, p. 242, note 50.
7. T. J. Clark, 'Jackson Pollock's Abstraction', in S. Guilbaut (ed.), *Reconstructing Modernism*, Cambridge, Mass., 1990, p. 180.
8. Guilbaut, *Reconstructing Modernism*, pp. 91 and 115.
9. Clement Greenberg, 'The Decline of Cubism', *Partisan Review*, March 1948, p. 369.
10. Guilbaut, 'Postwar Painting Games: The Rough and the Slick', in Guilbaut, *Reconstructing Modernism*, pp. 39–43.
11. Barnett Newman in 'Frontiers of Space' (interview), in J.P. O'Neill (ed), *Barnett Newman: Selected Writings and Interviews*, California, 1992, p. 251.
12. Greenberg, 'The Situation at the Moment', *Partisan Review*, January 1948.
13. Newman, 'The Sublime is Now', in O'Neill, *Barnett Newman*, p. 173.
14. Michel Tapié, *Un Art Autre où il s'agit de nouveaux dévidages du réel*, Paris 1952.
15. Jean Dubuffet, quoted in Peter Selz, *Jean Dubuffet*, MOMA, New York, 1962, p. 64.

16. *Ibid.*
17. See, for instance, Melanie Klein, 'A Contribution to the Psychogenesis of Manic-Depressive States' (1935), in J. Mitchell (ed.), *The Selected Melanie Klein*, London, 1986, pp. 115–46.
18. For Guilbaut on Bataille see his 'Postwar Painting Games', *Reconstructing Modernism*, pp. 50–60, whilst for a counter-argument see Sarah Wilson, 'Paris Post War: In Search of the Absolute', in *Paris Post War: Art and Existentialism 1945–1955* (ex. cat.), Tate Gallery, 1993, pp. 27 and 45.
19. Mark Rothko, 'The Romantics were Prompted …', in R. Motherwell and H. Rosenberg (eds), *Possibilities*, no. 1, 1947/8, p. 84.
20. Robert Motherwell, quoted by Guilbaut, *Reconstructing Modernism*, p. 177.
21. Greenberg, 'Review of Exhibitions of Jean Dubuffet and Jackson Pollock', *The Nation*, 1 February 1947.
22. Published in *Partisan Review*, Fall 1939 and July–August 1940 respectively.
23. Greenberg, 'American-Type Painting', *Partisan Review*, Spring 1955.
24. *Ibid.*
25. Greenberg, 'The Present Prospects of American Painting and Sculpture', *Horizon*, October 1947.
26. See John O'Brian, *Clement Greenberg: The Collected Essays and Criticism*, vol. 3, Chicago, 1995, pp. xxxvi–xxxviii.
27. See Roszika Parker and Griselda Pollock, *Old Mistresses: Women, Art and Ideology*, London, 1981, pp. 145–51. See also Pollock's recent discussion of Frankenthaler, 'Killing Men and Dying Women', in F. Orton and G. Pollock, *Avant-Gardes and Partisans Reviewed*, Manchester, 1996, pp. 221–94.
28. Patrick Heron, 'The Ascendancy of London in the Sixties', *Studio International*, December 1966, pp. 280–1.
29. *Ibid.*, p. 218.
30. Greenberg, 'Present Prospects'.

31. Edwin Denby, *The 1930s: Painting in New York*, New York, 1957. Quoted in Dore Ashton, *The Life and Times of the New York School*, London, 1972, p. 4.

32. See T. J. Clark, 'Clement Greenberg's Theory of Art', in F. Frascina (ed.), *Pollock and After*, London, 1985, pp. 47–63.

33. *Ibid.*, p. 59.

34. Harold Rosenberg, 'The American Action Painters', *Art News*, December 1952.

35. Fred Orton, 'Action, Revolution and Painting', in Orton and Pollock, *Avant-Gardes*, p. 195. See also David Craven, *Abstract Expressionism as Cultural Critique* (Cambridge, 1999) for a discussion of continuing left-wing sympathies among the Abstract Expressionists in the 1950s and 1960s.

36. Allan Kaprow, 'The Legacy of Jackson Pollock', *Art News*, 57, no. 6, 1958.

Chapter 2. Duchamp's Legacy: The Rauschenberg–Johns Axis

1. Marcel Duchamp, 'The Creative Act', trans. in M. Sanouillet and E. Peterson, *Salt Seller*, New York, 1973.

2. John Cage, 'Experimental Music', in *Silence* (1971), London, 1980, p. 12.

3. See 'The Richard Mutt Case' in *The Blind Man*, no. 2, May 1917.

4. Leo Steinberg, 'Other Criteria', in *Other Criteria: Confrontations with Twentieth Century Art* (1972), Oxford, 1975, p. 88.

5. David Halberstam, *The Fifties*, New York, 1993, p. 501.

6. Brian O'Doherty, 'Rauschenberg and the Vernacular Glance', *Art in America*, September–October 1973.

7. Steinberg, 'Other Criteria', p. 90.

8. Robert Rauschenberg, letter to Betty Parsons, 18 October 1951, reproduced in Walter Hopps, *Robert Rauschenberg: The Early 1950s* (ex. cat.), Menil Collection/Houston, 1991, p. 230.

9. See my 'Questioning Dada's Potency', *Art History*, vol. 15, no. 3, September 1992. See also James Leggio, 'Robert Rauschenberg's "Bed" and the Symbolism of the Body', in *Essays on Assemblage*, MOMA, New York, 1992.

10. See Helen Molesworth, 'Before Bed', *October*, no. 63, Winter 1993, pp. 68–82.

11. Mary Douglas, *Purity and Danger: An Analysis of the Concepts of Pollution and Taboo*, London, 1966.

12. The term first appears to have been used by Robert Rosenblum in a review of an exhibition incorporating Rauschenberg and Johns at Castelli's gallery in May 1957.

13. William Seitz, *The Art of Assemblage* (ex. cat.), MOMA, New York, 1961, p. 87.

14. Allen Ginsberg, 'Howl' (1955), *Selected Poems*, Harmondsworth, 1996, p. 49.

15. See Laurie Monahan, 'Cultural Cartography: American Designs at the 1964 Venice Biennale', in Serge Guilbaut (ed.), *Reconstructing Modernism*, Cambridge, Mass., 1990, pp. 369–407.

16. William de Kooning, 'Content is a Glimpse' (interview with David Sylvester), *Locations*, 1, Spring 1963, pp. 45–8.

17. Clement Greenberg, 'After Abstract Expressionism', *Art International*, October 1962.

18. For close examination of the picture's surface see Fred Orton, *Figuring Jasper Johns*, London, 1994, pp. 125–7.

19. Moira Roth, 'The Aesthetics of Indifference', *Artforum*, November 1977, pp. 46–53.

20. *Ibid.*, p. 51.

21. Orton, *Figuring Jasper Johns*, pp. 145–6.

22. For Duchamp's position on the 'readymades' in the 1960s see William Camfield, *Marcel Duchamp: Fountain*, Menil Collection/Houston, 1989, pp. 81–99.

23. Duchamp, note 18 in P. Matisse (ed.), *Marcel Duchamp, Notes*, Boston, 1983.

Chapter 3. The Artist in Crisis: From Bacon to Beuys

1. John Russell, *Francis Bacon*, London, 1979, p. 10.

2. Georges Bataille, 'La Bouche' (The Mouth), *Documents*, Paris, no. 5, 1930, pp. 299–300.

3. Dawn Ades, 'Web of Images', in *Francis Bacon* (ex. cat.), Tate Gallery, London, 1985, pp. 13–15.

4. David Sylvester, *Interviews with Francis Bacon*, London, 1980, reprinted 1985, p. 17.

5. John Berger, 'Staying Socialist', *New Statesman and Nation*, 31 October 1959.

6. Jean-Paul Sartre, 'The Search for the Absolute', in *Alberto Giacometti: Sculptures, Paintings, Drawings*, Pierre Matisse Gallery, New York, 1948.

7. Jean Genet, 'L'atelier d'Alberto Giacometti', *Derrière Le Miroir*, June 1957, p. 7.

8. Jacques Lacan, *The Four Fundamental Concepts of Psycho-analysis*, London, 1977, pp. 72–3.

9. Antonin Artaud, 'Le Visage Humain' (manuscript version), as quoted by Agnès de la Beaumelle in M. Rowell (ed.), *Antonin Artaud: Works on Paper*, MOMA, New York, 1996, p. 90.

10. See Rowell, *Antonin Artaud*, p. 13.

11. Peter Selz, *New Images of Man* (ex. cat.), MOMA, New York, 1959, p. 12.

12. Michel Foucault, *Les Mots et les Choses* (Paris, 1966), trans. as *The Order of Things*, London, 1989, p. 387.

13. Daniel Spoerri, *An Anecdoted Topography of Chance*, trans. M. Green, Atlas, London, 1995, p. 87.

14. Yves Klein, 'Le vrai devient réalité', *Zero*, Düsseldorf (1958–61), reprinted Cambridge, Mass., 1973, p. 88.

15. Yves Klein, 'Mon Livre', section published in *Yves Klein*, Musée National d'Art Moderne, Paris, 1983, p. 172.

16. Thierry de Duve, 'Yves Klein or the Dead Dealer', *October*, 49, Summer 1989.

17. Marcel Duchamp, note of 1914, as trans. in M. Sanouillet and E. Peterson (eds), *The Writings of Marcel Duchamp*, Oxford, 1973, p. 24. See also Gerald Silk, 'Myths and Meanings in Manzoni's "Merda d'Artista"', *Art Journal*, Fall 1993, vol. 52, no. 3, pp. 65–75.

18. Benjamin Buchloh, 'Beuys: The Twilight of the Idol', *Artforum*, vol. 18, January 1980, pp. 39–40.

19. Beuys, quoted in Caroline Tisdall, *Joseph Beuys*, London, 1979, p. 17.

20. Tisdall, *Joseph Beuys*, p. 105.

21. See Caroline Tisdall, 'Beuys: Coyote', *Studio International*, July/August 1976, pp. 36–40.

22. Buchloh, 'Beuys', p. 38 and *passim*.

23. Georg Baselitz and Eugen Schönebeck, *Pandemonium 1*, Berlin, November 1961, trans. in *Georg Baselitz, Paintings 1960–83*, Whitechapel Gallery, London, 1983, p. 23.

Chapter 4. Blurring Boundaries: Pop Art, Fluxus, and their Effects

1. Thomas Crow, 'Modernism and Mass Culture in the Visual Arts', in his *Modern Art in the Common Culture*, New Haven and London, 1996, pp. 3–37.

2. Lawrence Alloway, 'The Long Front of Culture', *Cambridge Opinion*, no. 17, 1959.

3. Walter Benjamin's essay was first published in *Zeitschrift für Sozialforschung*, vol. V, no. 1, New York, 1936.

4. Richard Hamilton, 'Persuading Image', *Design*, February 1960, pp. 28–32.

5. Hamilton, 'An Exposition of *$he*', *Architectural Design*, October 1962.

6. Hamilton, Letter to the Smithsons, 16 January, 1957. In his *Collected Words*, London, 1982, p. 28.

7. Dick Hebdige, 'Towards a Cartography of Taste', *Block*, no. 8, 1983, pp. 54–68, and David Alan Mellor, 'A Glorious Techniculture', in D. Robbins (ed.), *The Independent Group: Postwar Britain and the Aesthetics of Plenty*, Cambridge, Mass., 1990, pp. 229–36.

8. Lawrence Alloway, 'The Development of British Pop', in L. Lippard (ed.), *Pop Art*, London, 1966, reprinted 1974, p. 66.

9. Theodor Adorno, 'On Commitment', translated in A. Arato and E. Gebhardt (eds), *The Essential Frankfurt School Reader*, New York, 1978, p. 318.

10. See Kristine Stiles, 'Between Water and Stone: A Metaphysics of Acts', in *In the Spirit of Fluxus* (ex. cat.), Walker Art Center, Minneapolis, 1993, pp. 77–9 and *passim*.

11. *Ibid.*, p. 72.

12. Susan Sontag, 'Notes on Camp', *Partisan Review*, Fall 1964, pp. 515, 526–7.

13. Andreas Huyssen, 'Mass Culture as a Woman', in *After the Great Divide: Modernism, Mass Culture, Postmodernism*, Indiana University Press, 1986.

14. Harold Rosenberg, 'The American Action Painters', *Art News*, 51, December 1952, pp. 21–2.

15. Charles Baudelaire, 'The Painter of Modern Life', in *The Painter of Modern Life and Other Essays*, trans. Jonathan Mayne, New York, 1964, p. 33.

16. Andy Warhol, interview with Gene Swenson, 'What is Pop Art?', *Art News*, 62, November 1963, p. 25.

17. See Crow, 'Saturday Disasters: Trace and Reference in Early Warhol', in his *Modern Art in the Common Culture*, pp. 49–65. For the issue of social conscience in Warhol, see also Anne Wagner: 'Warhol Paints History, or Race in America', *Representations*, 55, 1996, pp. 98–119.

18. Warhol, interview with Gene Swenson, 'What is Pop Art?'

19. For Warhol's work and the 'pathological public sphere' see Hal Foster, 'Death in America', *October*, Winter 1996, pp. 37–59.

20. See Caroline Jones, *Machine in the Studio: Constructing the Postwar American Artist*, Chicago, 1996, pp. 221–2.

21. See Gene Swenson, 'The F-111: An Interview with James Rosenquist', *Partisan Review*, vol. XXXII, no. 4, Fall 1965, pp. 589–90.

22. S. Polke and G. Richter, joint text for ex. cat., Galerie h, Hanover, 1966. Trans. D. Britt in H.-U. Obrist (ed.), *Gerhard Richter: The Daily Practice of Painting*, London, 1995, p. 42.

Chapter 5. Modernism in Retreat: Minimalist Aesthetics and Beyond

1. See his 'Art-as-Art', *Art International*

(Lugano), December 1962.

2. Clement Greenberg, 'After Abstract Expressionism', *Art International*, October 1962.

3. Robert Rosenblum, *Frank Stella*, Harmondsworth, 1971, p. 21.

4. Michael Fried, *Three American Painters: Noland, Olitski, Stella* (ex. cat.), Fogg Art Museum, Cambridge, Mass., 1965, reprinted in his *Art and Objecthood*, Chicago, 1998, p. 256.

5. See Anna Chave, 'Minimalism and the Rhetoric of Power', *Arts Magazine*, vol. 64, no. 5, January 1990, pp. 46–51 and *passim*. See also Brenda Richardson, *Frank Stella: The Black Paintings* (ex. cat.), Baltimore Museum of Art, 1976.

6. See Caroline Jones, *The Machine in the Studio: Constructing the Post-War Artist*, Chicago, 1996, pp. 156–7.

7. *Ibid.*, p. 167.

8. 'Questions to Stella and Judd', interview by Bruce Glaser, ed. Lucy Lippard, *Art News*, September 1966.

9. See Donald Judd, 'Specific Objects', *Arts Yearbook*, 8, New York, 1965, pp. 74–82.

10. Richard Wollheim, 'Minimal Art', *Arts Magazine*, January 1965.

11. Robert Morris, 'Notes on Sculpture, Part 2', *Artforum*, vol. 5, no. 2, October 1966, pp. 20–3.

12. *Ibid.*, p. 1

13. See Hal Foster, 'The Crux of Minimalism', in H. Singerman (ed.), *Individuals: A Selected History of Contemporary Art 1945–86*, Museum of Contemporary Art, Los Angeles, 1988, pp. 162–83.

14. Rosalind Krauss, 'LeWitt in Progress', in *The Originality of the Avant Garde and Other Modernist Myths*, Cambridge, Mass., 1985, pp. 245–58.

15. Sol LeWitt, 'Paragraphs on Conceptual Art', *Artforum*, vol. V, June 1967, p. 79.

16. Fried, 'Art and Objecthood', *Artforum*, vol. V, June 1967.

17. Greenberg, 'Recentness of Sculpture', first published in *American Sculpture of the Sixties* (ex. cat.), Los Angeles County Museum of Art, 1967.

18. Carl Andre, quoted in David Bourdon, 'The Razed Sites of Carl Andre', *Artforum*, October 1966.

19. Andre, quoted *ibid.*, p. 107.

20. See the editorial, *Burlington Magazine*, April 1976, pp. 187–8, and Richard Morphet's response in the same journal, November 1976, pp. 762–7.

21. See Agnes Martin, 'Answer to an Inquiry', in Dieter Schwarz, *Agnes Martin:*

Writings/Schriften, Winterthur Kunstmuseum, Switzerland, 1992, p. 29.

22. Krauss, 'Afterthoughts on "Op"', *Art International*, June 1965, pp. 75–6.

23. Krauss, *The Optical Unconscious*, Cambridge, Mass., 1993, ch. 3.

24. Robert Morris, 'Anti Form', *Artforum*, vol. 6, no. 8, April 1968, pp. 33–5.

25. Lucy Lippard, catalogue essay of 1966, cited by Lippard in *Eva Hesse*, New York, 1976, p. 83.

26. For a sophisticated psychoanalytic approach to Hesse see Briony Fer, 'Bordering on Blank: Eva Hesse and Minimalism', *Art History*, vol. 17, no. 3, September 1994.

27. Eva Hesse, *Notebooks*, cited by Anne Wagner, *Three Artists (Three Women)*, California, 1996, p. 238.

28. See Douglas Crimp, 'Serra's Public Sculpture: Redefining Site Specificity', in Laura Rosenstock (ed.), *Richard Serra/Sculpture*, MOMA, New York, 1986, pp. 40–56.

Chapter 6. The Death of the Object: The Move to Conceptualism

1. See Douglas Crimp, 'The End of Painting', *October*, 16, 1981, pp. 69–86.

2. Asger Jorn, 'Detourned Painting', in Elizabeth Sussman (ed.), *On the Passage of a Few People Through a Rather Brief Moment in Time: The Situationist International 1957–1972*, ICA, Boston, 1989, p. 140.

3. Daniel Buren, interview with David Batchelor, *Artscribe*, November/December 1987, pp. 51–4.

4. This reading relies heavily on Alexander Alberro's 'The Turn of the Screw …', *October*, 80, 1997, pp. 57–84.

5. See Stefan Germer, 'Haacke, Broodthaers, Beuys', *October*, 45, 1988, pp. 63–75.

6. Quoted by Haacke in *Hans Haacke: Unfinished Business*, ed. Brian Wallis, Cambridge, Mass., 1986, p. 96.

7. See Peter Bürger, *Theory of the Avant Garde*, trans. M. Shaw, Minnesota, 1984, esp. ch. 4.

8. Gordon Matta Clark, as quoted by Donald Wall, 'Gordon Matta Clark's Building Dissections', *Arts Magazine*, 50, no. 9, 1976, p. 76.

9. Germano Celant, from Celant (ed.), *Arte Povera*, Milan, 1969, trans. as *Arte Povera. Conceptual or Impossible Art*, London, 1969, p. 226.

10. *Ibid.*, p. 230.

11. Robert Smithson, interview with Bruce Kurtz, in Nancy Holt (ed.), *The Writings of Robert Smithson*, New York, 1979, pp. 200–4.

12. Smithson, 'The Spiral Jetty', in Holt, *The Writings*, p. 113.

13. Smithson, 'A Sedimentation of the Mind: Earth Projects', *Artforum*, September 1968.

14. Ian Hamilton Finlay, 'Unconnected Sentences on Gardening', in *Nature Over Again After Poussin: Some Discovered Landscapes* (ex. cat.), University of Strathclyde, Glasgow, 1980, pp. 21–2.

15. Lucy Lippard, *Six Years: The Dematerialization of the Art Object*, New York, 1973.

16. Joseph Kosuth, 'Art After Philosophy' (parts I–III), *Studio International*, vol. 178, nos 915–17, October, November, and December 1969.

17. See Benjamin Buchloh, 'From the Aesthetics of Administration to Institutional Critique …', *October*, 55, 1990, pp. 124–8 and *passim*.

18. See Lippard's preface to her *Six Years*.

19. See Tony Godfrey, *Conceptual Art*, London, 1998, p. 224.

20. See Buchloh, 'Aesthetics', pp. 128–9 and *passim*.

21. See Charles Harrison, *Essays on Art & Language*, Oxford, 1991, chs 3 and 4.

22. Roland Barthes, 'Myth Today', in *Mythologies*, trans. A. Lavers, London, 1973, reprinted 1981, p. 116.

23. See Victor Burgin, 'Sex, Text, Politics', interview with Tony Godfrey, *Block*, 7, 1982, pp. 7–8.

24. Robert Hughes, 'An Obsessive Feminist Pantheon …', *Time*, vol. 15, December 1980, p. 85.

25. See Griselda Pollock, 'Screening the Seventies …', in her *Vision and Difference*, London, 1988, pp. 155–99.

26. See Laura Mulvey, 'Visual Pleasure and Narrative Cinema', *Screen*, 16, no. 3, 1975, pp. 6–18.

27. For instance, *Of Grammatology* (1967), published in a 1976 edition (Johns Hopkins University Press), and *Writing and Difference* (1967), published London, 1978.

28. Willoughby Sharp, 'Body Works', *Avalanche 1*, Fall 1970, pp. 14–17.

29. Mary Kelly, 'Re-Viewing Modernist Criticism', *Screen*, 22, no. 23, 1981, pp. 41–62 (section on 'The Crisis of Authorship').

30. Jacques Derrida, 'The Theater of Cruelty and the Closure of Representation', *Writing and Difference*, London, 1978.

31. See Amelia Jones, *Body Art: Performing the Subject*, University of Minnesota Press, 1998, ch. 4. Jones's book has closely informed aspects of my reading of Body Art.

32. See Carolee Schneeman, *More Than Meat Joy: Performance Works and Selected Writings*, New York, 1997, pp. 234–9.

Chapter 7. Postmodernism: Theory and Practice in the 1980s

1. This periodization was developed by Ernest Mandel in his *Late Capitalism* (London, 1978) and taken up by Fredric Jameson in his seminal 'Postmodernism, or the Cultural Logic of Late Capitalism', *New Left Review*, no. 146, July–August 1984, pp. 59–92. For an account of 'post-Fordism' see David Harvey, *The Condition of Postmodernity*, Oxford, 1989, pp. 121–97.

2. See Ihab Hassan, 'The Culture of Postmodernism', *Theory, Culture and Society*, vol. 2, no. 3, 1985, pp. 123–4.

3. Charles Jencks, *The Language of Post-Modern Architecture*, London, 1977, reprinted 1987, p. 9.

4. Jean-François Lyotard, *La Condition Postmoderne, Rapport sur le Savoir*, Paris, 1979.

5. Habermas's lecture is published in Hal Foster (ed.), *Postmodern Culture*, London, 1985, pp. 3–15.

6. Jameson, 'Postmodernism'.

7. For Baudrillard on simulation see his 'Simulacra and Simulations', in *Selected Writings*, ed. Mark Poster, Oxford, 1988, pp. 166–84.

8. Jameson, 'Postmodernism'.

9. See Harvey, *The Condition of Postmodernity*, pp. 284–307.

10. Christos Joachimides, 'A New Spirit in Painting', from *A New Spirit in Painting* (ex. cat.), Royal Academy of Arts, London, 1981, p. 14.

11. Pierre Restany, 'Some Opinions on Documenta 7', *Flash Art*, November 1982, p. 42.

12. Achille Bonito Oliva, *La Transavanguardia Italiana*, trans. as *The Italian Trans-avantgarde*, Milan, 1980.

13. Donald Kuspit, 'Flak from the Radicals: The American Case Against German Painting', in Brian Wallis (ed.), *Art After Modernism: Rethinking Representation*, New York, 1984, p. 141.

14. Andreas Huyssen, 'Anselm Kiefer: The Terror of History, the Temptation of Myth', *October*, 48, Spring 1989, pp. 25–45.

15. Benjamin Buchloh, 'Figures of Authority, Ciphers of Regression …', *October*, 16, Spring 1981, pp. 39–68.

16. Schnabel was then aged 36. For a general account see Irving Sandler, *Art of the Postmodern Era*, New York, 1996, p. 438 and related notes.

17. Rosalind Krauss, 'Notes on the Index Parts I and II', *October*, nos 3 and 4, Spring and Fall 1977.

18. See Richard Bolton, 'Enlightened Self-Interest: The Avant-Garde in the 80s', in G.H. Kester (ed.), *Art, Activism and Oppositionality*, Duke University Press, pp. 41–2.

19. See Foster, *Postmodern Culture*, introduction.

20. Craig Owens, 'The Allegorical Impulse: Towards a Theory of Postmodernism, parts I and II', *October*, 12 and 13, Spring 1980, pp. 67–86, and Summer 1980, pp. 59–80, and Rosalind Krauss, 'The Originality of the Avant Garde …', *October*, 18, Fall 1981, pp. 47–66.

21. Thomas Lawson, 'Last Exit: Painting', *Artforum*, 20, no. 2, October 1981, pp. 40–7.

22. Eric Fischl, interview with Donald Kuspit in *Fischl*, New York, 1987, p. 53.

23. For Richter on *October 18, 1977* see Kai-Uwe Hemken, 'The Sons Die Before Their Fathers', in E. Gillen (ed.), *German Art from Beckmann to Richter*, Cologne, 1997, pp. 374–88. See also Benjamin Buchloh, 'A Note on Gerhard Richter's "October 18, 1977"', *October*, 48, Spring 1989, pp. 88–109.

24. See Jameson, 'Postmodernism', pp. 76–7.

25. See Gerhard Richter, statement in *Documenta 7* (ex. cat.), Kassel, 1982, vol. 1, pp. 84–5.

26. For a study of how racial difference becomes constituted see Homi Bhabba, 'The Other Question: The Stereotype and Colonial Discourse', *Screen*, vol. 24, no. 4, 1983.

27. See Peter Halley, 'Nature and Culture', *Arts Magazine*, September 1983.

28. See Hal Foster, 'The Art of Cynical Reason', in *The Return of the Real*, Cambridge, Mass., 1996, pp. 99–124.

29. See Foster's 'The Return of the Real' in *ibid.*, pp. 127–68.

30. Julia Kristeva, *Powers of Horror: An Essay on Abjection*, Paris, 1980, reprinted New York, 1982.

31. See Marina Warner, 'In the Garden of Delights: Helen Chadwick's "Of Mutability"', in Helen Chadwick, *Of Mutability* (ex. cat.), ICA, London, 1986.

32. Hal Foster, 'The Artist as Ethnographer', in *The Return of the Real*, p. 184. Foster's broader points are made on pp. 199–202.

Chapter 8. Into the 1990s

1. This reading owes much to Terry Atkinson, 'Dead Troops Talk', in *Jeff Wall: Dead Troops Talk* (ex. cat.), Kunstmuseum Lucerne and Irish Museum of Modern Art, 1993, pp. 29–45.

2. For accounts of Kulik see Ewa Lajer-Burcharth, 'Old Histories: Zofia Kulik's Ironic Recollections', in *New Histories* (ex. cat.), ICA, Boston, 1996, pp. 120–36, and essays by Simon Herbert and Adam Sobota in *The Human Motif: Zofia Kulik*, Zone Gallery, Newcastle-upon-Tyne, 1995.

3. See Richard Bolton (ed.), *Culture Wars: Documents from the Recent Controversies in the Arts*, New York, 1992.

4. Grant H. Kestner, 'Rhetorical Questions: The Alternative Arts Sector and the Imaginary Public', in G. Kestner (ed.), *Art, Activism and Oppositionality: Essays from 'Afterimage'*, Duke University Press, 1998, pp. 103–35.

5. For a critique of the yBas see Simon Ford, 'The Myth of the Young British Artist', *Art Monthly*, no. 194, March 1996, pp. 3–9.

6. See John Roberts, 'Mad For It! Philistinism, the Everyday and the New British Art', *Third Text*, Summer 1996, pp. 29–42.

7. Sophie Calle and Paul Auster, *Double Game*, Violette Editions, London, 1999.

8. Peter Wollen, 'Into the Future: Tourism, Language and Art', in his *Raiding the Icebox: Reflections on Twentieth-Century Culture*, London, 1993, pp. 190–212.

9. This interpretation of *Cremaster 4* is indebted to Norman Bryson, 'Matthew Barney's Gonadotrophic Cavalcade', and Michel Onfray, 'Mannerist Variations on Matthew Barney', in *Parkett*, no. 45, 1995, pp. 29–33 and 50–7 respectively.

Further Reading

Significant magazine articles and essays or chapters from books are normally referred to in the notes to the text. This essay largely concentrates on introductory books and exhibition catalogues. A few useful monographs on artists are included.

Abbreviations:
MOMA: Museum of Modern Art
MOCA: Museum of Contemporary Art

General
Modernism in Dispute: Art Since the Forties (Open University and Yale, 1993) by **Paul Wood, Francis Frascina, Jonathan Harris, and Charles Harrison** offers a series of challenging politicized readings of various moments within modernism and postmodernism, although it concentrates mainly on America. A notable attempt to get away from a 'formalist' Americanist model is **Benjamin Buchloh**'s essay 'Formalism and Historicity …', in Art Institute of Chicago, *Europe in the Seventies*, 1977. Three well-written studies have recently addressed themselves to various portions of the period: **Michael Archer**'s *Art Since 1960* (London, 1997), **Thomas Crow**'s *The Rise of the Sixties* (London, 1996), and **Brandon Taylor**'s *The Art of Today* (London, 1995). By far the most useful anthology of artists' statements and critical theory is **Charles Harrison and Paul Wood** (eds), *Art in Theory: An Anthology of Changing Ideas* (Oxford, 1992). For artist's writings see also **Kristine Stiles** and **Peter Selz** (eds), *Theories and Documents of Contemporary Art* (University of California, 1996).

Chapter 1. The Politics of Modernism: Abstract Expressionism and the European *Informel*
For Abstract Expressionism see **Irving Sandler**, *Abstract Expressionism: The Triumph of American Painting* (London, 1970), and

David Anfam's *Abstract Expressionism* (London, 1990). **Michael Leja**'s *Reframing Abstract Expressionism* (Yale, 1993) is a major revisionist study, whilst Ann Eden Gibson's *Abstract Expressionism: Other Politics* (New Haven and London, 1997) also offers a re-reading of the topic. On individual Abstract Expressionists see **Kirk Varnedoe and Pepe Kermel**, *Jackson Pollock* (MOMA, New York, 1998), **Thomas B. Hess**, *Willem de Kooning*, (MOMA, New York, 1968) and **David Anfam**, *Mark Rothko: The Works on Canvas: A Catalogue Raisonné* (National Gallery of Art, Washington, 1998).

The social background for Abstract Expressionism is set out in Erika Doss: *Benton, Pollock and the Politics of Modernism: From Regionalism to Abstract Expressionism* (Yale, 1991). Cold War issues are dealt with in **Serge Guilbaut**'s ground-breaking *How New York Stole the Idea of Modern Art* (Chicago, 1983) and **Francis Frascina** (ed.), *Pollock and After: The Critical Debate*, which collects together many key texts. A recent addition is **David Craven**, *Abstract Expression as Cultural Critique* (Cambridge University Press, 1999). For Communist-affiliated realism in Europe see **Francis Frascina**'s essay in **Paul Wood et al.**, *Modernism in Dispute* (cited in General section above).

Useful essays on French postwar art appear in the **Tate Gallery**'s *Paris Post War* catalogue (1993) and the **Barbican Art Gallery**, *Aftermath: France 1945–54: New Images of Man* (London, 1982). On Wols see **Kunsthaus Zürich** (ex. cat.) (1990), and on Dubuffet see **Mildred Glimcher and Jean Dubuffet**, *Jean Dubuffet: Towards an Alternative Reality* (New York, 1987). For Arshile Gorky see **Diane Waldman**, *Arshile Gorky 1904–1948: A Retrospective* (Solomon R. Guggenheim Museum, New York, 1981).

Key texts relating to Greenberg's and Fried's 'Modernist' aesthetics are collected in **Francis Frascina** (ed.), *Pollock and After* (see

above). Texts central to the foundations of 'modernist' thought are reprinted in **Francis Frascina** and **Charles Harrison** (eds), *Modern Art and Modernism: A Critical Anthology* (Open University and London, 1982), whilst the social origins of modernist sensibility are explored in **Marshall Berman**'s *All that is Solid Melts into Air: The Experience of Modernity* (New York, 1982).

For British abstraction of the 1950s see **Tate Gallery**, *St Ives 1939–64* (London, 1985, revised 1996). On Peter Lanyon see **Whitworth Art Gallery**, *Peter Lanyon* (Manchester, 1978). Patrick Heron's criticism is collected in **Mel Gooding** (ed.), *Painter and Critic: Patrick Heron Writings 1945–97* (London, 1998).

Chapter 2. Duchamp's Legacy: The Rauschenberg–Johns Axis

For comprehensive studies of Duchamp and his impact see **Dawn Ades, Neil Cox, and David Hopkins**, *Marcel Duchamp* (London, 1999), and **Martha Buskirk and Mignon Nixon** (eds), *The Duchamp Effect* (Cambridge, Mass., 1996).

For **John Cage**'s ideas see his writings collected in *Silence* (London, 1971). A recent study of Black Mountain College is **Mary Emma Harris**, *The Arts at Black Mountain College* (Cambridge, Mass., 1987).

On Rauschenberg see especially the **Solomon R. Guggenheim Museum**'s massive catalogue, *Robert Rauschenberg: A Retrospective* (New York, 1998) and **Walter Hopps**'s superb *Robert Rauschenberg: The Early 1950s* (Menil Foundation, Houston, 1991). **William Seitz**'s important catalogue *The Art of Assemblage* was published by MOMA, New York, in 1961. For Joseph Cornell see **Kynaston McShine** (ed.), *Joseph Cornell* (MOMA, New York, 1980). Art's relation to Beat culture is discussed in **Lisa Phillips**'s *Beat Culture and the New America 1950–1965* (Whitney Museum, New York, 1995).

For Cy Twombly the most comprehensive monograph is **Kirk Varnedoe**, *Cy Twombly: A Retrospective* (MOMA, New York, 1994). As regards Lucio Fontana, see the centenary exhibition catalogue edited by Enrico Crispolti, *Fontana* (Milan, 1999).

Gender is increasingly becoming an issue in the literature on Abstract Expressionism and the 1950s; see **Anne Wagner**'s fascinating *Three Artists (Three Women): Modernism and the Art of Hesse, Krasner and O'Keefe* (California, 1996). For Jasper Johns, see

Kenneth Silver's important essay in *Hand Painted Pop: American Art in Transition 1955–1962* (ed. Russell Ferguson, MOCA, Los Angeles, 1992). **Fred Orton**'s *Figuring Jasper Johns* (London, 1994) also touches on issues of masculinity, as does his excellent catalogue on the artist's sculpture, *Jasper Johns: The Sculpture* (Henry Moore Foundation, Leeds, 1996). Duchamp's attitude to the readymade in the 1960s is discussed in the latter half of **William Camfield**'s *Marcel Duchamp: Fountain* (Menil Foundation, Houston, 1988). For literature on Sherrie Levine et al. in relation to replication, see Chapter 7.

Chapter 3. The Artist in Crisis: From Bacon to Beuys

Links between existentialism and art are established in the **Tate Gallery**'s *Paris Post War* catalogue, which also discusses Giacometti (see above). For Henry Moore, **John Russell**'s *Henry Moore* (Harmondsworth, 1973) provides a readable introduction. For Francis Bacon see **David Sylvester**'s crucial *Interviews with Francis Bacon* (London, 1971, revised 1979) and **John Russell**'s introductory *Francis Bacon* (London, 1975). For Lucian Freud see the monograph edited by **Bruce Bernard and Derek Birdsall** (London, 1996).

For Giacometti see **Reinhold Hohl**'s monograph (London and Lausanne, 1972). See also **Fondation Maeght**, *Germaine Richier* (1996), and **Margit Rowell** (ed.), *Antonin Artaud: Works on Paper* (MOMA, New York, 1996).

Nouveau Réalisme as a movement is discussed in **Musée d'Art Moderne de la Ville de Paris**, *1960 Les Nouveaux Réalistes* (1986). For individual artists see **Museum of Fine Arts**, *Arman* (Houston, 1991), and **Sidra Stich**'s comprehensive *Yves Klein* (Hayward Gallery, London, 1995). A useful introduction to French Structuralism is **John Sturrock**, *Structuralism and Since* (Oxford, 1979). For Piero Manzoni see the catalogue for the Musée d'Art Moderne de la Ville de Paris (Paris, 1991).

The Beuys literature is extensive but the best general studies are **Caroline Tisdall**, *Joseph Beuys* (Solomon R. Guggenheim Museum, New York, 1979), and **Gotz Adriani, Winifried Konnertz, and Karin Thomas**, *Joseph Beuys: Life and Works* (New York, 1979).

For Berlin as an artistic centre see **Kynaston McShine** (ed.), *Berlin Art 1961–1987* (MOMA, New York, 1987). For Georg

Baselitz see **Solomon R. Guggenheim Museum**, *Georg Baselitz* (New York, 1995).

Chapter 4. Blurring Boundaries: Pop Art, Fluxus, and their Effects

The Independent Group: Postwar Britain and the Aesthetics of Plenty (London and Cambridge, Mass., 1990) contains excellent essays on the Independent Group, whilst Anne Massey's *The Independent Group: Modernism and Mass Culture in Britain, 1945–59* (Manchester, 1995) should also be consulted. See also **W. Konnertz**, *Eduardo Paolozzi* (Cologne, 1984) and **Tate Gallery**, *Richard Hamilton* (London, 1992). For British Pop of the 1960s see **David Alan Mellor**, *The Sixties Art Scene in London* (London, 1993). British Pop of the 1960s is usually discussed as part of an overall trend; see **Marco Livingstone**, *Pop Art: A Continuing History* (London, 1990), or **Lucy Lippard** (ed.), *Pop Art* (London, 1966, reprinted 1974). For key individuals see **Marice Tuchman and Stephanie Barron** (eds), *David Hockney: A Retrospective* (Los Angeles County Museum of Art, 1988–9), **South Bank Centre**, *Patrick Caulfield* (London, 1999), and **Tate Gallery**, (London), *Peter Blake* (London, 1983).

Michael Kirby (ed.), *Happenings* (New York, 1966) includes descriptions of these events, whilst many important documents are brought together in **Mariellen Sandford**'s *Happenings and Other Acts* (London, 1995). For digestible accounts of Fluxus see **Thomas Kellein**, *Fluxus* (London, 1995) and the superb essays in **Walker Art Center**, *In the Spirit of Fluxus* (ex. cat.) (Minneapolis, 1993). As regards Oldenburg's early Happenings, see the documents collected in **Claes Oldenburg and Emmett Williams** (eds), *Store Days* (New York, 1967).

Most general works on Pop discuss America (see above) but **Lawrence Alloway**'s *American Pop Art* (Whitney Museum, New York, 1974) is an important early study. The criticism is collected in **Steven Madoff**, *Pop Art: A Critical History* (University of California Press, 1997); an anecdotal account of the formation of a market and ambience for the style is given in **Calvin Tomkins**, *Off the Wall* (New York, 1980). **Cécile Whiting**'s *A Taste for Pop: Pop Art, Gender and Consumer Culture* (Cambridge, 1997) discusses the topic in relation to taste and consumerism.

For Roy Lichtenstein, see **Diane Waldman**'s catalogue (Solomon R. Guggenheim Museum, New York, 1993). Standard studies of Warhol are **Rainer Crone**,

Andy Warhol (New York, 1970), and **Kynaston McShine** (ed.), *Andy Warhol: A Retrospective* (MOMA, New York, 1989), whilst an interesting set of essays is collected in **Gary Garrels** (ed.), *The Work of Andy Warhol* (Washington, 1989).

Weegee's career is surveyed in **Miles Barth**, *Weegee's World* (International Center of Photography, New York, 1997).

Sidra Stich's *Made in the USA: An Americanization in Modern Art, the 50s and 60s* (University of California, 1987) provides social backgrounds for many American Pop works. For Rosenquist see *James Rosenquist: The Early Pictures 1961–1964* (Gagosian Gallery, New York, 1992). A good general introduction to Ed Keinholz is given in **Walter Hopps** (ed.), *Keinholz: A Retrospective* (Whitney Museum, New York). For Polke and Richter see **Sigmar Polke**, *The Three Lies of Painting*, (London, 1997), the **Tate Gallery** catalogue, *Gerhard Richter* (London, 1991), and **Terry Neff** (ed.), *Gerhard Richter: Paintings* (London, 1988).

Chapter 5. Modernism in Retreat: Minimalist Aesthetics and Beyond

Ad Reinhardt's writings are collected in **Barbara Rose** (ed.), *Art-as-Art* (New York, 1975, reprinted California, 1991). The standard monographs on Ad Reinhardt and (early) Frank Stella remain those of **Lucy Lippard** (New York, 1985) and **William Rubin** (MOMA, New York, 1970) respectively. **Don Judd**'s own writings, collected as *Complete Writings 1959–1975* (New York, 1975), are indispensable. For David Smith, **Rosalind Krauss**'s *Terminal Iron Works: The Sculpture of David Smith* (Cambridge, Mass., 1971) is a key study, whilst for Anthony Caro, **William Rubin**'s *Anthony Caro* (MOMA, New York, 1975) is a model of Modernist-style criticism.

Gregory Battcock's *Minimal Art: A Critical Anthology* (New York, 1968, reprinted 1995) is the main collection of critical texts on Minimalism. For a very concise general study see **David Batchelor**'s *Minimalism* (Tate Gallery, London, 1997). **Frances Colpitt**'s *Minimal Art: The Critical Perspective* (Washington, 1993) carefully follows the critical debates. For Robert Morris see **Solomon R. Guggenheim Museum**, *Robert Morris: The Mind/Body Problem* (New York, 1994). **Alicia Legg**'s edited monograph on Sol LeWitt (MOMA, New York, 1978) is useful on his early output.

For Carl Andre see **Diane Waldman** (ed.), *Carl Andre* (Solomon R. Guggenheim Museum, New York, 1970). A good

monograph on Agnes Martin is **Barbara Haskell** (ed.), *Agnes Martin* (Whitney Museum, New York, 1992).

For Bridget Riley see the **Serpentine Gallery** catalogue (London, 1999); for James Turrell see **Craig Adcock**'s monograph (California, 1990).

There have been few in-depth studies on 'process art' but Anti Form's relation to Minimalism has underpinned a recent thematic reading of post-1945 art, **Yves Alain Bois and Rosalind Krauss**'s *Formless: A User's Guide* (New York, 1997, originally a catalogue for an exhibition at the Centre Georges Pompidou, Paris, 1996). For Eva Hesse the outstanding monograph is **Lucy Lippard**, *Eva Hesse* (New York, 1997). **Louise Bourgeois**'s writings and interviews are collected in *Destruction of the Father/Reconstruction of the Father* (London, 1998). A general monograph is **Marie-Louise Bernadac**, *Louise Bourgeois* (Paris, 1996).

The outstanding study of Richard Serra is *Richard Serra: Sculpture* (MOMA, New York, 1986). Film in post-1945 is a topic in its own right, but useful essays are collected in **Russell Ferguson** (ed.), *Art and Film Since 1945: Hall of Mirrors* (MOCA, Los Angeles, 1996). See also **Michael O'Pray** (ed.), *Andy Warhol: Film Factory* (London, 1989). Bruce Nauman has had several big exhibitions in recent years: see the catalogues for the Walker Art Center (Minneapolis, 1994) and Centre Georges Pompidou and Hayward Gallery (Paris and London, 1997/8).

For post-Minimalist developments in British sculpture see **Charles Harrison**'s essay in **Terry A. Neff** (ed.), *A Quiet Revolution: British Sculpture Since 1965* (New York, 1987). See also **John Thompson**, **Pier Luigi Tazzi**, **and Peter Schjeldahl**, *Richard Deacon* (London, 1995) and the **Liverpool Tate Gallery**'s useful *Rachel Whiteread: Shedding Life* (Liverpool, 1997).

Chapter 6. The Death of the Object: The Move to Conceptualism

COBRA: 1948–1951 (Paris, 1980) includes reprints of their journal. The literature on Lettrism is sparse but see the relevant sections of **Greil Marcus**'s freewheeling *Lipstick Traces* (London, 1989). For Situationism see **Peter Wollen**'s essay in **Elisabeth Sussmann** (ed.), *On the Passage of a Few People Through a Rather Brief Moment in Time* (Cambridge, Mass., 1989); also **Simon Sadler**'s *The Situationist City* (Cambridge, Mass., 1998).

For **Daniel Buren** it is essential to read his own writings; see *Five Texts* (London, 1973) or *Limites Critiques* (Paris, 1970). The catalogue for the Marcel Broodthaers exhibition at the Walker Art Center (Minneapolis, 1989) is particularly recommended, whilst for a general study of Hans Haacke see **Brian Wallis** (ed.), *Unfinished Business* (Cambridge, Mass., 1986).

For Gordon Matta Clark see **MOCA**, *Gordon Matta Clark: A Retrospective* (Chicago, 1985).

Germano Celant's publications on *Arte Povera* are essential introductory texts; see, for instance, his *Arte Povera: Actual or Impossible Art?* (Milan and London, 1969). An excellent overview of the movement and its critical literature is **Carolyn Christov-Bakargiev**, *Arte Povera* (London, 1999).

For Robert Smithson his own writings are crucial: see **Nancy Holt** (ed.), *The Writings of Robert Smithson* (New York, 1979). He is often dealt with best from a quasi-philosophical standpoint. In this respect, see **Gary Shapiro**, *Earthwards: Robert Smithson and Art after Babel* (California, 1995). For concrete poetry see **Emmett Williams** (ed.), *An Anthology of Concrete Poetry* (New York, 1969). For Ian Hamilton Finlay see **Yves Abrioux**, *Ian Hamilton Finlay: A Visual Primer* (Edinburgh, 1985). Land Art is usefully surveyed in **Jeffrey Kastner and Brian Wallis**, *Land and Environmental Art* (London, 1998), and **Gilles A. Tiberghien**'s *Land Art* (London, 1995).

For Conceptual Art the essays in two catalogues, **Ann Goldstein and Anne Rorimer** (eds), *Reconsidering the Object of Art: 1962–1975* (MOCA, Los Angeles, 1995), and *L'art conceptuel, une perspective* (Musée d'Art Moderne de la Ville de Paris, 1988) are indispensable. **Tony Godfrey**'s *Conceptual Art* (London, 1998) is a very readable general study, and Michael Newman and Jon Bird (eds), *Rewriting Conceptual Art* (London, 1999) offers a wide-ranging set of historical studies. **Lucy Lippard**'s *Six Years: The Dematerialization of the Art Object, 1966–1972* (New York, 1973, reprinted California, 1997) remains an indispensable chronicle, whilst **Alexander Alberro and Blake Stimson**'s *Conceptual Art: A Critical Anthology* (Cambridge, Mass., 1999) collects together key texts. An important re-assessment of the global reach of the movement was **Queens Museum of Art**'s *Global Conceptualism: Points of Origin, 1950s–1980s* (New York, 1999). **Joseph Kosuth**'s seminal writings are reprinted in his *Art After Philosophy and After* (ed. Gabriele Guerciono, Cambridge, Mass., 1991). For Art & Language, see **Charles**

Harrison's *Essays on Art & Language* (Oxford, 1991); for **Victor Burgin**'s 1970s art production see his *Between* (Oxford, 1986).

The classic early texts of feminist art history are **Linda Nochlin**'s essay 'Why Have There Been No Great Women Artists?', *Art News*, vol. 69, January 1971, and **Roszika Parker and Griselda Pollock**, *Old Mistresses* (London, 1981). **Randy Rosen and Catherine C. Brawer**'s *Making Their Mark: Women Artists Move into the Mainstream 1970–1985* (New York, 1989) is useful on the increasing representation of women in 1970s and early 1980s art. For an excellent overview of Judy Chicago and related 'essentialist' forms of feminist art see **Amelia Jones** (ed.), *Sexual Politics* (California, 1996); for 'central-core' imagery **Lucy Lippard**'s *From the Center* (New York, 1976) is crucial. Theoretical opposition to 'essentialist' feminism is succinctly expressed in **Mary Kelly and Paul Smith**'s discussion 'No Essential Femininity', in **Mary Kelly**, *Imaging Desire* (Collected Writings, Cambridge, Mass., 1996). Mary Kelly's *Post-Partum Document* was published in book form (London, 1983).

Juliet Mitchell's *Psychoanalysis and Feminism* (London, 1974) is a key text for understanding feminist reinterpretations of Freud, whilst Jacques Lacan's ideas are usefully summed up in **Kaja Silverman**, *The Subject of Semiotics* (Oxford, 1983). For 'scripto-visual' feminist art see **Kate Linker and Jane Weinstock**, *Difference: On Representation and Sexuality* (New Museum of Contemporary Art, New York, 1985).

Derrida's thought, like Lacan's, presents difficulties, but a good introduction is via his interview with Henri Ronse: see **Jacques Derrida**, *Positions* (trans. Alan Bass, London, 1987).

General histories of Performance Art are **Roselee Goldberg**, *Performance Art: From Futurism to the Present* (New York, 1979, substantially revised 1988), and *Performance Art: Live Art Since the 1960s* (London, 1998), whilst **Gregory Battcock and Robert Nickas**, *The Art of Performance: A Critical Anthology* (New York, 1984), contains essays on 1970s performance. A comprehensive catalogue, with several important essays, is **MOCA**, *Out of Actions: Between Performance and The Object 1949–1979* (Los Angeles, 1998).

Recent studies of Body Art include **Amelia Jones**'s *Body Art / Performing the Subject* (Minnesota, 1998) and **Kathy O'Dell**, *Contract with the Skin: Masochism, Performance Art and the 1970s* (Minnesota, 1998). Carolee

Schneeman's performances are documented in **Bruce McPherson** (ed.), *More Than Meat Joy: Carolee Schneeman: Performance Works and Selected Writings* (New York, 1979, reprinted 1997). An introductory account of *écriture féminine* and related French feminist doctrines is given in **Toril Moi**, *Sexual/Textual Politics* (London, 1985). Useful monographs on male performance artists are: **Newport Harbour Art Museum**, *Chris Burden: A Twenty Year Survey* (Newport, 1988), **Kate Linker**, *Vito Acconci* (New York, 1994) and **ICA**, *Stuart Brisley* (London, 1981).

Gilbert and George 1968 to 1980 (Municipal Van Abbemuseum, Eindhoven, 1980) is comprehensive. For **Laurie Anderson** see her *Stories from the Nerve Bible: A Retrospective 1972–1992* (New York, 1994). Issues of performativity and masquerade are broadly discussed in **Jennifer Blessing** (ed.), *Rrose is a Rrose is a Rrose: Gender Performance in Photography* (Solomon R. Guggenheim Museum, New York, 1997).

Chapter 7. Postmodernism: Theory and Practice in the 1980s

Hans Bertens's *The Idea of the Postmodern* (London and New York, 1995) provides a useful history of the concept, and **Perry Anderson**'s *The Origins of Postmodernism* summarizes the main theoretical ideas. No comprehensive study on the concept's applicability to art exists, although **Henry M. Sayre**'s *The Object of Performance: The American Avant-Garde Since 1970* (Chicago, 1989) and **Irving Sandler**'s *Art of the Postmodern Era* (New York, 1996) are substantial accounts with an American bias.

Sandy Nairne's *State of the Art* (London, 1997) is good on the institutional support systems for 1980s art. Two essential anthologies combine theoretical texts and key critical writings on art; **Hal Foster** (ed.), *Postmodern Culture* (New York, 1995) and **Brian Wallis** (ed.), *Art After Modernism: Rethinking Representation* (New Museum of Contemporary Art, New York, 1984).

Cindy Sherman's early work is surveyed in **MOCA**, *Cindy Sherman: A Retrospective* (Los Angeles, 1997), whilst **David Thistlewood** (ed.), *Sigmar Polke: Back to Postmodernity* (Liverpool University Press and Tate Gallery, Liverpool, 1996), specifically addresses a 'postmodern' reading of this artist.

The catalogues for *A New Spirit in Painting* (Royal Academy, London, 1981) and *Zeitgeist* (Martin-Gropius-Bau, Berlin, 1982) are important for the return to painting.

Useful monographs on American painters are **Dore Ashton**, *A Critical Study of Philip Guston* (California, 1976) and **ICA**, *Leon Golub, Mercenaries and Interrogations* (text by **Jon Bird**, London, 1982). For Italian and German art see **Achille Bonito Oliva**'s polemical *The Italian Transavantgarde* (Milan, 1980) and **Thomas Krens, Michael Govan, and Joseph Thompson** (eds), *Refigured Painting: The German Image 1960–88* (Munich, 1988). Donald Kuspit's writings on German painting, along with other aspects of 1980s art, are collected in **Donald Kuspit**, *The New Subjectivism: Art in the 1980s* (New York, 1988). Monographs on individual German artists include **Philadelphia Museum of Art**, *Anselm Kiefer* (Philadelphia, 1987) and **MOMA**, *Jörg Immendorf* (Oxford, 1984). For Julian Schnabel see **Whitechapel Art Gallery**, *Julian Schnabel: Paintings 1975–1987* (London, 1987).

The criticism identified with *October* can be sampled by looking at two anthologies: **Annette Michelson, Rosalind Krauss, et al.** (eds), *October: The First Decade 1976–1986* (Cambridge, Mass., 1987), and *October: The Second Decade 1986–1996* (Cambridge, Mass., 1997). **Krauss**'s influential critical writings are collected in *The Originality of the Avant Garde and Other Modernist Myths* (Cambridge, Mass., 1985). Writings by *October*-related writers on issues such as photography, authorial removal, and 'situational aesthetics' are assembled in the following collections: **Douglas Crimp**, *On the Museum's Ruins* (Cambridge, Mass., 1993), **Craig Owens**, *Beyond Recognition: Representation, Power and Culture* (California, 1992), and Hal Foster, *Recodings: Art, Spectacle, Cultural Politics* (Washington, 1985). Monographs on individual artists include **Diane Waldman**, *Jenny Holzer* (New York, 1997), **Kate Linker**, *Love For Sale: The Words and Pictures of Barbara Kruger* (New York, 1990), **Hirshhorn Museum**, *Sherrie Levine* (Washington, 1988), **Lisa Phillips** (ed.), *Richard Prince* (Whitney Museum, New York, 1992).

The 'Photorealism' of the 1960s was the subject of **Gregory Battcock**'s anthology, *Super Realism: A Critical Anthology* (New York, 1995), as well as a lavishly illustrated study, *Photo-realism* by **Louis K. Miesel** (New York, 1980). Little has appeared since. For Malcolm Morley see the catalogue for the Whitechapel Art Gallery, London (1983); for Eric Fischl see **University of California Art Museum**, *Eric Fischl: Scenes Before the Eye* (1986). For Vija Celmins see the **ICA** *Vija Celmins* (London, 1996). There is an extensive literature on

Gerhard Richter. Along with books cited earlier in this essay (end of Chapter 4), see his own writings: *The Daily Practice of Painting: Writings and Interviews 1962–1993* (trans. David Britt, London, 1995).

Art and ethnicity is a massive theme but the following catalogues offer different approaches: **Centre Georges Pompidou**, *Magiciens de la Terre* (Paris, 1989), **University of California Art Museum**, *Mistaken Identities* (1993, with an essay by **Abigail Solomon-Godeau**), and **ICA**, *New Histories* (ex. cat.) (Boston, 1996). Two stimulating sets of essays are **Jean Fisher** (ed.), *Global Visions: Towards a New Internationalism in the Visual Arts* (London, 1994) and **Russell Ferguson** (ed.), *Out There: Marginalization and Contemporary Cultures* (New Museum of Contemporary Art, New York, 1990).

For **Terry Atkinson** see his *The Indexing, The World War I Moves and the Ruins of Conceptualism* (Circa Publications and Irish Museum of Modern Art, Belfast, 1992); for **Jimmie Durham** see his selected writings, *A Certain Lack of Coherence* (ed. Jean Fisher, London, 1993). On Robert Mapplethorpe see **Germano Celant**'s *Mapplethorpe* (Hayward Gallery, London, 1992). For Lorna Simpson see **Deborah Willis**, *Lorna Simpson* (San Francisco, 1992).

For late 1990s American art **Hal Foster**'s collection of critical essays *The Return of the Real* (Cambridge, Mass., 1996) is invaluable.

For Simulation see also **ICA Boston**, *Endgame: Reference and Simulation in Recent Painting and Sculpture* (Cambridge, Mass., 1986). For Jeff Koons see the catalogue produced by **MOMA** (San Francisco, 1992). A useful catalogue on Tony Cragg is the one for the Hayward Gallery, London (1987). **Sidra Stich**'s edited exhibition catalogue, *Rosemarie Trockel* (University of California Art Museum, 1991) is also recommended.

An interesting set of essays relating theories of abjection to art is the **Whitney Museum** *Abject Art: Repulsion and Desire in American Art* (New York, 1993). Monographs include those by **Thomas Kellein**, *Mike Kelley* (Kunsthalle Basel and ICA, London, 1992), and **Museum Boymans-van Beuningen**, *Robert Gober* (Rotterdam, 1990). For **Helen Chadwick** see her *Effluvia* catalogue (Serpentine Gallery, London, 1994).

For installation as a medium of the late 1980s and early 1990s, see the catalogue of *Dislocations* (MOMA, New York, 1992).

There is no major monograph as yet on Richard Wilson but see the **Serpentine**

Gallery's *Richard Wilson Jamming Gears* (London, 1996). For **Damien Hirst**, his own *I Want to Spend the Rest of my Life Everywhere, With Everyone, One to One, Always, Forever, Now* (London, 1997) provides a catalogue of his output.

Chapter 8. Into the 1990s

The range of European and American practices of the 1990s can be appreciated via *Parkett* magazine (based in New York, Zürich, and Frankfurt), which devotes special issues to artists' works. *Frieze* magazine, based in London, has also been very influential. See also the catalogues for Kassel's Documenta exhibitions (nos 9 and 10, 1992 and 1997) and the Venice Biennale (1990, 1993, 1995, 1997, 1999).

Few attempts have so far been made to characterize 1990s art. **Bonnie Clearwater**'s catalogue, *Defining The Nineties: Consensus-Making in New York, Miami and Los Angeles* (MOCA, Miami, 1996), interprets changes in taste formation in American art centres. Two significant British exhibitions, seemingly arguing for a newly reflective spirit in art, were the **Hayward Gallery**, 'Double Talk: Collective Memory and Current Art' (London, 1992) and the **Tate Gallery**, 'Rites of Passage: Art at the End of the Century' (London, 1995).

As far as Jeff Wall is concerned, see **Thierry de Duve, Ariella Pelenc, and Boris Groys**, *Jeff Wall* (London, 1996). Monographs on Ilya Kabakov are proliferating but see **Boris Groy, David A. Ross, and Iwona Blazwick**, *Ilya Kabakov* (London, 1998).

The yBa phenomenon in Britain has generated a lively, if often insubstantial, literature. The catalogue for 'Sensation', the important Royal Academy, London, exhibition of 1997, has a good essay by **Richard Shone** plotting the origins of the phenomenon. **Patricia Bickers**'s pamphlet *The Brit Pack: Contemporary British Art, the View from Abroad* (Cornerhouse, Manchester, 1995) carefully tracks its international flowering. A set of polemical essays on the yBa phenomenon, *Occupational Hazard*, eds **Duncan McCorquadale, Naomi Sidefin, and Julian Stallabrass**, was published in

London (1998), whilst Stallabrass' *High Art Lite* (London, 1999) offers a sustained critique of the 1990s British art scene.. For individual artists who emerged under the yBa umbrella see the brief essays in **Sarah Kent**, *Shark Infested. Waters: The Saatchi Collection of British Art in the 1990s* (London, 1994). For Sarah Lucas see *Parkett* magazine, no. 45, 1995.

For the *fin de siècle* morbidity of 1990s art see **Christoph Grunenberg**, *Gothic: Transmutations of Horror in Late Twentieth Century Art* (Cambridge, Mass., 1997), or, in a different register, the exhibition catalogue *Secret Victorians* (South Bank Centre, London, 1998).

Douglas Gordon is the subject of a monograph published by the Stedelijk Van Abbemuseum, *Douglas Gordon* (Eindhoven, 1998), whilst a recent monograph on Gillian Wearing is **Russell Ferguson, Donna De Salvo, and John Slyce**, *Gillian Wearing* (London, 1999).

For video art in general, one useful catalogue, with a historical component, is the **Albright-Knox Art Gallery**'s *Being and Time: The Emergence of Video Projection* (1996). For Nam June Paik's pioneering use of the medium see also **Edith Decker-Philips**, *Paik Video* (New York, 1998). **Bill Viola**'s writings are collected in *Reasons for Knocking at an Empty House: Writings 1973–1994* (London, 1995). A useful catalogue on Gary Hill is **MOMA and Tate Gallery**, *Gary Hill: In Light of the Other* (Oxford and Liverpool, 1993). For Willie Doherty see **Tate Gallery**, *Willie Doherty: Somewhere Else* (Liverpool, 1998).

Sophie Calle's photographs relating to *Suite vénitienne* were published with a text by **Jean Baudrillard**: *Suite vénitienne / please follow me* (Seattle, 1988). See also *Parkett*, no. 36, 1993. Yinka Shonibare features in **Ikon Gallery**, *Yinka Shonibare: Dressing Down* (Birmingham, 1999). More on Louise Bourgeois's *Red Rooms* appears in the **Tate Gallery**'s *Rites of Passage* catalogue cited above. For Matthew Barney see **Museum Boymans–van Beuningen**, *Matthew Barney: Pace Car for the Hubris Pill* (Rotterdam, 1996), whilst *Parkett* no. 45, 1995, contains some interesting essays.

Timeline
Galleries and Websites
Picture Credits
Index

Art

1945 Jackson Pollock paints *There Were Seven in Eight* (MOMA, New York).
Jean Fautrier's 'Hostages' exhibition, René Drouin's gallery, Paris.
Special issue of New-York-based Surrealist magazine *View* on Marcel Duchamp.
Howard Putzel's exhibition 'A Problem for Critics' in New York.

1946 Francis Bacon's *Three Studies for Figures at the Base of a Crucifixion* (Tate Gallery, London) exhibited in London.
Arts Council of Great Britain is formed.
Lucio Fontana's *White Manifesto* published in Buenos Aires (leads to Italian artist's concept of 'Spatialism').
Duchamp begins work on *Etant Donnés* in New York.

1947 Jackson Pollock produces first 'drip' paintings.
Alberto Giacometti produces his sculpture *Man Pointing* (MOMA, New York).
International Surrealist exhibition held in Paris.
Antonin Artaud makes dramatic appearance at Vieux Colombes theatre, Paris.

1948 Suicide of Arshile Gorky.
Willem de Kooning produces important 'black paintings' (series begun in 1946) [16].
Germaine Richier in France completes *The Storm* [36].
The American journal *Possibilities 1*, (Winter 1947/48), carries key statements by Pollock and Rothko.

1949 CoBrA group publishes its journal, *Copenhagen*.
Robert Motherwell's *At Five in the Afternoon* [12] initiates his series of *Elegies to the Spanish Republic*.
Life magazine runs an article on Pollock: 'Is He the Greatest Living Artist in the US?'
Willem de Kooning paints *Asheville* (Phillips Collection, Washington) and *Attic* (Metropolitan Museum and Newman Collection).

1950 Jean Dubuffet begins *Corps de Dames* series [9].
Willem de Kooning starts large-scale series of *Women* [23].
Mark Rothko's mature style crystallizes.
American sculptor David Smith produces welded-steel sculptures at Bolton Landing, upstate New York.

1951 Pablo Picasso paints *Massacre in Korea* (Musée Picasso, Paris).
Barnett Newman's *Vir Heroicus Sublimis* [6].
Robert Rauschenberg's *White Paintings*.
Publication of the book *The Dada Painters and Poets* edited by Robert Motherwell.

1952 Harold Rosenberg's essay 'The American Action Painters' appears in *Art News*.
Cage–Rauschenberg 'Happening' at Black Mountain College, North Carolina, and first performance of John Cage's *4'33"* in Woodstock, New York.
Helen Frankenthaler paints *Mountains and Sea* (National Gallery, Washington).
Eduardo Paolozzi epidiascope lecture showing 'Bunk' materials at London's ICA.

1953 Robert Rauschenberg's *Erased de Kooning* gesture.
André Fougeron's *Civilisation Atlantique* [5].
Larry Rivers repaints *Washington Crossing the Delaware* (MOMA, New York).
London's Independent Group mount 'Parallel of Life and Art' exhibition [46].

Events

1945 America drops atom bombs on Hiroshima and Nagasaki. End of Second World War.
Maurice Merleau-Ponty's treatise *The Phenomenology of Perception* (English translation, 1962).
George Orwell's book *Animal Farm*.
Roberto Rossellini's film *Rome, Open City*.

1946 Churchill denounces Soviet Union in 'Iron Curtain' speech in Fulton, Missouri, US.
War in French Indochina.
Italy becomes a republic.
Jean-Paul Sartre's booklet 'Existentialism and Humanism' (English translation, 1948).

1947 Cominform established at Warsaw Conference imposing common policies on all Eastern European Communist Parties (President Tito's Yugoslavia expelled in 1948).
Marshall Plan extends US aid to Europe.
Greek Civil War breaks out, leading to Truman Doctrine.
First transistor radios.

1948 Berlin Blockade and Airlift.
Soviet-backed *coup* establishes Communist government in Czechoslovakia.
Alfred Kinsey publishes *Sexual Behavior in the Human Male*.
Alfred Hitchcock's film *Rope*.

1949 Federal German Republic established in West Germany, German Democratic Republic in East Germany.
North Atlantic Treaty (NATO) alliance signed in Washington DC.
USSR explodes its first atomic bomb.
Simone de Beauvoir's book *The Second Sex*.

1950 Senator Joseph McCarthy warns President Truman that the US State Department is 'riddled with Communists'. Alger Hiss convicted of perjury.
Korean War begins.
First colour televisions in US.
Jean Cocteau's film *Orphée*.

1951 Rosenbergs sentenced to death as Soviet spies in US.
Chrysler introduces power steering for cars.
'Festival of Britain' exhibition on London's South Bank.
J.D. Salinger's book *The Catcher in the Rye*.

1952 Dwight D. Eisenhower becomes US President.
Britain conducts first atomic tests. America develops hydrogen bomb.
First contraceptive pill developed.
Samuel Beckett's play *Waiting for Godot*.

1953 Stalin dies. Krushchev becomes USSR Party Secretary.
Anti-French riots in Morocco (until 1955).
Kinsey's *Sexual Behavior in the Human Female*.
Henry Miller's play *The Crucible*.

Art

Events

1954

1954 Painter Henri Matisse dies in France.
Robert Rauschenberg begins producing 'Combines'.
Arensberg Collection of Duchamp's work goes on display at Philadelphia Museum of Art.
Jasper Johns begins first *Flag* painting [**28**] (completed early 1955).

1954 War begins in Algeria (continues until Algeria achieves independence from France, 1962).
Censure of Senator Joseph McCarthy by US Senate.
William Golding's novel *The Lord of the Flies*.
Tennesee Williams's play *Cat on a Hot Tin Roof*.

1955

1955 Alberto Burri's work [**21**] popular in New York. Included in 'The New Decade: Twenty-two European Painters and Sculptors' at MOMA.
First Documenta exhibition, Kassel, West Germany.
Robert Rauschenberg produces his 'Combine painting' *Bed* [**19**].
Richard Hamilton's 'Man, Machine and Motion' exhibition, Newcastle-upon-Tyne and London.

1955 Warsaw Pact established in Eastern Europe.
West Germany joins NATO.
African-American Rosa Parks refuses to give up her seat on a bus to a white man in Alabama, US. Successful black boycott of Montgomery bus service.
French forces leave Vietnam.

1956 Tate Gallery, London, shows 'Modern Art in the United States' exhibition.
Independent Group contributes to 'This is Tomorrow' exhibition, Whitechapel Art Gallery, London.
Kurt Schwitters retrospective, Hanover.
Jackson Pollock dies in a car crash.

1956 Krushchev denounces Stalin's crimes in Soviet Union.
Hungarian uprising suppressed by Soviet troops.
Allen Ginsberg's poem *Howl* published in US.
Elvis Presley's US single *Heartbreak Hotel*.

1957 Situationist International founded at Cosio d'Arroscia in Italy.
Duchamp delivers 'Creative Act' lecture in US.
Leo Castelli's gallery opens in New York.
Yves Klein exhibits monochromes at Galleria Apollinaire, Milan.

1957 USSR launches first intercontinental ballistic missiles, followed by Sputniks I and II.
Treaty of Rome establishes European Economic Community.
Roland Barthes's essays published as *Mythologies* in France.
Jack Kerouac's *On The Road* published in US.

1958 'The New American Painting' exhibition starts touring in Europe.
Jasper Johns has first solo exhibition at Leo Castelli's, New York.
Zero Group founded in Düsseldorf.
Allan Kaprow's essay 'The Legacy of Jackson Pollock' published in *Art News*.

1958 Return of De Gaulle as French president.
US launches first space satellite.
Campaign for Nuclear Disarmament (CND) founded, London. First Aldermaston March.
Mies Van der Rohe's Seagram Building, New York City.

1959 Lawrence Alloway's essay 'The Long Front of Culture' published in *Cambridge Opinion*.
Allan Kaprow's *18 Happenings in 6 Parts* held at Reuben Gallery, New York.
Frank Stella works on 'black paintings' (begun previous year) [**65**].
'New Images of Man', MOMA, New York.

1959 In Havana Fidel Castro proclaims Cuban revolution.
'Kitchen Debate' between Krushchev and US Vice-President Nixon on US television.
William Burroughs's *The Naked Lunch*.
Günter Grass's *The Tin Drum*.

1960

1960 Claes Oldenburg's installation *The Street* at Judson Memorial Church, New York.
Followed next year by *The Store* [**53**].
Pierre Restany's manifesto launches 'New Realism' in Paris.
Publication of English translation of Duchamp's notes for his *Large Glass*.
Yves Klein performs *Leap into the Void* and *Anthropometries of the Blue Age*, Paris [**39**, **40**].

1960 American U-2 spy plane shot down by USSR.
First laser developed in Houston, Texas.
Lifting of ban on D.H. Lawrence's *Lady Chatterley's Lover* in Britain after heavily publicized obscenity trial.
Alfred Hitchcock's film *Psycho*.

1961 Georg Baselitz and Eugen Schönebeck in West Berlin collaborate on 'Pandemonium Manifesto'.
Clement Greenberg's 'Modernist Painting' essay published in *Arts Yearbook*.
Piero Manzoni cans his *Merda d'Artista* [**41**].
'The Art of Assemblage' exhibition, MOMA, New York.

1961 Berlin Wall is built.
Soviet cosmonaut Yuri Gagarin becomes first man in space.
John F. Kennedy becomes US president.
'Bay of Pigs' fiasco. Failed invasion by anti-Castro forces supported by the US.

1962

1962 First event under Fluxus banner in Wiesbaden, West Germany. Nam June Paik performs *Zen for Head*.
Andy Warhol's *Campbell Soup Cans* shown at Ferus Gallery, Los Angeles. His *Marilyn* series follows.
'The New Realists' exhibition at Sidney Janis Gallery, New York.
Daniel Spoerri's *An Anecdoted Topography of Chance* published to coincide with exhibition in Paris.

1962 Cuban Missile Crisis. After ultimatum by Kennedy, Soviet missiles withdrawn from Cuba.
Marilyn Monroe commits suicide in US.
Alexander Solzhenitsyn's *One Day in the Life of Ivan Denisovich*.
Federico Fellini's film *8 ½*.

Art

1963 Andy Warhol's *Five Deaths Seventeen Times in Black and White* [**56**].
Duchamp Retrospective at Pasadena Art Museum, California.
Robert Morris and Don Judd show proto-Minimalist work at Green Gallery, New York.
Richter and Lueg mount 'Life with Pop – A Demonstration of Capitalist Realism', Düsseldorf.

1964 Carolee Schneeman's *Meat Joy* performed in Paris, London, and New York.
Joseph Beuys performs *The Silence of Marcel Duchamp is Over-Rated* live on West German television.
Robert Rauschenberg wins the main prize at the Venice Biennale.
Susan Sontag's essay 'Notes on Camp' appears in *Partisan Review.*

1965 James Rosenquist's *F-111* mural shown at Leo Castelli's gallery, New York.
Joseph Beuys performs *How to Explain Painting to a Dead Hare*, Schmela Gallery, Düsseldorf.
Shigeko Kubota performs her *Vagina Painting* at 'Perpetual Fluxus Festival', New York [**51**].
'Three American Painters' exhibition at Fogg Art Museum, Harvard.

1966 'Primary Structures' exhibition at Jewish Museum, New York. Lucy Lippard's 'Eccentric Abstraction' show at New York's Fischbach Gallery.
John Latham and students in London chew up Clement Greenberg's book *Art and Culture.*
'Destruction in Art Symposium' held in London.
David Hockney paints bather images in California [**49**].

1967 Michael Fried's essay 'Art and Objecthood' published in *Artforum.*
Roland Barthes's essay 'Death of the Author' published in *Aspen* magazine in US. French publication in 1968 in *Manteia.*
Germano Celant launches *Arte Povera* in Italy.
Anthony Caro's sculpture *Prairie* [**68**].

1968 Death of Marcel Duchamp.
Daniel Buren's 'stripes' borne by sandwichmen in Paris [**82**].
Marcel Broodthaers's Musée d'Art Moderne (Section des Aigles) opens in Brussels.
Robert Morris publishes 'Anti Form' in *Artforum.*

1969 Art Workers' Coalition mounts anti-Vietnam demonstrations at MOMA, New York.
'When Attitude Becomes Form' exhibition at Kunsthalle, Berne.
Joseph Kosuth's 'Art After Philosophy' appears in *Studio International.*
Gilbert and George's *Singing Sculpture* first performed in London.

1970 Robert Smithson's *Spiral Jetty*, Great Salt Lake, Utah [**88**].
Hans Haacke's *Visitors' Poll*, MOMA, New York.
Robert Morris exhibition at Tate Gallery, London, shut down as 'physically dangerous'.
Willoughby Sharp inaugurates concept of Body Art.

1971 'Contemporary Black Artists in America', Whitney Museum, New York.
Daniel Buren's contribution removed from Guggenheim International Exhibition, New York.

Events

1963 President Kennedy assassinated, Dallas, Texas.
Martin Luther King leads march on Washington DC.
President Ngo Dinh Diem of South Vietnam assassinated in US-supported *coup.*
Betty Friedan's book *The Feminine Mystique.*

1964 Leonid Brezhnev replaces Krushchev as Soviet leader.
Harold Wilson forms Labour government in UK.
'Beatlemania' hits Britain and the US.
Antonin Artaud's *The Theatre and its Double* first published in Paris.

1965 Kennedy's successor, President Lyndon Johnson, steps up bombing raids on Vietnam.
Race riots in Watts district of Los Angeles.
Bob Dylan's LP *Highway 61 Revisited*, including 'Like A Rolling Stone'.
Harold Pinter's play *The Homecoming.*

1966 In China, Mao Zedong launches the Great Proletarian Cultural Revolution to step up his Great Leap Forward begun in 1958.
US *Surveyor 1* sends back photographs of the moon's surface.
Publication of French intellectual historian Michel Foucault's *Les Mots et les Choses* (*The Order of Things*).
Publication of Masters and Johnson's *Human Sexual Response.*

1967 British parliament decriminalizes abortion and homosexuality.
The Beatles' LP *Sergeant Pepper's Lonely Hearts Club Band* features cover by artist Peter Blake.
Jean-Luc Godard's film *Week-end.*
Jacques Derrida's post-Structuralist treatises *Of Grammatology* and *Writing and Difference* published in Paris.

1968 Martin Luther King and Robert Kennedy assassinated in US.
Student unrest throughout Europe. In Paris this leads to a General Strike.
Warsaw Pact forces crush liberal reforms of Alexander Dubcek in Czechoslovakia.
Electronic composer Karlheinz Stockhausen's choral composition *Stimmung.*

1969 De Gaulle resigns as French president.
Outbreak of 'Troubles' in Northern Ireland.
US astronaut Neil Armstrong becomes first man to set foot on the moon.
Woodstock Music Festival in upstate New York.

1970 US President Richard Nixon (elected in 1968) extends American offensive in Vietnam to Cambodia.
Four students protesting against Vietnam War are shot by National Guard at Kent State University, US.
Alarming increase in international terrorism.
Miles Davis's LP *Bitches' Brew.*

1971 American losses in Vietnam top 45,000.
President Nixon and national security adviser Henry Kissinger pursue *détente* with Soviet Union.
Publication of Sylvia Plath's novel *The Bell Jar.*

Art

1971 Linda Nochlin's essay 'Why Have There Been No Great Women Artists?' appears in *Art News*.
Vija Cemins's *Untitled (Ocean with Cross, no.1)* [**112**] (theme dates back to the late 1960s).

1972 Vito Acconci's *Seedbed* performance, New York.
'The New Art' exhibition, Hayward Gallery, London.
Leo Steinberg's essay 'Other Criteria' describes Rauschenberg's conception of painting as 'post-Modernist'.
Art & Language exhibit *Index 01* at Kassel Documenta exhibition.

1973 Death of Pablo Picasso.
Sale of the Robert and Ethel Scull art collection in New York.
Robert Smithson dies in plane crash.
Mary Kelly begins *Post-Partum Document* [**95**].

1974 Chris Burden performs *Transfixed*, in Venice, California. (He is 'crucified' against the rear section of a Volkswagen).
Gordon Matta Clark's *Splitting* [**85**].
'Nice Style' perform *High up on a Baroque Palazzo*, Garage, London.
Joseph Beuys performs *Coyote* at René Block Gallery, New York [**42**].

1975 Anthony Caro exhibition, MOMA, New York.
Philip Guston in New York paints *The Magnet* (Saatchi Collection).
Carolee Schneeman's *Interior Scroll* performance, Long Island, New York [**98**].
'Bodyworks' exhibition, MOCA, Chicago.

1976 *October* journal starts up in New York.
Victor Burgin's *Possession* posters appear in Newcastle-upon-Tyne, England [**92**].
Outrage over purchase of part of Carl Andre's *Equivalents I–VIII* by London's Tate Gallery followed by COUM Transmissions 'Prostitution' show at the ICA.
Christo's *Running Fence* project, Sonoma and Marin Counties, California.

1977 Walter De Maria's *Vertical Earth Kilometer* at Kassel Documenta Exhibition.
'Pictures' exhibition, Artists Space, New York.
Charles Jencks's *The Language of Post-Modern Architecture* published in London.
Cindy Sherman begins *Untitled Film Stills* series [**101**].

1978 Death of Giorgio de Chirico.
'Bad Painting' exhibition, New Museum of Contemporary Art, New York.
Malcolm Morley's *The Ultimate Anxiety* [**109**].
Jörg Immendorf begins *Café Deutschland* paintings in Düsseldorf.

1979 Judy Chicago's *The Dinner Party* [**94**] exhibited in San Francisco.
Joseph Beuys's retrospective exhibition at Guggenheim Museum, New York.
Julian Schnabel's first solo exhibition at Mary Boone's Gallery, New York, sells out.
Georg Baselitz in Germany begins producing expressionist wood carvings as well as paintings.

1980 Achille Bonito Oliva's *La Transavanguardia Italiana* published.
Anselm Kiefer and Georg Baselitz critically acclaimed at Venice Biennale.
Art & Language's *Portraits of V. I. Lenin in the Style of Jackson Pollock* [**1**].
'Women's Images of Men', ICA, London.

1981 Tony Cragg's *Britain Seen from the North* [**118**].
'A New Spirit in Painting' exhibition at London's Royal Academy.

Events

1971 Stanley Kubrick's film *A Clockwork Orange*.

1972 Presidents Nixon and Brezhnev sign Strategic Arms Limitation Treaty (SALT 1).
'Bloody Sunday' massacres in Londonderry, Northern Ireland. British troops fire on Republican demonstrators.
Pruitt-Igoe housing estate in St Louis, US, is demolished.
Luis Buñuel's film *The Discreet Charm of the Bourgeoisie*.

1973 OPEC oil crisis. Prices are quadrupled over next four years.
America withdraws troops from Vietnam.
Thomas Pynchon's *Gravity's Rainbow*.
Bernardo Bertolucci's film *Last Tango in Paris*.

1974 Miners' Strike in Britain.
High inflation begins to affect European economies.
President Nixon resigns in US in aftermath of Watergate scandal.
Alexander Solzhenitsyn forced into exile.

1975 North Vietnamese enter Saigon, ending the war.
General Franco dies. Democracy, under King Juan Carlos, returns to Spain.
US and USSR launch first joint space mission.
Video recorders and floppy disks introduced for home use.

1976 Jimmy Carter elected Democrat US president.
US space-probe *Viking 1* lands on Mars.
Punk rock becomes established in UK. Sex Pistols' single 'Anarchy in the UK' released.
Martin Scorsese's film *Taxi Driver*.

1977 First cases of AIDS diagnosed in New York City.
Apple begins boom in home computers.
Centre Pompidou opens in Paris, designed by Piano and Rogers.
George Lucas's film *Star Wars*.

1978 Red Brigade terrorism in Italy culminates in murder of a senior Christian Democrat politician, Aldo Moro.
First test-tube baby born in UK.
Astronauts discover a moon orbiting Pluto.
Edward Said's *Orientalism* published.

1979 Russia invades Afghanistan.
Margaret Thatcher becomes Conservative prime minister of Britain.
Publication of Jean-François Lyotard's treatise *The Postmodern Condition* in France.
Francis Ford Coppola's film *Apocalypse Now*.

1980 Green Party established in West Germany, devoted primarily to ecological issues.
John Lennon shot dead in New York.
Strikes in Poland's Gdansk shipyards lead to emergence of 'Solidarity' movement demanding reforms.
Martin Scorsese's film *Raging Bull*.

1981 Ronald Reagan inaugurated as Republican US president.
François Mitterand elected Socialist president in France.

Art	**Events**
1981	
1981 Publication of Rozsika Parker and Griselda Pollock's feminist art-historical study *Old Mistresses: Women, Art and Ideology*. 'Objects and Sculptures' exhibition, Bristol and London.	**1981** Chinese scientists successfully clone a golden carp fish. Facsimile (fax) machines become widespread.
1982 'Zeitgeist' exhibition held in Berlin. Joseph Beuys begins *7,000 Oaks* project at Documenta 7 in Kassel. Documenta 7 registers return to painting. Sigmar Polke's *This Is How You Sit Correctly (after Goya)* [**102**].	**1982** Falklands War between Britain and Argentina. Helmut Kohl elected chancellor, West Germany. Launch of insulin manufactured from bacteria marks first commercial use of genetic engineering. Ridley Scott's film *Blade Runner*.
1983 Publication of Mary Kelly's book *Post-Partum Document*. Laurie Anderson's performance *United States I–IV* in New York. 'The New Art' exhibition at Tate Gallery, London. Gerhard Richter's *July* [**113**].	**1983** President Reagan denounces USSR as 'Evil Empire' and announces Strategic Defence Initiative (SDI), or 'Star Wars' programme, for space-based missile systems. Compact discs first marketed. They quickly replace records and tapes. First artificially created chromosome produced at Harvard University, US. Jean Baudrillard's *Simulations* published.
1984 Fredric Jameson's essay 'Postmodernism, or the Cultural Logic of Late Capitalism' published in *New Left Review*. Turner Prize established in Britain. First winner Malcolm Morley. 'Primitivism and 20th Century Art' exhibition, MOMA, New York. The exhibition 'Difference: On Representation and Sexuality', New Museum of Contemporary Art, New York.	**1984** Prolonged miners' strike in Britain. Its defeat heralds measures by Margaret Thatcher's government to reduce power of trades unions. Ronald Reagan wins second term as US president. Britain and Hong Kong agree on procedures to return Hong Kong to China in 1997, symbolizing an end to British colonialism. Angela Carter's *Nights at the Circus* published
1985	
1985 Jenny Holzer's 'Truisms' on electronic billboards in Times Square, New York. Jimmie Durham's *Bedia's Stirring Wheel* [**115**]. Saatchi Gallery opens in London. Jeff Koons's 'Equilibrium' show in New York.	**1985** President Gorbachev comes to power in USSR. Inaugurates economic restructuring and greater cultural liberalism. British scientists discover hole in ozone layer over Antarctica. Following Greenpeace campaign against nuclear testing, French secret agents sink *Rainbow Warrior* in Auckland Harbour, New Zealand. Primo Levi's book *The Periodic Table*.
1986 Death of Joseph Beuys. Museum Ludwig opens in Cologne and Museum of Contemporary Art in Los Angeles. Helen Chadwick's *Of Mutability* installation, ICA, London. 'Endgame' exhibition at Boston ICA.	**1986** Privatization of companies begins in UK. Chernobyl nuclear accident in USSR. Reactor explodes in Ukraine. 25,000 cases of AIDS diagnosed in US. David Lynch's film *Blue Velvet*.
1987 Death of Andy Warhol. Mike Kelley's *More Love Hours Than Can Ever Be Repaid* [**120**]. 'New York Art Now' at Saatchi Gallery, London. Richard Wilson's *20/50* first installed at Matt's Gallery, London [**122**].	**1987** Stock market crashes on 'Black Monday'. US and USSR sign treaty eliminating intermediate-range missiles. Bill Gates, founder of Microsoft, becomes microcomputer billionaire. Toni Morrison's book *Beloved*.
1988 Gerhard Richter's *October 18, 1977* cycle [**111**]. 'Freeze' exhibition in London's Docklands. Jeff Koons's 'Banality' works go on show in New York. Jasper Johns's *False Start* (1959) fetches $17.1 million at auction.	**1988** Widespread strikes in Poland. Internet computer virus affects over 6,000 US military computers. Salman Rushdie's *The Satanic Verses* arouses worldwide controversy. Physicist Stephen Hawking's book *A Brief History of Time*.
1989 Reproduction of Andres Serrano's *Piss Christ* (1987) torn up by Republican congressman in US Senate. Richard Serra's *Tilted Arc* (1981) destroyed at order of US authorities. Robert Mapplethorpe's retrospective 'The Perfect Moment' begins to tour in America. 'Magiciens de la terre' exhibition, La Villette and Pompidou Centre, Paris.	**1989** Soviet Army withdraws from Afghanistan. Communist rule ends in East Germany, Poland, Romania, Hungary, and Czechoslovakia. Berlin Wall comes down. Protesters massacred in Tiananmen Square, China. American *Voyager 2* space-probe reaches Neptune. *Galileo* probe launched for Jupiter.
1990	
1990 Controversial installation by Gran Fury collective at Venice Biennale, on the subject of AIDS. 'High and Low: Modern Art and Popular Culture' exhibition, MOMA, New York. Rachel Whiteread produces cast sculptures *Ghost* and *Untitled* (bath) (Saatchi Collection).	**1990** After release from prison black South African leader Nelson Mandela negotiates end of apartheid with President De Klerk. Margaret Thatcher resigns as British prime minister. Succeeded by John Major. Union of currencies of East and West Germany as a prelude to reunification.

Art

1991 Christian Boltanski's *The Missing House* installation, East Berlin.
'Dislocations' (installation) exhibition, MOMA, New York.
'Metropolis' exhibition in Berlin.
Sherrie Levine's polished bronze urinals, *After Marcel Duchamp* [**30**].
Damien Hirsts's *In and Out of Love* installation [**123**] and *The Impossibility of Death in the Mind of Someone Living*.

1992 Ilya Kabakov's *The Toilet* installed at Documenta 9 in Kassel.
'Post Human' exhibition, Lausanne and elsewhere, curated by Jeffrey Deitch.
Gary Hill's *Tall Ships* video work.
Bill Viola's *Nantes Tryptich* video work.

1993 Hans Haacke's *Germania* installation in German Pavilion at Venice Biennale.
Louise Bourgeois represents America at Venice Biennale with five *Cell* installations.
'Abject Art' exhibition, Whitney Museum, New York.
Douglas Gordon's *24 Hour Psycho* video.

1994 Demolition of Rachel Whiteread's *House* [**81**] in London after press controversy.
Death of American critic Clement Greenberg.
'Bad Girls/Bad Girls West' exhibition, New York.
Matthew Barney's *Cremaster 4* video [**130**].

1995 Damien Hirst wins Turner Prize, London.
'Rites of Passage' exhibition, Tate Gallery, London.
'Brilliant: New Art from London' exhibition at Walker Art Center, Minneapolis.
'Reconsidering the Object of Art', exhibition on Conceptualism, at MOCA, Los Angeles.

1996 'L'informe' exhibition, Pompidou Centre, Paris.
'life/live' exhibition in Paris.
Publication of American critic Hal Foster's book *The Return of the Real*.
Douglas Gordon wins Turner Prize, London.

1997 Death of Willem de Kooning.
Documenta 10 at Kassel emphasizes globalization and politics.
'Sensation' exhibition at Royal Academy, London.
'Rrose is a Rrose is a Rrose: Gender Performance in Photography' exhibition, Guggenheim Museum, New York.

1998 Major retrospective of Jackson Pollock at MOMA, New York (travels to London, 1999).
Exhibition 'Out of Actions: Between Performance and the Object 1949–1979' at MOCA, Los Angeles.
Painter Chris Ofili wins Turner Prize in London.
Exhibition 'Wounds: Between Democracy and Redemption in Contemporary Art' at Moderna Museet, Stockholm.

1999 Publication of art historian T.J. Clark's *Farewell to an Idea: Episodes from a History of Modernism*.
Opening of Portugal's major contemporary art museum, Museu de Serralves, Oporto.
Painter Gary Hume represents Britain at the Venice Biennale. Komar and Melamid represent Russia. Louise Bourgeois is awarded Golden Lion achievement award.
Exhibition 'Abracadabra: International Contemporary Art' at Tate Gallery, London.

2000 Opening of Tate Modern (Bankside) gallery on London's South Bank.

Events

1991 Threat of global warming recognized.
Gulf War breaks out. UN forces expel Iraqi forces from Kuwait.
Boris Yeltsin becomes Russian president. USSR is dissolved.
Quentin Tarantino's film *Reservoir Dogs*.
Jonathan Demme's film *Silence of the Lambs*.

1992 Ethnic violence breaks out between Muslims and Serbs in former Yugoslavia.
Bill Clinton elected Democrat president in US.
'Euro-Disney' opens in Paris.
Digital video is launched.

1993 Maastricht Treaty comes into effect. Members of European Community agree to introduce a common currency.
The Internet or 'Information Super-highway' starts to be promoted widely.
Jane Campion's film *The Piano*.
Steven Spielberg's film *Schindler's List*.

1994 Russian forces invade breakaway republic of Chechnya.
Official end of white rule in South Africa.
Robert Altman's film *Short Cuts*.
Quentin Tarantino's film *Pulp Fiction*.

1995 Serb atrocities in Srebrenica spark NATO air raids on Bosnia-Herzegovina. Dayton Accords lead to peace settlement in the region.
On 50th anniversary of Nagasaki, President Clinton announces a halt to nuclear testing.
Gaullist Jacques Chirac elected French president.
Irish poet Seamus Heaney wins Nobel Prize for Literature.

1996 IRA resumes campaign of violence in Northern Ireland.
Controversy over claims to property, confiscated from Jews by Nazis, still being held by Swiss banks 50 years after Second World War.
Daniel Liebeskind's Jewish Museum, Berlin.

1997 Tony Blair becomes Labour prime minister of Britain, ending 18 years of Conservative rule.
Evidence of global warming increases in Antarctica.
Frank Gehry's Guggenheim Museum, Bilbao, Spain.
Cloning of a sheep at Roslin, near Edinburgh, UK, highlights concerns about genetic engineering.

1998 Peace Deal set up in Northern Ireland.
US President Clinton accused of perjury after alleged sexual impropriety.
Gerhard Schröder becomes German chancellor.
The Cohen brothers' film *The Big Lebowski*.

1999 Controversy over genetically modified foods.
President Clinton acquitted of charges of perjury and obstruction of justice by US Senate.
Prolonged NATO bombing leads to Serb surrender after Serbian massacres of ethnic Albanians in Kosovo.
Massive exodus of refugees from Kosovo.

This list represents the most significant collections of artworks relevant to the text of this book.

Gallery/Museum	Website	
Australia		

Gallery/Museum	Website
Museum of Contemporary Art Sydney	www.mca.com.au
Musées Royaux des Beaux-Arts de Belgique **Musée d'Art & Musée d'Art Moderne** Brussels	www.fine-arts-museum.be
National Gallery of Canada Ottawa, Ontario	www.nationalgallery.ca
Galerie Rudolfinum Allovo Nâbo, Prague	www.mpo.cz
Carré d'Art Musée d'Art Contemporain, Nîmes	
Centre Pompidou Paris	www.cnac-gp.fr
Fondation Cartier Paris	www.paris.org/museescartier.art. contemporain
Musée d'Art Moderne, Villeneuve d'Ascq	
Musée des Beaux-Arts de Lyon Lyon	www.mairie-lyon.fr
Guggenheim Museum Berlin	www.guggenheim.org
Museum Ludwig Köln Cologne	www.museenkoeln.de
Museum of Modern Art Frankfurt am Main	www.frankfurt-business.de/mmk
Irish Museum of Modern Art Dublin	www.modernart.ie
Guggenheim Museum Venice	www.guggenheim.org
Palazzo Grassi SPA Venice	www.palazzograssi.it
National Museum of Western Art Tokyo	www.nmwa.go.jp
Museo de Arte Moderno Mexico City	www.artshistory.mx/museos/mam
Stedelijk Museum Amsterdam	www.stedelijk.nl
Museum Boijmans Van Beuningen Rotterdam Rotterdam	www.boijmans.rotterdam.nl

Country labels (left margin):
- Australia
- Belgium
- Canada
- Czech Republic
- France
- Germany
- Ireland
- Italy
- Japan
- Mexico
- Netherlands

Gallery/Museum	Website
Norway	
Astrup Fearnley Museum of Modern Art Oslo	www.af-moma.no/index_e.html
Spain	
Fundacio Antoni Tapies Barcelona	
Museo Guggenheim Bilbao	www.guggenheim.org
Museo Nacional Centro de Arte Reina Sofia Madrid	www.spaintour.com/museomad.htm
Sweden	
Moderna Museet Stockholm	www.modernamuseet.se
Switzerland	
Museo d'Arte Moderna Lugano	
UK	
Hayward Gallery London	www.hayward-gallery.org.uk
Institute of Contemporary Art London	www.ica.org.uk
Museum of Modern Art Oxford	www.moma.org.uk
Scottish National Gallery Edinburgh	www.natgalscot.ac.uk
Tate Modern (*Bankside*) London	www.tate.org.uk Includes links to Tate Britain, Tate Liverpool, and Tate St Ives
Whitechapel Art Gallery London	www.whitechapel.org
USA	
Corcoran Gallery of Art Washington DC	www.corcoran.org
Dia Center for the Arts New York	www.diacenter.org
Guggenheim Museum New York	www.guggenheim.org
The Museum of Contemporary Art Los Angeles	www.moca-la.org
Museum of Modern Art New York	www.moma.org
San Francisco Museum of Modern Art San Francisco	www.sfmoma.org
Walker Art Center Minneapolis	www.walkerart.org
Whitney Museum of American Art New York	www.whitney.org

Websites

www.artchive.com
Fully illustrated directory of artists, including Sigmar Polke, Jackson Pollock, and Andy Warhol.

www.artcyclopedia.com
Commercial site with directory of artists such as Eva Hesse and Damien Hirst, images, information about artists and movements, and listing of museums which hold the work of specific artists (with links).

www.artincontext.org
Extensive directory of artists offering images, exhibitions, information, and international museum links.

www.artnet.com
Directory of artists including images and other information. Covers Robert Rauschenberg, Art & Language, Andy Warhol.

www.eai.org
Electronic Arts Intermix website for artists working with video and new media.

www.icom.org/vimp
International Council of Museums website. Useful directory offering links to international museums and libraries, and a search facility.
www.iniva.org

The website of the Institute of International Visual Arts in London, which has a particular interest in new technologies, site-specific work, and artists from diverse cultural backgrounds.

www.lichtensteinfoundation.org
Contains links to Lichtenstein's public sculpture and murals, awards, and exhibitions.

www.marcelduchamp.net
Images, links, and information about the work of Marcel Duchamp.

www.newmedia-arts.org
A guide to new media installation art, cataloguing works from the Pompidou Centre and other European museums.

www.uwrf.edu/history/women
Illustrated directory of 300 women artists from the medieval period to the present day, with links to other relevant websites. Includes material on Frida Kahlo, Lee Krasner, and Jenny Holzer.

Picture Credits

The publisher would like to thank the following individuals and institutions who have kindly given permission to reproduce the illustrations listed below.

1. Art & Language, *VI Lenin by V. Charangovich (1970) In the Style of Jackson Pollock II*, 1980. Enamel and cellulose paint on canvas, 293 x 210 cm. Photo: Gareth Winters. Reproduced courtesy of the Lisson Gallery, London.

2. Jackson Pollock, *Guardians of the Secret*, 1943. Oil on canvas, 121.9 x 191.8 cm. Photo Ben Blackwell. Reproduced courtesy of San Francisco Museum of Modern Art, Albert M. Bender Collection. Albert M. Bender Bequest Fund Purchase. © ARS, NY, and DACS, London, 2000.

3. Jackson Pollock, *Full Fathom Five*, 1947. Oil on canvas with nails, tacks, buttons, key, coins, cigarettes, matches, etc., 129.2 x 76.5 cm. Reproduced courtesy of The Museum of Modern Art, New York. Gift of Peggy Guggenheim. Photo 2000, The Museum of Modern Art, New York. © ARS, NY, and DACS, London, 2000.

4. Renato Guttuso, *La Discussione*, 1969–70. © Tate Gallery, London, 1999/DACS, 2000.

5. André Fougeron, *Civilisation Atlantique*, 1953. Reproduced courtesy of Galerie Jean Jacques Dutko. © ADAGP, Paris, and DACS, London, 2000.

6. Barnet Newman, *Vir Heroicus Sublimis*, 1950–51. Oil on canvas, 242.2 x 513.6 cm. Photograph © 2000, The Museum of Modern Art, New York, ARS, NY, and DACS, London, 2000. Reproduced courtesy of The Museum of Modern Art, New York. Gift of Mr and Mrs Ben Heler. ©ARS, NY, and DACS, London, 2000.

7. Jean Fautrier, *La Toute Jeune Fille (Very Young Girl)*, 1942. Reproduced courtesy of Lauros-Giraudon. © ADAGP, Paris, and DACS, London, 2000.

8. Wols (Alfred Otto Wolfgang Schulze), *Manhattan*, 1948–9. Oil on canvas, 146 x 97 cm. © ADAGP, Paris, and DACS, London, 2000.

9. Jean Dubuffet, *Le Metafisyx*, 1950. Centre Georges Pompidou, Paris. Photo Jacques Faujour © ADAGP, Paris, and DACS, London, 2000.

10. Brassai, *Le Mort (Death)*, courtesy the estate of the artist.

11. Mark Rothko, *Green & Maroon*, 1953. Oil on canvas, 231.8 x 139.1 cm. Reproduced courtesy of the Phillips Collection, Washington, DC. Acquired 1957. © ARS, NY, and DACS, London, 2000. (1664)

12. Robert Motherwell, *At Five in the Afternoon*, 1949. Casein on canvas, 38.1 x 50.8 cm. Dedalus Foundation, © Estate of Robert Motherwell/VAGA, New York/DACS, London, 2000.

13. Morris Louis, *Blue Veil*, 1958–9. Acrylic resin painted on canvas, 233.05 x 396.24 cm. Courtesy of the Fogg Art Museum, Harvard University Art Museum, Gift of Lois Orswell and purchase from the Gifts for Special Uses Fund. © President and Fellows of Harvard College, Harvard University.

14. Peter Lanyon, *Bojewyan Farms*, 1951–? Oil on masonite. The British Council Collection, London. Permission of Mrs S. Lanyon.

15. Henri Michaux, *Untitled*, June 1960. Indian ink on paper, 74.9 x 109.9 cm. Photo David Heald. © Solomon R. Guggenheim Foundation, New York. Reproduced courtesy of Solomon R. Guggenheim Museum, New York. Gift of Thomas and Remi Messer, 1974. © ADAGP, Paris, and DACS, London, 2000. (74.2082)

16. Willem de Kooning, *Untitled*, 1948–9. Enamel and oil on paper on composition board, 94.8 x 127 cm. Reproduced courtesy of the Art Institute of Chicago, Mary and Earle Ludgin Collection. © ARS, NY, and DACS, London, 2000. (1981.260)

17. Marcel Duchamp, *La Boite- en-Valise*, 1941. Various materials. Reproduced courtesy of Scottish National Gallery of Modern Art,

Edinburgh. © Succession Marcel Duchamp/DACS, 2000. (GMA 3472)

18. Marcel Duchamp, *The Bride Stripped Bare by her Bachelors, Even (The Large Glass)*, 1915–23. Oil, varnish, lead foil, lead wire, and dust on two glass panels (cracked), each mounted between glass panels, with five glass strips, aluminium foil, and a wood and steel frame, 277.5 x 175.9 cm. Photo: Graydon Wood, 1997. Reproduced courtesy of the Philadelphia Museum of Art. Bequest of Katherine S. Dreier. © Succession Marcel Duchamp/DACS, 2000.

19. Robert Rauschenberg, *Bed,* 1955. Combine painting: oil and pencil on pillow, quilt, and sheet on wood supports, 191.1 x 80 x 20.3 cm. Reproduced courtesy of The Museum of Modern Art, New York. Gift of Leo Castelli in honour of Alfred H. Barr Jr. Photo © 2000 The Museum of Modern Art, New York, © Untitled Press inc./VAGA, New York/DACS, London, 2000.

20. Joseph Cornell, *Untitled (Medici Princess)*, *c.*1948. Wood box with mixed media, 44.5 x 11.4 cm. Reproduced courtesy of Joseph & Robert Cornell Memorial Foundation, Agnes Gund Collection. Photo courtesy Joseph Helman Gallery, NY.

21. Alberto Burri, *Sacco H8,* 1953. Burlap, oil, and Vinavil on canvas, 86 x 100 cm. Private collection, Italy.

22. Cy Twombly, *School of Athens*, 1961. Oil, house paint, crayon, and pencil on canvas, 190.3 x 200.5 cm. Private collection.

23. Willem de Kooning, *Woman and Bicycle,* 1952–3. Oil on canvas. 194.3 x 124.5 cm. Collection of Whitney Museum of American Art. Purchase © ARS, NY, and DACS, London, 2000.

24. Lee Krasner, *Bald Eagle,* 1955. Oil, paper, and canvas on linen, 195.6 x 130.8 cm. Collection of Audrey and Sydney Irmas, courtesy Robert Miller Gallery, New York, © ARS, NY, and DACS, London, 2000.

25. Marcel Duchamp, *Belle Haleine, Eau de Voilette,* 1921. © Succession Marcel Duchamp/DACS, 2000.

26. Jasper Johns, *Target with Plaster Casts,* 1955. Encaustic and collage on canvas with plaster casts, 130 x 111.8 x 8.9 cm. Private collection. © Jasper Johns/VAGA, New York/DACS, London, 2000.

27. Robert Morris, *I-Box,* 1962. Painted plywood cabinet covered with sculptmetal, containing photograph, 48.3 x 32.4 x 3.5 cm. Leo Castelli Collection. Photo Dorothy Zeidman. Reproduced courtesy of Solomon R. Guggenheim Foundation, New York. ©

ARS, NY, and DACS, London, 2000.

28. Jasper Johns, *Flag,* 1954–5, Encaustic, oil, and collage on fabric mounted on plywood, 107.3 x 153.8 cm. Reproduced courtesy of the Museum of Modern Art, New York. Gift of Philip Johnson in honour of Alfred J. Barr Jr. Photo 2000, The Museum of Modern art, New York, © Jasper Johns/VAGA, New York/DACS, London, 2000.

29. Jasper Johns, *Numbers,* 1966. Metallic powder and graphite wash on polyester fabric. Reproduced courtesy of the National Gallery of Art, Washington. Gift of Leo Castelli in memory of Tony Castelli, Photo Dean Beasom. © Jasper Johns/VAGA, New York/DACS, London, 2000.(1981.82.1./DR)

30. Sherrie Levine, *Fountain 5 (After Marcel Duchamp),* 1991. Cast bronze, 38 x 63.5 x 38 cm. Photo courtesy Pamela Cooper Gallery, New York. Reproduced courtesy of the artist.

31. Robert Gober, *Two Urinals,* 1986. Plaster, wire lath, wood, semi-gloss enamel. Reproduced courtesy of the artist. (86.002)

32. Henry Moore, working model for *Reclining Figure, (Internal and External Forms)*, 1951. Bronze, 53.3 cm (length). Reproduced courtesy of the Henry Moore Foundation.

33. Francis Bacon, *Study of a Baboon,* 1953. Oil on canvas, 198.3 x 137.3 cm. Reproduced courtesy of The Museum of Modern Art, New York . James Thrall Soby Bequest. Photo © 2000, The Museum of Modern Art, New York, © ARS, NY, and DACS, London, 2000.

34. Lucian Freud, *Interior near Paddington,* 1951. Reproduced courtesy of the Board of Trustees of the National Museums and Galleries on Merseyside (Walker Art Gallery).

35. Alberto Giacometti, *Standing Figure,* 1955. Pencil, 63.8 x 48.3 cm. Reproduced courtesy of the Sainsbury Centre for Visual Arts, Norwich. Photo James Austin. © 1996 Sainsbury Centre for Visual Arts, ADAGP, Paris, and DACS, London, 2000. (68/4511)

36. Germain Richier, *L'Orage (The Storm)*, 1947. Cliché Musée National d'Art Moderne, Paris. © ADAGP, Paris, and DACS, London, 2000. (1980/814)

37. Antonin Artaud, *Self-Portrait*, 1946. Pencil on paper, 55 x 54 cm. Cliché Musée National d'Art Moderne, Paris. © ADAGP, Paris, and DACS, London, 2000.

38. Arman, *In Limbo,* 1952. Broken dolls in wood and glass box, 101.6 x 30.5 cm. Galerie Beauborg, Paris. © ADAGP, Paris and DACS, London 2000.

39. Yves Klein, *Single Day Newspaper*

(November 27th 1960) incorporating photograph captioned 'The Painter of Space Hurls Himself into the Void'. © ADAGP, Paris, and DACS, London, 2000.

40. Yves Klein, *Anthropometries of the Blue Age,* 1960. Photo © Harry Shunk. © ADAGP, Paris, and DACS, London, 2000.

41. Piero Manzoni, *Manzoni with Merda d'Artista,* (at Angli Shirt Factory, Herning, Denmark), 1961. Photo Ole Bagger. Reproduced courtesy of Countessa Elena Manzoni, Herning Kunstmuseum. © DACS, 2000.

42. Joseph Beuys, *Coyote,* 1974. Performance. © DACS, 2000. Photo by Caroline Tisdall.

43. Joseph Beuys, *Filter Fat Corner,* 1962. © DACS 2000. Photograph taken in the artist's studio in Düsseldorf by Eva Beuys-Wurmbach (not preserved).

44. Georg Baselitz, *Die Grosse Nacht im Eimer (The Great Piss-Up),* 1962/3. Museum Ludwig, Köln, Stadt Köln. © Rheinisches Bildarchiv. (ML 1252)

45. Eduardo Paolozzi, *Evadne in Green Dimension,* 1952. Collage on paper. Board of Trustees of Victoria and Albert Museum, London. © Eduardo Paolozzi, 2000, all rights reserved, DACS. (19784)

46. Independent Group, *Parallel of Life & Art,* photograph of exhibition installation, ICA, London, September–October 1953. Reproduced courtesy of the Tate Gallery Archive.

47. Richard Hamilton, *$he,* 1958–61. Oil, cellulose paint, and collage on wood. © Tate Gallery 1999, London/Richard Hamilton, 2000, all rights reserved, DACS. (T01190/101)

48. Nigel Henderson, *Head of a Man,* 1956. Photo collage on paper, 168 x 131 cm. Tate Gallery, London.

49. David Hockney, *Sunbather,* 1966. Acrylic on canvas, 72 x 72 in, © David Hockney. (66B25)

50. Jim Dine, *The Car Crash* (Happening), 1960. Photo Robert R. McElroy, New York.

51. Shigeko Kubota, *Vagina Painting,* 4 July 1965. Photo George Maciunas. Reproduced courtesy of Gilbert & Lila Silverman Fluxus Collection. (04831.6/8)

52. Willem de Ridder, *European Mail-Order Warehouse/Fluxshop,* 1965. Originally arranged for photograph and reassembled 1984 by Jon Hendricks as installation, Contemporary Arts Museum, Houston, Texas. Photo Rick Gardner. Reproduced courtesy of Gilbert & Lila Silverman Fluxus Collection Foundation, New York.

53. Claes Oldenburg, *The Store,* 1961.

Reproduced courtesy of the artist. Photo Robert R.McElroy.

54. Roy Lichtenstein, *Big Painting VI,* 1965. Oil and magna on canvas, 233 x 328 cm. Photo Walter Klein. Courtesy of Kunstsammlung Nordrhein-Westfalien, Düsseldorf. © Estate of Roy Lichtenstein/DACS, 2000.

55. Andy Warhol, *Cow Wallpaper,* 1966. Silkscreen ink on paper, 111.8 x 78.2 cm. © The Andy Warhol Foundation for the Visual Arts, Inc/DACS, 2000.

56. Andy Warhol, *Five Deaths – Seventeen Times in Black and White,* from *Disasters* series, 1963. Silkscreen print on canvas, 217 x 418 cm. Photo Martin Buhler. Reproduced courtesy of Offentliche Kunstsammlung, Basel Kunstmuseum. © The Andy Warhol Foundation for the Visual Arts, Inc./DACS, 2000. (G.1972.2)

57. Ed Ruscha, page from *Twentysix Gasoline Stations* (Artist's Book*),* 1963. Reproduced courtesy of the artist.

58. Weegee, '*Sudden Death for One ... Sudden Shock for the Other ...' Mrs Dorothy Reportella, Accused of Hitting Bread Truck with Her Car, September 7, 1944* Photograph. Reproduced courtesy of Hulton Getty Picture Collection, London. (07.09.44)

59. James Rosenquist, *Painting for the American Negro,* 1962–3. Oil on canvas, 203 x 533 cm. Reproduced courtesy of National Gallery of Canada, Ottawa. Purchased 1967. © James Rosenquist/VAGA, New York/DACS, London, 2000. (15292)

60. Robert Rauschenberg, *Retroactive I,* 1964. Oil, silkscreen, ink on canvas. 213.4 x 152.4 cm. Reproduced courtesy of Wadsworth Atheneum, Connecticut. Gift of Susan More Hilles. © Untitled Press Inc/VAGA, New York/DACS, London, 2000.

61. Ed Keinholz, *Five Car Stud,* 1969–72. Tableau: cars, plaster casts, guns, rope, masks, chainsaw, clothing, oil pan with water and plastic letters, paint, polyester resin, styrofoam rocks, and dirt. Dimensions variable. Photo Robert C. Bucknam. Kawamura Memorial Museum of Art, Sakura, Japan.

62. Öyvind Fahlström, *World Politics Monopoly,* 1970. Variable painting, magnetic elements, acrylic on magnets, vinyl on board, 91.4 x 128.3 cm. Private collection. © DACS, 2000.

63. Sigmar Polke, *Bunnies,* 1966. Acrylic on linen, 149.2 x 99.1 cm. Photo Lee Stalsworth. Courtesy of Hirshhorn Museum and Sculpture Garden, Smithsonian Institute, Washington, DC. Joseph H. Hirshhorn Bequest and Purchase Funds, 1992.

64. Ad Reinhardt, *A Portend of the Artist as a Yhung Mandala*, 1955. Collage of ink and paper, 51.4 x 34.3 cm. Collection of The Whitney Museum of American Art, New York, Anonymous Gift. Photo © 1997, Whitney Museum of American Art. (76.45)

65. Frank Stella, '*Die Fahne Hoch!*', 1959. Enamel on canvas, 308.6 x 185.4 cm. Reproduced courtesy of Whitney Museum of American Art, New York. © ARS, NY, and DACS, London, 2000.

66. Donald Judd, *Untitled*, 1966-8. Stainless steel and amber plexiglass, 86.4 x 86 x 86 cm. Reproduced courtesy of Milwaukee Art Museum, WI; Layton Art Collection purchase. © Estate of Donald Judd/VAGA, New York/DACS, London, 2000.

67. David Smith, *Lectern Sentinel*, 1961. Stainless steel, 44.8 x 84 x 52 cm. Whitney Museum of American Art. Gift of the friends of the Whitney Museum and purchase. © Estate of David Smith/VAGA, New York/DACS, London, 2000.

68. Anthony Caro, *Prairie*, 1967. Steel painted matt yellow, 96.5 x 582 x 320 cm. Collection of Lois & Georges De Meril, USA, c/o National Gallery of Art, Washington, DC. © Anthony Caro/VAGA, New York/DACS, London, 2000.

69. Robert Morris, Installation at the Green Gallery, New York 1964–5. Photograph courtesy of Solomon R. Guggenheim Museum. © ARS, NY, and DACS, London, 2000.

70. Sol Lewitt, *Circles, Grids, Arcs from Four Corners and Sides*, 1973. Detail of wall drawing in pencil. Installation, L'Attico Gallery, Rome. Draughtsmen: Climbo, Piccari, Battista, Pranovi. © ARS, NY, and DACS, London, 2000.

71. Carl Andre, *144 Magnesium Square*, 1969. 1 x 366 x 366 cm. © Tate Gallery, London 1999/Carl Andre/VAGA, New York/DACS, London, 2000. (T01767/101)

72. Agnes Martin, *Flower in the Wind*, 1963. Oil and pencil on canvas, 190.5 x 190.5 cm. Daros Collection, Switzerland.

73. Bridget Riley, *Blaze*, 1962. Emulsion on board, 109 x 109 cm. Private collection. © Bridget Riley, all rights reserved. Photo courtesy Karsten Schubert, London.

74. James Turrell, *Sky Window I*, 1975. Skylight and interior ambient light. Collection Guiseppe Panza di Biumo, Varese, Italy.

75. Eva Hesse, *Accession II*, 1967. Galvanized steel, 78 x 78 x 78 cm. Reproduced courtesy of Detroit Institute of Arts. Founders Society Purchase, Friends of Modern Art Fund and Miscellaneous Gifts Fund. Photo © Detroit Institute of Arts. (79.34)

76. Louise Bourgeois, *Double Negative*, 1963. Latex over plastic, 49.2 x 95.2 x 79.6 cm. Collection of Kroller–Muller Museum, Otterlo. Photo P. Bellamy. Reproduced courtesy Cheim & Read, New York, © Louise Bourgeois/VAGA, NY/DACS, London, 2000.

77. Richard Serra, *Hand Catching Lead*, 1968. Film still. © ARS, NY, and DACS, London, 2000.

78. Bruce Nauman, *Dance or Exercise on the Perimeter of a Square*, 1967–8. Film still. Reproduced courtesy of Electronic Arts Intermix, New York, © ARS, NY, and DACS, London, 2000.

79. Bruce Nauman, *My Last Name Exaggerated Fourteen Times Vertically*, 1967. Neon tubing with clear glass tubing suspension frame, 160 x 83.8 x 5.1 cm. Solomon R. Guggenheim Museum, New York, Panza Collection. Extended Loan. Reproduced courtesy Sperone Westwater, New York. © ARS, NY, and DACS, London, 2000.

80. Richard Deacon, *Untitled*, 1980. Galvanised steel and concrete, 138 x 374 x 138 cm. Photo Richard Deacon. Private collection, London. Reproduced courtesy of the artist.

81. Rachel Whiteread, *House*, 1993. Photo: John Davies.

82. Daniel Buren, *Untitled*, 1968. © Daniel Buren, ADAGP, Paris, and DACS, London, 2000.

83. Asgar Jorn, *Le Canard Inquiétant*, 1959. Oil on old canvas, 53 x 54.5 cm. Photo Lars Bay. Reproduced courtesy of Silkeborg Museum of Art, Denmark.

84. Marcel Broodthaers, *Musée d'Arte Moderne, Département des Aigles, Section des Figures*, 1972. Reproduced courtesy of Maria Gilissen. © DACS, 2000.

85. Gordon Matta Clark, *Splitting*, 1974. Black and white photo-collage, 101.6 x 76.2 cm. Reproduced courtesy of Estate of Gordon Matta Clark/David Zwirner Gallery, New York.

86. Luciana Fabro, *Italia d'Oro (Golden Italy)*, 1971. Reproduced courtesy of the artist.

87. Jannis Kounellis, *Horses*, 1969. mixed media, black and white photo. Private collection. Reproduced courtesy of Bridgeman Art Library, London.

88. Robert Smithson, *Stills from Spiral Jetty Film*, 1970. Gelatin-silver prints, 3 parts. Part 1: 64.1 x 110.5 cm. Collection of Museet for Samtidstkunst, The National Museum for Contemporary Art, Norway. Reproduced

courtesy James Cohan Gallery, New York. ©
Estate of Robert Smithson/VAGA, New
York/DACS, London, 2000,
89. Ian Hamilton Finlay, *Wave Rock,* 1966.
Private Collection.
90. Walter de Maria, *Lightning Field,* 1977.
Courtesy Dia Center for the Arts. Photo John
Cliett.
91. On Kawara, *9 Ago 68,* 1968. Liquitex on
canvas, 20.5 x 25.5 cm. Photo Rudolf Nagel.
Reproduced courtesy of Museum für
Moderne Kunst, Frankfurt am Main. (1990/2)
92. Victor Burgin, *Possession,* 1976. Photo-
lithographic print, 109.2 x 109.2 cm. Original
in colour; 500 copies posted in the streets in
centre of Newcastle Upon Tyne, Summer
1976. 'Shocks to the System' exhibition, South
Bank Centre Foyer Galleries, 12 March–24
April 1991. Reproduced courtesy of Arts
Council Collection, Hayward Gallery,
London.
93. Bernd & Hilla Becher, *Typology of Water
Tower* (groups A, B, C, and D), 1972. Six suites
of nine photographs, each 40 x 29.8 cm.
Reproduced courtesy of the Eli & Edythe L.
Broad Collection, Santa Monica, CA.
94. Judy Chicago, *The Dinner Party.* Wing
Three, featuring the Virginia Woolf and
Georgia O'Keefe place-settings, 1979. Mixed
media, 121.9 x 106.7 x 7.6 cm. Photo © Donald
Woodman, © Judy Chicago Collection.
95. Mary Kelly, *Post-Partum Document,* 1983.
From *Documentation I, Analysed Faecal Stains
and Feeding Charts (prototype),* 1974. Perspex
units, white card, diaper lining, plastic
sheeting, paper, ink, 28 x 35.5 cm. Photo Kelly
Barrie. Collection of the Generaldi
Foundation, Vienna. Reproduced courtesy of
the artist. © DACS, 2000.
97. Adrian Piper, *Self-Portrait Exaggerating
my Negroid Features,* 1980. Pencil drawing, 25.4
x 20.3 cm. © Adrian Piper.
98. Carolee Schneeman, *Interior Scroll,* 1975.
Performance. Photo by Anthony McCall. ©
Carolee Schneeman.
*99. Vito Acconci, Step Piece (Steps: Stepping-Off
Place),* 1970. Activity/performance, Acconci
Studios, New York, 4 months (February,
April, July, November); varying times each
day. Reproduced courtesy of Barbara
Gladstone Gallery.
100. Gilbert & George, *The Alcoholic,* 1977.
Reproduced courtesy of the artists.
101. Cindy Sherman, *Untitled Film Still, No. 6,*
1977. Black and white photograph, 25.4 x 20.3
cm, edition of 10. Reproduced courtesy of the
artist/Metro Pictures, New York.
102. Sigmar Polke, *This is How You Sit*

Correctly (after Goya), 1982. Acrylic, 200 x 180
cm. Private collection.
103. Philip Guston, *Talking,* 1979. Oil on
canvas, 174 x 198 cm.
104. Leon Golub, *Mercenaries II,* 1979. Acrylic
on canvas, 305 x 366 cm. Photo Phillipe
Bérard. Reproduced courtesy of Montreal
Museum of Fine Arts Collection. Horsley and
Annie Townsend bequest. (1983.1)
105. Anselm Kiefer, *Shulamite,* 1983. Oil,
acrylic, emulsion, shellac, and straw on canvas,
with woodcut, 290 x 370 cm. Reproduced
courtesy of the artist.
106. Hans Haacke, *Taking Stock (Unfinished),*
1983–4. Oil on canvas, 241.3 x 205.7 x 17.8 cm.
Photo Zindman/Fremont. Lila and Gilbert
Silverman Collection. © DACS, 2000/VG
Bild-Kunst.
107. Jenny Holzer, *Truisms: Abuse of Power
Comes as No Surprise* (T-shirt modelled by
Lady Pink), 1977–9. Photo Lisa Kahane.
Reproduced courtesy of the artist. © Jenny
Holzer. (S1.24.01)
108. Richard Prince, *Untitled (Cowboy),*
1991–2. Ektacolor print, 121.9 x 182.9 cm.
Reproduced courtesy Barbara Gladstone
Gallery, New York. (RP502)
109. Malcolm Morley, *The Ultimate Anxiety*,
1978. Oil on canvas, 184.2 x 248.9 cm. Courtesy
of Sperone Westwater, New York.
110. Eric Fischl, *The Old Man's Boat and the Old
Man's Dog,* 1982. Oil on canvas, 213.4 x 213.4 cm.
Private collection. Courtesy Mary Boone
Gallery, New York,
111. Gerhard Richter, *Dead (Tote) from October
18, 1977,* 1988. Oil on canvas, 62 x 62 cm.
Reproduced courtesy of The Museum of
Modern Art, New York. Purchase. Photo ©
2000, The Museum of Modern Art, New
York.
112. Vija Celmins, *Untitled (Ocean with Cross
#1),* 1971. Graphite on acrylic ground on paper.
Collection of Edward R. Broida Trust.
Courtesy of the artist/Anthony d'Offay
Gallery, London.
113. Gerhard Richter, *July 1983.* Oil on canvas,
250 x 250 cm. Private collection.
114. Terry Atkinson, *The Stone Touchers I, Ruby
and Amber In The Gardens of their old Empire
history-dressed Men,* 1984–5. Acrylic on canvas.
213 x 152 cm. Reproduced courtesy of Gimpel
Fils. Private collection, Vancouver.
115. Jimmie Durham, *Bedia's Stirring Wheel,*
1985. Various materials, 121.9 x 48.3 cm. Photo
Fred Scruton, New York. Collection of Karen
& Andy Stillpass, Cincinnati. Reproduced
courtesy of Nicole Klagsbrun Gallery, New
York.

116. Lorna Simpson, *Guarded Conditions*, 1989. Eighteen Polaroid colour prints with 21 plastic plaques, plastic letters, 231.1 x 332.7 cm, Museum of Contemporary Art, San Diego, Museum purchase. Contemporary Collectors Fund, 1990. (12.1-28)

117. Jeff Koons, *Made in Heaven*, 1989. Lithograph billboard, 152.4 x 228.6 cm. Reproduced courtesy of Jeff Koons, New York. © Jeff Koons.

118. Tony Cragg, *Britain Seen from the North*, 1981, Purchased 1982. © Tate Gallery 1999, London.

119. Rosemarie Trockel, *Balaclavas*, 1986. Series of five woollen hoods. Reproduced courtesy of Monika Sprüth Gallery, Cologne. © DACS, 2000.

120. Mike Kelley, *More Love Hours Than Can Ever Be Repaid*, 1987. Handmade stuffed animals and afghans sewn on canvas backing. Reproduced courtesy of the artist/Metro Pictures, New York.

121. Helen Chadwick, *Loop my Loop*, 1991. Courtesy of the Zelda Cheatle Gallery. © The estate of Helen Chadwick.

122. Richard Wilson, *20/50*, 1987. Installation: used sump oil, steel. Dimensions variable. Photo Anthony Oliver. Reproduced courtesy of the Saatchi Gallery, London.

123a. Damien Hirst, *In and Out of Love (White Paintings & Live Butterflies)*, 1991. Installation. Five white canvases with pupae, steel shelves with potted flowers, bowls of sugar-water solution, table, radiators, humidifiers, and live butterflies. Dimensions variable. Reproduced courtesy of Jay Jopling, White Cube Gallery, London.

123b. Damien Hirst, *I Love You*, 1994–5. Gloss household paint and butterflies on canvas, 2.14 x 2.14 m. Photo courtesy Jay Jopling (London).

124. Jeff Wall, *Dead Troops Talk (A Vision after an Ambush of a Red Army Patrol near Moqor, Afghanistan, Winter 1986)*, 1991–2. Transparency in lightbox, 229 x 417 cm. Collection David Pincus, Philadelphia. Reproduced courtesy of the artist.

125. Zofia Kulik, *From the Series Columns: Right Sword, Left Garland*, 1992. 300 x 850 cm. Courtesy of the artist.

126. Sarah Lucas, *Au Naturel*, 1994. Mattress, water-bucket, melons, oranges, and cucumber, 84 x 167.6 x 144.8 cm. Reproduced courtesy of the Saatchi Gallery, London. (LUC.0011)

127. Gillian Wearing, *Dancing in Peckham*, 1994. Videotape; 25 mins, colour, silent. Government Art Collection, London/ Southampton City Art Gallery. Courtesy Maureen Paley Interim Art.

128. Yinka Shonibare, *How Does a Girl Like You Get to be a Girl Like You?*, 1995. Installation of three costumes of wax-print cotton textiles tailored by Sian Lewis, approx. height, 168 cm. Courtesy of Stephen Friedman Gallery.

129. Louise Bourgeois, *Red Room (Child)*, 1994. Installation: mixed media, 210.8 x 353 x 274.3 cm. Collection Musée d'Art Contemporain de Montréal. Photo Marcus Schneider. Reproduced courtesy of Cheim & Reid, New York. © Louise Bourgeois/VAGA, New York/DACS, London, 2000.

130. Matthew Barney, *Cremaster 4*, 1994–5. Video still. Photo Michael James O'Brien. Reproduced courtesy of Barbara Gladstone Gallery, New York.

The publisher and the author apologize for any errors or omissions in the above list. If contacted they will be pleased to rectify these at the earliest opportunity.

Index